CANADIAN
ART
in the
Twentieth
Century

Joan Murray

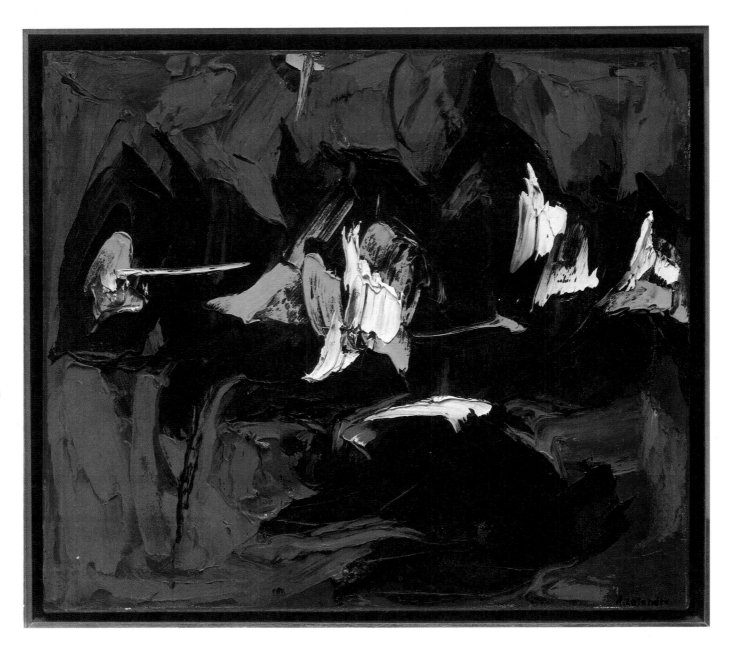

2

Fig. 116. Rita Letendre (b. 1929)
Retrovision, 1961
Oil on canvas, 45.7 x 50.8 cm
Private Collection

Joan Murray

CANADIAN ART
in the Twentieth Century

DUNDURN PRESS
TORONTO • OXFORD

Editor: Sarah Bowser
Design: V. John Lee
Printer: Transcontinental Printing Inc.

Canadian Cataloguing in Publication Data

Murray, Joan
 Canadian art in the twentieth century

Includes bibliographical references and index.
ISBN 1-55002-332-2

1. Painting, Canadian. 2. Painting, Modern — 20th century — Canada — History. I. Title.
ND245.M855 1999 759.11 C99-932166-8

1 2 3 4 5 03 02 01 00 99

We acknowledge the support of the **Canada Council for the Arts** for our publishing program. We also acknowledge the support of the **Ontario Arts Council** and we acknowledge the financial support of the Government of Canada through the **Book Publishing Industry Development Program** (BPIDP) for our publishing activities.

Care has been taken to trace the ownership of copyright material used in this book. The author and the publisher welcome any information enabling them to rectify any references or credit in subsequent editions.

J. Kirk Howard, President

Printed and bound in Canada.

 Printed on recycled paper.

Dundurn Press
8 Market Street
Suite 200
Toronto, Ontario, Canada
M5E 1M6

Dundurn Press
73 Lime Walk
Headington, Oxford,
England
OX3 7AD

Dundurn Press
2250 Military Road
Tonawanda NY
U.S.A. 14150

Table of Contents

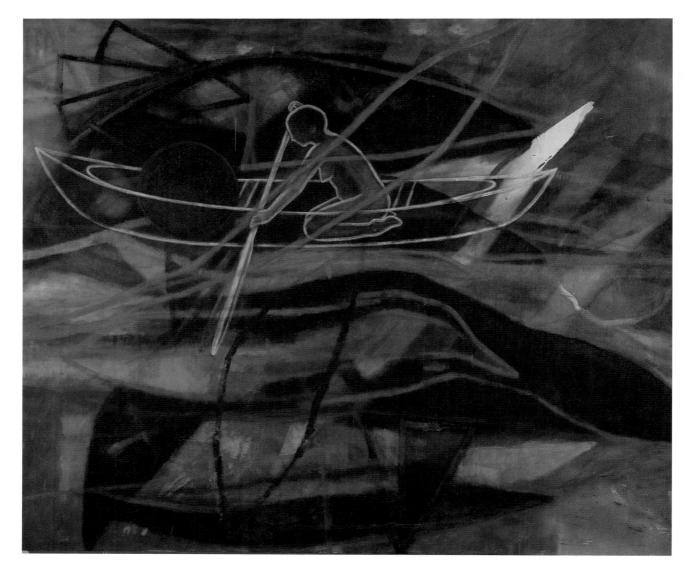

Fig. 1. Landon Mackenzie (b. 1954)
Canoe/Woman, 1987-1988
Acrylic on canvas, 152.4 x 182.9 cm
(approx.)
Private Collection

6

Introduction

Place is the dominant feature of civilizations, writes John Ralston Saul in *Reflections of a Siamese Twin* (1997). A great deal of culture is born from sharing a place. It determines what people can do, how they live and create their culture. Saul believes that place takes on a conscious importance for people who live on the geographic margins as we do in Canada. In this country, we have an English-speaking empire and a French-speaking empire. The art created by the two groups interacts. That the United States is next door creates an intense nearby cultural presence. Mexico, too, has its influence.

Time is the crucial factor in our sense of place: it is the quality without which we cannot experience anything. Canadian art has its own time and place, its own fabric and texture. Has it its own favourite national symbols? The beaver, the maple leaf, the canoe? None of these is really national in the sense of being pervasively present across the country; none carries the country along with it as a whole. Take the canoe, for instance. In the exhibition *In the Wilds*, at the McMichael Canadian Art Collection in Kleinburg in 1998, curator Liz Wylie focused on the canoe as a symbol — or cliché — that has permeated Canadian culture and art. However, the undecked, bark-covered boat, the model for today's typical Canadian canoe, was a regional variant. In that respect, as writer John Barber has suggested, the Canadian canoe is exactly like the maple leaf, "which comes from a tree that, west of Ontario, is either rare and shrubby or unknown."[1]

Even the word canoe is not from a North American aboriginal language; it comes from the Caribbean Arawak and means "boat."[2] Yet the notion of a national icon strikes a chord; canoeing experience enters or informs the work of many artists. For Canadians, the canoe serves as a barque similar to the *soul boat* of the Egyptians — a boat that carries the gods, the spirits, the shaman.[3] It is a symbol that, like the beaver and maple leaf, acts as a link between Canadian art and the wilderness, which, for many, is the significant aspect of Canadian art.

You don't have to read Canadian literature or history to understand the allure of the environment. Anyone who has ever stepped outside his front door knows that this is a part of Canada that will not, we hope, degrade and change. In art, the aura, the authentic atmosphere around the original may vanish; the image of a specific place, time, and season endures.

"Environments are not passive wrappings, but are, rather, active processes which are invisible," wrote Marshall McLuhan.[3] Art reflects the environment in which it is made but as art is made, it alters us and future art. Tom Thomson painted Algonquin Park, thereby providing a template for future nature painters, but in the process of seeing Algonquin Park through his images, Canadians come to understand nature in a different way, a way which in time forms its own myth. To understand this process, it is necessary to understand not only the place art holds in the nation's values, but the way artists maintain and pass on their beliefs. Each work of art is not only a study of style changes and techniques; it is also a many-layered meditation on the vicissitudes and pleasures of the environment. Beyond doubt, the accepted myth of our environment is in some measure the creation of our artists. It is also, now, part of our history.

Many twentieth-century histories of world art begin with Picasso's *Demoiselles d'Avignon*, conceived in 1906 and fin-

ished (some would say abandoned) during the succeeding year. In music, Arnold Schoenberg, the Austrian-born composer, had by 1909 arrived at *atonality*; in 1923, he introduced to the world his method of composing with twelve notes. I locate the beginning of Canadian art in the twentieth century with an account of the changes wrought by Post-Impressionism.

In 1929, at the Museum of Modern Art in New York, curator Alfred Barr, in a memorable image, described the progress of art as a torpedo: the tail of the torpedo is contemporary art; its forward flight creates the new definitions of future art. What artists seek out defines where the century begins its art. In Canada, we look to the achievement of individuals such as Thomson, but Thomson's work grew out of a distinctive art movement: — Post-Impressionism, spearheaded in Canada by four great pioneers: James Wilson Morrice, John Lyman, David Milne, and Lawren Harris. For these individuals, picture-making was the main subject, a way of working that defines the modern period.

For these artists, the heroes were the formal innovators among the European Post-Impressionists, among them Paul Cézanne, who wished "to make of Impressionism something solid and enduring, like the art of the museums." Cézanne, Gauguin, and van Gogh provided a model of artistic freedom to North Americans, a way of expressing their personal vision. Post-Impressionism, which expanded upon qualities of colour, simplifying form, and creating a cohesive structure, was the initial phase of modern art in Canada.

Canadian art in the twentieth century offers substantial if limited riches. It's a multifaceted phenomenon, which mostly lagged behind developments in Europe, where by 1920, the date of the founding of the Group of Seven, Pablo Picasso had already worked his way past Cubism to his Classical period. Though not so advanced, Canadian art has its own vitality, flair, and its own mythology, which from the beginning of the century concerned the environment.

8　　Early in the century, Canadian life was basically rural. This self-image lingered and was made over into pioneering adventure by Tom Thomson and the Group of Seven. Distilled in early abstract work, a reference to the environment emerges, though only occasionally, in the art of later affiliates of abstraction and passes like an echo into the tradition of Canadian art. Even today, Canadian artists pursue this theme repeatedly, though by now it is symbolically ambivalent, more a spiritual attachment for a nation that views itself as well aware of its surroundings.

The development of Canadian art is marked by great contradictions and counter distinctions, endless experimentation and innovation. At the start of the century, the term Tonalism describes the low-toned work of progressive painters; this moment in art is followed by Post-Impressionism, which eliminates tonal modelling and introduces colour high in key. The pioneers of modernism change the way Canadians look at art, as did Tom Thomson and the Group of Seven. In the 1920s in Canada, artists begin to approach abstraction but, with the 1930s and 1940s, the social aspect of art comes to the fore, as well as a shifting relationship between mechanization and the natural world. To the post-war period, Abstract Expressionism offers a healing rationale based on the individual and nature; in the 1960s and 1970s, artists re-introduce nature and figuration. Expanding on possibilities inherent in abstraction, they create works of Minimal and Conceptual art, or using popular culture, Pop art. The 1970s are an especially fruitful period of art in Canada, a time filtered through a different sensibility, one perhaps shaped by its orientation to practices considered "alternate" though the strategies of art include representation in all its myriad forms. We are still undergoing the effects of this redefinition though by the late 1970s, the idea of modernism

is challenged by Post-Modernism, an art multiple in discourse and related in a complex way to its context.[5] The concept of the environment is only one marker among many ways of looking at the circumstances of art; stress is laid by artists on the impermanence and contingency of time. Art today is in transition, an art in process, open to change and the unexpected. It is marked by fresh insights and approaches and focuses on radically divergent subjects. Artists challenge the usual expectations of what they can or should be doing in the world. These new images could be a turning point, and likely are, to the start of something completely different.

In this book, I address stylistic developments at the start of the chapter, followed by a discussion of individuals or groups of artists. In form, the discussion in the book, designed as a long trek through the history of Canadian art, is shaped like a widening path.

In preparing this text, I have been greatly helped by scholars and curators who assisted with information about difficult points along the way. Liz Wylie of the University of Toronto kindly read the entire manuscript; Gerta Moray at the University of Guelph offered pointers on Emily Carr, Marnie Fleming on contemporary Canadian Art. Joyce Millar in Montreal read chapters: all three offered suggestions, as did Charles C. Hill, Denise Leclerc, and Rosemary Tovell of the National Gallery of Canada, and many curators, directors, and registrars of galleries across the country, critics, and artists mentioned in the book. I thank them for their help. On the McLaughlin staff, Linda Jansma and Melanie Johnston offered assistance. I am deeply grateful to Isabel McLaughlin for her financial assistance with the colour reproductions: without her participation, this volume would have lacked its present vivid appearance. I would also like to thank the following individuals and public and private galleries for their help in supplying photographs: Serge Vaisman of Art 45, Montreal; Felicia Cukier of the Art Gallery of Ontario, Toronto; Rachel Brodie of the Beaverbrook Art Gallery, Fredericton; Peter Blum of the Peter Blum Gallery, New York; Jacques Bellefeuille and Mark Lanctôt of Galerie de Bellefeuille, Montreal; Bruce Dunbar of the Edmonton Art Gallery; Mira Godard and John Kinsella of the Mira Godard Gallery, Toronto; Susan Hobbs of Susan Hobbs Gallery Inc., Toronto; Catriona Jeffries of Catriona Jeffries Gallery, Vancouver; Claire Christie of Olga Korper Gallery, Toronto; Barry Fair of the London Regional Art and Historical Museums, London; Stephen Long of Long Fine Art, New York; Bruce H. Anderson of the MacKenzie Art Gallery, Regina; Rod Green of Masters Gallery Ltd., Calgary; Karen Eckhart of the Mendel Art Gallery, Saskatoon; Linda-Anne D'Anjou of the Montreal Museum of Fine Arts; Paulette Duquette of the Musée d'Art Contemporain de Montréal; Mayo Graham, France Duhamel, and Raven Amiro of the National Gallery of Canada, Ottawa; Jared Sable and Patrizia Libralato of the Sable-Castelli Gallery, Toronto; Lissa McClure of the Jack Shainman Gallery, New York; Miriam Shiell of Miriam Shiell Fine Art Ltd., Toronto; Susan Robertson of Sotheby's, Toronto; Anneke Shea Harrison of the Winnipeg Art Gallery; Peter Ohler of Peter Ohler Fine Arts; and Ash Prakash.

One last word is necessary: I made a concerted effort to trace copyright holders for art works reproduced in this book and contacted them if I could. Information about omissions will be gratefully received.

Joan Murray,
Oshawa, 1999

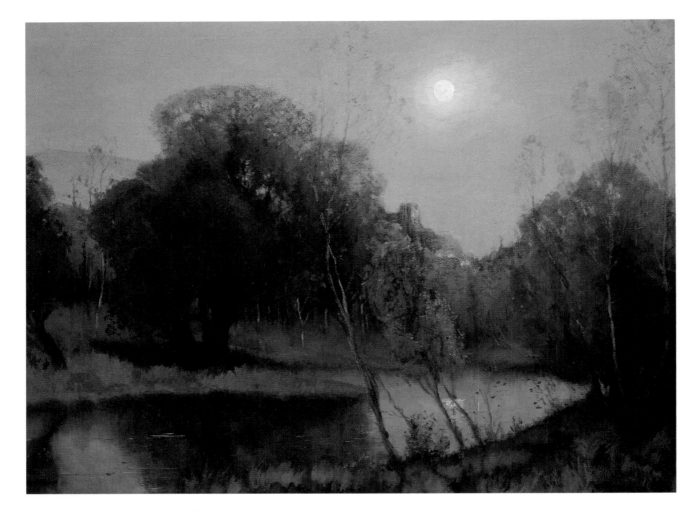

10

Fig. 2. Archibald Browne (1866-1948)
The Mill Stream, Twilight, 1911
Oil on canvas, 84.3 x 109.7 cm
Robert McLaughlin Gallery, Oshawa
Photo: T.E. Moore

Tonalism to Post-Impressionism

anada in the early part of the century was still largely wilderness and raw agricultural frontier. For Canada, the centre of the art world was Europe, and many of our young artists travelled to Paris or London to learn about the most progressive art of the day. The advanced art of the new century as it was displayed by Canadian artists was less a concerted movement than a convergence of styles — "Tonalism." The American art critic Charles Caffin (his *The Story of American Painting* was published in 1907) defined the term as "intimacy and expressiveness interpreting specific themes in limited color scales and employing delicate effects of light to create vague suggestive moods."[1] Flourishing from about 1880 to 1915, Tonalism was manifested chiefly, but not exclusively, in landscapes executed with soft painterly application and muted colour harmonies. It had two principal tributaries: the Canadian followers of the French Barbizon School, such as William Brymner, and the followers of Aestheticism, like Archibald Browne who trained in Scotland and Paris before moving to Toronto in 1888. Tonalists tended to emulate one style or the other or to combine features of both. Some Tonalist works also reveal aspects of Symbolism, the French literary and artistic movement that advocated expression of otherworldly, imaginary, even psychological experience to awaken feeling.

Certain qualities, such as radiance or the duality of light and dark, have long histories of symbolic meaning in Western culture. In Tonalism, light appears subtly as the gleam of the moon reflected on the surface of a stream or distant building. Poetry is found most often in fugitive moments, these painters seem to say. Artists depict the land as a source of dreams, with weightless and vaguely silhouetted forms and luscious but muted colour. They viewed paintings more as "arrangements" or harmonies than factual reports. Archibald Browne's *The Mill Stream, Twilight* (1910-1911, fig. 2), for instance, evokes a peaceful moonlit scene of stream and distant castle.

That such a moment in art could occur at a time when Canada was experiencing increasing industrialization and urbanization suggests the nostalgia felt by the art audience for an earlier age. The art that was being made was

an idyllic hymn to lost innocence or to the end of an era.

The effect of using such dim light was to turn the painting away from naturalism so that it became an abstract emblem of contemplation in calming tones of brown, orange, dark green, and turquoise, in a generally greyed range. The analysis of the way light fell — or didn't fall — on the subject expanded the imaginative horizon of both artist and viewer. Tonalism's way of evoking the world had a liberating effect, much like abstraction later in the twentieth century, for which it was the precursor. Through the pathway of Tonalism passed many a painter who later developed into an Impressionist or even after a period of time spent exploring the possibilities of colour, a Post-Impressionist. However, the low-key effects of Tonalism were criticized by painter and art critic J.A. Radford who wrote that it was a dreamy, non-committal, low-toned, washy style. He continued:

> all things are grey and ... without form and void; a smudge of greenish grey and a perpendicular stalk is a willow; a brown smear with a darker stalk, an oak; a round daub of orange in a yellow sky, a rising moon. Figures must be formless and legless, sheep and cattle must merge without the semblance of an outline into the surrounding fog. And this is supposed to represent the verdant mead of the poets. The true believer goes into a state almost hypnotic over a spot of dim orange surrounded by dark purple and supported by two or three olive green trees like cabbage, and that is called "Sunset."[1]

Despite such adverse comment, more progressive artists in Canada advocated tonal effects. Several of them, along with critics and collectors interested in the new work, grouped around the painter Edmund Morris to form the Canadian Art Club in Toronto (1907-1915) (fig. 3).

Most of the members of the group trained in France, and several of the artists from Quebec had rarely shown their work in Canada. Of the group, James Wilson Morrice, who studied at the Académie Julian and later under the French painter Henri Harpignies (1819-1916), was best known internationally, largely through exhibitions in Paris like the annual Salon d'Automne. In 1909, Louis Vauxcelles, a leading French critic, wrote that since Whistler's death in

1903, Morrice had become the North American painter who achieved in France the "most notable and well-merited place in the world of art."[3] The member-ship of the Club included Franklin Brownell, an American with French training who taught art in Ottawa; Archibald Browne; New York-based Horatio Walker, the Millet-inspired painter of habitant sub-jects who achieved major success in the United States; and Homer Watson.[4]

For seven years, the Canadian Art Club in Toronto grew to include painters like William Brymner; William H. Clapp, a stu-dent of Brymner's before he went to Paris; Ernest Lawson, a Halifax-born painter who became a major member of the American Impressionist school; and Suzor-Côté,

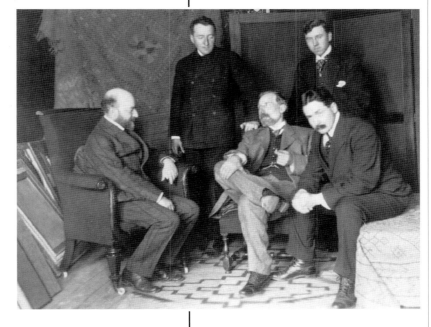

Paris-trained (at the Académie Julian in 1891), who, from 1907, made bronzes that showed the texture of the material with atmospheric effect and a feeling of action much like his Impressionist canvases. Sculptor-members included A. Phimister Proctor and Walter Allward. Proctor, a Canadian living in the United States and a friend of President Theodore Roosevelt, sculpted bronze depictions of the vanishing wildlife of the Northwest.

Later members such as Clapp, Lawson, and Suzor-Côté were more artisti-cally progressive than the club's founders. Although they used a tonal, atmos-pheric style in their early work, by the time they showed with the Club, they were Impressionists with a virtuoso technique aimed at representing the appearance of the world out-of-doors as it is affected by light, its reflection, and atmosphere. Suzor-Côté was particularly successful in combining vivid colour with a long-term project in which he documented snow-bordered rivers (fig. 4).

To many of the artists whose work was regarded as experimental, the opportunity to exhibit in Canada for the first time formed their initial attrac-tion to the Club, but they soon began to have doubts about the enterprise. They feared the works might not be sold, crating and shipping involved

Fig. 3. Members of the Canadian Art Club (from left) James Wilson Morrice, Edmund Morris, Homer Watson, Newton MacTavish, Curtis Williamson
Photograph courtesy of the Edward P. Taylor Reference Library and Archives,
Art Gallery of Ontario, Toronto

13

expense, and worse, nobody would understand their art. "I have not the slightest desire to improve the taste of the Canadian public," Morrice wrote Morris from Paris in 1911.[5]

With the death of Morris through an unfortunate accident — he drowned in 1913 in the St. Lawrence while on a sketching trip to Portneuf, Quebec — the Club lost its momentum. However, the shared cultural assumptions of the group had important repercussions for the future. It was the first group in Canada that joined together as a catalyst for artistic change and to present new developments in art to the Canadian public.

Some of the artists, such as Watson and Curtis Williamson, as they developed, recalled their Tonalist source. Others turned to the subcurrents that reflected bolder representations of reality that would in time reach out to changes sweeping over world art. Artists, during the first two decades of the century, influenced by the Impressionist style, or in reaction to it, invented a new visual language: Post-Impressionism. The term is applied to the development of various trends in painting in the period around 1880 to 1905. British art critic Roger Fry coined the name as the title of an exhibition in 1910, which was dominated by the figures of Cézanne, Gauguin, and van Gogh, who are considered the central figures of Post-Impressionism. The signs of Post-Impressionism are as follows: the elimination of tonal modelling, incidental detailing and depth progression following strict rules of perspective. Art became preoccupied with pictorial structure, design became flatter and more decorative with a strong linear emphasis. In the work of some artists, colour became bolder and more high-keyed, and artists found in it creative rather than descriptive possibilities. The result was a growing freedom of handling. The time of day changed: nocturnes brightened to daylight.

The representative figure of the introduction of Post-Impressionism into

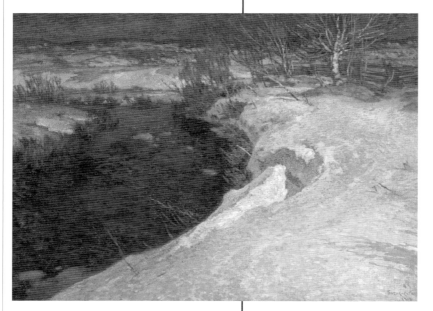

Fig. 4. Marc-Aurèle de Foy Suzor-Côté (1869-1937)
Paysage de Fin d'Hiver, Riviere Gosselin, 1918
Oil on canvas, 101.6 x 137.5 cm
Edmonton Art Gallery, Edmonton
Gift of Dr. R.B. Wells, 1927
Photo: H. Horol

14

Canada, and therefore our first pioneer of modernism (sometimes defined as the moment when art attempts to define aesthetic experience in itself[6])is James Wilson Morrice. The career of this member of the Canadian Art Club encompasses the change from Tonalism to more lively, vital Impressionism, and then Post-Impressionism, developing in the process a much wider range of subjects and means. In his early work, through contact with the painting of Whistler, Morrice introduced dark tones and muted light into his work to create atmospheric effect. A visit with the Canadian Impressionist Maurice Cullen in 1896 at Sainte-Anne-de-Beaupré lightened his palette: the result was a painting with the brilliant winter light of Canada, *Sainte-Anne-de-Beaupré* (1897, Montreal Museum of Fine Arts, Montreal). From 1900 until 1903, Morrice's paintings continue to evoke light and atmosphere; he combined rich loose brushwork with harmonies of tone created through the repetition of colour. His *Return from School* (1900-1903, Art Gallery of Ontario, Toronto) matches a

Fig. 5. James Wilson Morrice (1865-1924)
Paris, Quai des Grands Augustins, c. 1905
Oil on canvas, 48.3 x 74.9 cm
Private Collection

grey sky with a grey and cream road; he also painted with tones of grey the schoolchildren who advance towards the viewer but added brief touches of colour. Around 1903, Morrice began to substitute thin washes of paint for the impasto he had previously favoured and to respond more to the example of avant-garde French painters. The result was an emphasis on form, a disregard for the anecdotal, an emphasis on surface design, and an increased range of colour and lighter colour values, as in *Paris, Quai des Grands Augustins* (c. 1905, fig. 5) with its effect of pale winter twilight. The composition of *Quai de la Tournelle effect d'Automne* (fig. 6) indicates his sharpened sense of design. In the winters of 1911-1912 and 1912-1913, he accompanied Henri Matisse on visits to Morocco, and the influence of the French artist is apparent in Morrice's change to even lighter values, though he soon simmered down to a cooler palette. Often in his work, the artist's vantage point is elevated as though he

15

hovers over the scene; the effect combines well with his subtly keyed colours and textured handling. He once wrote Edmund Morris that he loved paint — and "the privilege of floating over things."[7]

In 1925, Matisse wrote to a friend about his stay with Morrice in Tangier. He spoke of him as the "artist with the delicate eye, so pleasing with a touching tenderness in the rendering of landscapes of closely allied values."[8] Ever the wanderer who pursued his quest for the exotic, Morrice found inspiration in North Africa, Jamaica, and the Caribbean: he died in Tunis in 1925. His painting at that time was still lively and adventurous, as painter A.Y. Jackson wrote.[9] He was a solid artist with an underplayed style; his work is important in Canadian art history. Its study is especially rewarding in view of contemporary art's approach to the past: Morrice's approach was inherently antiheroic. His work for all its painterly colour and touch has a distilled quiet that rivets the viewer in the here and now. Appropriately enough, the most important collection of his work, a large part of his life's production — over eight hundred paintings, watercolours, oil studies and sketch books — is in the Montreal Museum of Fine Arts, in the city where he was born.

Fig. 6. James Wilson Morrice (1865-1924)
Quai de la tournelle effect d'Automme
Oil on canvas, 64.5 x 54.6 cm
Private Collection

John Lyman, a friend of Morrice, and the second pioneer of modernism in Canada, also found the work of Matisse compelling. It was after seeing a painting by Matisse at the 1909 Salon des Indépendents in Paris that Lyman, studying at the Académie Julian, felt inspired to enrol at the Académie Matisse. His study at the school deeply influenced his art and thinking. Upon his return to Canada, Lyman participated along with Jackson in the Thirtieth Spring Exhibition of the Art Association of Montreal in 1913; his paintings caused a sensation. About a month later, his first solo exhibition, also held at the Art Association, added to the stir.

Lyman's work reflected a growing simplification. It conveys an important

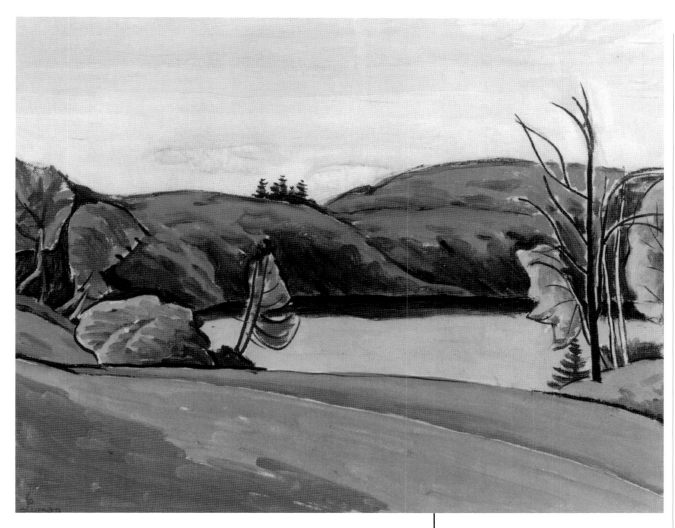

Fig. 7. John Lyman (1886-1967)
Wild Nature I: Dalesville, 1912
Oil on canvas, 31.4 x 40.1 cm
Musée du Québec, Québec
Photo: Jean-Guy Kérouac, 1996

shift in style, one which had occurred already in European artists' work. He was intent on exploring formal artistic strategies to capture what he considered essential and significant. In painting landscape, Lyman sought to convey a generalized feeling of space rather than a specific region. Matisse's training doubtless led to an increase in flatness and the use of monochrome to bring out the character of form.

Wild Nature (1): Dalesville (1913, fig. 7), which was probably shown in Lyman's one-man show as *Wild Nature Impromptu, 1st State*, was one of the paintings called crude by reviewers. This neatly constructed thinly brushed landscape (parts of the clouds are indicated by raw canvas) of a lake in the Laurentians inventively plays with spatial relations, stressing the two-dimensional surface. With Lyman, as with Morrice, Post-Impressionism had come to stay.

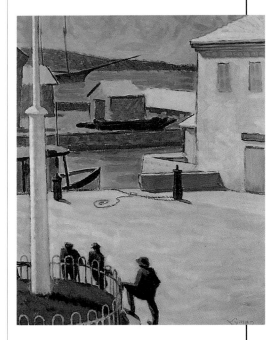

Fig. 8. John Lyman (1886-1967)
Landscape, Bermuda, c. 1914
Oil on canvas, 55.4 x 45.9 cm
National Gallery of Canada, Ottawa

Soon after his one-man show, disappointed by the savagery with which critics received his work, Lyman left Canada. He returned only in 1931 after years of travel. While abroad, the incipient modernism of his work advanced. All of his pictures are marked by his critical intelligence, formal invention and imagination. At the base of *Landscape, Bermuda* (1914, fig. 8), shadowy figures point the viewer's eye in the direction of the water in the background, but there is a core of defiance in the suggestion of depth: the background is decisively flat. As in other paintings, Lyman keyed the canvas to certain selected colours.

The third pioneer of modernism in Canada, David Milne, prized today for the raw energy of his imagery and the beauty of his expressive technique, developed in a different centre: New York. He arrived there from rural Ontario in 1903, and enroled at the Art Students League. Working part-time as a commercial artist, he became a Sunday painter. In 1910-1911, he made the decision to seriously commit himself to painting. In New York, he listened to lectures from Robert Henri, one of the founders of the American group called The Eight, dubbed the "Ash Can School," and he began to visit an important early gallery, one which the photographer Alfred Stieglitz had opened at 291 Fifth Avenue which promoted European and American modernism. Originally called the Little Galleries of the Photo-Secession, it came to be known simply as "291." At 291, from 1908 till it closed in 1917, Stieglitz presented one-person exhibitions of avant-garde artists; these shows had the effect of orienting Milne towards Post-Impressionism. Cézanne's painting was particularly important to him, and its lessons of pictorial structure. Milne's style in his 1911 watercolours indicates his assimilation of a changed aesthetic: with firm outlines to the forms, emphasizing structure and composition, he boldly depicted landscape and the urban environment. In 1913, Milne submitted five paintings to the International Exhibition of Modern Art at the 69th Regiment Armory in New York (the so-called Armory Show): all were accepted. His work at the time, with its broad, dramatically free handling of paint, recalls in subject and style the work of the American Post-Impressionist Maurice Prendergast, a fellow member of the New York Water Color Club.[10]

The Armory Show generated immense excitement. Though Milne later wrote that it had little direct effect on him, his work demonstrated a new deci-

siveness and energy.[11] His painting, in a manner similar to Prendergast's, became more expressive as he developed though he always retained a sense of underlying foundation and structure. In his oils, Milne applied paint thickly in layers of short strokes to create a dense atmosphere of colour; in his watercolours he used the same vivid colours and patterned brushstrokes played off against the white of the paper to suggest light, as in *Allied Workers* (c. 1914, fig. 9). Here, he brushes the figures and background in broadly in pale blue, red, dark blue, and green and indicates the darkened interior of the umbrella through the use of black. In 1915, Milne simplified his palette and began to demonstrate a greater interest in design. In 1916, a move to Boston Corners in the Taconic Hills of New York State provided him with what he called the perfect "painting place" (later he was to find many such locations). After making several trips between the United States and Canada, he settled in Canada for good in 1929. In later years, watercolour and drypoint were his favourite media, and he made a point of spareness. A frugal use of the medium, making a virtue out of a calligraphic shorthand of form, as in *Woman Seated on a Rocker* (c. 1922, fig. 10), is charac-

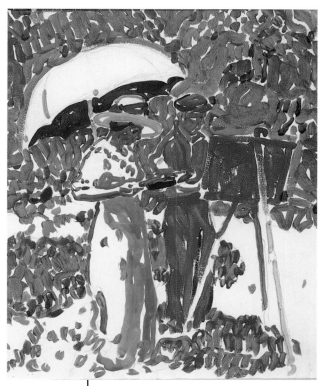

Fig. 9. David Milne (1882-1953)
Allied Workers, 1914
Watercolour on paper, 52.1 x 43.8 cm
Private Collection

19

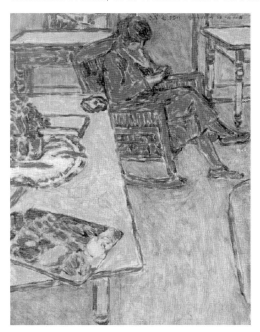

teristic of the rest of his long painting career, though Milne continued to refine his subject matter, producing works composed entirely of short dashes of paint and highly spontaneous watercolours. Often, as in his Palgrave paintings of 1931, he applied his oil paint as though it were watercolour, leaving contour lines and broad areas of exposed canvas. His dictum was "The

Fig. 10. David Milne (1882-1953)
Woman Seated on a Rocker, c. 1922
Oil on canvas, 40.6 x 30.5 cm.
Private Collection

thing that 'makes' a picture is the thing that makes dynamite — compression. It isn't a fire in the grass; it's an explosion."[12]

The First World War, in which Milne worked for the Canadian War Records from 1918 to 1919, confirmed the progress of his style, and gave him new subjects. In 1919, a painting journal Milne began at Boston Corners provided a milestone in his artistic life. He began to seriously read art critics such as John Ruskin and Clive Bell. Our perception of his role in the modern movement comes from his own artistic autobiography that he regularly wrote and re-wrote as a "consciously created resource for posterity."[13] He was reclusive and spent most of his time working on his own artistic pursuits. As one of the painters who most fully understood and applied the principles of the new art, through his example Milne quietly introduced the principles of modernism to Canada. His work eloquently made the case for the wonder of it all.

The career of Lawren Harris, the fourth great pioneer of modernism in Canada, because of his stylistic changes, still tantalizes. He was a painter who imposed his will on subjects and techniques developed by others and made them fresh and beguiling. Trained in Germany, in certain paintings he at first favoured the greyed twilight that characterized Tonalist painting; for the creation of his mature style Harris found decisive a show of Scandinavian art that he and painter J.E.H. MacDonald travelled to see in 1913 in Buffalo's Albright-Knox Art Gallery. In Harris's early work, he was strongly influenced by the stitch technique of the Italian Post-Impressionist Giovanni Segantini (1858-1899). Segantini juxtaposed thick strokes of complementary hues and painted in a naturalistic style with mystical overtones. Harris may have seen Segantini's paintings reproduced in magazines or studied his technique at a second remove by seeing the influence of Segantini on the work of American painter Marsden Hartley, who, in his landscapes of around 1906, used Segantini's cross-stitch stroke (possibly Harris made a visit to New York to "291," which showed the work of Hartley). From Hartley, or the American artist Childe Hassam, Harris may have adopted the square format of his large early paintings. He applied an almost square format in works like *Winter Sunrise* (1918, fig. 11), carefully detailing the shape of the snow bank, snow-covered

Fig. 11. Lawren Harris (1885-1970)
Winter Sunrise, 1918
Oil on canvas, 127.0 x 120.7 cm
MacKenzie Art Gallery, University of Regina
Collection, Regina
Photo: Bridgen's Regina

trees, and sky with strokes applied separately in varying combinations of pink, blue, yellow, lavender, and green.

Harris achieved other feats of picture-making. His houses painted in "The Ward" area of Toronto form an enduring image of early Toronto. In his later work like *Above Lake Superior* (c. 1924, fig. 12), with a sure grip on pictorial structure, Harris transformed the forms of nature into ferociously lucid designs. In these and similar paintings he reduced the shapes of mountains, shoreline, trees, lakes, and clouds to their essentials for distant monumental effect.

Above Lake Superior was pivotal in Harris's development: it marked a turn away from his earlier work, the paintings

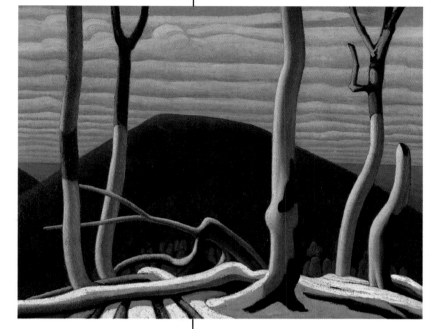

Fig. 12. Lawren Harris (1895-1970)
Above Lake Superior, c. 1924
Oil on canvas, 102 x 127.3 cm
Art Gallery of Ontario, Toronto
Bequest of Charles S. Band, 1970

of downtown Toronto, to a new phase that led in increasing steps to abstraction. Harris went to the north shore of Lake Superior with Jackson in 1921 and quickly realized he had found what was for him the perfect painting country. It fulfilled his desires for a simplified pared-down land with grandeur and tremendous vista. The water seemed to stretch to infinity.

At the time, Harris was becoming increasingly involved with theosophy, a system of belief in the attainment of knowledge of God by mystical intuition or occult revelation. It sprang partly from Buddhist and Hindu texts, partly from such philosophers as Emanuel Swedenborg, partly from the meditations of Madame Blavatsky (1831-1891) and Annie Besant (1847-1891). His intense interest in theosophy provided a spiritual backdrop to his work: Harris believed that art was the beginning of a knowledge of God. His philosophy helped him examine nature, find its essential elements, and then express them both directly and poetically according to an organizing principle that was forming in his mind. *Above Lake Superior* shows him involved in the process of simplification, the stripping-down of chaotic form into a painting of pristine elegant force. He saw a way to convey a subtle lesson about nature and the supernatural rolled into one in his work. He reached for the pencil and oil sketches he did of Lake

Superior and reworked them, making the clouds into a series of receding waves and adding tree tops to the lower slopes of the facing hill, which probably looked too bare without them. The essence of the scene — the birches and snow — he conveyed through the sharp white light of the North.

Harris loved Algoma and the north shore of Lake Superior. He painted in Lake Superior five successive autumns (1917-1922), in the Rockies from 1924 on, and in the Arctic in 1930, creating a number of paintings that are among the hallmarks of Canadian art. They display a unique and distinctively Canadian combination of restrained sensuality, boldness, and imaginative freedom.

A constant reader — and writer, too, of poetry and essays — Harris immersed himself in the spiritual offerings of the theosophists and the artist Vassily Kandinsky. By 1918, Harris had become a member of the International Theosophical Society; in 1923, he joined the Society's Toronto chapter, and in 1926, Harris began to contribute articles on art and on theosophy and the modern world to the *Canadian Theosophist* magazine. In the 1930s, as a result of his growing convictions about non-objective art, he began to introduce some of his beliefs into his paintings. By 1936, he had decided that the approach by way of abstraction was best for him. Non-representational painting allowed him to take expression away from the specific, the incidental, and enter a new realm of adventure. The turning point occurred in New Hampshire at Dartmouth College, where he was working as an artist in residence. From New Hampshire he went to Santa Fe, New Mexico, where he spent two years and became a member of the Transcendental Group of Painters. When he returned to Canada, it was to Vancouver, where he remained for the rest of his life.

When Harris was finding his path in his early work, a thirty-four-year-old artist from the small town of Leith, Ontario by way of Owen Sound and Seattle, who had arrived in Toronto in 1906 was earning a living as a commercial artist at a company called Grip Limited. Tom Thomson was, however, following closely the developments of avant-garde art in the city; he was fascinated by the formal research and discoveries of members of the group that would become the Group of Seven, some of whom worked at his firm. By 1912 he was focusing on painting. Modernism was to be his lifelong passion, hence the comment of his painting peers, A.Y. Jackson and F.H. Varley, who applied the label "Cubist" to Thomson's work in the autumn of 1914 because of an

advance in his small sketches towards stronger design and higher-keyed colour. Thomson is showing "decided cubistical tendencies,"[14] Jackson wrote a mutual friend that year. "Tom is rapidly developing into a *new* cubist."[15] wrote Varley. By 1914 Thomson had remodelled painting after nature by cherishing colour and shape. His sketches reveal him at the beginning of his short career, mastering the technique of oil painting and assembling with brio a new way of encompassing the natural world and brilliant colour. The result is closer to Fauve landscape. Thomson, like the Fauves — or "wild beasts," the appellation given this French group in 1905 by art critic Louis Vauxcelles — used intense colour applied in small patches with interstices of canvas[16] to achieve an astonishingly beautiful effect.

Thomson's total body of work, some thirty canvases and four hundred sketches produced in his five-year career, ranges from joyous encomiums to the mysterious North to occasional explorations in the sketch medium of a more abstract view of colour and surface design, though the imagery was tethered to landscape. His favourite painting place was Algonquin Park, then a relatively new and much-discussed tourist attraction: the more than 5,000 square kilometres of wilderness forest, lakes, and rivers was set aside in 1893 as a conservation area.

The park was wilderness that had to be protected, and the record of it became sacred, the material for a collective myth. The myth would in turn fuel Canadian society's spiritual and political engagement with nature. In capturing the spirit of Algonquin, Thomson became a being who briefly streaked onto nature's stage and off again, opening a new act in the growth of Canadian political self-consciousness. It was Thomson who paved the way to an appreciation of the national environment: he was an environmentalist who did not know the word, an unconscious pioneer in the ecological movement. His creative development in conveying this

Fig. 13. Tom Thomson (1877-1917)
Sunset, Canoe Lake, 1915-1916
Oil on board, 21.7 x 26.7 cm
Private Collection
Photo: Gallery Gevik, Toronto

23

natural paradise was toward small, thickly painted, vividly coloured formally condensed paintings; at his best he disposes trees and rocks like musical notes that play off the viewer's vision (fig. 13).

Thomson's way of dazzling an audience has less to do with colour and technique than with his ability to toy with his viewers' perceptions, presenting contradictions and seeming to reconcile them at the same instant. For a time, one of the ways he achieved this was by shuttling between the worlds of Tonalism and Post-Impressionism. His early sketches that his friends in the later Group of Seven found important (works like these caught the northern character of the country) are sometimes couched in the greyed tones of Tonalism even to the misty hills in the distance. In later works, Thomson often illuminates a scene in nature by transforming it into a decorative pattern, while at the same time making a point of an increasingly bold handling. He enjoyed creating variations of earlier subjects and painted them with impeccable virtuosity while suggesting that beneath the motif lies an actual place of uncommon beauty. In a way, his work is a discourse on a painting format that he himself created.

Fig. 14. A.Y. Jackson (1882-1974)
The Monastery, Assisi, 1912
Oil on canvas, 65.0 x 81.5 cm
Mendel Art Gallery, Saskatoon
Gift of the Mendel family, 1965

24

Thomson's knowledge of styles current abroad was cemented by his friendship with Jackson, who on a trip to Europe from about 1910 to 1913, began to introduce Post-Impressionist effects into his work. In paintings created in Cucq, Assisi, and Venice, Jackson combined tonal effects with the beginnings of exploration into complementary colours, bolder paint handling, and an attention to surface design. Paintings like *The Monastery, Assisi* (1912, fig. 14), provide a colour feast, combining golds and oranges and placing them in contrast to green, purple, and blue. It was at this point, Jackson believed, that he became a real painter.

When he shared a studio with Thomson in 1913, Jackson told him about a more scientific analysis of colour, Seurat and Pointillism; he would have

described to him the excitement with which his own work was received, since he had only that year exhibited his paintings at the Thirtieth Spring Exhibition in Montreal, astonishing the public and critics. Later he remembered telling Thomson about "clean-cut dots" of colour.[17] He may also have mentioned the use of loose strokes of colour contrasted against their complementaries and the intensified attention to surface design. Certainly, Jackson felt that Thomson's style changed under his influence — especially when Thomson painted in Petawawa in 1916.[18] Thomson's work of that date does show a structure composed of bold turquoise and orange dots. In his major canvases too, such as *The Jack Pine* (1916, fig. 15), Thomson juxtaposed complementary colours: the underpainting of the dark green foliage of the branches is crimson red.

"Lift it up, bring it out," Thomson said of the way he developed a motif. His way of focusing on a particular aspect of composition can be understood from a comparison of the sketch for *The Jack Pine* with the larger finished painting done later in the Toronto studio. From the Algonquin sketch he took the motif of the tree down to its crimson undercoat, then formalized and strengthened the design. He made the sky, water, and shoreline into bands of delicate luminescent colour: they recall the radiance of stained glass and help evoke in the viewer the feeling that the scene witnessed is sacred.

Throughout his short career, Thomson, who looked closely at the work of Harris, experimented with pure colour, elongated structured brushstrokes, and simplified compositions. His broad brushwork reinforced the simple forms of the northern Ontario landscape, and he applied impasto.

Thomson's paintings are far quieter and more relaxed than those of European artists. His real contribution to the history of Canadian art lies in his remarkable sensitivity to chromatic harmony. Since his death his way of

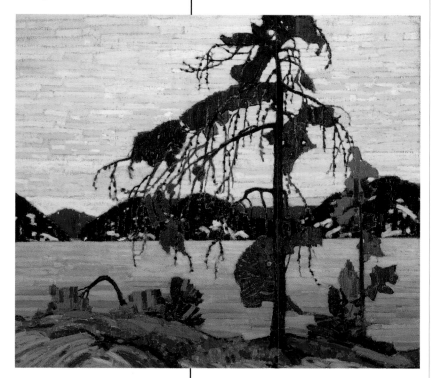

Fig. 15. Tom Thomson (1877-1917)
The Jack Pine, 1916-1917
Oil on canvas, 127.9 x 139.8 cm
National Gallery of Canada, Ottawa

25

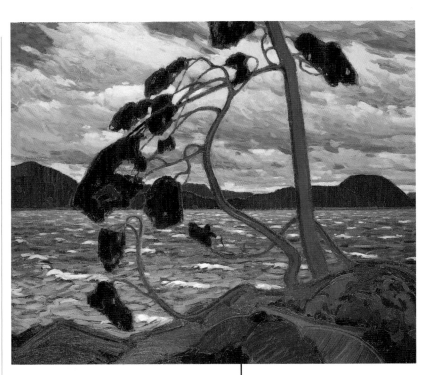

Fig. 16. Tom Thomson (1877-1917)
The West Wind, 1917
Oil on canvas, 120.7 x 137.2 cm
Art Gallery of Ontario, Toronto
Gift of the Canadian Club of Toronto, 1926

interpreting the intense colour of the northern landscape and his painting technique have been as much remarked upon as his interpretation of nature's moods. One other quality in Thomson's work proves important for later artists. In his own way, he seeks to reconcile objective vision with subjective experience. Thomson's gift to painting was a vocabulary of self-expression.

The West Wind (c. 1917, fig. 16) is the most popular of Thomson's works and virtually a national institution, but like many celebrated pictures it has been obscured by its fame. When Thomson painted it, he was in his late thirties. The strong design, bold network of blatant brushstrokes, and rich colour all serve to reinforce his way of making a statement. The picture of trees at water's edge was part of his manifesto for change, or at least, with some improvements, he meant it to be: the painting was wet on his easel when he died and likely unfinished. But the most evidently innovative aspect of the work was that in it Thomson treated apparently simple subject matter on a grand scale.

The West Wind is a big picture. Yet its subject is nothing more than a scene of a tree on a patch of land in the new provincial park. In the painting, Thomson suggests that a picture of no more than a short stretch of water and land, seen and painted by a person immersed in the place, can amount to a great theme. His insistence on the location — "his" place only by association — suggests that the location itself was not his only subject. His truest subject was himself. The improvisational quality of the sketch for the work was his attempt to conjure the movement and changes of nature. The result, although altered to accommodate the larger format, was the fast-moving clouds and energy of *The West Wind.*

That Thomson bridged the gap between objective and subjective is one reason his art is seen by later artists in Canada as a source for their work. Equally

necessary is his connection to the landscape and the environment; it is a common thread in Canadian art that laces together artists of diverse styles, origins, and interests. Today, as one of their crucial subjects, artists explore their aesthetic response to the environment.

Environmentalism, writes John Ralston Saul in *Reflections of a Siamese Twin* is a contemporary face — often presented in rational or romantic garb — of the "all-inclusive animism which Europeans found here when they arrived and with which they lived for a good three centuries before actively trying to erase it....The thing itself ... penetrated their own culture."[19] Artists, and the public, looked to Thomson to see that in its origins, modernism in Canada, though it drew on contact with Europe for its stylistic language, also drew on indigenous roots, and these had to do with the environment.

The inheritance Thomson passed to the Group of Seven, which formed in 1920 three years after his death, was his fiery approach to colour and his role as explorer-artist. In the years after Thomson's death, Harris, Jackson, Arthur Lismer, and Franklin Carmichael showed his influence, painting broadly and decoratively, flattening the image to stress large forms and movements and boldly analyzing colour; they also believed they must travel to obtain subject matter, as in Harris's *Decorative Landscape, Algoma* (c. 1918, fig. 17). Thomson's early death meant that only his paintings remained, and these became talismans. Harris summarized their feeling about him in saying of his own painting *In Memoriam to a Canadian Artist* (1950):

> When I laid in the painting, it suddenly struck me that it could express Tom Thomson, and thereafter it was Tom I had in mind — his remoteness, his genius, his reticence.[20]

Fig. 17. Lawren Harris (1885-1970)
Decorative Landscape, Algoma, c. 1918
Oil on canvas, 121.9 x 141.0 cm

27

Fig. 18. F.H. Varley (1881-1969)
The Sunken Road, 1919
Oil on canvas, 132.4 x 162.8 cm
Canadian War Museum, Ottawa, #8912

28

There were other influences that helped shape the members of the Group of Seven, primarily the First World War. The Canadian War Memorials Program, established in 1916, assigned artists the difficult job of recording events of the war or reconstructing war events. Those selected to be part of the program included both traditionalists and modernists. As with painting in Canada, the landscape was often the painter's choice to represent the war zone although the topography of the front line meant, for some, a change in aesthetic. Tonalism found its adherents in Maurice Cullen, for instance, who veiled his scenes in misty haze or twilight. Disciples of modernism like Jackson and Varley thrust the viewer into scenes of swampy countryside, blasted trees, and the dark side of war. In Varley's *The Sunken Road* (1919, fig. 18), he took the figures of the dead — a German gun crew — from a photograph, the site from one of his oil sketches. The rainbow in the distance symbolizes hope for the future as well as satirizing the tragic sight. In the painting, Varley comments on the anonymity of death on the battlefield. That the figures are painted in the same colours as the rocks reveals his view of the war, as does his depiction of a dead soldier who has had the top of his head blown off.

Working for the war records had its value. The imagery of war encouraged an appreciation of how landscape in general might be viewed, as well as developing new subjects.[21] Sculptors Frances Loring and Florence Wyle, for instance, portrayed women munition workers with sympathy and understanding. A length of stay in London, developing his work in a studio, introduced A.Y. Jackson first-hand to British modernism. More important, reaction to the war led to an intensified feeling of nationhood, a belief in Canada, which became an important feature in the program of the Group of Seven (fig. 19).

The decision of the Group of Seven was to depict, with optimism, the land as untamed wilderness, a place of bold effects, powerful weather conditions, and vastness. Their aesthetic concerns were no less powerful than the north-

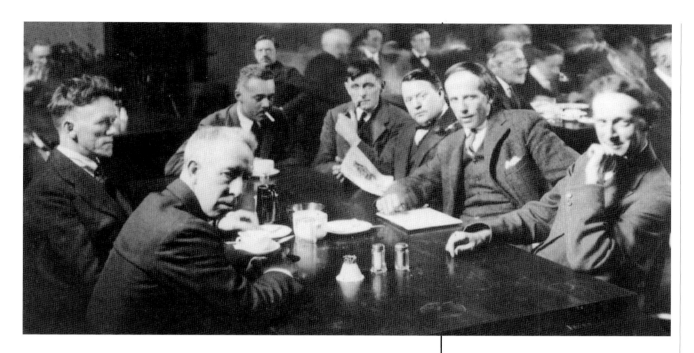

Fig. 19. The Group of Seven, Toronto, c. 1920
From left to right: F.H. Varley, A.Y. Jackson,
Lawren Harris, Barker Fairley (non-member),
F.H. Johnston, Arthur Lismer,
J.E.H. MacDonald

ern landscape that was their theme. In 1926, F.B. Housser, a friend of Harris,
documented their ideals in his book, *A Canadian Art Movement: The Story of
the Group of Seven* (1926). Group work presented a direct reaction to nature,
one with a native flavour (as Jackson said of J.E.H. MacDonald's works).[22]
Their paintings had strength, wrote MacDonald, and followed faithfully all
the seasons, with a broad, colourful treatment.[23] The forms were massive,
architectural.[24] Together they suggested an intensification of the subject, said
MacDonald's son, Thoreau MacDonald, full of the power of Canada.[25] The key
ideas with which they wished to imbue their work were grandeur and beau-
ty, a sense of the sublime, vastness, majesty, dignity, austerity, and simplici-
ty.[26] Jackson suggested that the novice painter use a restricted palette.[27]
Handling was to be powerful and brisk. "Don't niggle," Jackson told a stu-
dent.[28] MacDonald told others, "Think big, be generous, don't fiddle, enlarge
yourselves."[29]

The great vista or panorama of MacDonald's *Falls, Montreal River* (1920, Art
Gallery of Ontario, Toronto) is visually rich, with the strong directional flow
and sense of movement over the surface characteristic of Group of Seven
painting. Here the lines of water and hills guide the viewer's eye. Comparing
the painting with a photograph of the view in Algoma taken under the super-

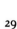

29

vision of MacDonald, we can see how he emphasizes decorative pattern. He uses the scene as a setting for his excitingly turbulent and decorative style.

The Algoma region north of Sault Ste. Marie was a favourite painting place for Jackson, too. As he wrote in his autobiography, *A Painter's Country* (1958), "In October it is a blaze of colour." The paintings of Algoma Jackson created at this time have an extraordinary range of reds and oranges; Jackson often used a band of trees laid horizontally across the painting's background, like some rich tapestry, revealing his delight in natue. In other paintings in this period Jackson used snow flecks to veil a scoop of hot-coloured land; they convey a more mystical mood, one of silence and surprise. A very different work, *St. Agnes in Winter* (1938, fig. 20), a recasting of a canvas Jackson painted in 1931, contains a powerful agglomeration of natural and architectural forms, compacted together into a time capsule of a career and a period.

When Lismer painted in that favourite painting place of the Group of Seven, Algoma, he prepared the result through numerous pencil and oil sketch-

es. The painting *Isles of Spruce* (1922, fig. 21), arrived at through many such sketches, is a typically Group canvas: a strongly delineated sky pattern in the background, simplified volumetric shapes, dark contours around the rocks and brilliant colour in the one yellow tree on the island, but it is more readable than some Group works, perhaps due to Lismer's feeling that all things have a place designed for them.

The Group's choice of subject reveals a love of the country's natural environment, especially Canada's northland. At first they painted what could be called Ontario's hinterland, then they moved farther afield.[30] In selecting such subjects these painters reflected the intellectual and psychological climate of the early decades of the twentieth century in Canada. Their paintings developed against the complex cultural background that produced the poets Bliss Carman and Duncan Campbell Scott. The future members of the

Fig. 20. A.Y. Jackson (1882-1974)
St. Agnes in Winter, 1938
Oil on canvas, 55.9 x 71.1 cm
Private Collection

Group were drawn first to Algonquin Park, then they widened their subject matter to include territory new to painting. As F.B. Housser wrote:

> The wilderness is being reclaimed and the forest is making its last stand ... But in these Northern Ontario canvases is a spirit which as time advances will be capitalized in literature ... while these pictures live we can never forget our cradle-environment.[31]

These were revolutionary matters for Canadian art, and the revolutionaries wanted to exhibit the work. The society exhibitions, such as those mounted by the Royal Canadian Academy and the Ontario Society of Artists, were dominated by conservative attitudes. Impatient with established tradition, the Group decided to organize its own exhibition in 1920. Initially, selecting a name

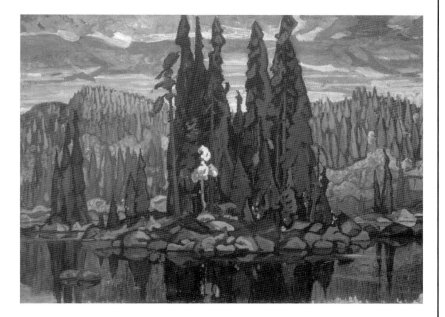

Fig. 21. Arthur Lismer (1885-1969)
Isles of Spruce, c. 1922
Oil on canvas, 119.4 x 162.5 cm
Hart House, Permanent Collection
University of Toronto, Toronto

31

that would precisely describe such a diverse membership — Carmichael, Harris, Jackson, Frank H. (later, Franz) Johnston, Lismer, MacDonald, and F.H. Varley — proved impossible. After discussion, they decided that a number was suitably neutral. Through the influence of Harris, they arranged to show their work at the (then) Art Gallery of Toronto. The exhibition established them as a new power in art. Eight more Group shows were held, between 1920 and 1931.

The Group's stress on presenting Canada may have had the effect, for

Fig. 22. F.H. Varley (1881-1969)
Blue Ridge, c. 1932
Oil on board, 30.5 x 38.1 cm
Private Collection

32

some, of disguising the modernist intentions of the Group. However, in their early work, the use of simultaneous contrast of colours, impastoed surfaces, rhythmically applied brushstrokes, strong colour, and boldly simplified forms mark their paintings as modernist. Their style became a form of shared expression, a product of their assertion of a distinct national identity combined with the common heritage drawn from painters who had from the beginning of the century influenced Canadian artists, such as Cézanne, van Gogh, and Gauguin, combined with modern Scandinavian painters such as Gustav Fjaestad and British artists associated with the Bloomsbury Group. The stylistic references are usually thoroughly absorbed, as in Varley's *Blue Ridge* (c. 1932, fig. 22), painted in the Lynn Valley looking towards Mount Seymour. The result, with its bracingly bright colours, is solidly worked. Yet the artists of the Group of Seven sometimes make an allusion to the work of Post-Impressionist painters as though they had heard about them from other artists or read about them in magazines, not seen their work on gallery walls. MacDonald's *The Tangled Garden* (1916, fig. 23), for instance, features sunflowers, that favourite flower of van Gogh, but here, thriving in a crowded backyard, they convey the environmentally oriented self-image characteristic of Canadian art.

Once they became a group, what these artists shared lasted only briefly for some. Despite the unanimity they felt toward their subject, they did not all feel permanently at home with the group. Membership was flexible, and its exhibitions varied as different painters showed with them. Through the years, three new members were added: A.J. Casson (in 1926), Edwin Holgate (in 1931), and L.L. FitzGerald (in 1932). Each of them added a host of images that enhanced the texture of Canadian art: Casson, the small towns and villages of Ontario (fig. 24); Holgate, solidly constructed figures in the landscape; and FitzGerald, the city of Winnipeg and surrounding prairie landscape. Other spirited newcomers

33

Fig. 23. J.E.H. MacDonald (1873-1992)
The Tangled Garden, 1916
Oil on beaverboard, 121.4 x 152.4 cm
National Gallery of Canada, Ottawa
Gift of W.M. Southam, F.N. Southam, and H.S.
Southam, 1937, in memory of their brother
Richard Southam

such as Yvonne McKague Housser, Isabel McLaughlin, Rody Kenny Courtice, Randolph Hewton, Lowrie Warrener, and Gordon Webber, were among invited contributors to Group shows. Catalogues of successive exhibitions indicate a change in rhetoric, from a glorification of Canada's natural environment to an encouragement of communicating ideas. The imagery of some of the painters, especially invited exhibitors, adjusted accordingly.

Today, the Group of Seven's view of itself as a viable avant garde has been challenged.[32] Their work is sometimes diverting, occasionally moving, even pride-inspiring, but conservative when compared with developments in twentieth-century Europe. Nor was the Group of Seven alone in its search for a collective voice at the time. Other groups, such as the Beaver Hall Hill Group (1920-1922), a short-lived Montreal collective of eighteen painters and one sculptor, were founded just after the Group of Seven held its first exhibition.

Fig. 24. A.J. Casson (1898-1992)
Whitney, Ontario, c. 1942
Oil on board, 91.4 x 114.3 cm
Private Collection

Fig. 25. Regina Seiden Goldberg (1897-1991)
Portrait of South American Girl, 1927
Oil on canvas, 74.0 x 61.5 cm
Robert McLaughlin Gallery, Oshawa
Photo: T.E. Moore

34

Located in a building on a short street between Phillips and Victoria Squares in Montreal, it served a similar purpose, of uniting a disparate group. Some distinguished artists and members and associates of the Group of Seven belonged: Jackson and Holgate, for instance, and Randolph Hewton, Anne Savage, Regina Seiden [Goldberg], and Henrietta Mabel May, among others.[33] Other good artists such as Sarah Robertson and Kathleen Morris were affiliated with it. Like the Studio Building in Toronto, 305 Beaver Hall Hill provided a studio and meeting place; for the women members, it also provided role models and a support group that helped them overcome obstacles — both internal and external — in their path to becoming professional artists in a society that still believed that a woman's place was only in the home. By contrast with the Group of Seven, the Beaver Hall Hill Group often stressed portraiture, scenes of the Eastern Townships and still life. Regina Seiden Goldberg's *Portrait of a South American Girl* (1927, fig. 25) is elegantly and formally conceived, with a strong message of dignity. Sarah Robertson's appealing *The Red Sleigh* (1924, fig. 26) and Kathleen Morris's *Market Day, Byward Market, Ottawa* (1924, fig. 27), also demonstrate the powerfully evocative nature of work associated with this group. Like other Post-Impressionists in Canada at this moment, Robertson and Morris were consistently drawn to simplified, flattened form, strong colour, and movement.

The quality that distinguished the Group of Seven from the Beaver Hall Hill Group, besides its remarkable leadership, was staying power. Through the group it founded in 1933 — the Canadian Group of Painters, which was in existence until 1969 — it lived on: its influence is felt, though distantly, even today. Exhibitions of the work of members of the Group of Seven, and the Group of Seven itself, still offer devotees of twentieth-century painting a chance to experience some exhilarating paintings and a fresh way of

thinking about even the most familiar of them. Particularly with Jackson and Harris, it is possible to feel the trail-blazing spirit of the avant garde. The pulse of the paintings themselves recalls the heady atmosphere of the early Canadian modernist world.

One of the most attractive virtues of the Group of Seven was the generous encouragement they offered to emerging artists. One who counted Harris as a source of inspiration was Emily Carr from Victoria on Vancouver Island. In her work of 1911, Carr was an *afficionada* of Post-Impressionist style, using a high-keyed palette and vigorous brushwork.

This development in Carr's work followed periods of study in California and England. She arrived in Paris in 1910, armed with a letter of introduction to the British painter Henry Gibb, who brought her into the artistic milieu of Post-Impressionism and Fauvism. Her first month was spent as a student at the Académie Colarossi. She then joined the private studio of the Scottish artist John Duncan Fergusson. He began to teach with the portrait painter Jacques-Emile Blanche at La Palette and invited Carr to join him. But Carr found her real inspiration in 1911 working in Crecy-en-Brie, a little village outside Paris, painting landscape with Gibb. That year she travelled to Brittany in the company of Gibb and his wife and studied under New Zealand expatriate Frances Hodgkins at Concarneau. The trip enriched the colour in her work: it became looser, more dynamic, playful, and less finished. In *Brittany, Kitchen* (c. 1911, fig. 28), for instance, Carr applied yellow-gold and orange to represent the surface of the walls, yellow to the sunlit sections and purple to the shadows.

Like Morrice, and at the same moment — 1911 — Carr showed her work at the Salon d'Automne along with Matisse, Fernand Léger, and Marcel Duchamp. Vigorous in colour — with dramatic purples, oranges, and greens or reds, and dark blues — and with flat planes and strong contours, her colours and sub-

Fig. 26. Sarah Robertson (1891-1948)
The Red Sleigh, 1924
Oil on panel, 38.1 x 45.7 cm
Private Collection

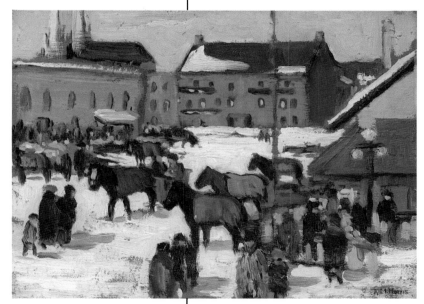

Fig. 27. Kathleen Morris (1893-1986)
Market Day, Byward Market, Ottawa, 1924
Oil on panel, 25/4 x 35.6 cm
Private Collection

35

jects now reflect her absorption of Post-Impressionism. The change in style gave her "brighter, cleaner colour, simpler form, [and] more intensity," she wrote in her book *Growing Pains*.34 Already around 1912 in a watercolour, *Cumshewa* (1912, National Gallery of Canada, Ottawa), she let drips of paint show on the surface, an early appearance of what was to become a commonplace of modern art in Canada. She was, like earlier pioneers of modernism, in touch with the artistic vanguard. Upon her return to Canada, financial difficulties and the inveterate provincialism of Canadian life made it difficult for her to keep up her high painting spirits. In 1912, Carr carried out an ambition that stemmed from a visit in 1899 to Ucluelet on the West Coast of Vancouver Island, reinforced by a cruise she made to Alaska in 1907; she painted as many as she could of the totem poles that stood in the villages of the First Nations in British Columbia. Her project to create a historic record of the poles was also a romantic quest for understanding the First Nations. In works like *West Coast Eagle Totems* (1912, fig. 29), she interpreted the pole with passion, using strong outlines, recalling through her handling her response to the work of her teachers. Here, the totem is the centre of attention: she painted it with strokes of black and dark blue, and touches of red, blue, and gold.

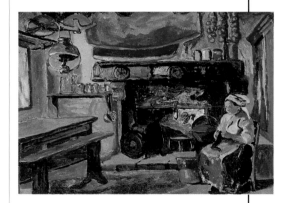

36

Fig. 28. Emily Carr (1871-1945)
Brittany, Kitchen, 1911
Oil on board, 51 x 66 cm
Private Collection

For the next fifteen years, Carr suffered a period of relative inactivity; she was snapped back into full painting mode by an invitation from anthropologist and writer Marius Barbeau of the National Museum of Canada in Ottawa to show her work in the 1927 exhibition *Canadian West Coast Art, Native and Modern*. The works on view, some of which were drawn from collections of aboriginal art spanning five decades, formed a lively and eclectic gathering in which Carr kept kindred-spirit with aboriginal art. It was the first moment in which Canada, in a manner typical of modernism elsewhere in the world, annexed what it saw as "primitive" art as part of its artistic heritage. The exhibition served as a lesson in the intricacies of art and politics since it occurred at a moment when Canada was rejecting aboriginal landclaims in British Columbia, and, through its policies of assimilation, actively suppressing the cultural traditions of the First Nations. The show also serves as an introduction to the endlessly absorbing subject of the influence of First Nations culture on Carr herself. Due to the show and the encouragement of Lawren Harris, she

returned to her West Coast subject matter and started to translate what she saw in nature into three-dimensional pictorial form, following Paul Cézanne's idea of "passage" — weaving her forms into a cohesive spatial matrix through contour. Carr was influenced, too, by a workshop with the American painter Mark Tobey, which he gave in her studio in Victoria, B.C. in 1928 — but these paintings belong to a later chapter of this book.

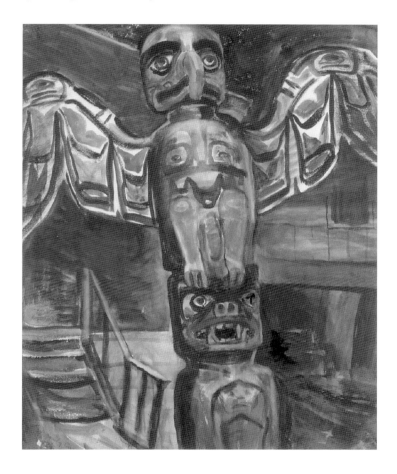

Fig. 29. Emily Carr (1871-1945)
West Coast Eagle Totems, 1912
Watercolour on paper, 53.3 x 43.2 cm.
Private Collection

37

Fig. 30. Kathleen Munn (1887-1974)
Untitled, c. 1926-1928
Oil on canvas, 37.0 x 60.0 cm
National Gallery of Canada, Ottawa
Purchased, 1990

Approaches to Abstraction

Abstraction, which for some is the primary force in art of the twentieth century, was discovered to celebrate the inner forces of spirit, mind, and nature in fresh visual language. The artist who is credited with the first abstract painting is Vassily Kandinsky (1866-1944) in 1910: in his well-known abstract watercolour of that year he uses patches of colour and gestures of the brush. His use of colour and shapes drawn from his imagination was philosophical and spiritual in intention, aligned with metaphysics in a search for inner life. In the following years, Kandinsky applied a musical analogy, using titles such as *Improvisation* and *Composition* for his densely layered paintings with their lyrical mosaic of line and colour in which one can still discern hints at figuration. That is, abstraction with Kandinsky was not at first, "free from representational qualities," the definition of abstraction according to the *Oxford Dictionary*.[1] Only later did his work become completely abstract or non-objective.

Abstraction, as used in Canada by Canadian artists, had similar qualities to the early work of Kandinsky. The artists who were the pioneers in abstraction often used nature-based subject matter. They took as images landscape and the figure, filtered through methods we still think of today as abstracting — summarizing, abbreviating, and stylizing. But we may wonder wherein lies the difference from artists who create representational works: they, too, often employ these methods.

Because of the difficulties of being certain where and when abstract art began in Canada, and because, in Canada, abstract artists did not constitute a single movement, and abstraction was a tentatively grasped idea that led to myriad strands of development, we should call the work of these breakthrough artists approaches to abstraction. The title is suggestive: among the components of their work was the jumpy, just-suppressed energy of modern art.

In this second phase of the development of modernism in Canada, artists sought to subvert their viewers' experience, to make them think and re-imagine their experience of the objective world. To reach back into time, we must

39

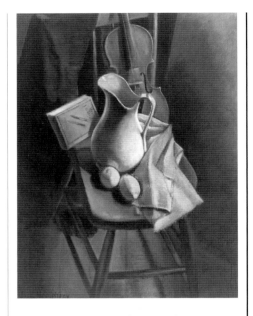

Fig. 31. Jack Humphrey (1901-1967)
The White Pitcher, 1930
Oil on canvas, 84.3 x 71.6 cm
Beaverbrook Art Gallery, Fredericton
Gift of the Second Beaverbrook Foundation

40

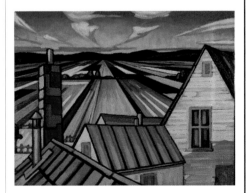

Fig. 32. Marian Scott (1906-1993)
Quebec Fields, 1931
Oil on canvas, 50.8 x 60.9
Ottawa Art Gallery, Firestone Art Collection, Ottawa
Photo: Tim Wickens

look at these works of art anew, at artists who began the process of separating qualities or attributes from the individual objects to which they belong.

At least three artists have been described as the first Canadians to paint abstractly: Henrietta Shore, who showed abstract work in 1923; Lowrie Warrener in 1925; and Bertram Brooker in 1927. In 1923, at the same time as Shore, Kathleen Munn showed full-scale Cubist paintings. Her innovative pictorial intelligence marks her as a member of this group of innovators. These four artists are just beginning to be better known in Canada. Munn's oil paintings, for instance, have been collected recently by the National Gallery of Canada (in 1990) (fig. 30).

The work of these artists was followed closely by an energetic Toronto-based group that included Lawren Harris, whose work at this moment showed the influence of abstraction (to which he would turn full-time about 1936), and Isabel McLaughlin, whose work, beginning in 1928, showed her sympathy with his aims. Fritz Brandtner, who arrived in Halifax from Europe in 1928, went on to Winnipeg and then Montreal and quickly set about painting expressionistic abstractions. In Calgary in 1928, Maxwell Bates painted *Male and Female Forms*: the original is lost but the study, though it may have been more naturalistic than the painting, indicates two roughly delineated abstract forms, one more rounded than the other.[2] In 1929, Jack Humphrey of Saint John, New Brunswick, assimilated the conventions of Cubism during a course at the Art Students League in New York: he sought to apply its essential qualities in the choreographed voids and volumes of *The White Pitcher* (1930, fig. 31), a painting that combines firm outlines and precise delicacy, with planes seen from different viewpoints. Though Humphrey's approach is cautious, the painting shows a heightened degree of aestheticism and sophistication. In Montreal, at much the same moment, Marian Scott in paintings like *Quebec Fields* (1931, fig. 32) began to blend landscape imagery to make paintings whose patterned surface is a complex welter of allusions.

Canadian artists painted abstractly for many reasons. Among them was the wish to grapple with the spiritual. The span of attention to the new work differed. For Warrener, a commitment to abstraction characterized his entire body of work. For Brooker, who was inspired by L.L. FitzGerald to turn to naturalism around 1929, abstraction was less a conversion of the heart than a peri-

od of experimentation from which he emerged revitalized. For Humphrey, Cubist work was but a isolated adventure; he only experimented in depth with abstraction much later, beginning in 1944. Bates was somewhat similar; his abstract period dates from 1958 to 1962.

Yet these individuals had much in common. They were painters who valued intuition over logic; they believed in universal truth. As idealists they expressed their aspirations through art: the First World War and the Depression brought about a desire for change, cultural freedom and a better human condition. For these pioneers, art was becoming both a place to make a home and a pathway to spiritual life.

The common ground for a select few of them was mysticism. Brooker, for instance, had had an "out-of-body" experience.[3] Others, and no doubt Brooker too, drew upon European and American art, as they knew them most often through books and magazines, to shore up their position. Their paintings still offer us an intimate beauty that earlier centuries believed to be an essential part of visual art. Seen together, their work appears curiously unified, made of concentrated, deceptively simple, and rather private statements. The forms these painters used are often block-like, solid, and three-dimensional. They use colour as an expression of mood or ideas rather than as a reflection of the natural world. The images they often explore are of germination or growth, which expresses their sense of being at the beginning of a journey. As a subject they often choose roads: they felt they were carving out a new path and had to pass through numerous difficulties such as the "Valley of Dreadful Rocks" of which John Bunyan wrote. Beyond were the mountains. Cézanne found Monte Ste-Victoire near his home in Provence fascinating; Kandinsky also painted *his* mountains. The symbolism of mountains formed a rich source of imagery for the period, one explored by Lawren Harris among others. Now a new group of artists mined suggestive shapes and symbolism.

The imagery of a painting done around 1927 by Brooker shows the kind of inspiration common to advanced painters of the period.[4] In works like *The Finite Wrestling with the Infinite* (c. 1927, Mendel Art Gallery, Saskatoon), based on a figure seeking spiritual inspiration on a mountain top, viewers might catch a reference to the hero of Friedrich Nietzsche's book, *Thus Spoke Zarathustra* (1891), who went to live in the mountains. Munn was another artist

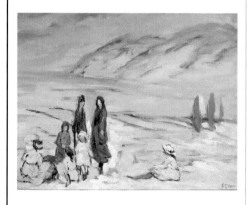

Fig. 33. Henrietta Shore (1880-1963)
On the Beach, c. 1914
Oil on canvas, 50.8 x 61.0 cm
Private Collection

41

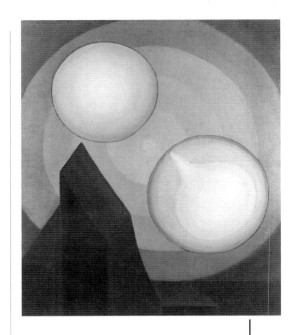

Fig. 34. Henrietta Shore (1880-1963)
Two Worlds, c. 1921
Oil on canvas
Nora Eccles Harrison Museum of Art, Utah
State University, Logan, Utah
Gift of the Marie Eccles Caine
Foundation, 1988

42

who, around 1929, drew a figure of a man in the mountains, perhaps similarly inspired.

There were many other influences. Henrietta Shore provides an instructive example. She was Canadian-born but travelled widely, studying in London before settling in Toronto, where she became a pupil of Laura Muntz Lyall. In 1912 or 1913, she left Canada for California, where, in 1916, she became a founding member of the Los Angeles Art Society. In 1921, she lived in New York for a brief period. New York seems to have meant a break with the past for her: she became an American citizen that year. Till then, as we can see from her canvas *On the Beach* (c. 1914, fig. 33), Shore's paintings had been, at least in their subject matter, traditional, though with the glowing palette of Post-Impressionism and its bold energetic handling. Now she began to paint more abstractly. Her work, shown in New York at the Ehrich Galleries in 1923, examines the botanical and natural world in a semi-naturalistic way. Although she said later that she did not title the works herself, the titles of the eighteen paintings in her one-person show suggest her concerns: *The Source, Growth, Embryo, Life Emerges, Creation.* She called the work her "Creative Group."[5] In *Envelopment,* for instance, her story is about creation: two upright leaves, one cream-coloured, one red, spring from a single base, two parts of the same plant. The same subject appears in *Life* (c. 1921, Los Angeles County Museum of Art, Los Angeles) where human life springs from a source in vegetation. Like her other work of this period, it makes a generic statement about nature: there is an ambiguity to the shapes encouraged by the painting's title. The feeling in the picture is one of welling growth though the subject is ambiguous. The forms in *Two Worlds* (fig. 34), a work reproduced in the catalogue to the 1923 show, may indicate two people. The picture is placed on a page opposite a picture of a mother nursing a child, titled *Maternity,* so perhaps the painting is an abstracted version of a mother-child relationship. The effect again, is ambiguous. Raymond Henniker-Heaton, the writer of the catalogue, stressed the aesthetic quality of the paintings. "Names or descriptions, however mysterious, have nothing whatever to do with this."[6] Shore herself wrote in 1939:

Nature does not waste her forms. If you would know the clouds — then study the rocks. Flowers, shells, rocks, trees, mountains, hills — all have the same forms within themselves used with endless variety, but with consummate knowledge.[7]

To paint what she did, Shore may have looked at American books on modern art, such as A.J. Eddy's *Cubists and Post-Impressionism* (1914). It reproduced in colour a pastel of around 1911-12 by Arthur Dove, based on leaf forms, together with a statement by Dove: "It is a choice of three colours, red, yellow, and green, and three forms selected from trees and the spaces between them that to me were expressive of the movement of the thing which I felt."[8] His words may have struck a sympathetic chord in Shore. No doubt she also knew of the lively New York gallery scene of the period, perhaps even visited Stieglitz's Gallery "291" to see the work of Dove on her way to California.

Munn's work draws on a similar cross-cultural background; she was influenced by Cézanne and the experiments with colour of the American artists with whom she studied at the Art Students League in New York and its summer school in Woodstock (see fig. 35). Her painting *The Dance* (c. 1923, fig. 36) with its faceted pattern of triangles — a step forward from the squares she used painting cows — suggests a knowledge of the works of both Picasso and

Matisse; she might have discovered them through her own explorations or through teachers at the school. She may also have read one of Jay Hambidge's influential books such as *Dynamic Symmetry: the Greek Vase* (1920) with its attempt at structure-recipes. Her compositional structure seems to reflect his influence.[9]

In the same years, probably around 1924, Bertram Brooker first painted abstract works in tempera on paper. His son Victor remembered *Noise of a Fish* (1922?, fig. 37) as the first such work by his father that he

Fig. 35. Kathleen Munn (standing) painting with Ethel Williams in the Catskills, c. 1920
Photograph courtesy of Lenore Richards, Toronto

43

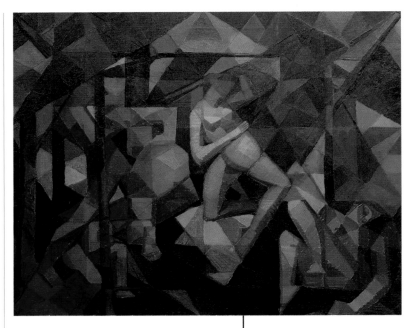

Fig. 36. Kathleen Munn (1887-1974)
The Dance, c. 1923
Oil on canvas, 61.0 x 76.2 cm
Private Collection

Fig. 37. Bertram Brooker (1888-1955)
Noise of a Fish, c. 1922?
Tempera on paper, 21.3 x 16.5 cm
Robert McLaughlin Gallery, Oshawa

saw.[10] It was inspired by a ray of light at night in a hallway around the angle of a bedroom door.[11] In it Brooker, drawing upon his everyday work as a commercial designer, combined simple geometric forms with differently coloured planes. In other works of the group, the forms have a more industrial look; they look machine-made. One sketch with a diamond shape at left, like *Noise of a Fish*, suggests light at night.

Besides these individual efforts, a more receptive atmosphere towards modern art was developing in Toronto. J.E.H. MacDonald taught at the Ontario College of Art; in 1928, he became principal. He enjoyed helping students. Carl Schaefer, one of these students, recalled that MacDonald introduced them to the writings of Roger Fry and Clive Bell.[12] MacDonald in fact suggested that they read a wide variety of books to assist in a general comprehension of the world, pointing the way for students to think creatively as Schaefer said.[13] Harris also was sympathetic to emerging artists; he helped Lowrie Warrener, a former student at the college, obtain a studio in the prestigious Studio Building he and his friend Dr. MacCallum had built in 1914 on Severn Avenue off Yonge Street.

Besides assisting with study in Toronto, the Group of Seven encouraged talented graduates to study abroad. Warrener doubtless went to Antwerp to study at the Académie Royale des Beaux Arts because Lismer had studied there. In Europe, he dis-

covered more about new currents in art. The book that struck a sympathetic chord with Warrener and his friends was Clive Bell's *Art* (1914), which drew extensively on ideas of Roger Fry. Milne may have read the book in 1919.[14] Warrener read it with enthusiasm in 1925 and wrote Schaefer about it, warning him to give the book a fair trial since it put a painter on the track of pure art and beautiful forms. To Schaefer he stressed the necessity for strong design, the solid and three-dimensional. "Be sure and use figures, heads etc.," wrote Warrener, "but make them as designs and marks."[15] As to landscape, Warrener advised: "Keep to your houses, trees, and turn everything into a form you can take hold of, or feel that it has sides." Most important, painters had to forget the colours around themselves and put in what each shape suggested. As Warrener said, "... a big roundish shape is happy, so put in light, happy colour, and don't smear or work over it while wet."[16] He advised Schaefer to "forget whether a thing looks natural ... as long as it gives you a beautiful feeling."[17]

Bell's *Art* gave painters of this generation the words to articulate their work. In the 1920s it encouraged progressive tendencies by offering the consolation of "higher things." In Warrener's letters we hear the echo of Bell: he does not quote Bell, only paraphrases him. Warrener speaks, for instance, of the climb up the ladder of truth to aesthetic beauty; Bell of the rungs in the ladder by which the artist climbs to the stars.[18] By 1925, Brooker had also read *Art*. Like Bell, he speaks of music as a way of transporting the artist from the world of man's activity to the world of aesthetic exaltation.[19] What stuck with readers was Bell's idea of "art for art's sake," his moral seriousness ("Art and Ethics" is the title of one chapter), his elevation of formal design, and the way his analyses offered audiences a way of seeing and appreciating modern painting.

Warrener was also influenced by developments in art in Paris, where, in 1924, he worked at the Académie de la Grande Chaumière, an open studio. On

45

Fig. 38. Lowrie Warrener (1900-1983)
Evening Sun, Northern Ontario, 1925
Oil on pressed board, 27.7 x 37.7 cm
Robert McLaughlin Gallery, Oshawa
Photo: Roy Hartwick

his return to Canada, in sensuous evocations of rugged haunts such as *Evening Sun, Northern Ontario* (1925, fig. 38), he proved he had learned the lesson of art abroad. In 1924 he wrote Schaefer that his teachers at the Antwerp Academy said his paintings recalled those of van Gogh in their way of stylizing nature into design. These small panels do have a van Gogh-like vigour, but Warrener's highly charged brush and witty balancing of representation and abstraction hint at a knowledge of the early work of Kandinsky. Much later, when Warrener was eighty-two, he spoke of his lack of knowledge when he started to paint abstractly. "I didn't know what abstract was," he said disarmingly.[20] "These things just happened."[21] "I had never done anything much but I decided to mix my own colours ... the first one I did was up in the Wahanipatai River [which runs between Georgian Bay and Sudbury], in the period 1921 to 1923."[22]

Fig. 39. Lowrie Warrener (1900-1983)
Solitude, 1929-1930
Oil on canvas, 138.5 x 143.5 cm
Robert McLaughlin Gallery, Oshawa

46

When interviewed, Warrener declared that he felt the key to his work lay in the way he handled colour: "I picked out my own type of colours that I liked and I filled space."[23] "I started with something, a shape, from I suppose, things I observed in the past, and I would start up at the left hand corner ... and come down."[24] He called his art an abstract impression of colour. The works done after Warrener returned from Europe burst with colour and enthusiasm, as though bathed with an inner fire. They have an exotic quality, probably from the look of the plants. Part of the powerful effect of these works is from the red contour line with which Warrener outlined forms, and from his use of dark red underpainting. His images are essentially subjective and evocative. Their blunt execution in harsh and defiant outlines in radiant colour mark them as energetically modern. No wonder he was invited to contribute to the 1926 exhibition of the Group of Seven. In the following year, influenced by Lawren Harris's oil sketches of the Rockies, Warrener's work darkened and simplified into block-like, semi-geometric shapes. He kept his rich colouration, but now he favoured greys and blues. The path in *Solitude* (1929-1930, fig. 39) is painstakingly placed, the whole organized in a firm composition. Painted in blackish browns against a lighter sky, the mountain majestically looms in a huge block, set to one side of the canvas. By 1929, in his *Cross Worshippers*

(1929, Robert McLaughlin Gallery, Oshawa), a painting of penitents in the background of a diagonally placed cross (with the hint of a mask and, beneath it, a sword), Warrener seems to have been thinking of O'Keeffe or the dramatic chiaroscuro of the movies of Sergei Eisenstein. His inclination was towards the theatre. Warrener became a set designer in 1930 for various theatrical productions in Toronto written by avant-garde playwrights, and in 1930 he wrote a play, *Symphony, A Painter's Play*, which was to be a part of the new drama developed by playwright and teacher Herman Voaden, which Voaden called *Symphonic Expression*. Warrener intended the play to combine pantomime, drama, and music to extraordinary effect.

There were other students who went abroad to study. Isabel McLaughlin, one of the adventurous young women painters, studied in Paris from 1921 to 1924, and again in the period 1929 to 1930, when she attended the newly founded Scandinavian Academy. Visiting innumerable commercial galleries, she discovered the modern European masters, among them one of her favourites, Georges Braque.

The Group went out of its way to connect such talented young people to others, and their help extended across the Atlantic. Jackson, for example, wrote McLaughlin and Prudence Heward letters of introduction to each other: Heward was a student working abroad (she had studied in London and Paris in 1925, in Italy in 1926, and was in Paris in 1929). They met and became good friends. Gordon Webber, who had been recognized as one of the emerging talents since 1930 when he was invited to show with the Group of Seven, with Lismer's assistance, went to study in Chicago in 1939 at the New Bauhaus (later the Institute of Design). His teacher was László Moholy-Nagy, a central figure at the Bauhaus in Weimar and Dessau from 1923 to 1928, and in Chicago from the time he arrived in 1937. As well as playing an important role as painter, graphic artist, photographer, and teacher, Moholy-Nagy was an influential theoretician. He wrote books about "the new vision" [das neue Sehen], the phrase he used as the title for the first volume of the New Bauhaus Books (published in 1938), written to inform lay people and artists alike about the basic elements of the Bauhaus education: the merging of theory and practice in design.

What the student might discover in such a school as the Bauhaus can be seen if we look at a "before," Webber's *Cactus* of 1935, an O'Keeffe-inspired

Fig. 40. Gordon Webber (1909-1965)
Cactus, 1935
Watercolour on paper, 21.6 x 29.8 cm
Robert McLaughlin Gallery, Oshawa
Gift of Isabel McLaughlin, 1989
Photo: Tony Cruysen

48

Fig. 41. Gordon Webber (1909-1965)
Untitled, c. 1939
Ink and collage on paper, 15.4 x 15.4 cm
Robert McLaughlin Gallery, Oshawa
Photo: Roy Hartwick

subject and compare it with an "after," a collage of around 1939 (figs. 40-41) with Surrealist content, biomorphic forms, and references to inner and outer space. The latter is a monoprint with a moss-green surface and cut-outs from coloured papers and magazines glued on top, which Webber had finished by playfully connecting, covering, or outlining the shapes with nimble black lines in ink. It is clear that through the school, he greatly extended his range.

Among Toronto painters, Bertram Brooker stands out as an early pioneer of abstraction. Since the start of the First World War, he had been drawing in a symbolist-derived, abstract manner. In 1927, in a show sponsored by Harris and Lismer, he exhibited at Toronto's Arts and Letters Club — paintings involving compositions that used geometry and rod forms, transforming earlier nature-inspired paintings composed from patterns of energy. Ann Davis suggests that he had read a theosophical book by C.W. Leadbeater, *Man Visible and Invisible*, to explore intense anger clairvoyantly.[25] He was also painting symbolic subjects that represent essential qualities of the human spirit. By 1927, his shapes reflect his knowledge of Cubism, which was confirmed by the *International Exhibition of Modern Art from the Collection of the Société Anonyme, New York*, a show Harris helped to bring to Toronto later that year in the belief that it was the most representative and most stimulating exhibition of advanced modern art on the continent.[26]

The show was organized by the Brooklyn Museum with the help of the Société Anonyme in New York (of which Harris was a member), to be shown at the Art Gallery of Toronto. In the pamphlet's introduction, Katherine S. Dreier, the president of the group, spoke of conserving the vigour and vitality of the new expression, by which she meant mainly Expressionism and Constructivism. The exhibition included such modern masters as Piet Mondrian, Fernand Léger, and Giorgio de Chirico, as well as Kandinsky, Kurt Schwitters, Picasso, Braque, and Constantin Brancusi. Dreier concluded her catalogue essay with the hope that the exhibition could encourage young tal-

ents to remain true to themselves. While the show was in Toronto, she lectured at the gallery and gave a more informal talk in Harris's studio to a group of artists and interested members of the public.

Painters like Brooker found confirmation for their inspiration in the exhibition. Certain motifs, such as the chords of colour in *Sounds Assembling* (1928, fig. 42), the series of futuristic pen-and-ink sketches he began to do that year, one of which was published in the *Canadian Forum*, and the rhythmic shapes of other paintings of this date reveal this. In the show there were two works by Marcel Duchamp's brothers, a painting, *Jockeys*, by the Cubist Jacques Villon, and a bronze figure by the sculptor Raymond Duchamp-Villon.[27] Brooker must have looked closely at the Villon painting. It uses the colour red and employs form to suggest motion, but contains no figures. There were also examples of paintings that seemed to indicate, in some complex way, the ebb and flow of time and the emotions. Kandinsky's *Gaiety* was reproduced opposite the catalogue foreword; it had radiating lines and shapes of a moon, sun, stars, and parts of landscape, possibly cities or roads, to indicate lines of movement.

Kandinsky's poetic interpretation of the natural world and expressive style and rhythm were inspiring. Charles Comfort, later a prominent artist in Canada and the director of the National Gallery, worked as a docent at the show. He compared it to the New York Armory Show in its importance. Because of the show, he wrote:

Hortense Gordon, Edna Taçon, Brooker, Webber, Lowrie Warrener, Lawren Harris and I were moved not only to discuss the exhibition but to experiment with non-objective composition. I am convinced that this exhibition marked the beginning of Canadian interest in, and indeed the employment of abstract forms in composition.[28]

Fig. 42. Bertram Brooker (1888-1955)
Sounds Assembling, 1928
Oil on canvas, 112.3 x 91.7 cm
Winnipeg Art Gallery, Winnipeg

49

Inspiration is not unfamiliar in artists' histories, and, as we know, an interest in abstraction began earlier in Canadian art. However, the ideas generated by the show did offer a coherent narrative, one vouched for by a catalogue. Furthermore, the effect of the paintings, massed, was profound. Seeing them altogether was more viscerally exciting than study abroad or in reproduction.

To understand the broad impact of the show, we can look at the development of innovative modernists like the sculptor Elizabeth Winnifred ("Wyn") Wood. After completing her post-graduate year at the Ontario College of Art in 1926, Wood went to New York to attend the Art Students League, where she studied modelling with Beaux-Arts-trained Edward McCarton, and wood and stone carving with the modernist American sculptor Robert Laurent. At a show at New York's

Fig. 43. Elizabeth Wyn Wood (1903-1966)
Northern Island, 1927
Cast tin on black glass base, 20.5 x 37.7 x 20.8 cm; without base
National Gallery of Canada, Ottawa
Bequest of Mrs. J.P. Barwick
(From the Douglas M. Duncan Collection, 1985)

Brummer Gallery, she saw the sculpture of Constantin Brancusi. She may also have seen the *International Exhibition* at the Brooklyn Museum before it moved on to Toronto.[29] Upon her return to Canada, in search of a personal and modern mode of sculptural expression, Wood began to explore alternative materials and new visual forms through the juxtaposition of masses abstractly conceived in stylized planes. Her experiments with casting in tin, a material she found appealing because of its association with industry, proved to be a refreshing aesthetic alternative to the darker surface of traditional patinated bronze. Wood often chose to exhibit her work in this medium on black glass, a juxtaposition that emphasized the contrast between the two materials.

In 1927, influenced by the Group of Seven and by the desire to give sculptural form to her drawings of Georgian Bay, Wood distilled nature to its essence using streamlined three-dimensional form as in *Northern Island* (1927, fig. 43): it helped to establish her reputation. She was soon dubbed the Lawren Harris of sculpture. In her handling of form, her work was quite different from that of other sculptors in Canada at this time.

The excitement in creating work like this was part of the impetus behind the founding of the Sculptors' Society of Canada in 1928 by Wood and her hus-

band, the more traditional sculptor Emanuel Hahn, along with Frances Loring, Henri Hébert, and Alfred Howell. Like the Group of Seven, they wished to provide increased opportunities for the exhibition and purchase of work (to this end, the sculptors wished to act in an advisory capacity for public memorials); they also desired to advance their profession.

The same excitement led Canadians to travel to Europe in search of new forms of expression. Some of the work in the International Exhibition of 1927 was said to be done according to the "Cizek Method." Franz Cizek in Vienna pioneered ways of exploring children's creativity, often through music. In 1930, two Canadians, Yvonne McKague Housser and Isabel McLaughlin, travelled to Vienna to study with O. Rainer, Supervisor of Art Instruction in the Vienna secondary schools. McLaughlin recalled that a pianist played music — Wagner and Debussy — that students interpreted with coloured chalks.[30]

There was also a steady stream of visitors to New York to see exhibitions of the modern masters at the commercial galleries. In 1939 the Museum of Non-Objective Painting (later renamed the Solomon R. Guggenheim Museum) opened, and Kandinsky's work was often on view. Rolph Scarlett of Guelph, Ontario, who had moved to New York in 1918 and gained firsthand experience of modernism through exhibitions and the study of artists such as Paul Klee, landed a scholarship, later a lectureship, at the museum; his association with it continued for fifteen years. Smart and knowing, Scarlett developed along a parallel path to the pursuit of abstraction in his homeland, and his abstract work was soon appreciated in New York. A Scarlett appears in the 1939 catalogue of the museum,[31] and his work was often exhibited in various museums and commercial galleries in the United States and France (today, the Guggenheim collection includes some thirty of his paintings). His intriguing works from the late 1930s until the 1960s show the influence of Kandinsky, and Rudolf Bauer, with whom he was associated at the Museum. He favoured geometric abstraction. The same geometric tendencies

Fig. 44. Rolph Scarlett (1889-1984)
Composition, 1938-1939
Oil on canvas, 65.5 x 85.0 cm
Private Collection

51

Fig. 45. Rolph Scarlett (1889-1984)
Lyric Dynamic, c. 1945
Gouache and ink on paper, 47.5 x 59.6 cm
Private Collection

52

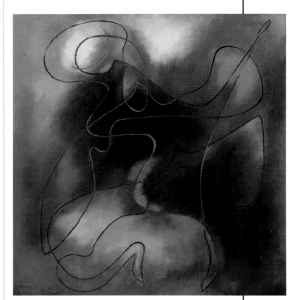

Fig. 46. Edna Taçon (1905-1980)
Fleeing, 1946
Oil on canvas board, 48.1 x 45.1 cm
Robert McLaughlin Gallery, Oshawa
Alexandra Luke Collection

appear in Scarlett's streamlined modern industrial designs, set designs, and one-of-a-kind silver jewellery. Paintings like *Composition* (1938-1939, fig. 44), a geometric non-objective, suggest a musical analogy similar to Kandinsky's early improvisations. *Lyric Dynamic* (c. 1945, fig. 45), one of his lyrical non-objectives, reveals his individual touch in gouache; typically, a high-spirited experimentation with colour, exquisite surface effects, and elegant line. Scarlett was later to recall his experience of Kandinsky's work as overwhelming, even hypnotizing.[32]

There were other Canadians in New York by the end of the 1930s and in the early 1940s. Quebec painter Irène Legendre, for instance, was there from 1939 to 1944, studying with Alexander Archipenko and Amédée Ozenfant. The result in her work was the adjustment of her Cubist vocabulary to landscape.[33] In 1941, the interesting painter Edna Taçon, who lived in Hamilton, Ontario, joined Scarlett at the Museum of Non-Objective Painting where she had won a scholarship. In 1943, she became a guide at the museum. Soon she was exhibiting her innovative collages, influenced by the later work of Kandinsky and inspired by music and nature, in New York and Toronto. *Fleeing* (1946, fig. 46) is an example of her carefully rendered, delicate oil paintings. Art critic Pearl McCarthy suggested that the source for the imagery lay in Taçon's emotional and psychological response to the idea of a man fleeing after truth in a setting of beauty.[34]

In 1943, Quebec painter Madeleine Laliberté studied at Ozenfant's workshop along with Legendre and Quebec sculptor and painter Charles Daudelin. He sought the advice of the French painter Fernand Léger, then living in exile in the city. The training they received served as a confirmation of, and rallying point for, creative energies. Daudelin, for instance, on his return to Montreal, turned full-time to sculpture. Awarded a provincial

scholarship, he went to Paris to study in 1946 and frequented the studios of Léger, the sculptor Henri Laurens and Georges Braque.[35]

The use of intuition and feeling were part of the new movement. Already by the early and middle 1930s, artists were reading Kandinsky's *Concerning the Spiritual in Art* (1912). They felt its influence in different ways. Some, like Lawren Harris, were interested mainly in Kandinsky's colour theory, the way he opposed yellow and blue to suggest earth (and material things) and heaven (and the spirit), warm and cold, and movement in relation to the spectator. According to the Russian artist, white versus black formed a second antithesis, and represented light versus dark, birth versus death. Harris also developed ideas about colour from theosophy, as in *Untitled (Mountains near Jasper)* (c. 1930, fig. 47) where blue is the colour of the magical mountains.[36] Theosophic ideas may also have assisted in the evolution of his simplification of form.

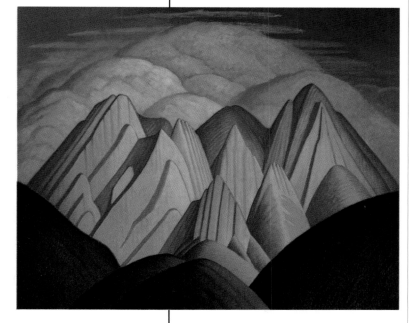

Harris's deeply held belief in theosophy had an influence on other artists. Curator Dennis Reid believes that Brooker was strongly affected after reading Lawren Harris's powerful article, "Revelation of Art in Canada," which appeared in the *Canadian Theosophist* in 1926.[37] Similar generalized forms occur in the work of Brooker (fig. 66) and Emily Carr. Carr's work changed due partly to the influence of Harris whose work she had seen on a trip to Toronto in 1928, and partly to her own investigations of Cubism. Her works of 1929 and into the 1930s like *Big Raven* (1931, fig. 48) have disciplined, geometricized forms. They strike a note similar to Harris. "Organized, orderly form," Carr called it in a poem she wrote in Port Renfrew, British Columbia. In such scenes, she felt "the nearness of God / the unity of the universe," she wrote. In 1930, Carr visited New York and met with Georgia O'Keeffe and Harris's contact for the 1927 International Exhibition, the admirable Katherine Dreier.

As artist-in-residence at Dartmouth College, New Hampshire, Harris moved

53

Fig. 47. Lawren S. Harris (1885-1970)
Untitled (Mountains near Jasper),
c. 1930
Oil on canvas, 127.8 x 152.6 cm
Mendel Art Gallery, Saskatoon
Gift of the Mendel family, 1965

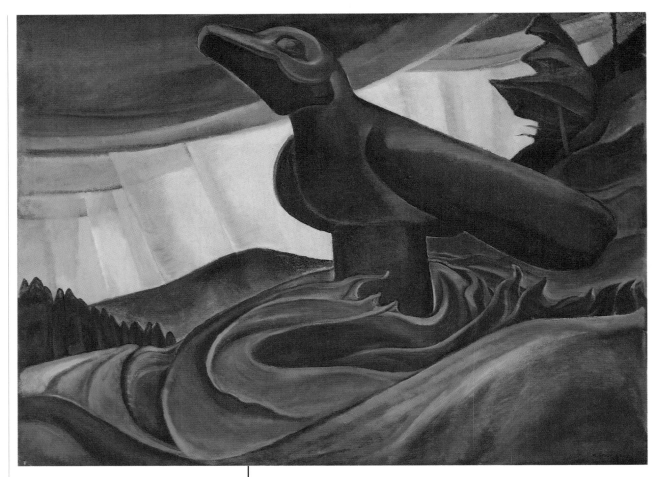

54

Fig. 48. Emily Carr (1871-1945)
Big Raven, 1931
Oil on canvas, 87.3 x 114.4 cm
Vancouver Art Gallery, Vancouver
Photo: Vancouver Art Gallery/Trevor Mills, VAG 42.3.11

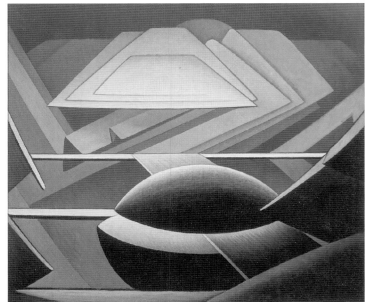

Fig. 49. Lawren Harris (1885-1970)
Riven Earth I, 1936
Oil on canvas, 77.5 x 90.1 cm
Robert McLaughlin Gallery, Oshawa
Gift of Isabel McLaughlin, 1987

through the drawing medium into non-objective art. In Santa Fe, New Mexico, he worked with Emil Bisttram, leader of the Transcendental Group of Painters, which Harris helped found in 1939. His work in Vancouver (1940-1970) continued to explore abstraction, rhythmically played out against peaked and swirling cloud shapes. Through some of his paintings, which use forms derived from landscape or with a reference to the universe of objects, Harris sought to portray a binding and healing conception of the universe. Harris himself spoke of creative life as a bridge and often painted bridges, abstracted, in his work. In *Riven Earth I* (1936, fig. 49), a bridge that resembles a wooden board splits the earth to imperfectly connect with what look like folded paper steps to the sky.

Abstraction differed from one painter to another at this early moment. Harris's work, with its powerful, crisp, architectonic shapes and geometric forms, is distinctive. Unlike those who changed styles under varying influences, he was able to create a coherent body of work by continuing to paint abstractly for over three decades. However, his work did change through the years. His abstract paintings range from the flat, frontal, and emblematic to subjects that float or are set in deep pictorial space. Harris's forms develop a cold purity as he becomes more aggressively interested in total abstraction. Yet his kind of abstraction is very different from the abstract work of artists like Fritz Brandtner.

Brandtner arrived in Canada from Danzig in 1928. His art was under the influence of Cubism and Surrealism, a movement that began in 1924 and continued into the 1930s; it took its content from the imagination and was concerned with the exploration of the unconscious mind through psychoanalysis, free association, and dream imagery. The way Brandtner exercised his imagination was always to be spontaneous. His sketches in coloured inks are all faces and interwoven movement, a hectic pattern, often of city life (fig. 50).

Fig. 50. Fritz Brandtner (1896-1969)
The City, c. 1926
Ink, watercolour on paper
Robert McLaughlin Gallery, Oshawa

Fig. 51. Fritz Brandtner (1896-1969)
Men on Horses, c. 1939
Watercolour and wax crayon on paper,
50.1 x 68.8 cm
Robert McLaughlin Gallery, Oshawa
Gift of Isabel McLaughlin, 1987

55

Fig. 52. Emily Carr (1871-1945)
Strait of Juan de Fuca, c. 1936
Oil on paper mounted on canvas, 56.2 x 87.0
Edmonton Art Gallery, Edmonton
Gift of Mrs. Max Stern, Dominion Gallery, 1973
Photo: E. Lazare

Fig. 53. Kathleen Munn (1887-1974)
**Descent from the Cross,
(Passion Series) 1934-1935**
Ink on paper, 72 x 52 cm (sight)
Robert McLaughlin Gallery, Oshawa
Photo credit: Art Gallery of York University

His landscapes are dark and passionately expressionistic with roads that wind upwards guided by the example of "reformed" Fauvists such as André Derain and Maurice Vlaminck (even as Brandtner learned from Fauvist colour).

Brandtner gave painting a new sense of visual forthrightness and urgency. He thrived on energy, his own and that of the world around him, simultaneously exposing the nuts and bolts and emotional core of painting. *Men on Horses* (c. 1939, fig. 51), a skewed, heaving, nearly abstract painting, reveals the dynamism that pervaded his vision. The effect of rhythm is reinforced by the lines of energy which divide the scene into powerful thrusting planes.

At much the same time, others showed a similar vibrant energy. Carr, in her sprightly oil on paper landscapes of the 1930s, used calligraphic brush strokes to express the coherence and seething rhythm of sky and water (fig. 52). The worshippers in Munn's *Descent from the Cross (Passion Series)* (c. 1934-1935, fig. 53) tumble almost head over heels; the sky is filled with triangles of light. In Saskatoon, around 1936, in the watercolour medium, Stanley Brunst embarked on the path that would lead him to abstraction. By 1939, in *Non-Objective* (fig. 54), in watercolour with brush and ink, ballpoint pen and pencil, Brunst fitted together interlocking planes in three-dimensional puzzle-like pieces shaped like pathways in a city of the imagination.

Meanwhile in Vancouver, in 1934, Jock Macdonald was making his first totally abstract paintings. For Macdonald, painting the first such work was a milestone. The work, an abstract canvas of a flower image, *Formative Colour Activity* (1934, fig. 55), he called an "automatic" painting. He used the unconscious, he said, and painted directly: "I created the canvas with no preconceived planning, I just started off with pure vermilion."[38] Macdonald got the idea from Kandinsky's theory that colour harmonies could be constructed without reference to nature, and it led to a new freedom in his work. The later "modalities" of Macdonald, as he called them, are the boundary line that mark

the end of this chapter and the beginning of a new phase in the development of abstraction in Canada. Two decades more would pass before abstraction became an enduring strain of modern art in Canada, one capable of being revised, expanded, and transformed by succeeding generations. In the interval, during the 1930s and 1940s, many artists influenced by the School of Paris, were involved in the re-entrenchment of figuration. Yet we can still look with pleasure at that brief moment when abstraction began to answer many of the questions artists have about the world.

Fig. 54. Stanley E. Brunst (1894-1962)
Non-objective, 1939
Watercolour, ink on card, 63.3 x 43.2
Mendel Art Gallery,
Gift of Dr. and Mrs. C.G. Morrison, 1982
Photo credit: Grant Arnold

57

Fig. 55. Jock Macdonald (1897-1960)
Formative Colour Activity, 1934
Oil on canvas, 77.0 x 66.4 cm
National Gallery of Canada, Ottawa

58

Fig. 56. Nathan Petroff (1916-)
Modern Times, 1937
Watercolour over graphite on wove paper
57.5 x 39.2 cm
National Gallery of Canada, Ottawa

Chapter Three
Innovations of the 1930s

Throughout the 1930s, the situation in Canada, as in much of the rest of the world, was one of economic collapse and social and political discontent. The crash of the Canadian stock market occurred in 1929. The industrial depression that followed was accompanied and aggravated by an agricultural one. Unprecedented dry weather on the prairies meant a farming crisis. In 1933, the bottom of the depression was reached. Already in 1933, discontent had given risen to a new political movement with a promise of socialism: the Co-operative Commonwealth Federation (the CCF) was launched at Regina that year. The Social Credit movement also offered hope and a remedy, as did the development in Quebec of the Union Nationale. In 1938, Canada, which had been largely isolationist since 1920, was drawn into the increasing world crisis: in 1939, it became committed to war against Germany. By the end of 1940, it had been transformed.

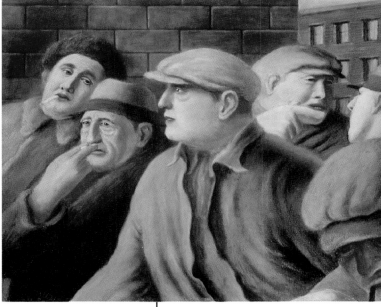

Fig. 57. Miller Brittain (1912-1968)
Longshoremen, 1940
Oil on masonite, 50.8 x 63.4 cm
National Gallery of Canada, Ottawa

Canadian artist Nathan Petroff sought to suggest the problems of life in the 1930s. In *Modern Times* (1937, fig. 56), a painting of a girl who has planted her feet on the newspapers in which she's been studying the Spanish Civil War, Petroff made his audience conscious of the world crisis. Individually, and through such organizations as the Federation of Canadian Artists (founded in 1941) and the Labour Arts Guild in Vancouver (founded in 1944), artists worked to integrate their lives and art with other elements of society.

Artists of the period examined political and social issues. Miller Brittain studied drawing in New York at the Art Students League (1930-1932) before returning to St. John, New Brunswick, to spend the rest of his life. A passionate observer of nature in all its forms including human nature, with a genius for narrative and the defining

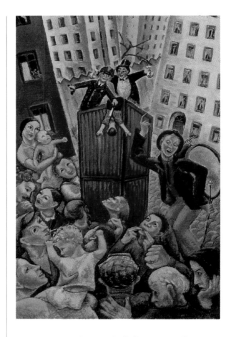

Fig. 58. Paraskeva Clark (1898-1986)
Petroushka, 1937
Oil on canvas, 122.4 x 81.9 cm
National Gallery of Canada, Ottawa

Fig. 59. André Biéler (1896-1989)
Wartime Market, 1943
Mixed media on composition board,
45.7 x 85 cm
Agnes Etherington Art Centre, Queen's
University, Kingston
Bequest of W.B. McNeill, 1959

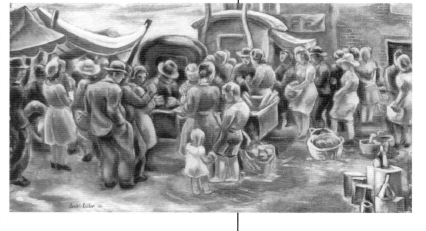

gesture, Brittain developed a pencil drawing in 1936 of a Communist Party speaker relaying his message to an audience, from on-the-spot sketches. He enhanced his subjects of working-class men and women like his *Longshoremen* (1938-1940, fig. 57) with rounded forms and a subtle painting technique.

Paraskeva Clark was born Paraskeva Plistik in Leningrad. She studied with Kuzma Petrov-Vodkin from 1918 to 1921 at the Free Art Studios (formerly the Imperial Academy of Fine Arts). In 1923, she moved to Paris, where she met Philip Clark, whom she married before moving to Canada in 1931. A political activist, she revealed moral urgency in her work. In 1937, she organized not only an exhibition to Aid Spanish Democracy but painted *Petroushka* (1937, fig. 58). The work, which shows a crowd of workers who admire or detest a Punch-and-Judy show that refers to the slaughter of steel strikers by police in Chicago, has a bold narrative. The objects in one of her watercolours of this date are gifts sent to her from Spain by Dr. Norman Bethune, and refer to the appalling spectacle of the Spanish Civil War. In other works, often portraits, Clark deftly manipulates paint in the manner of Cézanne and other Post-Impressionists, flattening space and setting her subjects in a perspectival space.

André Biéler, artist-in-residence at Queen's University, Kingston from 1936 to 1963, also expressed his social conscience in his work; he studied with an uncle, Ernest Biéler, and at the Art Students League summer school at Woodstock, New York in 1920 and 1921. The use of a crowd of people in many of his works, as in *Wartime Market* (1943, fig. 59) painted in a three-dimensional way with weight and modelling, reflects both his Art Students League training and his interest in the new currents sweeping the art world. "Today the artist is returning to the study of life, people working, the crowds of city streets, the social aspect which is so much of our time," he said.[1] To relate artists to the social issues of the day, Biéler organized the first National Conference of Canadian Artists, held at Queen's University, Kingston, in 1941 (see fig. 60).

Social commentary as a viable direction appealed to artists like John Lyman. His painting *Trouble* (1938), depicting two nude girls seated dejectedly at the edge of a bed, exhibited in 1942 under the title *Poverty*, reveals the melancholy tone characteristic of the period.

As an aid in creating socially conscious painting, many artists looked to the example of Mexico, particularly the work of muralists Diego Rivera, David Alfaro Siqueiros, and José Clemente Orozco. Canadian artists travelled there, and some, such as Leonard Brooks, who went to Mexico to study with Siqueiros, moved there permanently.

Even if social and political issues were not the themes of their work, artists were tenaciously inquisitive about the uncertainties and pace of the period. Their art, especially their choice of subjects, gives us an inkling of their feeling that their lives were in constant flux. A frenetic but fugitive energy was the keynote. These artists articulated a vision of art better suited to a world of shrinking distances, as well as continuing with the Group of Seven's exercises to loosen up conventional art. But during the same period, as though in reaction, artists were fuelled by a desire for an art that grew out of a specific area of native soil, sometimes equated with the history of a

Fig. 60. André Biéler at the Kingston Conference, 1941 (Seated at centre right)
Photograph courtesy Queen's University Archives, Frances K. Smith fonds.

61

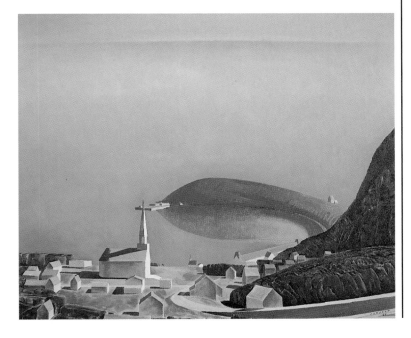

Fig. 61. Charles Comfort (1900-1994)
Tadoussac, 1935
Oil on canvas, 76.1 x 91.4 cm
National Gallery of Canada, Ottawa

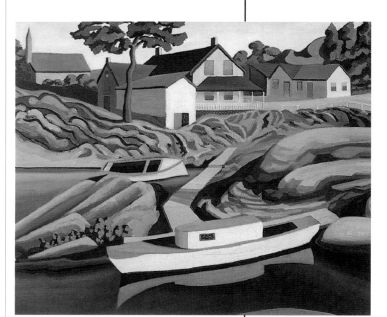

Fig. 62. Isabel McLaughlin (b. 1903)
Stan White's, Whitefish Falls, 1936
Oil on canvas, 76.2 x 66 cm
Private Collection

62

region. The environment offered challenge. To some of these artists, it served as a source of local colour. In terms of style, artists took up borderline positions, tangential to many artistic developments but adhering to none.

The contribution of artists of the 1930s in terms of style involves some form of familiarity with Post-Impressionism, followed by a marriage between Cubism and the natural world. Analysis of a painting like Charles Comfort's *Tadoussac* (1935, fig. 61), or Isabel McLaughlin's *Stan White's, Whitefish Falls* (1936, fig. 62) reveals a reference to Cubist methods — like geometric simplification of form, strong formal relationships, and a flattening of the picture plane, combined with shallow space. The result is a stylized modernist blend, solid and precise shapes, and smooth surfaces, that resembles work known in the United States as Precisionism, a term coined by the American painter-photographer Charles Sheeler (1883-1965).

Many Canadians artists went to Europe for their lessons about the dynamic potential in art. When Prudence Heward, Yvonne McKague Housser, and Isabel McLaughlin chose industrial sites or the figure as subjects, they knew that artists in Europe, particularly in Paris and Vienna, were tracking similar lines of investigation. Often working together, as at Whitefish Falls in the La Cloche country north of Georgian Bay in 1936 (see fig. 63), they concurred in their drive to create an art that would embody clarity, logic, and firm structure. On this order, they felt, they would build a new art.

The art of the 1930s does manage to introduce fairly distinct new material. First there is the industrial landscape. Then there is the urbanscape, a subject already developed in depth by Harris in his many paintings of "The Ward" area of Toronto. And finally there is the figure, and here new ground is developed in the introduction into art of contemporary life. Paraskeva Clark made much play out of the subject, calling for Canadian painters "to come out from behind the Canadian Shield," writing that it was time to paint the "raw, sappy life that moves ceaselessly about you, paint portraits of your own Canadian leaders ...

think of the human being, take actual part in your own times, find their expression and translate it...."[2]

Particular regions of Canada were also stressed, mostly by individuals who lived or visited there: Jack Humphrey painted Saint John, New Brunswick, his home. In Ontario, Carl Schaefer painted the landscape and architecture of Hanover. In Quebec, John Lyman painted the Laurentians, and a whole contingent of artists, Baie St. Paul in Charlevoix County. The trees and grass-covered sandbanks of Beausejour, Manitoba, were the realm of painter Caven Atkins (fig. 64).

These artists might indicate characteristic features of the landscape or architecture that reflected social life. The nominal subject of Schaefer's *John Voelzing's Farm* (1935, fig. 65), for instance, is a dwelling that evokes a sense of profound

Fig. 63. A group of friends at Whitefish Falls, 1936
(Top left to right): Randolph Hewton, Mr. Whittall, Charles Comfort, Yvonne McKague Housser
(Middle row): Isabel McLaughlin, Gordon Webber, Bennie Hewton
(Bottom row): Hal Hayden, Audrey Taylor, Prudence Heward, Rody Kenny Courtice, Mr. Macdonald
Photograph courtesy of the Robert McLaughlin Gallery, Oshawa

Fig. 64. Caven Atkins (b. 1907)
Landscape with River, Beausejour, Manitoba, 1932-1937
Oil on canvas, 91.5 x 122 cm
National Gallery of Canada, Ottawa

63

loneliness, but to the scene Schaefer adds naturalistic details that suggest the rock-solid life of the people who live in the house.

Industrial images have a long history in Canadian art of the twentieth century, but in the mid and late 1920s new attention focused on the subject — due partly to the development of the economy, partly to a new interpretation of industrialization as a symbol of the hopes and values of society. Artists perceived that the great achievement of technology was an entirely new way of life. Painting the machine world was a way of suggesting social and economic progress. They would have been able to follow the changes taking place in the United States, the leader in the new culture. They might have looked at the photographs of Paul Strand, especially his portraits of machines, and perhaps read the essay in which he claimed that man has "consummated a new creative act, a new Trinity: God the Machine, Materialistic Empiricism the Son, and Science the Holy Ghost."[3]

In *Vanity Fair*, February, 1922, Edmund Wilson wrote entertainingly about "The Aesthetic Upheaval in France: The Influence of Jazz in Paris and Americanization of French Literature and Art," an article which would have added to a growing literature about the Americanization of art.[4] In *The Little Review*, they could read more on the subject. Of the *Machine-Age Exposition* in New York, one reviewer, the artist Louis Lozowick (1892-1973) wrote that the history of America is a history of "gigantic engineering feats and colossal mechanical construction;" he found the dominant trend in America was towards order and organization as symbolized by the geometry of the city.[5] They could have looked closely at reproductions in various magazines of drawings and paintings of grain elevators and industry by Preston Dickinson and at Charles Demuth's *My Egypt*, a picture of a grain silo painted in 1927. They may have known Elsie Driggs's *Pittsburgh*, painted the same year, and Margaret Bourke-White's 1929 photograph *Ore-Loading, Great Lakes*. (The composition

Fig. 65. Carl Schaeffer (1903-1995)
John Voelzing's Farm, 1935
Watercolour on paper, 40.6 x 55.9
Private Collection

64

Fig. 66. Adrien Hébert (1890-1967)
Montreal Harbour
Oil on canvas, 76.5 x 96.5 cm
Montreal Museum of Fine Arts, Montreal
Gift of Dr. Jacques Olivier
Photo: Montreal Museum of Fine Arts, Brian Merrett

Fig. 67. Adrien Hébert
The Blacksmith's Shop, c. 1926
Oil on canvas, 61.2 x 73.8 cm
Robert McLaughlin Gallery, Oshawa
Photo: T.E. Moore, Toronto

in this photograph, in which a triangular wedge shape is silhouetted against a dramatic sky, might have been recalled by Yvonne McKague Housser when painting the industrial town of Cobalt the following year.)

Richard Guy Wilson in his chapter on "Machine Aesthetics" in the catalogue for the Brooklyn Museum show of 1986, *The Machine Age in America, 1918-1941,* says that there were two reactions to the machine in the 1920s and the 1930s: exaltation or rejection. "Exaltation meant recognition of the primacy of the machine for the new age and the attempt to make it into art."[6] Canadian artists meant to exalt, but sometimes added a personal touch, stressing the workers who peopled the frontier.

Montreal was the centre for many of these pioneers of urban subject matter and the idea of the city as a stage on which contemporary society was playing out a drama. Adrien Hébert and Marc-Aurèle Fortin painted the port. From 1924, Hébert's depictions of the unusual angles

made by boats set before buildings populated by dock workers as in *Montreal Harbour* (fig. 66) set the tone for his vivacious scenes of the city and country and his muscular interiors (fig. 67). Fortin's harbour landscape, around 1928, depicted more dramatic events like the billowing clouds from a downtown fire as in *Fire in the Port of Montreal* (c. 1928, fig. 68).

In Ontario, artists often studied the Group of Seven's work for its organizational principles, then moved on to potent new work. Lismer had painted his *Copper Mining Town, Ontario*, a vivacious industrial scene with a path leading into the distance. There were several other examples in the late 1920s of industrial landscape; Franklin Carmichael enjoyed painting the La Cloche Hills in the nickel belt southwest of Sudbury. In 1930, Carmichael sketched Cobalt, about four hundred kilometres north of Toronto, and produced from these drawings

Fig. 68. Marc-Aurèle Fortin (1888-1970)
Fire in the Port of Montreal, c. 1928
Oil on canvas, 88.4 x 116.5 cm
National Gallery of Canada, Ottawa

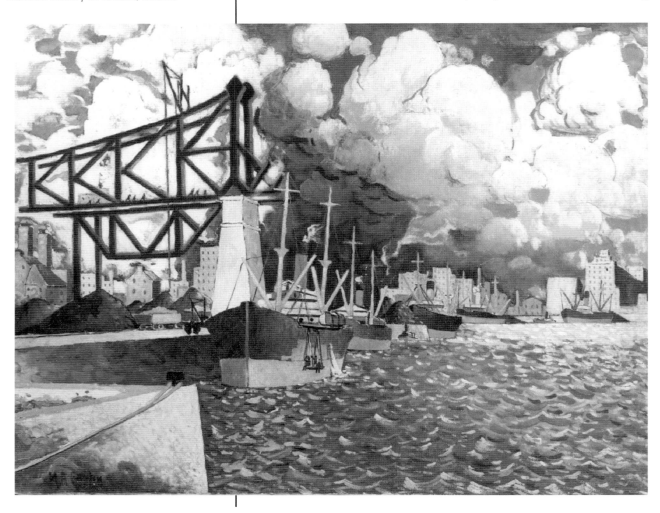

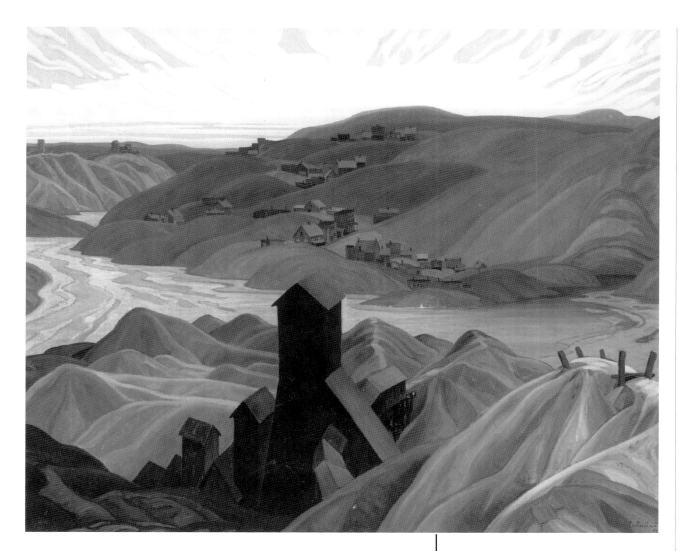

and paintings *A Northern Silver Mine* (1930, fig. 69), a classic Canadian state-ment on the theme. In Carmichael's picture, the abandoned mine and slag heaps look dark and ominous. Yet the radiant sky over the peaceful town sug-gests that the scene is a harbinger of the future. Like most Canadian artists who focused on northern imagery, Carmichael was optimistic in his message. As curator Rosemary Donegan has pointed out in *Industrial Images,* the catalogue that accompanied her groundbreaking 1987 exhibition, to artists interested in industrial subject matter the north meant mining and lumbering, the opening up of the last frontier; the inhabitants of the mining communities embodied the spirit of frontier life.[7]

Fig. 69. Franklin Carmichael (1890-1945)
A Northern Silver Mine, 1930
Oil on canvas, 101.5 x 121.2 cm
McMichael Canadian Art Collection, Kleinburg
Gift of Mrs. A.J. Latner

Fig. 70. Yvonne McKague Housser, 1931
M.O. Hammond collection
Photograph courtesy of the National Gallery
of Canada, Ottawa

68

The career of Yvonne McKague Housser (fig. 70), one of the innovative painters of the period, who was also an important teacher at Toronto's Ontario College of Art from 1918 to 1946 and at many other schools,[8] provides an instructive example of the way artists used their imagination to improve on what they saw to convey the romantic call of the frontier.

Housser had first discovered Cobalt on a trip in 1917 when she was still a student.[9] She quickly decided that she loved the architecture, especially the mining shafts.[10] They looked romantic to her, like a castle on a hill of slag heaps.[11] "At night it was like a stage set," she said.[12] She also loved the surrounding countryside, for her a new world of bush and rock.[13] The town, founded in 1904, had a rough-and-ready quality. The houses, the twisting streets, the rocks set crazily on cliffs and hills, all seemed to be distributed helter-skelter. When Housser first saw Cobalt, it was still a strong producer of silver: its age of greatest prosperity was from 1907 to 1920. By 1930, its more than thirty mines were deserted, and the town a graveyard.[14] The industry's diminishment caught her imagination.[15]

In her Cobalt paintings, Housser strove for the vastness, majesty, and sense of the sublime that were characteristic of Group work, accenting the pattern through exaggeration. She referred to the Group in her use of strong plastic

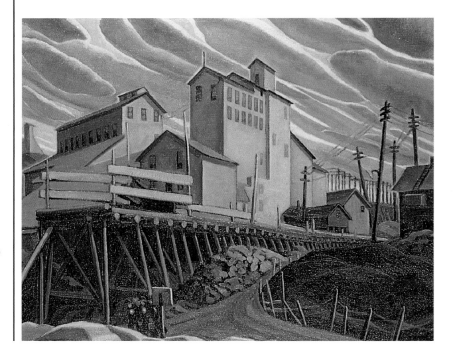

Fig. 71. Yvonne McKague Housser (1898-1996)
Silver Mine, Cobalt, 1930
Oil on canvas, 76.2 x 88.7 cm
London Regional Art and Historical
Museums, London
F.B. Housser Memorial Collection, 1945

effect, simplified forms, and dark colour range, but humanized these qualities. Her houses and mines look inhabited, usually through the handling of details, such as the windows of houses and factories: they appear curtained or shining with light if the scene is at night. She also enjoyed introducing figures trudging down a road or seated on a porch, or indicated their presence by inserting details such as a passing car or laundry flapping from a line. Her anecdotal way of handling subject matter was common to many cityscape painters of the period (it appears in the work of Fortin, too). What was more distinctively hers was the subject matter. Her artist friends McLaughlin and Rody Kenny Courtice accompanied her on some of her trips; and in time McLaughlin and Courtice essayed the industrial subject in their work.

They often found inspiration in Cobalt; they also went to Gowganda, Nipissing, and Kirkland Lake. Two of Housser's finest paintings, *Cobalt* (1931, National Gallery of Canada, Ottawa) and *Silver Mine, Cobalt* (1930, fig. 71) are the result: the first follows Lismer's lead in composition, the second develops new, dramatic ground. McLaughlin also essayed new approaches in *Nipissing Mine, Cobalt* (c. 1931, Art Gallery of Windsor, Windsor), and *Goldmine, Kirkland Lake* (c. 1932, fig. 72) where she symbolizes the gold of the mine in the beaming sun's rays. Along with Housser's *Ross Port, Lake Superior*

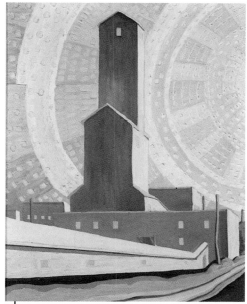

Fig. 72. Isabel McLaughlin (b. 1903)
Goldmine, Kirkland Lake, c. 1932
Oil on canvas, 86.4 x 66 cm
Macdonald Stewart Art Gallery,
University of Guelph, Guelph

69

Fig. 73. Yvonne McKague Housser (1898-1996)
Ross Port, Lake Superior, 1929
Oil on canvas, 55.9 x 81.3 cm
London Regional Art and Historical
Museums, London
F.B. Housser Memorial Collection

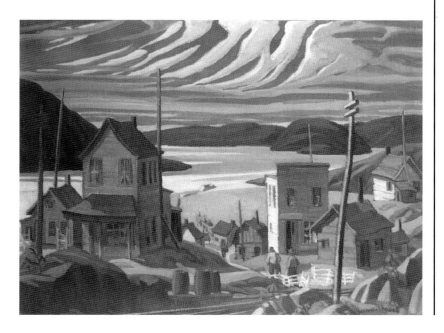

Fig. 74. Paul Rand (1896-1970)
Coal Diggers, 1935
Oil on canvas, 105.4 x 120.6 cm
National Gallery of Canada, Ottawa

Fig. 75. Philip Surrey (1910-1990)
Children at Night, 1939
Oil on canvas, 86.4 x 66.0 cm
Art Gallery of Ontario, Toronto

(1929, fig. 73), they mark a high point of the work of these artists.

Many other painters depicted industrial Canada. Charles Comfort's *Smelter Stacks, Copper Cliff* (1936, National Gallery of Canada, Ottawa) in which he makes the smoke stack the focus of the painting displays his characteristic seriousness and ambition. Paul Rand, in a hymn to progress based on memories of coal mining and the town of Coleman, Alberta in *Coal Diggers* (1935, fig. 74), painted industrial workers, shovel and pick in hand, at work on faceted ore that recalls the crystalline structure of jewels. Marian Scott painted the urban landscape in works such as *Cement* (1938-1939, McGill University, Montreal).

Scott studied at the Slade School of Art in London from 1926 to 1927. By 1935 she had come into contact with the British group known as "Unit One," and begun to bask in the best of influences for machine age modernism, that of Léger's. In tune with the times, which by now had begun to doubt the potential of technology as reflected in the urban experience, Scott's mood is much bleaker than that of Housser and McLaughlin.

Philip Surrey looked to the pulse of the modern city as a powerful subject and explored in depth its highly structured but dynamic world. Often, the hue that he selected as the predominant tone of his painting adds to the mood, which may be fraught with repressed tension. The convulsive vitality of his *Children at Night* (1939, fig. 75), for instance, in which he orchestrated a twilight drama involving his love of artificial lighting with a magical picture of children at play, evokes city streets with a hint of foreboding. For him, the city was a place where light was mysterious and sometimes played tricks on the viewer.

Other artists compassionately convey the humanity of their subjects

through their depictions. Leonard Hutchinson, who helped organize an artist's union in Hamilton in 1936, the same year that he was appointed curator of the Art Gallery of Hamilton, recorded workers' lives in crisp black-and-white woodblock prints like *Got Anything to Eat Mister?* (fig. 76); they express his sympathy for the impoverished. In Montreal, artist Louis Muhlstock had a similar empathy with his subject. Muhlstock, Alexander Bercovitch, Ghitta Caiserman-Roth, and Sam Borenstein often painted the streets and houses of Montreal, and specifically, workers and their lives. Borenstein's *Old Montreal at Night* (1938, fig. 77) caught the sombre spirit of the era. But throughout such depictions ran a thread of hope for the future. Fred Ross expressed the mood for all when in 1947, he created murals for Fredericton High School of *The Destruction of War* (in one panel) and the *Rebuilding the World through Education* (the second). The cartoons for these murals, now in the collection of the National Gallery of Canada, show the sorrows of war and its aftermath, victims, and destruction but also the new world that Ross hopes will result from the war.

Fig. 76. Leonard Hutchinson (1896-1980)
Got Anything to Eat Mister? c.1938-1942
Wood engraving on wove paper, 44.8 x 36.5

The figure, devoid of literary or social content, was also a favourite subject. Painters had good precedent for painting the figure from John Lyman in Montreal and from the Group of Seven with portraitists like Varley (fig. 78) and Edwin Holgate. Lyman was at his best in depicting small groups, where he sensitively registers subtleties of light. Varley's best work has a sensuous concentration that seems almost akin to love — revealing his appetite for female beauty. Holgate, by contrast, was taught by Adolphe Milman, a devotée of Cézanne, and he monumentalized and distanced his subjects, placing them in landscape so that they became as sculptural as his background hills. In Calgary, Maxwell Bates and William Leroy Stevenson adopted Post-Impressionism following a trip to the Chicago Art Institute in 1929. Stevenson, in his figure paintings, developed an excitingly painterly style, thick with manipulated paint, resonant colour, and

Fig. 77. Sam Borenstein (1908-1969)
Old Montreal at Night, 1938
Oil on masonite, 45.7 x 66.0 cm
Private Collection

71

Fig. 78. F.H. Varley (1881-1969)
Portrait of Vera, 1935
Oil on board, 38.1 x 30.5
Private Collection

Fig. 79. Maxwell Bates (1906-1980)
Girl with Scarf, c. 1957
Oil on canvas, 50.6 x 40.6 cm
Robert McLaughlin Gallery, Oshawa
Gift of Ron Bloore, 1974

an aura of emotional involvement reminiscent of the French painter André Dunoyer de Segonzac.[16] Bates broadened his horizons with a trip to England in 1931, returning in 1946. Interested in Pablo Picasso, Henri Matisse, and English artists such as Christopher Wood, Bates became a member of the British Twenties Group (titled for the age of most of the participants), which included Barbara Hepworth and the novelist Mervyn Peake, among others. Back in Calgary, Bates created expressive paintings, drawings, and watercolours that blurred the boundaries between naive and fine art and were characterized by a strong contour line, witty form, and vivid colour. He produced a diverse passionate body of work, often of figure subjects, that alternated between assimilation, despair, unhappiness, and tranquillity, though his serenity was evoked mostly in his landscapes. From 1949 to 1950, Bates lived in New York and attended the Brooklyn Museum Art School studying with Max Beckmann and Abraham Rattner — both of whom created work he had long felt to be in sympathy with his own. *Girl with Scarf* (1957, fig. 79) packs quite a bit of knowledge of the art of the century into limited space.

Montreal painter Prudence Heward was another painter with a persistent and attentive eye to the changes being wrought by the twentieth century. In her strong portrait and figure paintings, she used simplified forms, often integrating them into her backgrounds. However, her choice of subject — often women of colour or those of the First Nations — opened Canadian art to include the outsider considered primitive, instinctual. She was among the first in Canadian art to conceive of First Nations' subjects as powerful and confident individuals, though hauntingly mysterious as in her insightful *Indian Head* (1936, fig. 80).

Housser also painted northern Canadians, often women, with psychological acuity (and an echo of Gauguin). In Saint John, New Brunswick, Jack Humphrey took as his subject not only the city but portraits of the people who lived there, particularly children, as in his appealing *Boy with Red Hair (Fred Smith)* (c. 1941, fig. 81). Their naturalness as subjects must have contributed to his lack of self-consciousness when painting. A mood of intimacy is often the result.

Pegi Nicol MacLeod, by contrast, often using her own body as a subject, expressed an endearing sense of wonderment about the figure. If we look at

her *Costume for Cold Studio* (1925-1930, fig. 82) and compare it with her *Self-Portrait with Flowers* (c. 1935, fig. 83), we realize that her appearance serves to echo the process of discovery her work was undergoing. In the first, painted during her years in her hometown of Ottawa, she stands deliberately posed, intense, her clothes distinctive, unconventional but soft, her small face charming as she looks into the mirror located somewhere in the viewer's space. The handling of space invigorates the painting: it forms almost a vortex into the distance. The second painting reveals a consciousness of her sexuality, as she boldly juxtaposes her nude figure with daffodils. The comparison of the body with the tubular forms of plants and the delicate petals of flowers is an evocative metaphor, and one with a magical power rare in Canadian art. The intervening years MacLeod had spent mostly in Montreal, sketching in the street, recording her surroundings, or in the company of such painter friends as Scott, Heward, and Goodridge Roberts. Hers is action-oriented painting, vigorous, rhythmic, full of movement and figures, often in unusual positions. "Man moving and acting; persons by shape and form, by personality and feeling, juxtaposed against each other," she said in 1941, as though defining her own approach, although she was writing about the work of New Brunswick painter Miller Brittain.[17]

In the mid-1930s and later (she moved to New York in 1937), Pegi Nicol MacLeod, as though to prove that she was *en rapport* with the latest developments in art, added to her irrepressible paintings a touch of Surrealism. MacLeod's use of the concept was more evocative than radical, however, as in her *Descent of Lilies* (1935, fig. 84), where her interpretation involves a choreography of colliding forms. Like many of her contemporaries, she found abstraction a blind alley and never painted any non-objective works. Her development was towards a growing, though compressed, vivacious movement. Her draughtsmanship also changed, becoming more sinuous, her surface pattern simpler, and her use of colour more sustained and bolder. She conveyed this change in her paintings in the early 1940s of war-related subjects. Like other artists of the 1940s, she paid careful attention to design and structure. A.Y. Jackson recognized the trend and advised an artist to "Try some still life and bold solid patterns as though you chopped out the shapes with an axe."[18]

At about the same period of time, the work of the painters Lismer, McLaughlin,

Fig. 80. Prudence Heward (1896-1947)
Indian Head, 1936
Oil on board, 36.0 x 30.6 cm
Robert McLaughlin Gallery, Oshawa
Gift in memory of Woodruff Band, 1993
Photo: Roy Hartwick

73

Fig. 81. Jack Humphrey (1901-1967)
Boy with Red Hair (Fred Smith), c. 1941
Oil on masonite, 60.7 x 50.8 cm
Beaverbrook Art Gallery, Fredericton
Gift of the Committee for Jean F. Humphrey

Fig. 82. Pegi Nicol MacLeod (1904-1949)
Costume for a Cold Studio, 1925-1930
Oil on canvas, 53.5 x 38.3 cm
Robert McLaughlin Gallery, Oshawa
Photo: T.E. Moore

Fig. 83. Pegi Nicol MacLeod (1904-1949)
Self-Portrait with Flowers, c. 1935
Oil on canvas, 91.4 x 68.5 cm
Robert McLaughlin Gallery, Oshawa

Fig. 84. Pegi Nicol MacLeod (1904-1949)
Descent of Lilies, 1935
Oil on canvas, 122.0 x 91.6 cm
National Gallery of Canada, Ottawa

Housser, B.C. Binning, L.A.C. Panton, and Hortense Gordon developed a growing modernism. The way pictorial intensity could be enhanced by design is dramatically illustrated in McLaughlin's *Flying Impressions* (c. 1945-1950, fig. 85). With recognizable imagery composed of the most vivid and durable emblem of twentieth-century technological aspiration — the airplane — and clouds, this painting, all wiry contours and exquisite colour, has the effect of suggesting to the viewer a non-representational reading. The shifting relationship between the mechanical and the natural is largely generated by a skillful and highly sensitive accommodation of volumetric

forms to a resolutely flattened surface. McLaughlin's finesse in making solidity and two-dimensonal planes cohabit lies at the centre of her ability. Accordingly, the works she created later, devoted to the traditional genres of still life and landscape, firmly insist on a similar approach.

Montreal painter Goodridge Roberts, who studied at New York's Art Students League under John Sloan of the Ashcan School, Boardman Robinson and Max Weber, was interested in the artistic freedom made possible by Matisse and learned

Fig. 85. Isabel McLaughlin (b. 1903)
Flying Impressions, c. 1945-1950
Oil on canvas, 67.5 x 90.5 cm
Robert McLaughlin Gallery, Oshawa

from his example the placement of a volume in space and pictorial organization. In his *Portrait of a Lady in a Green Hat* (c. 1936, fig. 86), he echoed the work of the French master, opposing the colour of the background with the colour of the face for three-dimensional effect. In his paintings of nudes of the late 1930s, Roberts emphasized the contour of the form as had Matisse and also

challenged himself to paint the nude in a non-academic way. He treated the model as a neutral element: the background is as important as the figure. Elsewhere, in his unpretentious and often ragged landscapes sometimes painted from a high spot overlooking an expanse, Roberts condensed the forms, emphasizing low-key colour and earth tones in an austere vision. His still life subjects, too, trace a progression at once driven and hesitant. One

Fig. 86. Goodridge Roberts (1904-1974)
Portrait of a Lady in a Green Hat, c. 1936
Oil on canvas, 53.3 x 40.0 cm
Edmonton Art Gallery, Edmonton
Purchase 1976 with funds donated by the Women's Society of the Edmonton Art Gallery

75

of his favourite motifs was a vase, jug, or pot of flowers on a table: he painted it with obsessive regularity, repeatedly dissecting the colours the subject offered as in *Still Life on a Table* (c. 1932, fig. 87). Robert's work came alive when he demonstrated that his vision of space could be as dynamic as it was descriptive. His shapes tautly add to the vitality so that his work looks effortless. The animated exchange between paint and nature and between the artificial and the perceived are, in Roberts's best canvases, a key to his work.

During the 1930s, there were changes, too, in the materials with which art was made. In 1926, the esteem for watercolour had led Carmichael and Casson to found, with F.H. Brigden, the Canadian Society of Painters in Water Colour. Watercolour is a delicate medium; it enabled both Carmichael and Casson to convey their sense of light and qualities that reflect those of their own personalities, precision and subtlety among them (fig. 88). Four years after the group was formed, Carmichael and Casson convinced the other Group members to set aside a special space in the 1930 Group of Seven exhibition for the

Fig. 87 Goodridge Roberts (1904-1974)
Still Life on a Table, 1932
Watercolour on paper, 50.8 x 63.5 cm
Private Collection

76

Fig. 88. Franklin Carmichael (1890-1945)
Bay of Islands, 1930
Watercolour on paper, 44.5 x 54.6 cm
Art Gallery of Ontario, Toronto
Gift of Friends of Canadian Art Fund, 1930

display of watercolour, which marked an important step in the medium's acceptance.

Painters in Canada who had been Carmichael's students like Charles Goldhamer looked to his work as an example when developing watercolour for themselves. Goldhamer always recalled the way Carmichael urged him to discover the shape of clouds, for instance, but Goldhamer's precise evocations of landscape and harbourside and depictions of the craftspeople of Quebec are directed by

Fig. 89. Charles Goldhamer (1903-1985)
Fishing Boats, Atlantic Coast, 1939
Watercolour on paper
Private Collection

his sharp vision (fig. 89). Other painters who used watercolour, like Carl Schaefer, looked to American sources as they produced their sophisticated bodies of work. Schaefer had met the Buffalo painter and master of the watercolour medium, Charles Burchfield, and deeply admired his way of creating a scene that transcended the particulars of place.

The use of mixed media championed by André Biéler from around 1938 because it contributed to tonal gradations, was in common use in the 1940s. Due to an increasing interest in textural effects, artists combined crayon and pastel with watercolour, scratching or scraping into the paint surface as well as roughening paint texture with sand.

In the years between the world wars, Canadian printmaking blossomed, and new subjects were introduced such as the realities of life during the Depression. W.J. Phillips in Winnipeg explored the subtleties possible in the woodblock, tackling western landscape subjects (fig. 90). Sybil Andrews, who emigrated to Canada from Great Britain in 1947, was an important artist associated with the Grosvenor School of Modern Art, a London institution

Fig. 90. W.J. Phillips (1884-1963)
York Boat on Lake Winnipeg, 1930
Colour woodcut, 26.1 x 35 cm
Masters Gallery, Calgary
Edition: 150

77

formed in 1925, and was influenced by modernist English movements such as the Vorticists. Her linocuts convey her heady sense of events and energy exploding or imploding.

Wood became one of the popular materials in sculpture produced during the 1930s, perhaps because it provided an inexpensive medium during the Depression. It is an elegant material that encourages textural effects, and its use may have influenced Florence Wyle's technique as she applied a stippled finish to the surface of her figures in clay. At around the same time, Elizabeth Wyn Wood employed similar textural effects in clay.

The group in central Canada dedicated to the exhibition of modern art in this period was the Canadian Group of Painters, founded in 1933; it included most of the artists who had exhibited with the Group of Seven in previous years. Its strength paralleled the development of modernism in Canada, and since that occurred up to the time of the early stirrings of Abstract Expressionism in Canada in the late 1940s, its period of greatest importance was at its inception and for the first fifteen years of its existence. Housser was one of the founding members, along with Carr, Brooker, Heward, McLaughlin, Sarah Robertson, and Anne Savage. When it began, its members believed that its creation meant a fresh start by comparison with earlier groups such as the Ontario Society of Artists and the Royal Canadian Academy; they believed that in its drive toward clarity, lightness and openness lay its Canadian quality.[19]

At each successive show new artists appeared, and permanent members were drawn from among them. The Group's credibility, as with the Group of Seven from which it developed, rested on the collective strength of older members' work shown alongside that of younger invited artists. New members usually exhibited work for two years and in the third year were asked to join. Thus only artists who had proven themselves active contributors were admitted. Though the belief in exhibiting new work was real, change occurred slowly.[20]

One of the problems of the Canadian Group lay with its aims. The letters patent said it had come into existence to "promote closer co-operation among artists of Canada who have for a period of years expressed a sympathetic kinship in their interpretation of the Canadian environment." "Sympathetic kinship" is a vague phrase, and not unlike the aims of other societies such as "fostering Original Art" which was in the charter of the Ontario Society of Artists,

founded in 1872. The aim of the Canadian Group was kept nebulous to make membership as broadly based as possible, but it led to accusations of a certain greyness. Some said the exhibitions lacked a sense of occasion, even of focus. In 1943, the Montreal branch felt (as the notes of an executive member say) that "no one knows what the Group really is, that we are so intermingled that there is no definite character of our own, that some of the invited contributors are so derivative, and that they have no interest in developing Canadian motifs."[21] Randolph Patton writing for the *Winnipeg Tribune* in 1952 thought that the Canadian Group was under an obligation to make the next great leap after the Group of Seven's development of landscape painting and achieve a characteristically Canadian "liberation" in the field of figure painting.[22] The criticism lasted to the end of the days of the Canadian Group. By the 1950s, it should be said, work in Canadian Group shows did have a middle-of-the-road quality.

Group members were sensitive to this problem. Arthur Lismer's foreword to the 1945 catalogue of the annual show attempted to widen the guidelines of the Group, saying: "The signs point not towards a personal or even national desire to express merely an environment, but to a definite and compelling demand on the artist in a more organic world to interpret a wider view, to see deeper and further than others in a world in which space, time, and the larger patterns of living have a meaning."[23] McLaughlin and Housser stressed the encouragement of artists who were exploratory and original in approach, concerned with industrial and sociological activities. In 1958, Jack Bush wrote the president a letter asking the Group to take more advantage of the "adventurous, daring, and distinctive work being done from coast to coast," and develop a much more vital policy, one that would include abstract artists.[24] In time, it did. Yet change came too late. Complaints from young contenders like Harold Town, who said the annual exhibitions of the groups like the Canadian Group of Painters "told us art was alive and proved it was dead,"[25] contain a grain of truth. A new era had dawned: that of groups dedicated to evolving forms of art.

In Montreal, John Lyman believing less in the Canadian scene and more in the spirit of innovation, brought together Goodridge Roberts; Jack Humphrey of St. John, New Brunswick; Jori Smith, Eric Goldberg, and Alexander Bercovitch, all of Montreal, to form another early group. The name by which

79

they first exhibited, in 1938, was the Eastern Group. The choice, by implication, suggests that they considered the Canadian Group of Painters the Western group. In 1939, to support contemporary trends in line with international art, Lyman started the Contemporary Arts Society. Its purpose was to sponsor shows, bring artists and collectors together, work as a lobby to counteract the influence of conservative art and help the public discover art; it acted as a catalyst to more advanced developments. Lyman surrounded himself with English and French-speaking painters although like the Canadian Group of Painters, the Society had its weaknesses. However, its early shows assisted in the emergence of a full-fledged modern movement in Quebec.

Groups such as the Canadian Group of Painters and the Contemporary Arts Society were helpful in the development of Canadian art because they offered a unifying strategy to members. They did a surprisingly effective job of dealing with a large and difficult subject, and in time, through their shows which aimed at presenting the best painting of the day, they helped expand our collective experience of what constitutes Canadian art. In both cases, the meetings made careers in art more accessible to women. The sales such groups made, however few, and the camaraderie counted for something during the decades when careers were blighted by the economy and the Second World War. Until they disbanded — the Contemporary Arts Society in 1948, the Canadian Group of Painters in 1969 — they offered a forum for committed and inventive practitioners of art.

A forum of a different sort was provided by the creation in 1943 of an official war artists' program that employed thirty-two artists by the end of the Second World War (fig. 91). From the outbreak of war in 1939, artists reflected on the impact of war, on how it affected the individual and society. They assisted the war effort by judging art competitions, staging exhibitions, and writing instruction manuals for servicemen and women.[26] On the Atlantic coast, in 1944, Jack Humphrey sketched Saint John, New Brunswick's ship-building sites. In Montreal, Fritz Brandtner, Alma Duncan and Louis

Fig. 91. Canada's War Artists, 1946
(From left): seated, H.O. McCurry, A.Y. Jackson; standing, Orville Fisher, George Pepper, Will Ogilvie, Edward J. Hughes, Molly Lamb Bobak, Charles Comfort, George F.G. Stanley (historical officer), Alex Colville, Campbell Tinning, Bruno Bobak.
In the background is Wyndham Lewis's Canadian Gunpit, 1918.

80

Muhlstock, sketched in Montreal's Vickers' Plant, Paraskeva Clark painted the R.C.A.F. Women's Service, as in her *Parachute Riggers* (1946-1947, fig. 92); Frederick Taylor worked at CPR's Angus plants in Hochelaga. In Toronto, Caven Atkins, who had left Winnipeg in 1934, recorded the shipyards. On the Pacific Coast, in 1943, Bobs and Peter Haworth recorded the military activities at the Naval Station Esquimalt, and A.Y. Jackson and H.G. Glyde sketched along the Alaska Highway. Rody Kenny Courtice's *The Game* (c. 1949, Robert McLaughlin Gallery, Oshawa) reduced war to a game in a toy theatre, viewed by black, white, and red chess pieces on a board with a hammer and sickle. Wyn Wood sculptured a *Munitions Worker* with a sickle behind her head that acknowledged at one and the same time the role of women in factory and agricultural work and Canada's war-time alliance with Russia (1944, National Gallery of Canada). Grant Macdonald, who served in the Canadian navy from 1943 to 1945, created wash drawings of the HMCS *Haida*; Moses Reinblatt in the R.C.A.F. painted Corporal Seagar, a rigger, thereby winning an art contest that enabled him to serve as an official war artist (fig. 93). The strength of Molly Lamb Bobak, the first and only female war artist

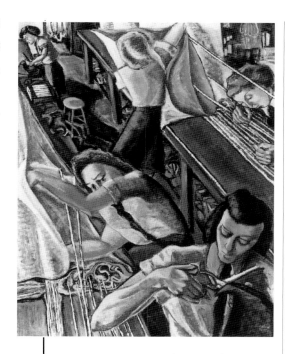

Fig. 92. Paraskeva Clark (1898-1986)
Parachute Riggers, 1946-1947
Oil on canvas, 101.7 x 81.4 cm
Canadian War Museum, Ottawa, #14086

(1944-1946), was confirmed in her beautiful and compelling portrait of *Private Roy, Canadian Women's Army Corps* (1946, fig. 94) and her humorous *Gas Drill* (1944). Others like Will Ogilvie, Lawren P. Harris (the son of Lawren Harris), Carl Schaefer and Miller Brittain, who served in the Royal Canadian Air Force (he flew thirty-seven missions over Germany) recorded the military effort in the field. The result was a rich variety of interpretations, all concentrating in various idiosyncratic ways on

Fig. 93. Moses Reinblatt (1917-1979)
Corporal Seagar (Rigger)
Oil on canvas, 67.3 x 58.5 cm
Robert McLaughlin Gallery, Oshawa
Gift of Lilian Reinblatt, 1982

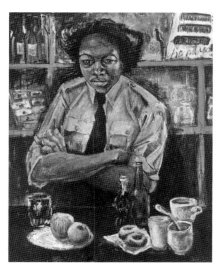

Fig. 94. Molly Lamb Bobak (b. 1922)
Private Roy, Canadian Women's Army Corps, 1946
Oil on masonite, 76.3 x 60.7 cm
Canadian War Museum, Ottawa, #12082

81

Fig. 95. Lawren P. Harris (1910-1994)
Tank Advance, Italy, 1944
Oil on canvas, 75.8 x 101.2 cm
Canadian War Museum, Ottawa, #12722

82

the subject with a scope that boded well for the continued vitality of Canadian art.

War artists were, because of the nature of the job, conservative in their work (only a few, Michael Forster among them, resolutely introduced abstraction into war work). But the influence of the modern age of painting, with its formal experiments and challenges, did not leave war work totally untouched: Harris's paintings of the battlefield, in particular, evoke certain aspects of Surrealism. In terms of the history of twentieth-century art, what the war offered the tradition was novel subject matter. Charles Comfort and Lawren P. Harris in *Tank Advance, Italy* (1944, fig. 95) offered dramatic images that suggest something of what it was like to be under fire. Harold Beament, in *Pink Frock* (1943, fig. 96), conveyed the appearance of a bombed home in an apartment house — here a pink dress on a hanger swinging idly in the breeze. "It almost seemed to do a sad little dance of mourning for its owner — now dead," he wrote.[27] "The bright pink suggested the character of the life that had been

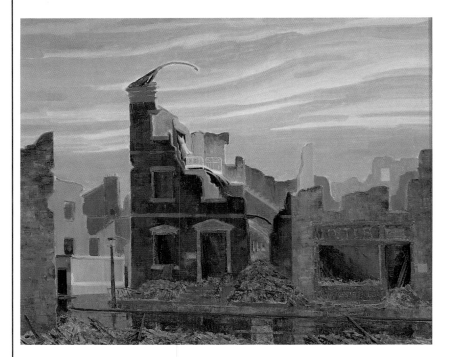

Fig. 96. Harold Beament (1898-1984)
Pink Frock, London (1944)
Oil on canvas, 51.4 x 61.3 cm
Private Collection

lost."[28] Painters such as Alex Colville helped expand the parameters of Canadian art, though without much altering the profile of the development of art since the 1930s. More harrowing are Colville's records (along with the paint-

ings of Aba Bayefsky) of Belsen Concentration Camp (fig. 97). Colville and Bayeksky's sketches and paintings are frightening depictions of conditions in the camp, but though they are compelling, they do not provide a new agenda for art. Realism was about to give way to a different aesthetic, a shift in sensibilities encouraged by the experience of these five years.

Fig. 97. Alex Colville (b. 1920)
Bodies in a Grave, 1945
Graphite on paper, 32.5 x 49.6 cm
Canadian War Museum, Ottawa

83

Fig.98. William Ronald (1926-1998)
Slow Movement, 1953
Casein and Duco with slight graphite on
masonite, 122 x 243.3
Robert McLaughlin Gallery, Oshawa
Photo: T.E. Moore

84

Chapter Four
Abstraction in Canada: the 1950s

B y the late 1940s, Canada had begun to emerge from the post-war years. It entered a decade during which national issues were to be complicated and intensified by the emergence of the United States as a nuclear world power. In the materially complex, intellectually sophisticated new and largely urban society, the old preoccupation with national expression dropped away. Canadian artists began to regard art as a form of personal expression. To encourage artists and create a public taste, the Canada Council was founded in 1957. In a world under the stress of a new and precarious balance of power and lit by flashes of apocalyptic menace, Abstract Expressionist painting offered a healing rationale based on the individual, nature, and freedom. It addressed the vague discontent and flickering uneasiness stirring beneath the surface of financial prosperity and served as a way to express the philosophical qualities missing from everyday life.

The phrase "Abstract Expressionism" was first used by *New Yorker* art critic Robert Coates, who referred to a similarity of outlook among a certain group of artists involved with spontaneous freedom of expression. They emphasized the surface of the canvas, all-over treatment, accidental effects, and bold, often central imagery. In the first stages of Abstract Expressionism, artists often tried to reconcile it with still life, the figure, or the larger rhythms of life, often by mixing biomorphic and geometric elements. To do this, they reconsidered the earlier modernist movements of Cubism, Surrealism, and Expressionism, as well as focusing on new cultural imperatives stemming from the art scene in New York.

Abstract Expressionism in Canada was illuminated by the urge to understand — the need to know — that fuels the best of all human endeavour, Canadian or otherwise. The importance of German Romantic and Idealist philosophy in the inception of abstraction led to the idea that art is a form of discovery and exploration. As the 1950s continued, a sense of reckoning had many people convinced that something was absent from their lives. Where prosper-

ity and technology turned out to be mixed blessings, abstraction offered a sense of higher purpose.

Abstract Expressionism provides an especially appealing gateway for feeling. Since its impact is nonverbal and immediate, it can be directly absorbed. Its system is portable, easy to separate from its original context, and ready to be appreciated on aesthetic rather than doctrinal terms. Abstract Expressionism also offered a quality increasingly rare in public life: strong passion. It provided spiritual nourishment without the time-consuming effort of learning philosophy or, for that matter, making a leap of faith — although a belief in the art form was a necessity. A commitment to Abstract Expressionist art gave a certain gravity, a kind of cultural seal of approval to artist and public alike. Moreover, as Serge Guilbaut has pointed out, the new frontier in art became equated with the ideology of postwar liberalism.[1] "Freedom" became a key word in art, as in post-war politics concerned with the cold war. An affiliation to Abstract Expressionism implied, as well, a certain cosmopolitanism, a way of looking further than mere national boundaries.

Abstract Expressionism could be elaborate or stark. It could be flamboyantly improvisational. Artists like Paul-Émile Borduas studied the underlying tenets of Surrealism, and as a result, learned to trust in the inspiration provided by the irrational. Others like Alexandra Luke built their work around ideas from books they read — such as P.D. Ouspensky's *In Search of the Miraculous* (1949), books that reflected their experience of spiritual life, philosophy, and science.

Abstract Expressionism also stroked cross-cultural longings: the idea that another culture had figured out something unknown at home. In Canada, artists created work in direct relation with art abroad and regarded artists in the United States and Europe as spiritual allies and mentors. They read popular magazines that carried articles on contemporary art like *Life* and *Time*, subscribed to the French art review, *Art d'Aujourd'hui*, which detailed art activities worldwide. They made trips to nearby cities in the United States with large collections of Abstract Expressionism — New York, the new centre of art, or Buffalo, home to the Albright-Knox Art Gallery. What they brought back, inevitably, as with Tonalism in the first decade of the century, reflected a combination of different sources. By contrast with art of the 1930s and 1940s,

Abstract Expressionism looks like a complete break. In fact, there are tracings back to earlier work, especially in the retention of glimmerings of the figure and landscape. Abstract Expressionism evolved rapidly due to the increased sophistication of Canadian artists and the increasing penetration of thought and ideals by American culture. The changes that had occurred brought big early sales and fame to a few individuals like Toronto painter William Ronald; with Abstract Expressionism, he achieved his first crack at international success.

Ronald is one of the best examples of the way Canadian artists of ambition fused diverse sources to achieve optically pleasing combinations of glossy and matt surfaces, open areas of bright colour, and quirky fragments of biomorphic abstraction, all painted in spontaneous fashion. His early art can be explained, up to a point, in terms of many predecessors: Picasso and painters of the New York School. But these connections were indirect as well as direct. Ronald took from Jackson Pollock, for instance, ideas about gravity and spillage, the use of industrial materials, and the possibility of painting as performance. In the same spirit as Pollock's free-flowing "drip" paintings with their rhythmically woven skeins of paint, combined with the idiosyncratic shapes of Franz Kline, Ronald created *Slow Movement* (1953, fig.98). In this long horizontal painting he thinly drips black paint and intermingles it with broadly painted opaque black areas to create an interlaced surface. Like Pollock, Ronald sought to render the deepest rhythms of existence — here, tropism, the turning of natural forms in response to the sun.

There were other artists of the New York School whom Ronald admired. He valued the work of Bradley Walker Tomlin, with its calligraphy and all-over hieroglyphic surfaces — "Zen" was the word Ronald used to describe him. Helen Frankenthaler, Clyfford Still, and Mark Rothko figure in his pantheon. But the figure against whom Ronald felt he had to "fight" (his word) was Willem de Kooning, in particular, de Kooning's energetic white-and-black, or pink-grey-white-and-black abstractions in oil and synthetic polymer paint of the late 1940s, and his more fragmented, layered compositions of the mid-1950s. Drawing on certain characteristics of de Kooning's work, particularly his layered way of handing the surface and bold central image, Ronald developed what he called his central image. In *J'accuse* (1956, fig. 99), the rectangular cen-

87

Fig. 99. William Ronald (1926-1998)
J'accuse, 1956
Oil on canvas, 152.4 x 175.9 cm
Robert McLaughlin Gallery, Oshawa
Photo: T.E. Moore

88

tral form in red and black depicts with clamorous, humming force something, perhaps a figure, that seems to point. In the context of the expansively painted gestural abstraction with its "accidents" clearly written on the surface, it conveys an ambiguous image but one that dominates the ground.

Ronald was important in the 1950s; his work was purchased by many Canadian and American museums. Influenced by artists like the French painter Georges Mathieu, who showed with the Kootz Gallery in New York, as Ronald did, he became an intelligent publicist of his work and that of many other artists. In the early 1960s as the host for the Canadian television show "The Umbrella," Ronald spoke on behalf of Abstract Expressionism.

Ronald, like many other Canadian artists, followed the move of American artists to new materials. Like Jackson Pollock, he switched from artists' quality paints to industrial and retail trade paints and experimented widely, as did his peers, with inexpensive media. Although the traditional support remained canvas on a stretcher, hardboard was common. Paint — often acrylics and pyroxylin paints ("Duco") of the kind used for painting automobiles — might be applied directly to unprimed canvas. Sometimes painters used house painter's brushes, the palette knife or applied colour directly from the tube. Among their elements were "dribbles and drips," accidental or deliberate surface calligraphy, the use of scraping, small forms in intricate patterns; and the application of foreign objects, especially torn papers. In sculpture, welding became the technique of choice. Art work was often quickly created, with an effect of spontaneity. Critic Robert Fulford, on the CBC and in writing for *Mayfair* magazine, *Canadian Art*, and *The Toronto Star* saw invention, originality. The reception of such work by the public was problematic.

In both Montreal and Toronto, abstraction paired an edgy romantic sensibility and psychologically charged elements. Painters applied rich colour to powerful, brilliant, though at first low-key, effect. Elsewhere, abstraction developed more as a trial: in Calgary, for instance, from 1958 to 1960, Maxwell Bates experimented with abstract work before returning to figuration.

In 1940, Alfred Pellan returned from Paris; he immediately began to contribute to the cultural scene what he had learned of new developments abroad, primarily about Surrealism with its changed relationships between figure and ground, big and small, process and product. His 1940 exhibition of work at the Musée de la Province de Québec, while not abstract, paved the way for the acceptance of more freedom in creativity. Works like *Desire in the Light of the Moon* (1937, fig. 100) with its bold colour, stress on flat planes and way of conducting a narrative that combines a phallus and moon and figures distantly recall Pablo Picasso and Joan Miró; they provide first-hand documents of the era's operative notions, which are filled with surprising combinations. Pellan had lived in Paris and met artists and writers influential in the Surrealist group, among them its leading figure, French writer André Breton. It was Breton who, in the First Surrealist Manifesto of 1924, defined Surrealism as pure psychic automatism, by which an attempt is made to express, either verbally or in writing, or in any other manner, the true functioning of thought.[2]

More proof of the changes taking place in Europe arrived. In 1943, Fernand Léger came to Montreal to lecture and show his important Surrealist film of 1924, *Le Ballet mécanique*, created in collaboration with American filmmaker Dudley Murphy and Man Ray.

John Lyman, founder of the Contemporary Arts Society in Montreal in 1939, had long been interested in the ongoing developments in French art. It seemed only natural that one of his protégés from the Society, Paul-Émile Borduas, carried French-Canadian art into the future. Attracted by French Surrealist writers like Breton, who advocated automatic writing, writing without preconceived ideas based on free associations, Borduas seized upon them as a source for art. His seminal importance to the *Automatist* movement, which he organized, can be recognized from the name of the group; a student critic, Tancrede Marsil Jr., writing in *Le Quartier latin*, the newspaper of the University of Montreal, took it from *Leeward of the Island (1.47)* (1947, fig. 101), whose original title was *Automatism (1.47)*, and applied it to the group for the first time.

Borduas, who died in 1960 at fifty-five, continues to be a figure of reverence for followers of the avant garde. He was a boldly innovative artist who grew out of conservative roots. Trained by the symbolist painter Ozias Leduc as an apprentice in church decoration, then encouraged by Leduc, Borduas

Fig. 100. Alfred Pellan (1906-1988)
Desire in the Light of the Moon, 1937
Oil on canvas, 161.8 x 97.1 cm
National Gallery of Canada, Ottawa

89

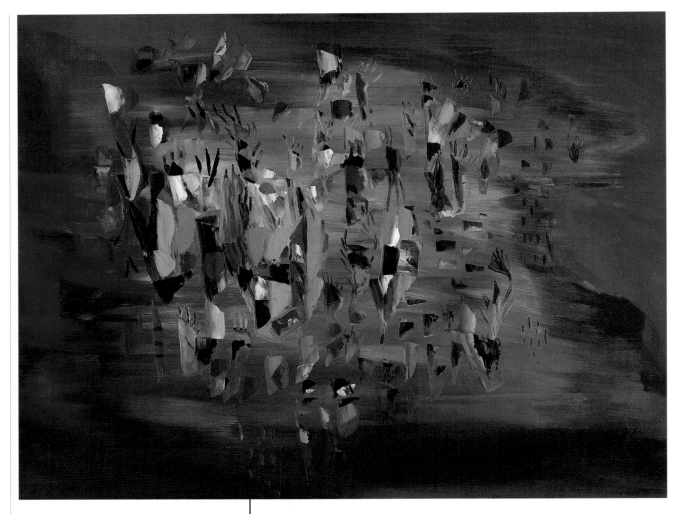

90

Fig. 101. Paul-Émile Borduas (1905-1960)
Leeward of the Island (1.47)
Oil on canvas, 114.7 x 147.7 cm
National Gallery of Canada, Ottawa

studied at the École des beaux-arts de Montreal (1923-1927), and from 1927 to 1929 in Paris at the Ateliers d'Art Sacré of painter Maurice Denis. But under the influence of Breton, Borduas' work changed, and he developed a rapid and direct technique. He used gouache and watercolour on paper, or applied pigment to canvas with the palette knife to create layers of varying thickness, juxtaposing and blending colour directly on the support. In her monumental 1992 exhibition catalogue *The Crisis of Abstraction in Canada: The 1950s*, curator Denise Leclerc suggests that it was in 1941 that Borduas focused on the still life, assembling its elements into a predominately central mass of joined units.[3] Subsequently that same year, he extracted this central mass to create his first non-figurative oil painting. Other abstractions of this period revolve around a compact core and ambiguous, but figurative, images.

Borduas was inspired by Breton's automatic writing to make art based on free associations. His thickly painted, mostly medium-size, vividly coloured formally condensed abstractions are his visionary contribution to Canadian painting. *Leeward of the Island (1.47)* reveals his use of broad strokes of red, grey, and green suspended in space in front of a creamy background that evokes a vast expanse. At this moment in his work, Borduas retains a sense of landscape — here, the land is a bird's eye view — although in time his work becomes resolutely nonfigurative.

There was an idealistic impulse behind Borduas' work. His restless intellect and his ability to look where no else was looking led to his radical critique of the sociology, culture, and aesthetics of French Canadian society. The *Refus Global (Total Refusal)*, a hand-assembled mimeographed collection of writings published in 1948 took its title from the main essay, which he wrote. The manifesto was intended as a group catalogue to accompany the third Automatist exhibition, but it appeared separately in the form of a political tract. It contained, in a cardboard portfolio illustrated with a watercolour by Jean-Paul Riopelle, two other pieces written by Borduas (*Comments on Some Current Words* and *About Today's Surrealism*); three short plays by the poet Claude Gauvreau (*In the Heart of the Bulrushes, The Good Life,* and *The Shadow on the Hoop*); the text of a lecture titled *Dance and Hope* by dancer Françoise Sullivan; an essay by medical student Bruno Cormier, later a distinguished psychiatrist, *A Pictorial Work is an Experiment*; and a statement by painter Fernand Leduc, *Like It or Not.* This stirring incendiary theoretical and poetic manifesto, an affirmation of avant-garde expression, was signed by sixteen people, largely painters — among them Riopelle, Pierre Gauvreau, and Jean-Paul Mousseau. In *Refus Global*, Borduas and Claude Gauvreau, Cormier, Sullivan, and Leduc dismissed out of hand aspects of the social environment they found oppressive, such as religion, authority, and the past. The authors challenged the moral bankruptcy of the post-war world and the authority of the Roman Catholic Church. Borduas described French Canada as follows:

> A little people, huddled on the skirts of a priesthood seen as sole trustee
> of faith, knowledge, truth and national wealth, shielded from the broad-
> er evolution of thought as too risky and dangerous, and educated mis-

91

Fig. 102. Paul-Émile Borduas (1905-1960)
Blue Drops, 1955
Oil on canvas, 127.0 x 102.2 cm
Montreal Museum of Fine Arts, Montreal
Gift of Dr. and Mrs. Max Stern

92

guidedly, if without ill intent, in distortions of the facts of history, when complete ignorance was impracticable[4]

His answer to these problems is well-known:

Make way for magic! Make way for objective mysteries!
Make way for love!
Make way for necessities![5]

In reaction to the *Refus Global*, Borduas was fired from the teaching position he held at the École du Meuble, a trade school where he had taught drawing since 1935 — a gesture with political overtones that suggests the reality of the oppression in the manifesto. Long interested in American painting, particularly in the work of Jackson Pollock, Franz Kline, Willem de Kooning, and Robert Motherwell, Borduas went to New York for two years (1953-1955), and then to Paris where he died of a heart attack in 1960. In New York, his paintings increased in scale and gestural freedom; their colour lightened and changed to reflect his new surroundings. In works such as *Blue Drops* (1955, fig. 102), the eye is caught by a sensuous maze of colour patches steadied by an underlying structure. Borduas gradually strengthened his sense of pattern, developing simpler structures and more

Fig. 103. Paul-Émile Borduas
The Black Star, 1957
Oil on canvas, 162.5 x 129.5 cm
Montreal Museum of Fine Arts, Montreal
Gift of Mr. and Mrs. Gérard Lortie
Photo: Montreal Museum of Fine Arts/Brian Merrett

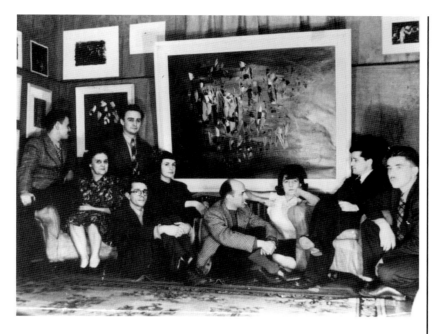

Fig. 104. Borduas's Apartment, Montreal, 1947
Foundation Borduas du Musée d'Art
Contemporain de Montréal
In the background is Borduas's *Leeward of the Island* (1.47)
Photo: Maurice Perron

massive and decisive forms (fig. 103). Brown and black against white or white-and-grey grounds give way to black shapes against white. His work became stark. This final development can be seen in the paintings from the last years of his life.

Borduas's enterprise can still have the imaginatively liberating effect of toppling axiomatic notions about art. In some of his definitions of space, he cut shapes out of planes, admitting lyrical patterns of light. *Composition 69* (1960, Private Collection), which was on his easel when he died, is likely his last work. With its solid black base surmounted by four black forms, it suggests a restricted world.

Borduas's legacy lives on as part of the folklore of modern art in Canada. In his wake followed talents like Riopelle, Marcel Barbeau, Marcelle Ferron, Pierre Gauvreau, Leduc, Sullivan, and Mousseau (fig. 104). He made a difference to them all — to Riopelle and Barbeau who were his students; to Gauvreau whom he introduced to Leduc and Sullivan; to Mousseau on whom he lavished attention. His studio was one of their early meeting places. As Sullivan said, he was the "master that I was seeking to learn something from, and the artists that grouped around him all felt the same way. He was fascinating, magical ... he could talk and we would become inflamed."[6]

Riopelle, who left Montreal in 1946 for Paris and skyrocketed to interna-

93

Fig. 105. Jean-Paul Riopelle (b. 1923)
Austria, 1954
Oil on canvas, 200.0 x 300.7 cm
Montreal Museum of Fine Arts, Montreal
Purchase, Horsley and Annie Townsend
Bequest
Photo: Montreal Museum of Fine Arts, Brian Merrett
Riopelle/SODRAC (Montreal) 1999

Fig. 106. Pierre Gauvreau (b. 1922)
Struggle of the Heart Sung by the Hay Bird, 1951
Oil on canvas, 76.3 x 91.4 cm
Musée d'Art Contemporain, Montreal
Lavalin Collection
Photo: Richard-Max Tremblay
Gauvreau/SODRAC (Montreal), 1999

94

tional fame in the 1950s, achieved his reputation for spectacularly optical canvases thick with extravagantly manipulated paint, resonant colours, and an aura of intense emotional involvement. His approach involved the use of the palette knife to apply a heavy layer of paint, which he often finished in his early work with rectilinear spurts of paint from the tube or jar. The effect of these spurts of coloured paint was that of numerous lines radiating from points. The pattern generated a sense of all-over subtly pulsing energy, one related to the drip technique of Jackson Pollock. By 1953, Riopelle had abandoned the spurts and consolidated an abstract art with brightly coloured, radiating, pervasive patterns. He spoke of the awe inspired by large spaces, of mental landscapes. His titles such as *Austria*, *Blue Night*, *Forest Blizzard*, and *Pavane*, reflect his desire to suggest the rhythm of light and colour in nature (fig. 105). Like Borduas and with the same inspiration, Riopelle believed he created his work under the impetus of the unconscious, automatically.

Pierre Gauvreau's dense accumulations of distinctively textured dark images, distributed here and there on brushy fields, were as adventurous.

Working easel-scale or smaller, he produced intricate moodily coloured linear compositions such as *Struggle of the Heart Sung by the Hay Bird* (1951, fig. 106) that call to mind Paul Klee, early Miró and later Kandinsky. But his playful elaborations of line and pattern, a mixture of ink blots, variously coloured grounds, dabs of colour, and scrapings explore their own implosive world. His brother, poet, dramatist, and art critic Claude Gauvreau similarly created an interior world, though his was in the medium of drawing.

Diversely innovative, Françoise Sullivan is a modern dancer as well as a sculptor and painter. Her work involves various interpretations of reality that usually introduce an element of freedom to the proceedings. She studied modern dance in New York (1946-1947) before returning to Montreal. With the view that dance was a spontaneous expression of intense emotion, she began to choreograph notably early works of performance art. In 1948, isolated motifs from her dance improvisations in nature during different seasons of the year were filmed by Riopelle (the film is lost) and photographed by Maurice Perron (fig. 107). (In 1977, seventeen of the

Fig. 107. Françoise Sullivan (b. 1925)
Dance in the Snow, part of the album *Dance in the Snow, 1948-1977* with 17 photographs by Maurice Perron
39 x 39 cm
Musée d'Art Contemporain de Montréal, Montreal

Fig. 108. Françoise Sullivan (b. 1925)
Fall in Red, 1966
Painted steel, 212.6 x 124 x 49 cm
Musée d'Art Contemporain, Montreal

Fig. 109. Jean-Paul Mousseau (1927-1991)
Abstract Composition, 1954
Oil on canvas, 127.0 x 76.5 cm
Robert McLaughlin Gallery, Oshawa
Photo: T.E. Moore
Mousseau/SODRAC (Montreal), 1999

photographs were printed, and, along with a serigraph by Riopelle and a text by Sullivan, were issued in an album that appeared as *Dance in the Snow.*) Sullivan also became a diligent welder of sculpture, partly from materials found in scrap yards, in the period 1959 to 1970, as in *Fall in Red* (1966, fig. 108). She evolved in the 1970s into a photographer with a strong Conceptual bent. In 1982, with characteristic ambition, she turned to painting.

Others in the Automatist group dealt with mutability and the shifting pull of moods combined with images of terrain. Endlessly inventive as abstract artists, they produced their playful surrealistic streams-of-consciousness apparently effortlessly. Mousseau, one of the strongest colourists of the group, produced expressionistic compositions that have great decorative vitality with dense yet wonderfully expansive areas, as in *Abstract Composition* (1954, fig. 109). In general, the group's most successful work was large-scale palette-knife painting. The effect of these compositions was heightened by rich colour schemes.

Automatism, as a movement, began in Quebec in 1943. An important early exhibition organized by Riopelle was held in Paris in 1947 at the Galerie du Luxembourg. It included his paintings and those of Borduas, Barbeau, Leduc, and Mousseau among others. Automatism lasted until 1954, the year of the group's last exhibition. Defenders of the gestural expressionistic form of painting, this group claimed that their work was free of all preconceived ideas. However, their art retained an evocative resonance.

Besides the Automatists, in Montreal during the same period, artists worked in an anthology of modes from abstract but nature-based work to figuration. Jean McEwen, acting on advice from Borduas, went to Paris in 1952 to meet Riopelle who introduced him to the American abstract painter Sam Francis. McEwen exhibited monochromatic white paintings in 1956 in Montreal before settling on an abstract style of painting with rich surfaces and ambiguous roughly geometric shapes that emerge from superimposed layers of varnish and mottled pigment brushed on or applied with a palette knife. His colour is particularly striking and contributes to the general effect of flux in his canvases.

Sculptor Louis Archambault, in works like *A Young Couple* (1954, fig. 110), one of a series on a theme, was influenced by Cubism and Surrealism and by

the thin, elongated figures of Alberto Giacometti. Archambault used fantasy as one of his strategies along with simplified, roughened, drawn-out form. His figures reflect his search for what lies beyond the appearance; in *A Young Couple* Archambault formally indicates erotic and symbolic characteristics of a heterosexual couple. The two personages are closely related, but one has five voids inside an ovoid shape perched on long legs; in the other the form makes a sharp penetrating angle. An important innovator, initially a ceramic artist, Archambault was recognized at the Canadian Pavilion of the Brussels Universal and International Exhibition in 1958 where he designed a wall for the Canadian Pavilion. After 1967, Archambault turned to geometric form and abandoned all vestiges of Expressionism; he began to use plywood and aluminum as his materials, and in 1980, wood.

Like Archambault, Montreal-based Anne Kahane evoked Cubism and Surrealism in her assemblages of the 1950s made from flat sheets of metal or wood. Unlike him, she never abandoned representation. Her maquette for the monument to *The Unknown Political Prisoner* (1953, fig. 111) bears many points of comparison to his work such as its expressive content. Characteristically, Kahane's sophisticated compositions couple wood and metal, flatness, and volume, the individual versus the group, form, and spirit.

Kahane's way of conveying the human condition through her figurative work was against the grain of the period in Quebec, where an emphasis on the "plastic" or three-dimensional elements characterized the group of painters that followed the Automatists: the Plasticiens. Their work stresses the importance of geometric pattern and purified colour, and the way these transcend, they believe,

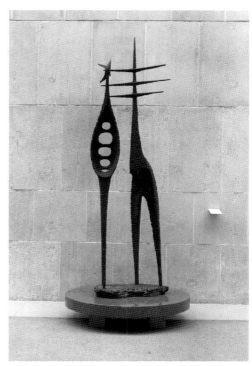

Fig. 110. Louis Archambault (b. 1915)
A Young Couple, c. 1954
Unique bronze cast, 263.0 x 76.0 x 50.0 cm
Robert McLaughlin Gallery, 1987
Gift of Isabel McLaughlin

97

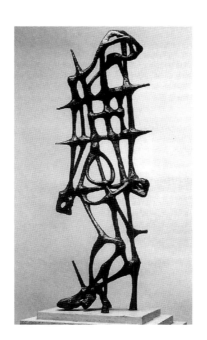

Fig. 111. Anne Kahane (b. 1924)
Maquette for The Unknown Political Prisoner, 1953
Copper tubing, plastic. wood and bronze paint,
52.0 x 22.2 x 20.0 cm
Musée du Québec, Québec

Fig. 112. Louis Belzile (b. 1929)
Untitled, c. 1955
Oil on canvas board, 50.8 x 40.3 cm
Montreal Museum of Fine Arts, Montreal
Photo: Brian Merrett

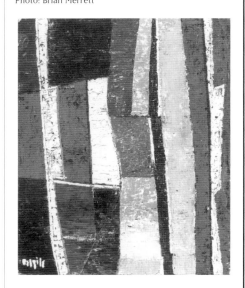

98

Fig. 113. Jean-Paul Jérôme (b. 1928)
Untitled, 1955
Oil on canvas, 76.9 x 92 cm
Montreal Museum of Fine Arts, Montreal
Photo: Brian Merrett

Fig. 114. Jauran (Rodolphe de Repentigny)
(1926-1959)
No. 28, c. 1955
Oil on waxed canvas, 40 x 41 cm
Montreal Museum of Fine Arts, Montreal
Photo: Brian Merrett

every trace of individual expression. By contrast to the gestural accidental quality so much a part of automatism, they proposed a rational detached structured approach. For them, Mondrian's dynamic coloured planes provided a new method of formulating a spatial structure, one that eliminated all illusion of depth and substituted instead a dynamic surface that integrates colour and structure. Members included Louis Belzile, Jean-Paul Jérôme, Fernand Toupin, and Jauran [the painter-name of art critic Rodolphe de Repentigny]. Their first exhibition was held in 1954 in Montreal at the Librairie Tranquille, a combined bookshop and exhibition space. In 1955, on the occasion of a group exhibition held at Montreal's L'Échourie café, Jauran published the Plasticien manifesto as an alternative to the earlier Automatist aesthetic, in which he reduces painting to its plastic aspects: tone, texture, form, line, over-all effect, and relation between the elements. "The real content of the picture is its order," Jean-Paul Jérôme had told Jauran in 1954.[7]

What the Plasticiens meant by "order," was abstract patterning and geometric division conveyed with colour and a light touch. The Plasticiens deliberately left their paintings untitled or identified them by number. Belzile, for instance, built a rational structure of rectangular forms combined with strong value contrasts and a restricted range of colours in his *Untitled* (c. 1955, fig. 112). Jérôme's *Untitled* (1955, fig. 113), included in the first exhibition of the Plasticiens, is notable for the geometric rigour of its overlapping abstract forms. Jauran's *No. 28* (c. 1955, fig. 114) is composed of gold geometric shapes on a ground with geometric shapes in colours of grey, brown, red, black, and white. Toupin began to modify the traditional shape of painting and make the

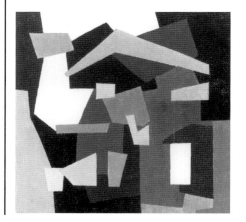

shape a consequence of the composition.

A second wave of Plasticiens, composed of Guido Molinari, Claude Tousignant, Denis Juneau, and Jean Goguen, stressed the importance of spatial composition composed of simplified forms, large blocks of colour, and coloured planes.

Molinari's *Abstraction* (1955, fig. 115) is a good example of his intention to structure his work. Impressively simple and small, it consists of reversible black-and-white forms in a dynamic balance, one of the lessons taught him by the work of Mondrian. In other black-and-white canvases of the 1950s, Molinari explored vector and mass relationships. The work of Tousignant, from the beginning, was equally one of austere form and subtle geometry; for Tousignant, from 1961, the artist to admire was Barnett Newman, whom he believed to be the most radical of the New York School. Newman's work of the 1950s involved heroically scaled canvases of brilliant colour, almost entirely solid though textured, with narrow stripes or divisions; the effect is calm and radiant. The initial works through which Tousignant became known, like his enamel painting *Orange Monochrome* (1956), expounded on the idea of a painting as an object, non-anecdotal and non-symbolic, with bright colours. A sculpture of 1960 has plywood planes covered with acrylic paint in blue, red, and white, at right angles to each other. For him, the word painting or sculpture applied to the art form mattered less than the structured thinking that went with it.

Rita Letendre is among those artists who developed their own visual vocabulary from the formal and theoretical challenges offered by Automatism combined with the rational approach of the Plasticiens. She first saw a show of Automatistes in 1947 or 1948 when she was a student at the École des Beaux-Arts in Montreal; Letendre was fascinated and felt that their way of painting offered a new freedom in art. As a result, Letendre became a painter. Borduas was her friend and a great influence; so was Riopelle. When she was at art school, she made sculpture and some paintings using the palette knife as a painting tool, as did Borduas. With Letendre's point of view — to express her interest in the painting of Vincent van Gogh and in the romantic stroke — she used the palette knife to create a textured painting surface. Her way of working allowed her art to be spontaneous: the one constant in her work is a sense of dynamism. Letendre's early paintings were lyrical abstractions with a distant reference to nature; hinting perhaps at the feeling of a starry night. By the time of Letendre's first solo show in 1955, her influence was Mondrian. From her geometric work, she became more interested in working on the surface, though in an automatic way with the brush, painting with more feeling and

Fig. 115. Guido Molinari (b. 1933)
Abstraction, 1955
Oil on canvas, 120.7 x 151.1 cm
The Artist

99

touch. Then in 1957, Letendre returned to her use of the palette knife. She began to make shapes more related to those of her later work, as well as using fiery colour. *Rétrovision* (1961, fig. 116) presents her broad dynamic handling and vibrant use of colour: here, green and white surface forms are silhouetted against dark forms on a radiating red ground. The result is inspired. Works like this painting by Letendre are absorbing to study: there is an ambition in the work which marks her as a true heir of Borduas.

By 1963, the underlying strength of Letendre's work was becoming more apparent, and her shapes clearer and stronger. In the following year, she painted tenser forms with sharper edges. The change crystallized in 1965 with the huge outdoor mural she painted at Long Beach, California, for the University of California. She had disciplined her work and become more of a perfectionist about finish in the same spirit as the American sculptor Larry Bell; he was a good friend, who in coated glass cubes extended the implications of Minimalism into the realm of sensory processes, acknowledging light as the essential component of perception.

In Montreal, artists used a clearer, more analytical language than artists in Toronto. To earn their living, Montreal artists often taught. In Toronto, by contrast, most painters worked in commercial art, as did Jack Bush. One of the few to teach was Jock Macdonald, who through his job at the Banff School of Fine Arts in 1945 met Alexandra Luke, later with him a member of Painters Eleven. In 1947, Macdonald moved to Toronto to instruct at the Ontario College of Art. Several members of the future Painters Eleven group like Ronald, Harold Town, and Kazuo Nakamura were graduates of the Ontario College of Art or of Toronto's Central Technical School; because of their work in commercial art, they were skilled in graphically bold devices.

Like the French Canadians, Torontonians could go straight to the source: a short trip landed them in New York. Alexandra Luke went to New York often and her friendship with Hans Hofmann and knowledge of artists like Mark Rothko and public and private art galleries made her a conduit of information

Fig. 116. Rita Letendre (b. 1929)
Retrovision, 1961
Oil on canvas, 45.7 x 50.8 cm
Private Collection

about advanced art. Like John Lyman at an earlier time, Luke was the person who supplied the energy to gather together exhibitions and groups. Her *Canadian Abstract Painters* exhibition in 1952, the first national show of abstraction, was shown in Montreal and at six venues in Southern Ontario. Along with Montreal abstract artists such as Marian Scott, it included nine of the artists who formed Painters Eleven. That the group held their first official meeting in Luke's studio, in Oshawa/Whitby in 1953, seems natural from her activist role and the influence in her own work of vanguard American art. The aim of the group was to increase opportunities to exhibit by the members: Jack Bush, Oscar Cahén, Hortense Gordon, Tom Hodgson, Luke, Macdonald, Ray Mead, Nakamura, Ronald, Town, and Walter Yarwood.

The group was formed in distinct steps. In 1953, Ronald, the founder, called together six other artists (Bush, Cahén, Hodgson, Luke, Mead, and Nakamura) to participate in *Abstracts at Home*, a display for the Simpson's department store where he worked. The show was conceived by interior decorator Carry Cardell who wanted to put paintings in seven display rooms of modern furniture on the fifth floor of the Queen Street store. There were also windows provided for the artists on Queen Street facing City Hall. Staff decorators created the room settings.[8] Today the newspaper advertisement for the interiors seems comical. Ronald's room was said to demonstrate the "timeless beauty" of a marble topped buffet. Luke's work graced a room of French Provincial furniture.

After the exhibition was on the walls, the artists went back to a studio for a publicity photograph. Some of the seven brought friends: Ronald invited Macdonald, his teacher at the Ontario College of Art; Cahén invited Town and Yarwood; Mead brought Gordon, a gifted woman artist from Hamilton.

During the first meeting in Luke's studio, Town, always gifted with words, devised the group's name. Eleven sounded better than a dozen: the number had a quality of flair, of idiosyncrasy. "Painters" stressed the group's primary medium, although some of the finest works of the group were in collage, and crayon and black ink were used brilliantly by Macdonald and Luke in concentrated "automatics" that were some of the best Painters Eleven work.

At the same meeting, the group opened a bank account to cover the expenses of their first exhibition. Town recounts that their thesis was a simple one.

We weren't really militant and were terribly innocent. We never expect-
ed to sell any pictures and we paid for those exhibitions ourselves. We
paid for the booze, the folders, the transportation, and insurance...."9

Nor was any artist appointed leader of the group — though leadership was later
provided by one member or another. Town, for instance, wrote the forewords
to the catalogues.

The structure of Painters Eleven was informal. Meetings, often lively if not
boisterous, were held in various places, often at Bush's home in Toronto.
Particular friendships formed within the group: the one between Bush and
Yarwood, for instance.[10] The nature of the interaction among individual mem-
bers was often one of influence. "We all influenced each
other," Mead said. He felt that Ronald understood him better
than any of the other painters; in turn he helped Ronald
name pictures.[11] In a sense, they were liberating one anoth-
er from convention through constant discussion.[12] Yarwood
would visit Mead, and they'd "discuss lines and perhaps that
colour areas were out of date and linear colour was a differ-
ent thing altogether." They would change their concept of
"what form was."[13] Mead would do the same with Ronald.

The organization was loose and open as described by
Town.[14] The Eleven never planned to expand their member-
ship. They hoped that, with time, other avant-garde painters
would organize movements. Ronald was quoted in *Time* as
saying "We'd rather see a bunch of small revolutions all over
Canada."[15]

By contrast with Automatists in Montreal, members of
the group exhibited a consistently more muted palette and a
more lively surface, often addressing the canvas as a responsive object
through bold stroking on a coloured ground. More oriented towards the
Abstract Expressionist movement in New York, their work offered gestural
painting, often animated by suggestions of the natural, the spiritual, the psy-
chological or the spatial. Luke, influenced by Hans Hofmann, held that colour
in itself determined painting structure, that plastic values were the sole con-

Fig. 117. Alexandra Luke (1901-1967)
Symphony, 1957
Oil on canvas, 246.7 x 208.3 cm
Robert McLaughlin Gallery, Oshawa
Gift of Mr. and Mrs. E.R.S. McLaughlin, 1972

102

Fig. 118. Jack Bush (1909-1977)
Breakthrough, 1958
Oil on canvas, 121.8 x 183.1 cm
Robert McLaughlin Gallery, Oshawa

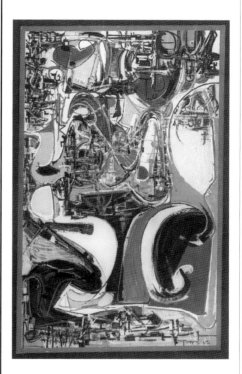

tent of a work, that painting's medium is the flat canvas. She felt she could create depth through vibrant juxtapositions of painting elements. She occasionally introduced a detail from real life. Her *Symphony* (1957, fig. 117), for instance, painted to music in her studio has, amid its shifting planes, the shape of a chair visible in the background. Many in the group, especially Mead, believed that accidents, upon which the art depended, had to be held in tension with acts of control. Subjects often involved energy in the form of movement, growth, an expansive rhythm, a spray of sound. They faced problems in paint with adventurousness and spontaneity.

Each of them reflected in his work an intense reaction to abstraction. In Jack Bush's *Breakthrough* (1958, fig. 118), he uses bright colour and simple drawing, painting narrow rectangular shapes moving somewhere, a subtle symbol of the new direction he was discovering. Harold Town articulated the unusual, often to suggest sound in paint: notice the small jagged forms in *Through Forest the Jungle of Industry* (1954, fig. 119).

103

Fig. 119. Harold Town (1924-1990)
***Through Forest the Jungle of Industry
c. 1954***
Oil on masonite, 177.7 x 105.1 cm
Robert McLaughlin Gallery, Oshawa
Gift of the artist's estate, 1994

Fig. 120. Alexandra Luke (1901-1967)
Journey through Space, c. 1956
Oil on canvas, 210.7 x 148.5 cm
Robert McLaughlin Gallery, Oshawa
Gift of the artist, 1967

Fig. 121. Tom Hodgson (b. 1924)
March Pond, 1958
Oil and fabric collage on canvas,
218.3 x 147.5 cm
Robert McLaughlin Gallery, Oshawa

104

Fig. 122. Walter Yarwood (1917-1996)
As in Winter, 1960
Oil on canvas, 152.7 x 190.9 cm
Robert McLaughlin Gallery, Oshawa

Strength emanates from the sense of scale and freedom of his collages, and the materials attached could be extremely varied. Luke's penchant lay in visual surprises both refined and stark: she moved easily between the extraterrestrial in *Journey through Space* (c. 1956, fig. 120) to a record of her garden in improvisational immediacy, simple scrapings of shape, and bright colours.

Paintings by the group seem to mingle and incite one another. Using olive greens and greyed blues, red, and gold, Tom Hodgson, in *March Pond* (1958, fig. 121), recorded the cold waters of Toronto's High Park; Walter Yarwood in *As in Winter* (1960, fig. 122) recorded a dark winter's day; Ray Mead in *Winter* (1958, fig. 123) referred to the dark green undergrowth and snow-covered hills of Beaurepaire, a suburb of Montreal where he lived. Most rewarding were his small radiant canvases or collages evoking meditations on floral shapes or central images. The subjects of Jock Macdonald and Kazuo Nakamura were more subtle: in *Rust of Antiquity* (1958, fig. 124), Macdonald records the mysterious aspects of nature seen under the microscope while Nakamura in *Infinite Waves* (1957, fig. 125) implies unlimited space through a series of parallel lines.

In this nature epiphany of sorts, there were unexpected shadows and jolts. Oscar Cahén bowed to the theme in the generalized shapes of *Small Structure* (c. 1953-1955, fig. 126) but his heart was more in the machine. He turned out to be one of the group's most peculiar colourists, tending towards fervid purple, pinks, and oranges. Hortense Gordon in *Mid Toronto Sky One* (c. 1952, fig. 127) conjured in wash and jagged strokes of yellow, green, and black, the city skyline — peaks of houses and television aerials.

On 26th November 1956, Cahén died in a car accident, an event that shocked and saddened the entire group. Both Ronald and Bush commemorated the event in paint: Ronald in *Requiem* (1956, Hudson River Museum, Yonkers), Bush in works on paper.[16] In a group portrait taken the following year, his paintings were hung in the background: they still counted him as one of them (fig. 128).

In 1957, Ronald resigned. That same year, Mead transferred to MacLaren's Advertising Limited in Montreal. By 1957, Painters Eleven members were brushing their canvases more loosely, using thinner paint and leaving more space between the forms. The results were more delicate and airy. At the same time, works grew larger and the forms flatter, the two-dimensional sur-

face cooler, more detached.

By the fall of 1958, after five full years, the group was showing signs of strain concerning that season's exhibition; Luke noted in her diary, "This should be the last Painters Eleven show, at least for some time, maybe forever."[17] Jock Macdonald agreed with her. In November of the same year, he also wrote concerning the show to a friend:

In all likelihood, it will be the last held by PXI. It is not a good show and the ten invited Quebec and Montreal guest artists are even more inferior. I have felt for the last 18 months that the PXI were at the end of their usefulness and had decided that I would drop out after this show. No

longer is there the old unity. Most are out for themselves, producing large 7 foot by 7 foot or 8 foot by 7 foot canvases to grasp the attention or the centre of walls, or even outdo the other. And those larger canvases fail to carry the qualities formerly evident in smaller works.... Town believes he has grown beyond the association he once desired with other artists. Yarwood paints decidedly better than most of the group."[18]

The same final note was sounded in the catalogue for the show. Since recognition for "vital, creative" painting had been accomplished, group members would no doubt soon return to the "singular ways that are best for painters, anywhere, anytime."[19]

Fig. 123. Ray Mead (1921-1998)
Winter, 1958
Oil on canvas, 101.6 x 81.6 cm
Robert McLaughlin Gallery, Oshawa

Fig. 124. Jock Macdonald (1897-1960)
Rust of Antiquity, 1958
Oil and Lucite 44 on masonite, 106.5 x 220.2 cm
Robert McLaughlin Gallery, Oshawa
Gift of Alexandra Luke, 1967

Fig. 125. Kazuo Nakamura (b. 1926)
Infinite Waves, 1957
Oil over string on canvas, 94.1 x 110.7 cm
Robert McLaughlin Gallery, Oshawa

Fig. 126. Oscar Cahèn (1915-1956)
Small Structure, c. 1953-1955
Oil on canvas board, 40.6 x 50.1 cm
Robert McLaughlin Gallery, Oshawa
Gift of Alexandra Luke, 1967

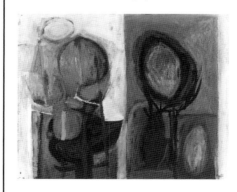

105

Fig. 127. Hortense Gordon (1887-1961)
Mid Toronto Sky One, c. 1952
Oil on canvas 92.5 x 107.9 cm
Robert McLaughlin Gallery, Oshawa
Gift of Julius Lebow, 1984

Fig 128. Photo of Painters Eleven, 1957
(From left): Tom Hodgson, Alexandra Luke,
Harold Town, Kazuo Nakamura, Jock
Macdonald, Walter Yarwood, Hortense
Gordon, Jack Bush, Ray Mead. Two canvases by
Oscar Cahén appear in the background; the
two canvases on which Town and Yarwood rest
their arms are by William Ronald. They are
turned to the wall because Ronald had moved
to New York.

But the group still functioned till the fall of 1960 when, in a final meeting in Hodgson's studio, the vote was taken to disband. Bush says the artists "were going in their own direction ... having their own shows ... we had done the job we set out to do, now we decided just to go on our own."[20] Ronald believed the demise occurred because there were enough commercial galleries in Toronto for experimental artists to show their work.[21]

The scene was a lively one, with — in Montreal — Galerie Agnès Lefort, which in 1950 opened the first gallery in Canada devoted to printmaking (though not exclusively), and Galerie du Siècle on Sherbrooke Street run by Denyse Delrue. In Toronto, the Greenwich Gallery opened in 1956 (in 1959, the dealer, Avrom Isaacs, renamed it the Isaacs Gallery). It lasted till 1991. In 1959, Dorothy Cameron's Here & Now Art Gallery opened on Cumberland Street with

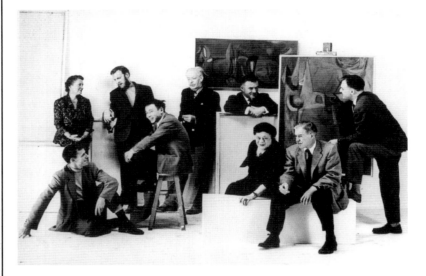

a show of Yarwood's work, and later she showed Macdonald (1960) and Luke (1961). She was to open the Dorothy Cameron Gallery on Yonge Street later. Walter Moos opened Gallery Moos in 1959. In Vancouver, the first commercial gallery that exhibited only contemporary work, the New Design Gallery, started by Alvin Balkind and Abraham Rogatnick, opened in 1955 (fig. 129).

Commercial venues existed for Canadians abroad, too. In New York, William Ronald was taken on in the winter of 1957 by the prominent Kootz Gallery. The artist's first solo exhibition opened there that spring, and he remained with the dealer until 1963. In London, there was Tooth's Gallery, which gave Borduas and Town one-man shows in 1958.[22]

Though Painters Eleven was a short-lived group, the work of its members, in particular Ronald's force-filled, boldly coloured central image paintings, had an impact on younger painters. In 1955 Dennis Burton and Gordon Rayner saw a show that electrified them of Ronald's work at University of Toronto's Hart House Gallery; over a bottle of wine in the apartment they shared, they vowed to paint abstractly for ever more. The result in the work of both artists was an intricate painterly mesh of voluntary shapes and dribbles. Richard Gorman, too, was influenced by Ronald, whom he had heard about from Macdonald, his teacher at the Ontario College of Art. He found Ronald's colour sense impressive. It influenced his own use of bright colour in the 1960s — bright oranges, reds, and greens. Gorman also assimilated the abstraction of Borduas. About 1955 or 1956, he passed the Laing Gallery on Bloor Street in Toronto and fell in love with a Borduas painting in the window. Later he saw more Borduas at the Art Gallery of Ontario, and at the Laing Gallery, where there was a Borduas show in 1960. Gorman admired the simplicity of execution, the palette, and the way Borduas handled space.

The effect of Painters Eleven may be seen in more subtle ways. John Meredith, another important painter of this generation, is Ronald's younger brother. Although he has stressed that they have always gone their separate ways, Ronald must have had an influence on him. Moreover, because Painters Eleven stressed the painting medium, the development of art in Toronto has had an unusual inclination towards that medium, and because of Cahén's hot colouring and influence on Bush, painters in Toronto for at least a decade had an uncommon, and often remarked upon, interest in colour.[23]

By the latter part of the 1950s, the fire and vigour of abstract art were taking possession of the country. Calgary painter Marion Nicoll was assisted in becoming an abstract artist through Jock Macdonald. While in Calgary in 1946, he had shown her how to work automatically. She continued to make automatic drawings daily from 1946 to 1957, regarding them as a way of learning in anticipation of cohesive works, as piano exercises prepare for compositions. The automatic drawing helped break down her academic prejudices and led to a major move in her work into abstraction. The results were particularly good paintings, often with hieroglyphic-like forms and strong silhouettes, as in *Ancient Wall* (1962, fig. 130).

Fig. 129. The New Design Gallery, opened in Vancouver in 1955.

107

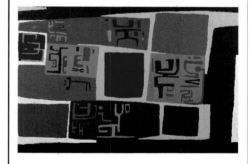

Fig. 130. Marion Nicoll (1909-1985)
Ancient Wall, 1962
Oil on canvas, 107.6 x 153.2 cm
Edmonton Art Gallery, Edmonton
Gift of Beta Sigma Phi
Photo: E. Lazare

Fig. 131. Jack Shadbolt (1909-1998)
Presences after Fire, 1950
Oil and casein on heavy wove paper,
68.5 x 93.5 cm
National Gallery of Canada, Ottawa

In Vancouver, for Jack Shadbolt, the passage to abstraction began with the war (he joined the Canadian Armed Forces at age thirty-three) and the notion, from the bombed ruins in London, that art means the dissection and reassembly of forms. The idea was reinforced in 1947 when he worked in New York at the Art Students League with Vaclav Vytlacil, a student of Hans Hofmann, and at the New School for Social Research. Upon his return to Vancouver, through small-scale paintings in watercolour, ink, and gouache, Shadbolt began to inquire into the forms of primitive masks, medieval armour, and insect forms as tools of construction for his dominant theme at the time — the individual in society. Influenced by Graham Sutherland and Arshile Gorky, Shadbolt abstractly paraphrased such forms to realize what he called "symbolic abstraction."[24] By the early 1950s, in his nature cycle theme, Shadbolt was painting calmer and more lyrical small abstractions based on observations around his home in Burnaby, British Columbia. In this series, he began to incorporate standard techniques of abstraction such as automatism.

Shadbolt's *Presences after Fire* (1950, fig. 131) moves between abstraction and illustrative realism, sometimes engagingly combining the two. Shadbolt's forms, as he intended, are slightly open-ended so that the images emerge naturally. There are hints of African shields and plant life. The paint colours are resonant and warm. These early works provide a signpost to a quality of introspection in Shadbolt's later paintings, a general mythologizing and spiritual symbolism that links him to the Abstract Expressionists and other postwar American artists.

Gordon Smith, from England, who settled in Vancouver in the 1940s, discovered American Abstract Expressionism in 1951 during a summer of study in San Francisco at the California School of Fine Arts. Under the guidance of painter Elmer Bischoff who told him to start painting without any preconceived ideas, Smith began to use house paint and house-paint brushes applied to big canvases spread on the floor. The black canvases he created were a revelation

to him. He had been subject-oriented. Bischoff taught him to manipulate paint.[25] While in San Francisco, Smith looked at work of artists of that city like Clyfford Still, Richard Diebenkorn, and Bradley Walker Tomlin. He also saw an exhibition of the work of Arshile Gorky.[26] In the years that followed, in paintings like *Wet Night* (1953, fig. 132), Smith formalized abstractions of nature into almost Cubist patterns of flat-colour rectangles that give both optical charge and metaphorical weight. The pattern of black trees superimposed on the grid sets up a dialogue between landscape and sky. By the decade's end, Smith had refined his technique into a more consistent, all-over approach.

Vancouver's Takao Tanabe, after training at the Winnipeg School of Art with Joe Plaskett (who had studied with Hans Hofmann in 1947), learned about Abstract Expressionism first-hand. During the winter of 1951-52, Tanabe studied with Hofmann and met Philip Guston and Franz Kline. In his "inscapes" of the late 1950s, Tanabe pondered abstraction as a psychic landscape. His keen sense of light permeated many of his paintings like

Fig 132. Gordon Smith (b. 1919)
Wet Night, 1953
Oil on canvas, 73.7 x 83.7 cm
Vancouver Art Gallery, Vancouver
Vancouver Art Gallery, Trevor Mills, VAG 53.7

Fig. 133. Takao Tanabe (b. 1926)
Landscape of an Interior Place, 1955
Oil on canvas, 71.5 x 91.5 cm
National Gallery of Canada, Ottawa

Landscape of an Interior Place (1955, fig. 133). He deployed his vision with a light and skillful touch, exploring memory and expressing it through calligraphic signs. During the late 1950s and 1960s, Tanabe's work underwent many changes but he retained a restrained application of paint and a concern for composition. He consciously considered landscape as a subject beginning in 1968, though he disciplined his choice (often, the Prairies), progressively eliminating references to the specific.

Montreal, Toronto, and Winnipeg also fostered contemporary sculpture. During the late 1950s, a number of sculptors began working in welded metal following the example of Cubist sculpture and, closer to home, David Smith. The results often had an anthropomorphic reference or link to nature. In Montreal, the aggressively decorative scrapyard sculptures of Armand Vaillancourt, obviously modelled on work abroad, fit into a flurry of interest in architecturally oriented work. In Toronto in 1958, Graham Coughtry designed cast-relief panels for the exterior of B'Nai Israel Beth David Synagogue in Downsview, and Gordon Rayner created a welded-steel sculpture with a found object aesthetic for a private home, *The Garden Fountain*. Gerald Gladstone, inspired by Rayner's welding, created a fountain for the William Lyon Mackenzie Building in Toronto; he continued to work in welded steel in the 1960s. In Winnipeg, a city that had some precedent for abstraction in the work of Group of Seven member L.L. FitzGerald, innovative abstract sculptures, mostly large-scale or public commissions, were created by Jim Willer, George Swinton, and Richard Williams. Their work was marginalized by being sited away from the public, often appearing in unexpected places like motor hotels, as fountains, or as wall reliefs for office buildings.

A new spirit of ambition and a new spirit of dissent also developed in Regina. The attitude of mind that fostered abstraction was running like a fissure through a group centred around the then Norman Mackenzie Art Gallery (where art historian and painter Ronald Bloore from Toronto was director from 1958 to 1966), and the Regina College School of Art (where artist Kenneth Lochhead from Ottawa was appointed director in 1950). Seminal to the development of the Regina Five group, as it was known, were the Emma Lake Workshops in northern Saskatchewan (Emma Lake is near Prince Albert). Begun in the 1930s, they were given a new lease on life by Lochhead and Arthur

110

Fig. 134. Arthur McKay (b. 1926)
Effulgent Image, 1961
Enamel on masonite, 122.0 x 122.0 cm
MacKenzie Art Gallery, University
of Regina, Regina
Gift of Clifford and Patricia Wiens

Fig. 135. Kenneth Lochhead (b. 1926)
Chevron Blue, 1962
Enamel on masonite, 121.9 x 182.9 cm
MacKenzie Art Gallery, University
of Regina, Regina
Gift of MacKenzie Art Gallery Society

Fig. 136. Kenneth Lochhead (b. 1926)
Blue Extension, 1963
Dept of External Affairs, Ottawa

III

Fig. 137. Ronald Bloore (b. 1925)
Painting No. 1, 1959
Oil on masonite, 116.8 x 116.8 cm
MacKenzie Art Gallery, University
of Regina, Regina
Gift of MacKenzie Art Gallery Society

McKay, an artist and fellow teacher at Regina College, in 1955. They introduced a wide-ranging group of Prairie artists to some of modernism's best known practitioners and critics, including the important New York art critic Clement Greenberg (in 1962). One of the key workshops occurred in 1959 when the American Abstract Expressionist Barnett Newman came to teach. Many of the artists who attended — including Roy Kiyooka, Arthur McKay, Ronald Bloore, Ted Godwin, Douglas Morton, and Robert Murray — were inspired by Newman's sense of the high purpose of painting. McKay, Bloore, Godwin, and Morton decided to band together, and in 1961, with the addition of Lochhead and the Saskatchewan architect Clifford Wiens, they held their first show at the Norman Mackenzie Art Gallery. Organized by Bloore, it was called *The May Show*. In December, the National Gallery of Canada organized the exhibition *Five Painters from Regina* based on *The May Show*.

Like their counterparts in Montreal and Toronto, painters in Regina made frequent use of a wide range of media, enigmatic, though often central imagery, and Oriental calligraphy. The results are distinctive, often quietly linear patterns that are unhistrionically intense. Arthur McKay's *Effulgent Image* (1963, fig. 134) has the characteristic energy exuded by the work of this group. About 1961, McKay began scraping enamel to create all-over fields in a circular or rectangular format, causing the viewer to look carefully at the way the abstract shapes seem to change as he regards them. Only Lochhead recalls in his work the jazzy brushwork of Toronto and New York (fig. 135), though by the

Fig. 138. Ted Godwin (b. 1933)
Tartan For Me Running, 1968
Elvacite on canvas, 190.8 x 251.2 cm
MacKenzie Art Gallery, University
of Regina, Regina

following year, he develops a more structured approach (fig. 136), and after working with Greenberg, a flirtation with colour field painting and spray gun.

The work of the Five was more geometrically ordered than that of painters in Toronto. Bloore, for instance, used circles and squares as imagery as in *Painting No. 1* (1959, fig. 137). Godwin took a geometric grid and liberated it with the organic flow of the serial colour interweaves known as Tartans, that became his *leitmotif*, as in *Tartan For Me Running* (1968, fig. 138). The way Bloore used the circle and the square influenced McKay to use the same forms to create paintings that looked new but somehow old. Almost inevitably, Bloore quarrelled with McKay over the use of the form. It was one of the "landmarks of the period: how the circle as a motif could be copyrighted," quipped Kiyooka.[27] Bloore subsequently concentrated on a white-on-white technique, which built on one of his own paintings of 1960, and imagery from non-Western cultures, among them Byzantium, Assyria, and Egypt.[28]

The constructed relief as a new medium of art was championed in Saskatoon by Eli Bornstein, who moved there from the United States to teach at the University of Saskatchewan in 1950 (he was born in Milwaukee, Wisconsin). In 1960 he founded the international art journal *THE STRUCTUR-IST*, which continues to be published biennially. In 1956 he created a series of abstract sculptures that culminated in a 4.58 m aluminum construction for the Saskatchewan Teachers' Federation Building. This work came to be known as the *Tree of Knowledge*. It was the first non-objective public art commission in Saskatoon, if not Western Canada, and resulted in considerable controversy. His continued exploration of structure, colour, space, and light, and their relationships to nature, resulted in further commissions — notably the Winnipeg International Art Terminal in 1962 and Wascana Centre Authority in Regina in 1982. His *Double Plane Structurist Relief No. 8* (1972, fig. 139), painted acrylic enamel on aluminum and plexiglass, demonstrates an early aspect

of Bornstein's growing involvement with the creative and expressive potential of structure and colour in space.

In 1959-60, Robert Murray produced a sculpture for Saskatoon City Hall, *Fountain Sculpture* (fig. 140). In his carefully considered installation, he invoked rain through what painter Wynona Mulcaster described as symbolic hand-like forms reaching to the sky.[29] The sculpture consists of two pieces of steel painted black over a green ground formed into curves placed on top of simple cut-out vertical bases. The two opposed curves substantiate sculpture's new vitality in a dramatic way. The work seemed open-ended and indeed, Murray, who had entered the field as a painter, found here the pathway to a career as an abstract sculptor. In 1960, he left Saskatchewan for a year in New York, but turned into a long-term resident in the United States. Despite his departure from the Canadian scene, his endeavour could not have been brought into being without the sympathetic climate to art in Saskatoon. His training at the Regina College School of Art as well as the crucial 1959 Emma Lake Workshop with Barnett Newman, served his career. Other qualities about Canada returned to haunt Murray later in his work. He often thought of the vast spaces of the prairie, and of the tipi shape, for instance, recalling the sight of the striking summer gatherings of tipis in Saskatoon he had seen as a youth. Often, too, to title his sculptures, he appropriated North American aboriginal words. His sculpture *Chilkat* (1977) is in the collection of the Metropolitan Museum in New York.

Fig. 139. Eli Bornstein (b. 1922)
Double Plane Structurist Relief No. 8, 1969-1973
Enamel, plexiglass, aluminum,
43.2 x 43.2 x 27.0 cm
Mendel Art Gallery, Saskatoon

113

Fig. 140. Robert Murray (b. 1936)
Fountain Sculpture, 1959-1960
Steel painted black-green, 243.8 cm
City Hall, Saskatoon

114

Fig. 141. Jack Bush (1909-1977)
Mainly Tan, 1967
Oil on canvas, 219.7 x 203.2
Miriam Shiell Fine Art, Toronto

Chapter Five
Post-Painterly Abstraction, Minimal Art, and Post-Minimal Art

During the decade that began in 1960, Canadian art passed through a transformation on its surface and in its depths. Until the mid-1960s, the transformation was to consist more of the recycling of methods of art-making from the 1950s and the erosion of old values and old loyalties than of the making and acceptance of new affirmations. It was the sad fate of Abstract Expressionism that it should provide the kindling and the fuel for the burning of the old order. Yet the explanation of that fate is to be found not only in the conjuncture of the times, but in the character of the art itself and in the genuine novelty of the art practices discussed in the next three chapters. Expanding art markets, increased internationalism within the art community, and the evolving status of the artist as star caused an unprecedented expansion of possibilities for visual expression.

Canadian artists in the generation following Abstract Expressionism sometimes pursued abstraction according to their own lights, sometimes passed it by entirely. They were often romantic loners with a dread of other people's expectations. In art, free association was their way of keeping their viewers on edge. Their work was among the most recognizable and unusual in Canadian art — subject-oriented, yet visceral, with a love of complex rhythms. It was marked by originality without being showy or faux-intellectual, it was geometrically girded; these artists were not afraid of visual clarity in their pictures.

Several terms need definition here: Post-Painterly Abstraction, Minimal art, Pop art, and Post-Minimal art. Post-Painterly Abstraction, as it was coined by Clement Greenberg, characterized a broad trend in American painting beginning in the late 1950s. The term as applied to Canadian painting has a certain validity. Greenberg used it as the title of an exhibition he organized in Los Angeles in 1964, which travelled to the Art Gallery of Toronto. In the show, Greenberg included Toronto painter Jack Bush and two painters in Regina, Kenneth Lochhead and Arthur McKay. In general, the term is applied to

Fig. 142. Robert Murray (b. 1936)
Track, 1966
Steel and aluminum, 137 x 439 cm
Walker Art Centre, Minneapolis

116

abstract painters who react against the gestural and painterly qualities of Abstract Expressionism in favour of painting that asserts pictorial qualities and particularly the power of colour with greater strictness. By contrast with Abstract Expressionism, Post-Painterly Abstraction was more controlled; expressive brushwork was replaced by broad areas of colour. Artists might follow the example of American painter Mark Rothko, who soaked his pigment into the canvas, to achieve a softer, more integral effect. In Canada, a good example is Bush's work, particularly his Sash series, as in *Mainly Tan* (1967, fig. 141), in which strokes of colour are hardly visible since they seem to melt into the ground. *Mainly Tan*, like many of Bush's works, is also an example of art that relies on optical effects — "Op Art:" the vibrant colour seems to have a vitality all its own.

Minimal art, which flourished in the 1960s and 1970s, was, like Post-Painterly Abstraction, a reaction against the excesses of Abstract Expressionism. It involved a specific, often austere, way of reacting to colour, form, and space. It is a term applied to a type of art, particularly sculpture, characterized by extreme formal economy: a unified structure that can be apprehended at a glance (sometimes called a holistic structure); plain, often industrial, and literally treated materials; geometric components with a modular grid; a restricted colour range; a bright clean look; and a deliberate lack of expressive content. As American artist Frank Stella said, "What you see is what you see." By contrast to Abstract Expressionism, Minimalism has a more detached sensibility, divested, or so it seems, of the creator's personal narrative. Often, the work was not made by artists themselves but fabricated by other people working from their plans. The early work of Robert Murray (who up to 1972 made holistic sculptures) provides an instructive example of the way in which artists could work within the formal confines of Minimal art but use it for their own ends. In Murray's *Track* (1966, fig. 142), for instance, the sculpture

consists of two raised tubes evocative of train tracks. The form can be apprehended at a glance but does not explain itself from one point of view, the aim of most Minimalists. But Murray's work follows Minimalist ideas from another point-of-view. He built the majority of his works (other than bronze castings) in metal fabricating plants, taking advantage of nuances developed during the fabricating process, and working with the men in the plant as the piece progressed.

Ronald Bladen, like Murray born in Vancouver, was one of the leaders of Minimalism, yet he applied to it his personal interpretation; his highly imaginative large architectural configurations have an expressionistic heart and sense of energetic muscularity. The radical shapes and dynamic relation to the environment of Bladen's sculptures give them a living presence, and even, at times, a quasi-anthropomorphic vitality. Made of wooden frameworks joined with screws and bolts, sheathed with plywood and painted a solid colour, often black, Bladen's sculptures reveal his appreciation of the poetic and his interest in Eastern philosophies. This taste formed from friendships with writer friends in San Francisco where Bladen trained and lived for fifteen years before moving to New York in 1957, and from pilgrimages to places like California's Big Sur's Slater Hot Springs (now Esalen). *Three Elements* (1965, fig. 143), three identical, starkly simple, aluminum-faced black wood boxes jutting from the floor at an inclined slant so that they seem to lean at an angle was a major milestone in the historic Minimal exhibition *Primary Structures* at the Jewish Museum in New York in 1966. (Today, a black-painted steel version of the work is in the collection of the Museum of Modern Art in New York.)

Yet at one and the same moment as Minimal art sought to deny expressive content, some artists sought to distinguish just such a narrative in their work; they drew on Dada, an anti-rational movement founded in 1922, the principle source of Surrealism, a revolutionary mode of thought launched in 1924, to

Fig. 143. Ronald Bladen (1918-1988)
Three Elements, 1965
(installed at P.S. 1 Contemporary Art Centre, Long Island City, N.Y., 1999)
Plywood and aluminum,
312.7 x 122.9 x 289.5 cm
Private Collection
Photo: Oote Boe

117

convey intense private fantasies or embrace the use of commonplace subjects. Pop Art was described in the writing of the English art historian and critic Lawrence Alloway as early as 1956 and in the United States in the years from 1959 to 1961, as a way of using real-world subjects with direct reference to the language of everyday life and especially to consumer culture. It became of interest to Canadian artists achieving maturity in the late 1950s, who were struggling to come to terms with social change; as a way of debunking the seriousness of the art world. Shrugging off the idea of the pristine art work, they responded to mass media and recycled images from the world of comic books, advertising, and television. Like Minimal art, Pop art was a reaction against Abstract Expressionism, though by contrast to Minimal art the imagery of Pop art was based on popular culture; it was marked by a return to the figure and the use of commercial techniques in preference to a painterly manner. Canadian Pop art was generally less brash. An example can be found in the work of Greg Curnoe, who will be discussed in chapter seven.

In both Post-Painterly Abstraction and Minimal art, serial work, the idea that the same forms could be transformed in provocative ways, became a constant. In materials, the fascination with the new led to an expanded repertory and new techniques. Plastic was one of the materials explored for its sensuous qualities. Polystyrene in the hands of Les Levine helped him present oblique approaches to perception that prefigure Conceptual art — the notion that the idea for a work of art is as crucial as the finished product.

Minimal art was quickly joined by Post-Minimal art, ushered in by a show in New York at the Fischbach Gallery, curated by Lucy Lippard, titled *Eccentric Abstraction*, of 1966.[1] Post-Minimalism encouraged a different attitude of mind toward procedures of art-making and materials. Prompted by Surrealism, it made use of eccentric abstraction, and funky, often malleable, seemingly absurd materials. Where Minimal art embraced the idea of incorporating the space in which the object is located in the piece, Post-Minimalists took the idea one step further and created work outdoors, in the landscape. Such projects often became permanent or long-term fixtures of their surroundings. Post-Minimal art often displays the era's penchant for a countercultural sensibility, interweaving pathos. An example in Canada is the work of An Whitlock, whose art in a wide range of (often soft) materials has a mysterious quality.

The idea that a work of art could be abstracted and formalized led to an interest in Conceptual art, which may be defined as favouring intellectual over visual experience and involving a more active participation on the part of the viewer, like installation and earth art. The artist, too, becomes involved in a different way with the work, as in body art (in which artists are oriented toward the discovery of their own bodies) and as in performance art. Post-Minimalism's diverse manifestations, incongruous juxtapositions, and extreme oppositions of materials and forms require a certain mental agility on the part of both artist and viewer. The idea of abolishing the physical appearance of the work led to a growing interest in the possibilities of videotape and photography, which, by the close of the 1960s and early 1970s, had joined the media of choice. In 1968, for instance, Lisa Steele began production on her video *The Gloria Tapes*, which features a young single mother on welfare, battling social agencies, her immediate family, and the justice system. The idea of the art work as a soap opera with a socialist-feminist basis pointed to a new era in Canadian art. So did artists such as Montreal's Serge Tousignant, who discovered in photography a way of creating images like *Sun Drawings*, which he made with natural elements — sun, sticks, and shadows. The effect was, he believed, at one and the same time, graphic, sculptural, spatial, and painterly; "fiction with the greatest amount of reality," he called it.[2] At the same time, Happenings and sculpture symposiums brought the viewer into direct contact with artists' work. The idea of progress, viewed from its technological and scientific aspects, was continually present.

The 1960s in Canada, with Post-Painterly Abstraction, introduced into abstraction a new emphasis on the literal: artists known for their expressive bold gestural work, such as William Ronald, presented in their work geometric forms with more compact paint surfaces. In the 1970s, artists often went through a change in subject matter, materials, and techniques and reintroduced the image, often one related to the urban way of life with the city as a principal motif or backdrop.

This was the period during which first official steps were taken in Canada towards the creation of a support system for contemporary art. The founding of the Musée d'Art Contemporain de Montréal (1964), the first museum in Canada devoted to this guideline, initiated a new round of activity. The Canada

119

Fig. 144. Grand Western Canadian Screen Shop,
Winnipeg, c. 1970
(From left): Len Anthony, Gord Bonnell, and
Bill Lobchuk
Photograph courtesy of Bill Lobchuk, Winnipeg

120

Council Art Bank, established in 1972 for the rental of contemporary Canadian art to federal departments and agencies, also offered promotion and recognition. (Today, its collection of contemporary Canadian art — 18,000 works in 1995 — is the largest anywhere.)

The 1960s and 1970s marked as well the opening of some of the main printshops in Canada, such as l'Atelier Libre de Recherches Graphiques, the first print workshop in Canada to make printmaking facilities available to contemporary artists; it was founded by Richard Lacroix in Montreal in 1963. He then founded La Guilde Graphique (1966), which served as the publishing house, distributor, dealer, and exhibition area for the prints produced by l'Atelier Libre. It was quickly followed by Pierre Ayot's Atelier Libre 848 (renamed Graff in 1970), another printmaking centre. Besides serving as a production centre, Graff fostered a group of artists interested in contemporary developments such as Pop art. Following Guilde Graphique, Graff founded Media Gravure in 1969 next door to its printshop to serve as its publisher and dealer. In Winnipeg, Bill Lobchuk founded the Grand Western Canadian Screen Shop in 1968 (fig. 144). The Nova Scotia College of Art and Design's Lithography Workshop was established under the direction of Jack Lemmon and master printer Robert Rogers in 1969. Open Studio, in Toronto, was founded by Richard Sewell and Barbara Hall in 1970; and the Moosehead Lithography Press in Winnipeg, was founded by David Umholtz in 1977. Such workshops provided artists with facilities and services in printmaking, along with advice from experienced artists for the novice. At Open Studio, for instance, technical advisers featured some of the finest printmakers in Canada, such as Otis Tamasauskas for etching and Don Holman for lithography. All these print shops encouraged excellence in production and educated the public to the possibilities of the medium. The vivacious and textured abstracts of Richard Lacroix, in particular, introduced a largely new audience to contemporary art. Largely as a result of this increased activity, the many organizations in Canada devoted to printmaking, merged in 1976 to become the Print and Drawing Council of Canada.

The 1960s and 1970s also saw the emergence of a new kind of dealer, the

artist-run centre (ARC) or "alternate" space. The Region Gallery begun by Greg Curnoe in London, Ontario in 1962, was the first in the country, followed by Fusion des arts, founded by Yves Robillard, Richard Lacroix, and others in Montreal. Among their descendants were A SPACE (1971), and Mercer Union (1979) in Toronto, the Forest City Gallery in London, Ontario (1973), SAW in Ottawa (1973), Intermedia (1966-1970) and the Western Front Society (1973), both in Vancouver, along with many others in a network across the country. Such galleries were dedicated to promoting contemporary artists and sales. They provided more opportunity for artists to exhibit, as well as a way for artists to control the display and distribution of their art, particularly large installations, performance, and video art. Vidéographe, which opened in Montreal in 1971, founded by Robert Forget of the National Film Board, led the way in encouraging the use of video recorders in a wide range of experimental contexts (it is still in existence today as a production, distribution, and exhibition venue for artists.) In 1972, A SPACE in Toronto established a Video Co-op that became an independent enterprise in 1978 as Charles Street Video. Other centres followed: in 1980, Toronto's V Tape was founded by Lisa Steele and Kim Tomczak.

Besides a new kind of gallery structure, in the early 1970s, the "independent" curator emerged, one not attached to an institution. For Peggy Gale in Toronto, the earliest practitioner of this in Canada, the transition from public gallery to independent status occurred naturally as an activity with her work on *Videoscape*, an exhibition in 1974 at the Art Gallery of Ontario where she had been a staff-member. She continued to put together projects from that time.

In terms of art, the era of the 1960s (into the 1970s) is best remembered as a period that featured a general interest in process. Artists whose work had developed during the 1950s had to re-orient themselves to the new climate in art. Using familiar components, they made work more oriented towards forms or rules of art they now felt to be more characteristic. Their work had in common a liking for simple shapes and strong colours — sometimes close to Minimal art, sometimes with a Pop flavour.

In Montreal, the Plasticiens continued to explore visual relationships based on geometric form and vibrant colour contrast. Their work holds the

Fig. 145. Guido Molinari (b. 1933)
Four Blue Bands, 1963
Acrylic latex on canvas, 132 x 118 cm
Carleton University Art Gallery, Ottawa
Anne Wilkinson Collection, 1967
Photo: Tim Wickens Photography

121

Fig. 146. Claude Tousignant (b. 1932)
Clair-obscur, 1970 (2 panels)
Acrylic on canvas, each 198.1 cm in diameter
Galerie de Bellefeuille, Montreal

wall with authority and visual density. In the 1960s, Guido Molinari used coloured stripes in large canvases like *Four Blue Bands* (1963, fig. 145), the effect varied according to their position. By 1972, Molinari developed a series of huge monochromatic paintings. Starting in 1966, Claude Tousignant used rings of concentric colours in circular paintings in which he gained a "hard-edge" effect through masking with tape prior to the application of acrylic paint, a new fast-drying medium. There are many handsome examples in his *Gong* series where Tousignant combined bands of wide concentric circles of colour with thin repeated inner circles or played one gong off against another — as in *Clair-obscur* (1970, fig. 146). The combination produces an often stunning, usually luminous, vibrating effect. During the 1970s, as in *Sun Mist* (1970, fig. 147), Rita Letendre explored colour, line, and composition through the use of forceful chevrons that cut across the composition diagonally or horizontally from one corner of the painting to the other. She obtained extra energy from applying narrow ridges of contrasting colour to the borders of each ray. In 1972, she softened the effect through the use of forms of spray paint, often contrasted with a single central hard ray.

Emerging talents in Montreal like Charles Gagnon and Yves Gaucher discovered American abstract painting for themselves. Gagnon made the obliga-

Fig. 147. Rita Letendre (b. 1929)
Sun Mist, 1970
Acrylic and graphite on canvas
Robert McLaughlin Gallery, Oshawa

tory trip to New York: he lived there from 1955 to 1960 and constantly visited museums like the Metropolitan Museum of Art as well as studying experimental film, dance, and music. The facades of the city, especially those with half-worn-off paint, were an inspiration to him, as they were to painters of the New York School. In 1960, Gagnon returned to Montreal, and the calligraphy of signs he had discovered became the structure of paintings in which he increasingly paid attention to negative space. In the early 1960s, he turned to the study of matters such as sound, developed with a restricted yet elegant colour range, sometimes with a rectangle within a window format. In the 1970s, he examined the effect of the seasons on light (fig. 148)

Fig. 148. Charles Gagnon (b. 1934)
Cassation/A Summer Day/D'Ete, 1978
Montreal Museum of Fine Arts, Montreal

For Yves Gaucher, who emerged on the scene as an innovative printmaker, music provided the gateway to the development of his art. In Paris from 1961 to 1962, he attended festivals of contemporary music. Particularly indelible for him was the experience of an Anton Webern concert; it led to a series of prints, *Homage to Webern*, in which he paid homage to the composer for enabling him to have the same experience in art that he had in music. The series meant for Gaucher the birth of subsequent work oriented towards broad expanses of colour in thin layers of paint, geometric reduction, and a simplified, asymmetrical format. In 1965, Gaucher began to paint diamond-shaped, abstract, and highly ordered canvases, interrupted by occasional coloured geometric shapes. In 1967, he began a series of *Ragas* based on Indian classical music, impassioned paintings in monotone that conveyed an impression of melodic lines appearing in a shallow picture space. In the 1970s, Gaucher developed handsome diagonally structured paintings like *Jericho 3* (1978, fig. 149) that he sometimes titled after the hues used in his huge areas of colour.

Jacques Hurtubise visited New York several times during his

123

Fig. 149. Yves Gaucher (b. 1934)
Jericho 3, 1978
Oil on canvas, 203.2 x 254.0 cm
The Artist

Fig. 150. Jacques Hurtubise (b. 1939)
Hyacinth, 1966
Acrylic on canvas, 173 x 173 cm (diagonal)
Montreal Museum of Fine Arts, Montreal

124

Fig. 151. Jacques de Tonnancour (b. 1917)
Fossile, 1979
Acrylic and collage on paper, 45.8 x 61.0 cm
Robert McLaughlin Gallery, Oshawa
Gift of Isabel McLaughlin, 1990

years at Montreal's École des Beaux-Arts (he graduated in 1960); then, following the pattern, he moved there for a year to discover American Abstract Expressionism for himself. Upon his return to Montreal, he came in contact with the Plasticiens, and like them, he began to build his paintings on a scaffolding of geometric form. However, in his work, Hurtubise developed a favourite hot colour range and blot motif. From the mid to late 1960s, he focused on Op art to create raucous pictures with brilliant colours. They have a lush painterly sensuality, and they speak to complex visual matters. Several of his combinations involved silver and fluorescent colours with zigzags of black; later, he focused on splashes, bursts, drips, and halved geometric shapes. *Hyacinth* (1966, fig. 150) has an explosive red and blue optical pattern.

Many other artists in this period mined abstraction, often working by going deep into the innermost byways of their own past experience and finding a way to tunnel back up. Jacques de Tonnancour in Montreal, for instance, who had been painting concise variations on a theme of Laurentian landscape since the mid and late 1950s, began to make relief collages in the 1960s. In the 1970s, he developed "writing" and "fossil" paintings with an original formal vision. (fig. 151)

In Toronto, Jack Bush (fig. 152) progressed to new heights in colour field painting. His talents lay in the area of formal invention and colour. His arrangements of colour were lyrical and exuberant, often high in key against lightly textured grounds, and always highly orchestrated. From 1963 to 1966, Bush used a basic format in his "Sash" series, of a waisted central column of irregular colour bands with fields of colour at either side. One source of inspiration came from a trip on a New York bus going uptown in 1962. From the bus window, Bush saw a store-window filled with mannequins wearing clothes with sashes around their waists:

> I just saw this and noted in my mind, this wonderful colour combination — and I went back to Chelsea Hotel where I was living at that time..., and I made a bunch of works on paper based on this, what we call now, the Sash series, which is the colour from the model, from her blouse, her sash and her skirt, flared out slightly.... There's no figure in it at all, but just the colour in this sash shape.... Clem [Clement Greenberg] said "Hey, why don't you try doing it like a fat lady and move the sash over and run right off the side of the canvas?"... So that led to a whole new series where the paint on the side was there, the sash shape was more or less there, but it got more complicated up to about fourteen different colours replacing the sash.... and that run through a whole other series.3

Fig. 152. David Mirvish Gallery, Toronto, during the exhibition, A Selection of Painting in Toronto, 1976
(From left): Paul Fournier, K.M. Graham, Jack Bush, Paul Sloggett, Alex Cameron
Photo: Jane Corkin

As Bush said, he continued his variations on the Sash format by moving the centralized stack of colour bars to one edge of the canvas. In late 1966, he began to pack his paintings with broad bars of colour stacked to fill the entire canvas creating a chorus line of irregular horizontal strips of colour. In the late 1960s and until 1976 (he died in 1977), Bush continued to use an expressive vocabulary of colour, shape, and gesture drawn from figural or natural sources to develop the formal confines of abstract painting. His different series include his *Calligraphic* pictures (1969); *Spasm* paintings using "heart throb" motifs, which he said was how he visualized his pain from a heart attack (1969); *Series*

Fig. 153. Daniel Solomon (b. 1945)
Emma Night, 1976
Acrylic on canvas, 168.0 x 106.1 cm
Private Collection

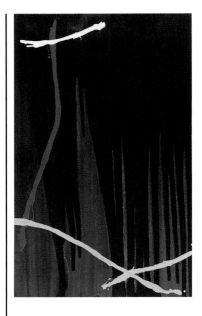

D paintings (1969-1970); *Irish Rock* paintings (1969); *Totem* series (1973-1974); *Handkerchief* series (1975-1976); and *Arabesques* of 1975. In the last, brushed bars of colour like loose gestural strokes cascade down or across a sponged background canvas, creating an effect both vigorous and beautiful.

Bush's influence was extensive, especially on emerging Canadian artists in the 1970s who were drawn to the possibilities of abstraction. They were a disparate group, nation-wide, and the way they

Fig. 154. Milly Ristvedt (b. 1942)
Helen's Valentine, 1977
Acrylic on canvas, 137.6 x 198.7 cm
Robert McLaughlin Gallery, Oshawa
Photo: T.E. Moore

126

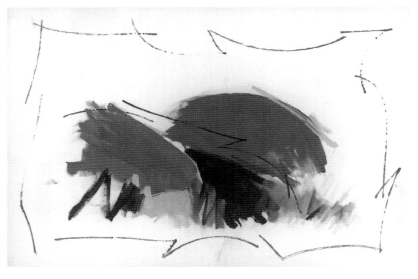

were inspired by Bush points to the special qualities in his work, particularly his expressive colour and lucid unpredictable compositions. Daniel Solomon,in the early 1970s in Toronto, varied his paintings from repetitive pattern pictures to pared-down canvases, to band paintings, expanses of saturated colour strung with narrow strips of contrasting colour, and pictures with clusters of parallel, over-scaled brushstrokes that float across the canvas (fig. 153).4 Milly Ristvedt, who studied in the early 1960s with Roy Kiyooka in Vancouver and had embarked on the road to abstraction before moving to Toronto, acknowledges

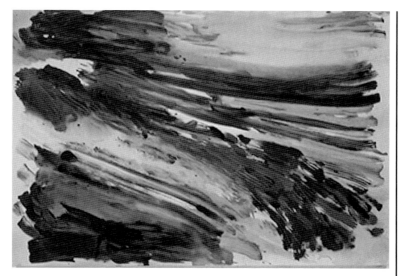

Fig. 155. Carol Sutton (b. 1945)
Yellow Key, Fan Series, 1979
Acrylic on canvas, 171.5 x 243.8 cm
The Artist, Toronto
Photo: Carol Sutton

Fig. 156. Douglas Haynes (b.1936)
Once Orange, 1978
Acrylic on canvas, 173.7 x 164.5 cm
Edmonton Art Gallery, Edmonton
Purchase with funds donated by the
Clifford E. Lee Foundation
Photo: E. Lazare

127

the tremendous support and enthusiasm that Bush gave to younger painters, including herself. In the first half of the 1970s, again in Toronto, Ristvedt's works were distinguished by colour introduced on the borders that flirted with a painting surface composed of a solid mass of one colour; in 1975-1976, she introduced a variety of colours in the centre of her painting, transforming them in 1977 into brilliant bouquets (fig. 154); in the late 1970s, she depicted grid-like images frosted with colour and texture. Carol Sutton in Toronto began painting in 1973 with acrylic on canvas, using a sponge and spray gun to explore form and light. She became well known in the 1970s for her "fan" paintings — characteristically composed of geometry shapes combined with pastel, powdery, flat colour (fig. 155) — and for her long horizontal pictures in which colour flowed diagonally in cascades across the canvas. In his "Split-Diamond" series of the late 1970s, Edmonton's Douglas Haynes preferred a basic format of broadly brushed "winged" images, outlined on a transparent colour field (fig. 156). Alex Cameron in Toronto, Bush's studio assistant, fashioned energetically drawn shapes, often fruit or birds, into elegantly abstract, richly coloured

Fig. 157. Alex Cameron (b. 1928)
Nubian Sun Dance, 1977
Acrylic on canvas, 186.2 x 140.0 cm
Robert McLaughlin Gallery, Oshawa
Photo: T.E. Moore

Fig. 158. K.M. Graham (b. 1913)
Tide Patterns, Grand Manan, 1985
Acrylic on canvas, 111.8 x 152.4 cm
Dr. and Mrs. Tasker, Toronto

128

paintings (fig. 157). K.M. (Kate) Graham, Bush's friend, presented abstractions of landscapes distilled from nature (often of the eastern Arctic) in which forms hovered and jostled. Coming in colour schemes such as pink, green, white, and brown, her paintings were playful, expansive, and unpretentious; in *Tide Patterns, Grand Manan* (1985, fig. 158), she combines visual opulence with

natural warmth.

Other good painters developed a touch of Bush. A loose transparent ground characterized the work of Toronto painter David Bolduc from 1974, but he favoured enigmatic, drawn, central images and vibrant, contrasting colour. Some of his paintings are dominated by powerful images from nature that speak in an eloquent language of signs and symbols and create the feeling of seeing the world through the eyes of someone — a Thoreau — with a transcendentally elevated consciousness (fig. 159). Joseph Drapell, working in

Toronto since 1970, established his reputation with energetic sweeps of paint made with an aluminum raking tool he developed. Drapell rejected the thin flat stained surfaces of Bush (and Morris Louis and Kenneth Noland) for a more personal approach involving thicker layers and suffused colour as in *Gates of Life* (1978, fig. 160). In the following two decades Drapell developed his vision in reaction to the art of Jules Olitski. In his *Island Paintings* in the 1980s, a new vocabulary of visual marks expressed his experience of Georgian Bay, his adopted spiritual home; in the 1990s, Drapell's abstraction evolved into *Archetypal Figures* and other themes. Since 1991, he has exhibited with the New New Painters, a group opposed to Post-Modernism, a movement which will be discussed in chapter seven.

Paul Fournier, like the others in this group, did not want to be bound by a particular style or credo. His first works were expressionistic abstractions that stressed spontaneous improvisational action in the application of paint. From

Fig. 159. David Bolduc (b. 1945)
Maroc, 1986
Acrylic on canvas, 213.7 x 227.9 cm
Robert McLaughlin Gallery, Oshawa
Gift of the estate of Alkis Klonaridis, 1993

129

Fig. 160. Joseph Drapell (b. 1940)
Gates of Life, 1978
Acrylic on canvas, 208.3 x 233.7 cm
Private Collection

Fig. 161. Paul Fournier (b. 1939)
Buena Vista (Florida Mirror No.7), 1976
Acrylic on canvas, 203.7 x 152.6 cm
Robert McLaughlin Gallery, Oshawa
Photo:T.E. Moore

130

Fig. 162. William Perehudoff (b. 1919)
Nanai No.18, 1969
Acrylic on canvas, 190.5 x 243.9 cm
MacKenzie Art Gallery, University
of Regina, Regina

1962 to 1969, Fournier evolved the concept of a corporeal mass emerging from darkness, mist, or light, gradually dematerializing it so that by 1969, his work was totally amorphous. In making it, Fournier too drew on an endless fascination with the natural environment, interpreted through archipelagos of lyrical colour, pulsating and reverberating, impastoed, scraped, and overpainted. In the 1970s, his work become more structured, often with a hint of Matisse (fig. 161). "Colour is the picture," Fournier said.[5]

In Saskatoon, during the 1960s, William Perehudoff and Otto Rogers developed their own forms of abstract painting. Perehudoff, who had a wide background in French and American art, in his paintings of the 1950s, was influenced by a modified form of Cubism. During the 1960s, he became an abstract painter, first applying acrylic to his canvases in vertical ray-like shapes; then in the late 1960s and 1970s, he stained his canvases with atmospheric washes, on top of which he carefully positioned bands, rectangles, or discs in acrylic or oil. In *Nanai No.18* (1969, fig. 162), Perehudoff uses a large block of ultramarine at the left, followed by vertical blocks of green, brown, red, yellow, pale blue, yellow-green, and ochre. Through the 1970s and 1980s, he pursued his strict form of soft ground hard-edge shape work, often expressed in overlapping areas of rich but more solid colour on canvases, which he titled numerically.

Otto Rogers, by contrast to Perehudoff juxtaposed qualities seen and experienced in nature with geometric elements, often static opaque blocks arranged structurally. Rogers often evokes qualities of the prairie landscape — its environment, light, and space, but offers a feeling of special magic through his orchestration of surface, colour, and references to plant elements. In 1960, he became a member of the Baha'i faith and sought through his work to express his belief that art is worship. For him, nature has a spiritual significance.[6] Through the 1970s and 1980s, Rogers continued to create paintings that involve multiplicity resulting in co-ordination. He did not aim at creating landscapes or abstractions. What he sought is a visual representation of a human condition in which motion and stillness play. His work strives for an inner peace contained and fostered by means of an ordered form.[7] In *The Land*

with Pink Rose Petal (1981, fig. 163), for instance, he found the form of a rose petal particularly appealing; the rose is sometimes believed to be a symbol of eternal life because of its many layered facets.

In Vancouver, through the 1960s and 1970s, Jack Shadbolt's work remained ambiguous, with flat collage-like elements and brilliant colour, but *Northern Elegy No.2* (1964, fig. 164), with its flat forms and hard edges, shows that he, like other artists, was searching for a new form of abstraction. The colour, too, suggests his interest in optical pattern. In the 1970s, Shadbolt grew fascinated with the stages of nature's life-cycle, especially as seen in the metamorphosis from larva to butterfly.

Other artists demonstrated an idiosyncratic affiliation with abstraction. Saskatoon-born Mashel Teitelbaum, a painter whose earliest work suggests a regional aesthetic, enroled in the California School of Fine Arts in San Francisco in 1950, where he studied with Clyfford Still; he also attended classes at Mills College in nearby Oakland with the German Expressionist painter Max Beckmann. During the late 1950s in arrangements of still life, and portraits, Teitelbaum developed his own form of portraiture, which featured

Fig. 163. Otto Rogers (b. 1935)
The Land with Pink Rose Petal, 1981
Acrylic canvas, 152.4 x 152.5 cm
Robert McLaughlin Gallery, Oshawa
Gift of Monty Simmonds, 1992

131

Fig. 164. Jack Shadbolt (1909-1998)
Northern Elergy No.2, 1964
Oil and lucite on canvas, 99.1 x 124.5 cm
Hart House, University of Toronto, Toronto

Fig. 165. Mashel Teitelbaum (1921-1985)
Dancers, 1972
Acrylic on canvas, 208.3 x 193.0 cm
Private Collection

132

Fig. 166. Gershon Iskowitz (1921-1988)
Autumn B, 1978
Oil on canvas, 168.7 x 307.3 cm
Robert McLaughlin Gallery, Oshawa
Photo: T.E. Moore

an expressive way of handling the medium. In Toronto where he had settled in 1961, Mashel Teitelbaum developed a reductivist procedure that led him from heavy and extroverted abstract paintings through increasingly centralized and colourful images to single Zen-like improvisatory gestures on unprimed canvas. By 1967, he had lost faith in painterly modernism and developed a series of twenty identically scaled works that sardonically criticizes the progress of modern art. In 1969 Teitelbaum returned to painting with a difference. In the paint skin constructions (which continued through 1973), Teitelbaum poured acrylic paint onto polyethylene sheets and when it was dry, peeled it off as a "skin." Separate pieces were then glued to the canvas support to create an assemblage (fig. 165). In 1976, he turned to painting landscape and exuberantly responded to the legacy of the Group of Seven and their contemporaries.

Gershon Iskowitz, who came to Canada in 1949 (a Pole, he had been interred in Buchenwald during the Second World War), was another strong

individual with his own way of handling expression through abstraction. From the early 1960s until his death in 1988, as in *Autumn B* (1978, fig. 166), Iskowitz painted densely patterned abstractions of the growth of trees and skies, the moods and colours of the seasons or times of day in the northern Canadian landscape. His work blossomed into broad abstractions, often in multiple panels with freely floating forms composed of blotches of rich luminous colour and glowing light seen as though through a filter. In 1967, a helicopter trip north of

Churchill, Manitoba, confirmed him in his choice of patterns of colour; later Iskowitz said that his *Uplands* series of paintings, diptychs, related to his view of the land as the pilot pulled up over hills and trees, his *Lowlands* series the land as the pilot dove down. In the mid-1970s, Iskowitz said:

> People say, oh, Gershon Iskowitz is an abstract artist. I hear that a lot of times. But it's a whole realistic world. It lives, moves ... it has to move, or it's dead! I see those things ... the experience, out in the field, of look-ing up in the trees or in the sky, of looking down from the height of a helicopter. So what you do is try to make a composition of all those things, make some kind of reality: like the trees should belong to the sky, and the ground should belong to the trees, and the ground should belong to the sky. Everything has to be united. That's painting.... I used to paint on the spot just to get experience.... Now, most of my work comes visu-ally from memories, and the colour also is self-invented. I reflect things I've seen before up north.... But it's nothing to do with documentary. It's above that, it's something you invent on your own. Okay, it's a lot to do with landscape, but you've got to project yourself into that form. I paint the country in my own way.[8]

In Toronto in the 1960s, the commercial galleries, each with its own saga, one usually initiated by one determined dealer against heavy odds, became the drop-in centres of the cultural world. One of these places was the Isaacs Gallery, owned and operated by Avrom Isaacs. The loose-knit band that exhib-ited there, sometimes called the Isaacs Gang, imbibed the effects and motifs of Surrealism combined with the ideas of Dada, before beginning their break-through achievements. A second centre, with artists a generation younger, emerged in the Carmen Lamanna Gallery (1966-1991). The David Mirvish Gallery (1963-1978) participated in the introduction of Canadian artists such as Jack Bush to the Canadian art scene, along with many American artists such as Frank Stella, and Kenneth Noland, and the British artist Anthony Caro. Many painters, curators, and collectors in Canada and the United States today remember the Mirvish as their classroom. This trend was continued in the 1980s by progressive spirits among the dealers like curator Ydessa Hendeles.

She created what appeared to be more of a museum than a trading-post in the business she opened in 1980, aimed at the museum market. Today, the Ydessa Hendeles Art Foundation, founded in 1988, has her own group of thoughtful and surprising installations in which Hendeles marries the historical to the contemporary.

Art-making of the 1960s and 1970s had a certain consistency, if only in its heroes, one of whom was Marcel Duchamp. He visited Toronto in 1961, and his example provided an indispensable resource. The result of his influence was an art that adopted a more improvisational and subjective structure, as well as offering a challenge to look at unconventional ways. Duchamp's idea of the ready-made, art made from pre-existent materials, was always to lie in an artist's imagination. Collage and assemblage in particular these artists found congenial and in line with their preference for serving as a link between objects. Theirs was a revised association with the environment.

Collage and assemblage taught important lessons about scale, space, abbreviation of form, and the need to distort to convey pictorial truth. In trying to discover new representation, the artist found juxtaposition helpful, as well as the precedent set by Marcel Duchamp. "Duchamp's aristocratic, hands-clean aloofness was intriguing," wrote Michael Snow. "Duchamp made little, had very few exhibitions, and the 'ready-mades' critiqued the hand-making of original works for sale."9

Due to Duchamp's influence, the idea of Dada permeated Toronto. Its influence resulted in *The Sign of Dada*, an exhibition organized by Toronto artists Richard Gorman and Dennis Burton in 1961-62,10 that became a yearly feature of the Isaacs Gallery as the Christmas Elves' Art Shows, in which the group explored ephemeral materials. Neo-Dada's high point in Toronto occurred in 1965 with a major Happening (really a fundraising party) at the Art Gallery of Toronto, on which this circle of artists advised and at which some of them entertained. The Artists' Jazz Band (AJB), then consisting of Gordon Rayner on drums, Graham Coughtry on trombone, Gorman on bass, and Nobuo Kabota on alto saxophone, played at the event.

Duchamp's anarchic spirit lived on in Les Levine, who used elements of Pop art in his work, but because Levine explored perception, feeling, and memory in topics such as communications and mass culture, he regarded himself more

as a media sculptor. A student of the Central School of Arts and Crafts, London, England, Levine moved to Canada in 1958 and then in 1964 settled in New York. During the early 1960s, with the intention of obliterating the idea of art as unique and precious, he began making spray paintings using chairs to create the forms, then chair environments, chairs encased in tight-stretched styrene that he regarded as three-dimensional drawings, as in *Chair (Plug Assist II)* (1965, fig. 167). Entertaining and unsettling shows such as *Slipcover* in 1966 at the Art Gallery of Ontario in which Levine covered the walls, ceiling and floors with heavy plastic material made him an international art star. An important precursor of Conceptual art, Levine's strength as an artist was the way he created art out of whatever concerned him; he was interested only in the concept and the freedom the concept allowed. Levine is notable for his serious approach to environmental issues at an early date and for his early forays into video (1966). In *Slipcover*, he used a video tape time-delay projection so that five seconds after viewers entered the room, they were able to see themselves projected. Levine was one of the first Canadian artists to be dubbed Post-Modern,[11] and he coined the phrase disposable art. In 1967, he asserted a distinction between his accessible objects and Andy Warhol's Brillo boxes.

> Warhol's thing turns out to be reliant on art history in the romantic sense that if you contemplate anything it can be art ... whereas I am not making a contemplative object. I choose to call what I make an experimental object.... Art could be a disposable thing, something that could be a transient experience, not a life lasting experience."[12]

Other artists such as Gordon Rayner were also interested in Dada. It genuinely amused Rayner, and throughout his work he has been consistently involved with entertaining himself. He likes Dada's element of simple surprise, its way of looking at things. That, and the use of collage in his work, made for intriguing combinations. He smuggled into his paintings some fairly unorthodox materials, for instance. Unlike the junk quality of collage masters like Kurt Schwitters, Rayner's work was large and of geometric orientation: the work literally is a pyramid or triangle. He went on to use furniture like tables or bureaus, cutouts from magazines, and found objects from the natural world —

Fig. 167. Les Levine (b. 1936)
Chair (Plug Assist II), 1965
Uvex plastic, wooden beams, aluminum frame,
128.8 x 88.8 cm
Robert McLaughlin Gallery, Oshawa
Photo: T.E. Moore

135

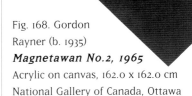

including birch bark and rocks — or patterns from decorative metal plates seized up and used for a moment. In terms of technique, Rayner's motto as a painter was variety: he brushed or poured acrylic paint and used paint thinly or thickly. The canvas itself Rayner stained or soaked, cut, ripped, split, stitched, folded, or shaped.

Rayner believed that different subjects merited different treatments. He travelled widely to capture characteristics of locations both abroad and in one of his favourite painting places, Magnetawan, two hundred miles north of Toronto. In his Magnetawan works Rayner was able to fully display his gift as a colourist of sensitivity. In *The Lamp* (1964, Robert McLaughlin Gallery, Oshawa), he uses his colour magic to recreate the effect of a lamp at night shining on the still lake waters of Northern Ontario, complete with variations from dark to light (dark blues, black, and yellow-greens), as well as contrasts between thick and thin areas. Weather conditions like a rare lightning storm or a day of solid torrential rain fascinated him, as did unusual high-angled views. In *Magnetawan No.2* (1965, fig. 168), Rayner captured the effect of the lightning with white paint poured over a black background. Finding the idea of an artist developing in a linear direction offensive, he proceeded to opposites — at one moment, influenced by Clement Greenberg towards simple flat shapes and gorgeous colour; at another, using odd, interlocked, erotic shapes. With his collages of 1974 and Persian carpet series of the late 1970s, Rayner continued his penchant for technical surprises that keep the viewer on the move.

Fig. 168. Gordon Rayner (b. 1935)
Magnetawan No.2, 1965
Acrylic on canvas, 162.0 x 162.0 cm
National Gallery of Canada, Ottawa

136

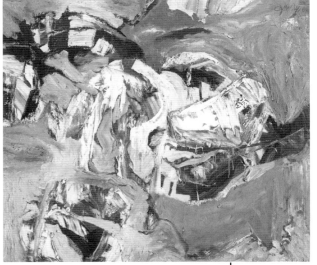

Fig. 169. Richard Gorman (b. 1935)
Frozen Heat, 1960
Lucite on canvas, 127.0 x 142.4 cm
Robert McLaughlin Gallery, Oshawa
Gift of Harry Malcolmson, Toronto, 1988
Photo: T.E. Moore

Richard Gorman shares many affinities of outlook with Rayner, including an abiding interest in Tom Thomson, but he has sought to make art on his own terms, often incorporating symbolic references to the psychological effect of moments in his life. To paintings such as *Frozen Heat* (1960, fig. 169), Gorman applied a richly textured surface and mixed creamy whites and greys with purples, areas of orange, red, and blacks

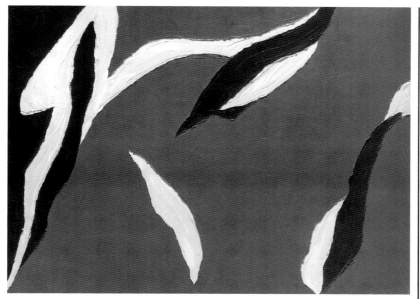

Fig. 170. Richard Gorman (b. 1935)
Green Lady, 1964
Oil and lucite on canvas, 152.7 x 203.7 cm
Robert McLaughlin Gallery, Oshawa
Photo: VIDA/Saltmarche, Toronto

in strong sweeps of paint. He continued to create rich surfaces of smeary painting. In 1961, Gorman began to make black-and-white monoscreens and vibrant large collages from torn monoprints; his imagery was a compendium of purely abstract elements. By 1963, his colour had become richer and more sustained, his forms firmer and not contained by the edges of the canvas. *Green Lady* (1964, fig. 170), for instance, incorporates the forest green colour of a dress worn by a friend with pumpkin orange and ultramarine blue. Where Rayner has been called the carpenter of Canadian art, bringing together disparate elements for exciting collage effects, for Gorman, as the American critic Harold Rosenberg once said of Action Painting, making art is a way of acting out a personal drama in front of the canvas. The painting itself remains the record of an existential act.

In the painting of Graham Coughtry, beginning in 1959, the nude female appears, disappears, couples, advances, recedes, and floats in an indeterminate space. Her presence is manifested in vibrantly beautiful many-layered colours — orange, red, purple, pink, and turquoise, and in paint that incorporates chance accidents that happen on the canvas. Fascinated with Pierre Bonnard's *Toilette* paintings, Willem de Kooning, and the sculpture of Alberto Giacometti, Coughtry developed a subtle painterly style. He first

Fig. 171. Graham Coughtry (b. 1931)
Two Figures No. 5, 1962
Oil and lucite on canvas, 177.6 x 127.0 cm
National Gallery of Canada, Ottawa

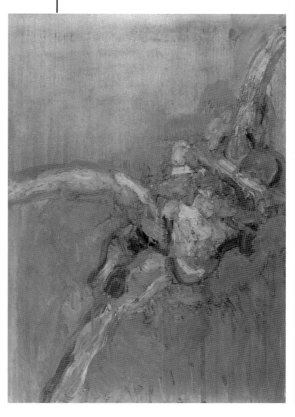

137

Fig. 172. Dennis Burton (b. 1933)
Egypt Asleep, 1965
Oil on canvas, 52.8 x 52.8 cm
Art Gallery of Hamilton, Hamilton
Gift of Walter Carsen, 1995
Photo: Lloyd Bloom

138

Fig. 173. Robert Markle (1936-1990)
Untitled, 1971
Coloured ink over graphite on paper,
89.2 x 58.6 cm
Robert McLaughlin Gallery, Oshawa
Photo: T.E. Moore

attracted attention in the early 1960s for his paintings of couples engaging in intercourse, but his evasive forms appear more androgynous than erotic (fig. 171). Sometimes his forms look like Henry Moore sculptures, simple organic definitions. His friend, artist Dennis Burton, during the same period, painted vaginas in rainbow colours and women in garterbelts. "Garterbeltmania," his work was titled by Toronto *Globe and Mail* art critic Kay Kritzwiser. In 1965, in *Egypt Asleep* (1965, fig. 172), Burton recreated his figure into a world landscape seen from a bird's eye view, a Mother Universe, with a garterbelt that makes a pyramid, breasts that suggest the sun and moon, and a strategically-placed ankh, the hieroglyphic sign for life. Of the genesis of another Garterbelt painting, *Mother, Earth, Love*, Burton said, guilelessly: "I focused on the breasts, accentuating their size and shape by adapting the design of a French nursing brassiere. Then I suggested the

panty-briefs and the garterbelt straps."[13]

Among Coughtry's admirers was the Mohawk artist Robert Markle. From Coughtry, he learned the vocabulary of paint; the language was Markle's and mainly involved the figure. Although he was of the First Nations, Markle chose to be more interested in the urban world than in his native past during the major part of his career: "No camping for me," he used to say.

"I'm an urban Indian." However, during the last ten years of his life, he began to incorporate the symbols of his First Nations heritage into his work. At the age of sixteen or seventeen, Markle worked as a sign painter and as a result developed a basically calligraphic approach to art. At the Ontario College of Art, Markle quickly found the drawing classes taught by Eric Freifeld of less interest than the streets of Toronto. His studio became the Victory Burlesque Theatre on Spadina Avenue in Toronto and places like the Palace Burlesque in Buffalo. Through his drawings and prints of burlesque dancers and nude lovers, he became interested in artists like the American painter and illustrator Reginald Marsh and the French nineteenth-century painter Eugène Delacroix. In show after show, Markle devoted himself to erotic subjects, often strippers, but glorified and in movement. He developed the subject using all the resources of abstraction and painterly technique at his disposal but added a special tribute to glamorous womankind (fig. 173).

The painting of John Meredith as in *Untitled* (1958, fig. 174), had a special sense of colouring and linear drawing to offer. From about 1964, his sketches, often in smudged ink, were his starting point but he transformed them into vigorous, broadly worked, dynamic canvases. His idiosyncratic calligraphy differed in its source from that of other members of the group: it was freer, more spontaneous, due to its roots in drawing. His forms are sometimes visceral and

Fig. 174. John Meredith (b. 1933)
Untitled, 1958
Oil on canvas, 132.5 x 95.7 cm
Robert McLaughlin Gallery, Oshawa

139

Fig. 175. Michael Snow, 1970
Michael Snow assembling ***Scope***, a stainless steel and glass sculpture, 1967, for his retrospective at the Art Gallery of Ontario, Toronto

organic in character. *Seeker* (1966, Art Gallery of Ontario, Toronto) was painted with the artist's parents in mind, considering them from a spiritual point of view. A triptych, the first the artist ever did, the work took four months to complete. Painted from a number of studies, it was Meredith's first major breakthrough in putting his drawings into his paintings. His black-and-white paintings from 1972 to 1980 suggest an influence from the Orient.

Michael Snow (fig. 175) occupies an important place in Canadian art. His work in film still serves as a point of definition for artists everywhere. Upon graduating from the Ontario College of Art in Toronto (in 1952), Snow made the usual European tour and came back to Toronto for a job with Graphic Associations, a film company run by animator George Dunning. (In 1968 Dunning directed The Beatles's *Yellow Submarine.*) At Dunning's studio, Snow met artist Joyce Wieland: they married in 1956. For Snow, wit and play, even in his early work of the mid 1950s influenced by Paul Klee, were always of paramount importance.[14] After a period of abstraction, he returned to the figure in 1961 with his series, *Walking Woman.*

Snow's leitmotif, from 1961 to 1967, was the generalized silhouette of a young woman caught mid-stride. In applying it, he defined a type of 1960s cool, using almost aseptic ideas in paint to illuminate his extraordinary vision of a world peopled by variations on his raffish cutout. From 1962 to 1967, Snow lived in New York, gaining first-hand knowledge about Minimal and Pop art and the multi-media Fluxus group, an eclectic international art collective founded in 1962 that shared a Dadaist sensibility with Canadian and American art. In a way similar to Dada, the Fluxus group conceived of art as a revolutionary mode of thought and action, a way of life rather than a set of stylistic attitudes.

Snow's interests are reflected in the way he developed the *Walking Woman* image, using every material and every method he could think of. In painting, this meant the use of watercolour, ink, tempera, oil, enamels, spray enamels,

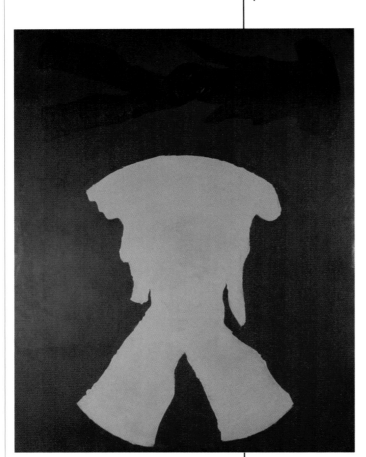

140

Fig. 176. Michael Snow (b. 1929)
Turn, 1961
Oil on cotton canvas, 228.5 x 177.5 cm
Robert McLaughlin Gallery, Oshawa

and acrylic paint. In sculpture, he viewed the image as a structure on which to hang various procedures and as a way of looking into the work through perspective, for instance. Or, he might stencil ties and sweatshirts with the image or stamp it on papers he scattered on the ground or in the subway, photographing the result.

The kind of visual play Snow enjoyed can be understood from *Turn* (Turning in the paint) (1961, fig. 176), in which he paints a shape similar to the "angels" made by a person lying in the snow. Here the snow is dark brown and the figure that turns exposes lime green. There is also a pun on Snow's name. Above, on her side in black, is Snow's *Walking Woman*, but the usual svelte simplified cut-out wearing a tight skirt is squeezed slightly tighter than usual and rotated. The size of the work, its simplicity and off-beat colour make it one of the impressive paintings in the series.

There's something absurd in the *Walking Woman* image, even wispy: she leaves the room in *Exit*. Sometimes, she appears as a multiple in blue, black, and red. By 1963, she's more sexy, and Snow plays with the application of paint; she may appear nude along with dressed images; or folded up in his "Foldages" (pictures of her folded). This mood climaxed in 1970 when Snow showed himself having sex with Walking Woman in the punningly titled *Projection*. She walks into one side of a painting called *Estrus*. At the other end is her cut-out. In *Gallery*, he showed her walking in front of a Mark Rothko painting. She can become a collage, rolled and weathered. At Expo '67, she became a series of stainless steel sculptures (today, in the collection of the Art Gallery of Ontario, Toronto). Every work of the *Walking Woman* was of a different kind, generated a different content.

From 1956, the time of his work at Graphic Associates, Snow made films. In New York, in 1963, inspired by American avant-garde cinema and especially filmmaker Jonas Mekas, Snow began to produce films that revealed and elaborated the formal structure and essence of the medium. It is in this area that he has made his most important contribution to world art. *Wavelength*, made in 1967, is one of the high-water marks of Structural film, the term coined by P. Adams Sitney in 1969 for minimalist experimental film of the late 1960s and early 1970s (fig. 177). In Structural film, the filmmaker refines the medium to its essentials: shape takes priority over content, and the medium is of primary

141

Fig. 177. Michael Snow (b. 1929)
Still from Wavelength, 1967
45 min., colour
Art Gallery of Ontario, Toronto

142

importance. It is, in some ways, a filmic equivalent of Minimal art. *Wavelength*, with its fixed camera position, use of framing, restricted camera movement and oblique understated way of indicating narrative, helped Sitney define the *genre*. In the movie, set in Snow's New York loft on Canal Street, the action consists of the camera's executing a 45-minute zoom slowly and inexorably toward the centre point of a four-windowed wall. Shortly before the camera hits the wall, the shot ends, centimetres away from a black-and-white, post-card-size photograph of ocean waves (hence, the title). Throughout the film, the scene changes. Light and sound play off each other in revealing ways. The light is partly natural, partly unnatural; at moments, through the use of filters, Snow turns it lurid. The sound, a "continuous electronic glissando against and with sync sound of traffic, speech, breaking glass and played-on-the-set radio," similarly combines the real and unreal.[15] In this narrativeless structure, Snow creates an eerie effect of suspense by having a man fall to the floor and a woman telephone for help.

Snow's work in film challenged the medium; it usually involved various ways of experimenting with the camera to twist reality one way or another. For *La Région Centrale* (1970), he designed a camera that could move three hundred and sixty degrees in every direction; for three hours of running time the camera rolls and twists to reveal many views of a rugged mountainous land-

scape, fulfilling Snow's ambition to make a film equivalent to the work of the Group of Seven. He also recorded a double album of solo musical works entitled *Musics for Piano, Whistling Microphone and Tape Recorder.*

Snow's art is always to be unusual in format, idiosyncratic and low-key in tenor. Usually, it stretches the medium in new directions — from film to photography, painting, sculpture, and music (he is an accomplished jazz pianist and trumpet player). He has also published three books. His photoworks of the 1970s anticipated a generation that used non-traditional media. In 1978, he created a Toronto landmark, *Flight Stop,* in the Eaton Centre, the city's largest shopping mall. Here, a flock of sixty geese, fibreglass bird forms feathered with hand-tinted black-and-white photographs of a Canada goose were suspended from the ceiling. A reference to the "real" was always to be one of his resources. Snow toyed with realism in his *Still-Life in 8 Calls* (1986, Montreal Museum of Fine Arts, Montreal), holographically represented images of a table stocked with paraphernalia that run from a "realistic" projection (at right) through different versions to the same image but seemingly in reproduction shaded in green, yellow, and red. The sequence can be read the other way so that the reproduction becomes the "real." Snow had other tricks up his sleeve when dealing with themes of psychological and social meaning. In 1989, his sculpture *Audience at the Sky Dome* featured an audience (below) that looked up at an audience that expresses approval and disapproval. His work is most accurately described as playing with the workings of the mind and variables in the act of seeing.

Joyce Wieland, the Toronto painter, quiltmaker, and filmmaker, was the first living woman artist to have retrospectives at the National Gallery of Canada (1971) and at the Art Gallery of Ontario (1987). Like Snow, she was influenced by New York underground film and Pop art. She worked as an animator from 1956 to 1958, and in her films of the 1960s, wittily sought to express her concerns: the environment, nationalism, and feminism. In *Rat Life and Diet in North America* (1968), for instance, the rats, who are threatened by cats, represent draft dodgers and ecologists. In 1976, Wieland made a full-length feature film based on a fictionalized life of Tom Thomson, *The Far Shore.* Its narrative concerns a small-town Quebec woman, Eulalie (played by Celine Lomez), who in 1919 marries a rich engineer, Ross Turner, who takes her home to

143

Toronto's Rosedale section, a bastion of WASP Ontario. Claustrophobic in her surroundings, unhappy with her husband, she falls in love with his friend, an artist named Tom. (We have no doubt that Wieland refers to Thomson. When we first see him in his studio, he's at work finishing *The Jack Pine*.) They come together, but death is the result.

Like others of her generation, Wieland was concerned with sexuality. Her work involves an analysis of gender differences that prefigures a later generation of feminist artists. In her stained paintings and collages of the late 1950s and early 1960s, like her *Time Machine Series*, she uses female sexual imagery, uteruses as mandalas. She was one of the first women artists in Canada to refer to menstrual (and other) blood in a work, as in her painting *Heart On* (1961, National Gallery of Canada, Ottawa), where she uses red ink to describe "accidents" on a sheet. By 1963, the form of her work changed to framed or boxed constructions and serial or film strip-like paintings of tragic events,

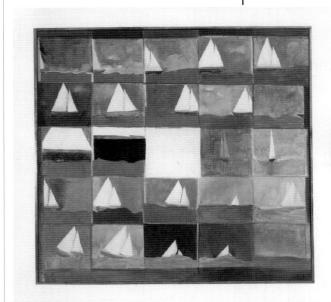

painted comic book fashion like her *Sailboat Tragedy with Spare Part* (1963, fig. 178). Her plastic collages of 1965 were stuffed and quilted. Because they involved her home and studio, she called them "home totems." In making them, Wieland used unusual materials and combined fine art with craft.

Wieland went on to explore the medium of the quilt, which had long enjoyed prestige in the structure of women's art. In 1967 and into the 1970s, she rejuvenated the quilt medium with political and ecological motifs (she was one of the first Canadians in a new breed of artist activists) and handled it almost as collage to express her spirited nationalism and love of nature. She made her quilt *I Love Canada* in English and French versions, or played on the word "Canada" itself. Elsewhere, she took an historical stance, examining Canada, its land, people, and resources. In *The Water Quilt* (1970, Art Gallery of Ontario, Ontario), there is a message under the muslim flaps embroidered with endangered Arctic flowers or grasses that front the sixty-four pillows. The

144

Fig. 178. Joyce Wieland (1931-1998)
Sailboat Tragedy with Spare Part, 1963
Oil on canvas, 129.4 x 134.8 and 21.3 x 24.5 cm
Vancouver Art Gallery, Vancouver
Photo: Jim Gorman
Photograph reproduced courtesy of
Joyce Weiland Estate, Toronto

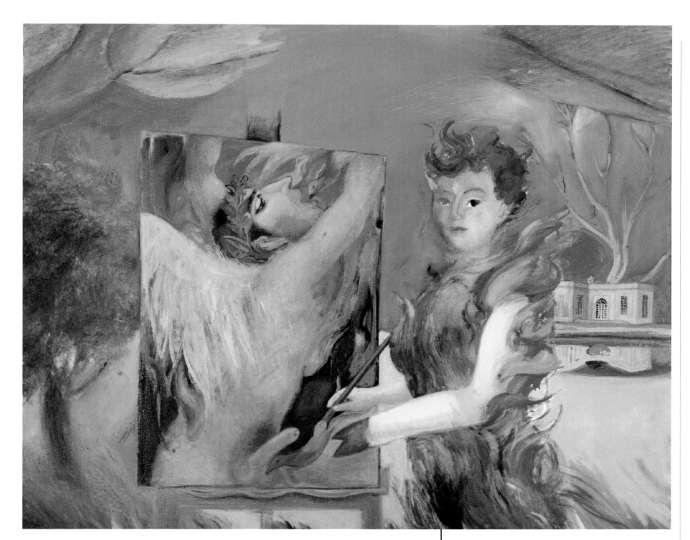

flaps may be raised to reveal texts taken from James Laxer's ecological and political study, *The Energy Poker Game* (1970). In 1978, inspired by a trip to Cape Dorset in the Arctic, Wieland began to draw goddesses with one of her favourite mediums, coloured pencil. In this format, she explored stories, often fantasies, of love, landscape, and myth.

Fig. 179. Joyce Wieland (1931-1998)
Artist on Fire, 1983
Oil on canvas, 106.7 x 129.5 cm
Robert McLaughlin Gallery, Oshawa

The impulse to mix categories inspired Wieland's 1982 flowering earth sculpture, *Venus of Scarborough*, for a Toronto Outdoor Sculpture show at the Guild Inn in Scarborough, created at the same time she was painting ethereal mythological and spiritual subjects. In her *Artist on Fire* (1983, fig. 179), she made explicit her dream of art as a transformative experience of body and mind. The painting contains a naked, winged male — her hero — with an erection; he is being painted by the artist. The setting seems to be Versailles, and

Fig. 180. John MacGregor (b. 1944)
*Pro Humanitae Tempus
(Time for all Mankind), 1983*
Papier maché, styrofoam, plywood, acrylic,
steel supports, 261.6 x 229.2 x 241.3 cm
Robert McLaughlin Gallery, Oshawa

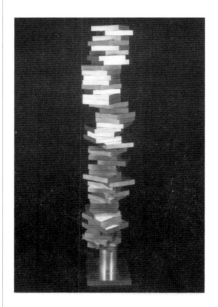

Fig. 181. Ulysse Comtois (b. 1931-1999)
Column No.6, 1967
Aluminum, 137.7 x 22.2 x 22.0 cm
Musée d'Art Contemporain, Montreal

Wieland makes the artist look like Madame du Pompadour with her pulled-back hair style. *Artist on Fire* is not so much a provocative statement of desire as a happy fabrication exalting women. An element of reality, Wieland's own face, pierces the dreamy soft-focus of the technique so that we look into the scene as theatre. After the retrospective in 1987, Wieland returned to the freedom of her early abstractions and combined this with her basic themes of growth, nature, love, and life.

John MacGregor, in the late 1960s and early 1970s, pursued a subject that involved an absurdist world of domestic objects — real chairs, tables, and pianos, often bent in serpentine curves, with the contours outlined in black. "I do uncommon things with mundane objects to tantalize, amuse and finally communicate," he said.[16] In the mid 1970s, process-driven, with dashing energy and brilliant colour, MacGregor turned to abstraction to paint some of his most successful and ambitious works. After a bout with abstraction, MacGregor reapproached the vocabulary of domestic objects that stamped his work with an immediately identifiable personality. In *Pro Humanitae Tempus (Time For All Mankind)* (1983, fig. 180), MacGregor weighed in for the first time with large-scale sculpture. The clock, of moulded paper pulp and plywood, cleverly extends into three-dimensions, half virtual, half real.

Sculpture in the 1960s and 1970s, like painting, expanded on a formal base drawn from Cubism and Minimal art. In Montreal, Ulysse Comtois, who had been a painter on the periphery of the Automatists, turned to welded metal sculpture with a playful format after visiting a New York exhibition of the Cubist sculptor Julio Gonzalez. Comtois was keenly interested in scrap industrial materials, space, and in the participation of the viewer through the manipulation of the mechanisms of the sculpture. In *Column No.6* (1967, fig. 181), the

aluminum plates on the steel base fan out tautly and can be moved to change the shape of the sculpture: the result has a precision and vitality that only looks effortless.

In the mid-1970s and 1980s, Roland Poulin and Claude Mongrain became known for their thoughtful, subtle, abstract sculpture. Poulin, who works in Sainte-Angèle de Monnoir, Quebec, regarded an encounter with Borduas's *Black Star* (1957, fig. 103) as his starting-point as an artist. Poulin graduated from the École des Beaux-Arts de Montreal in 1969; the following year, he worked as an assistant to sculptor Mario Mérola, one of his professors at the school. Poulin's interests, he found, lay, however, with the abstract painting of Barnett Newman and Mark Rothko — resonant abstract art imbued with a spiritual dimension. In the mid 1970s, Poulin's monolithic work expanded on a Minimalist vocabulary of elementary geometric forms combined with the errant notions of Post-Minimalism. From 1980 to 1985, his signature style in sculpture became a periphery around an empty core, both occupying and enclosing space, as in *Place* (1980, fig. 182). His work became ever more spare and reductive. In *Shadows in the Angles* (1981-1982,

Fig. 182. Roland Poulin (b. 1940)
Place, 1980
Cement, 32 x 163 x 161 cm
Montreal Museum of Fine Arts, Montreal
Gift of the artist

147

Fig. 183. Claude Mongrain (b. 1948)
Construction (Italie)
Concrete (10 sections), 63 x 240 x 170 cm
Canada Council Art Bank, Ottawa

Musée d'Art Contemporain, Montreal), for instance, rectangular cement pieces cast shadows.

Claude Mongrain's work was equally involved with occupying space,

Fig. 184. Robert Murray (b. 1936)
Kennebec, 1978
Painted aluminum, 119.3 x 114.3 x 40.6 cm
Art Gallery of Greater Victoria, Victoria
Purchase with funds provided by the Gwen
Scott B.C. Art Fund and the Women's
Committee Cultural Fund of the Art Gallery
of Greater Victoria

though he showed a greater fluidity in his use of materials. In his *Construction Series* (1978-1980), he uses binding wire and concrete with a uniformly white coloration to construct what looks, at first, like found objects, as in *Construction: Italie* (1979, fig 183).

Robert Murray made large simply structured elegant sculptures with flat metal or stalk shapes in steel and aluminum (later, bronze) that were equally assertive about objecthood. Murray's theme often involved a kind of dialogue between two dominant aspects of the work such as a cylinder and plank: his interest was in their interrelationship, and particularly in the space they created between them. After a decade (1963-1973) of using industrial processes to create metal works painted in strong brilliant colours and composed of forms tilted or folded at angles, Murray's sculptures began to look more dramatic and spontaneous. Their idiosyncratic curves and complex foldings become remarkable for their fluidity.[17] *Kennebec* (1978, fig. 184), for instance, consists of a "crinkled" rectangle standing on one side with wings at the corners. In the 1980s, Murray alludes in his sculpture to the

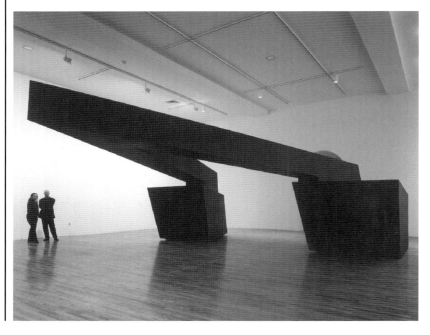

Fig. 185. Ronald Bladen (1918-1988)
Cathedral Evening, 1969
Painted wood, 294.6 x 751.8 x 873.8 cm
Private collection

aboriginal cultures that impressed him when he lived in Saskatchewan. In *Sioux* (1984, Delaware Art Museum, Wilmington), the metal mass abstractly recalls the coverings used on Prairie tipis.

Ronald Bladen, by contrast, sought an effect of light, speed, and weight-lessness in his work. In *Rockers* (1965, Private Collection), two square yellow pillars rise from three low "rocking" yellow and black forms. In *Cathedral Evening* (1969, fig. 185), the title from a Bob Dylan lyric, a huge V-shaped form like the prow of a ship thrusts outward and upward into space from two massive blocky forms, dramatically commanding space. In *Curve* (1969, Private Collection), a great U-shaped thick wall, slightly raised from the floor so that it seems to hover, black on the outside and white on the inside, provides a

Fig. 186. David Rabinowitch (b. 1943)
Sided Conic Plane in 3 Masses and 2 Scales, I, 1973
Hot rolled steel, 4 x 120 x 100 cm
Private Collection
Photo: Douglas M. Parker

149

metaphor of breakwater and wave, or of love and acceptance within a slightly forbidding exterior.

Like Bladen, David Rabinowitch, who has lived and worked in Europe and New York since 1972, is concerned with the basics of perception through highly specific structures, although his sometimes conjure art history. In his rigorous horizontal extension sculptures of the early 1970s that recall jig-saw puzzle pieces fit together through intersecting planes as in *Sided Conic Plane in 3 Masses and 2 Scales, I* (1973, fig. 186), Rabinowitch sets up the conditions for his

Fig. 187. John Nugent (b. 1921)
Oribark, 1982
Metal and steel welded,
181.0 x 62.5 x 38.0 cm
MacKenzie Art Gallery, Regina
Gift of the Artist
Photo: Don Hall

150

Fig. 188. Douglas Bentham (b. 1947)
Crown, 1978
Welded steel sculpture,
147.5 x 205.8 x 134.7 cm
Robert McLaughlin Gallery, Oshawa
Gift of the artist

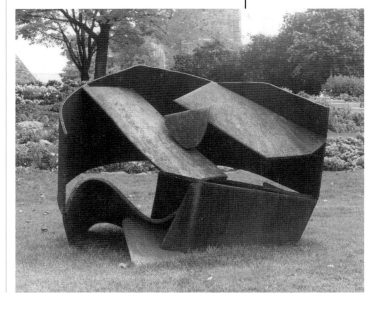

sites; he stresses the dialogue that takes place between sculpture and viewer by requiring viewers to walk around the work to perceive it. Royden Rabinowitch, his brother, who today lives in Belgium, believes equally that his cut and welded overlays from single shaped pieces of steel creased to show facets means that the viewer, by moving around the work, brings it into his time and space. The scale of the sculptures, which he calls bodies, he relates to body-size; the process of creation, to geometry. *Blue Piece* (1969, Canada Council Art Bank Collection, Ottawa), a large blue semi-circle, demonstrates his predilection for strongly marked geometric form. Moving around the sculpture reveals the magic trick of giving life to dumb geometry, and the viewer happily falls for it.

In Lumsden, Saskatchewan, John Nugent, who had visited the great American sculptor David Smith at Bolton Landing in New York (1961), cast bronze or welded precut steel in planar geometric combinations. In the 1980s, as in *Oribark* (1982, fig. 187), he uses shapes (and titles) fabricated by himself.

In Saskatoon, Douglas Bentham, who studied with the American Minimal sculptor Michael Steiner in 1970, combined found objects and fabricated elements in weighty arrangements of geometric solid steel planes like *Crown* (1978, fig. 188).

In Edmonton, Alan Reynolds, who also studied with Steiner, developed free-standing relief sculpture of wood or welded-and-painted steel, clay, and cast iron, reflecting on the complex play of small structural elements. Though his work was essentially formal in

orientation at the onset of his career, over time it came to reflect events and objects in his life with special meaning for him. Reynolds developed a symbolic visual vocabulary repeated in many sculptures. Such inspiration was expressed in a generalized way in *Fiddle Boy* (1988, fig. 189), for instance, where Reynolds uses irregular elongated metal forms, lean, jaunty lines, and a playful approach, to evoke boyhood.

In Toronto, André Fauteux combined metal objects as Bentham did — found steel and pieces of industrial origin — but, due to the time he spent assisting Anthony Caro welding and fabricating Caro's works at York University in Toronto in 1974 and to an interest in the work of Kenneth Noland, he worked more playfully and improvisationally (fig. 190).

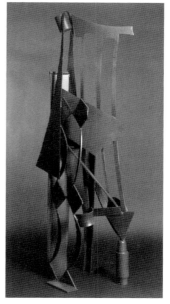

Fig. 189. Alan Reynolds (b. 1947)
Fiddle Boy, 1988
Welded steel and alkyd paint,
213 x 79 x 58 cm
R.D. Bell, Q.C., Calgary
Photo: H. Korol, Edmonton Art Gallery, Edmonton

151

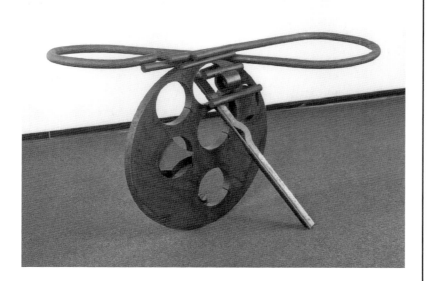

Fig. 190. André Fauteux (b. 1946)
Mashomack, 1983
Welded steel, 93.0 x 162.0 x 102.0 m
Private Collection

Henry Saxe in the mid 1960s, first in Montreal, then in Tamworth, Ontario, where he moved in 1973, built sculptures that referred to the machine and articulated their own creation, combining the Constructivist tradition with Minimalism; he focused on flexible chain and hinge linkage systems in aluminum or enamel on steel as in his half yellow, half blue

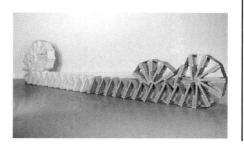

Fig. 191. Henry Saxe (b. 1937)
Fiftyflex, 1968
Aluminum, 61 x 30.5 x 1525 cm
Canada Council Art Bank, Ottawa

Fig. 192. Walter Redinger (b. 1940)
Caucasian Totems No.3, 1972
Fibreglass, 14 units up to 549.0 cm in height
Canada Council Art Bank, Ottawa

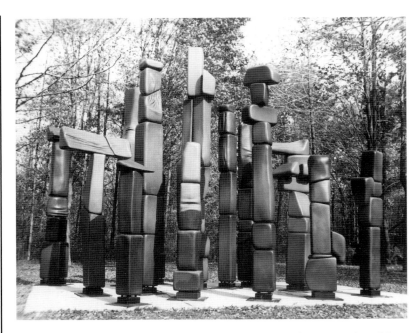

152

Fiftyflex (1968, fig. 191). In the 1970s, Saxe developed the material and formal contrasts of large triangular or circular shapes; in sculptures of half-inch steel plate he details his preoccupation with an imaginary model of space that includes motion, memory, and time.

By contrast, Walter Redinger and Ed Zelenak, both working in West Lorne, Ontario, encompassed organic shapes in their work. Redinger, in particular, is inspired by people, animals, and machinery in an ambiguous amalgam in which at any one time, one or more ingredients may stand out. Redinger had studied at Beal Technical School in London, Ontario; at Meinzinger Art School in Detroit; and with Jock Macdonald at the Ontario College of Art. In the period 1965-1971, Redinger became well known for his visceral forms, both abstracted and organic, full of a tension reflecting the condition of the human body in the twentieth century. In the early 1970s, he began to make totems like *Caucasian Totems No.3* (1972, fig. 192), that seem to change as the viewer moves around them. Redinger's work of this date suggests a certain evocative quality that continues in his work of the latter part of the decade, when he utilizes zebra stripes and swelling forms to create an exotic optical effect. In 1979-1980, Redinger switched to organic shapes amid geometric forms, often with central units in a ziggurat formation. One of his favourite materials has long been cast glass fibre over wood to which he applies enamel.

Well known in the 1960s and early 1970s for his huge outdoor monuments, Ed Zelenak presented enigmatic, organic, geometric work that addresses the nature of perception. About 1967, dissatisfied with plywood, the material he had been using, Zelenak switched to glass fibre. *Convolutions* (1969, fig. 193), for instance, one of his tube-shaped "intestinal" sculptures that deals with the entrapment of space, presents an appearance of buoyancy and swelling. He continued to discover

Fig. 193. Ed Zelenak (b. 1940)
Convolutions (1969)
Fibreglass, 82.6 x 177.8 cm
London Regional Art and Historical
Museums, London
Photo: Ian MacEchern

new and more personal ways of constructing methodical, meditative work. In the early 1970s, Zelenak began to cut into his construction materials, to define what was happening in one section of a cylindrical piece, exposing the interior volumes and material. Using resin with an aggregate of metal particles, he made a cement-like concoction. The result was more compressed work, which from the late 1970s on, often hugged the floor or wall. In the late 1970s, as in his floor sculpture that involves sculpture and drawing, which Zelenak intends to be read as a map, his work acts as a visual journal in tablets of lead and steel. It records certain investigations, graphic notations and forms Zelenak conceived during construction.

Halifax's John Greer made his debut as a sculptor in the late 1960s (he graduated from Vancouver's School of Art in 1967). His work has never fit into ready categories. Often, it has an elusive quality and temporal presence: his thought process draws upon the nature of time and logic, the paradoxical and mythological. He's long been involved with the semantics of meaning. Greer got the clue from the work of Surrealists such as Picabia and Man Ray, whose work he saw in Toronto years ago. In 1970, for his first show in Toronto, Greer made string *Elastic Airplanes*. In the early 1980s, his large works in granite recall Egyptian plinths inverted and Pictish carving in Scotland. In the base of *Comb Stone* (1982), there is a gold comb set teeth down. In the 1990s, Greer uses basic shapes, often drawn from nature, such as a grain of rice or wheat and develops these into large forms. His *Three Grains of Wheat* in bronze graces

153

the Donald Forster Sculpture Park of the Macdonald Stewart Art Centre in Guelph (1991, fig. 194). For Greer, what counts is the relationship of the mass to the void; these metre-long shapes add an expressive quality to the space. Greer's sculptures continually surprise the viewer with their shifting range of allusions, from the wings of angels to nesting birds.

Fig. 194. John Greer (b. 1944)
Three Grains of Wheat, 1991
Bronze, 99.0 x 43.0 x 32.0 cm
Macdonald Stewart Art Centre,
University of Guelph, Guelph
Gift of Isabel McLaughlin in memory of
Norah McCullogh, 1993

Like Greer, Calgary's Carroll Taylor-Lindoe casts a poetically oblique light; her materials though often drawn from the natural world offer a metaphor about language and the community of sculptors (fig. 195). In this school of thought, she is joined by Ontario artist An Whitlock, whose sculpture, usually wall-mounted and often made from materials such as latex rubber, cotton batting, cheesecloth, and cotton string, combines Post-Minimal forms and materials with personal implications. Whitlock's technique in *For David* (1973, fig. 196), effectively mines both design and the element of chance. In modular units on the wall, she places unbleached cotton batting with a skin of cheesecloth bonded to its surface as a grid, then introduces cotton strings at intervals across the weave of the

cheesecloth in each unit. She then pounds latex rubber into the surface. The dried latex creates dark patches in the batting, and the woven strings fell in tangled bunches rather than in a straight line. Whitlock realized that every time the piece was handled, it was subject to alteration. For her, these changes reinforced the sensibility she wished to express, with undertones having to do with the fragility

Fig. 195. Carroll Taylor-Lindoe (b. 1948)
Wing Slat, 1977
Mixed media

154

of life. Her subsequent work (and into the 1990s), using a diverse range of materials, continues to be informed by such basic themes. In 1990, Whitlock uses perforated steel to activate her sculpture *shadowline*, a work that alludes to domestic architecture; in 1993, she uses plaster casts of tiny patches of earth or other natural surfaces placed within wall-mounted boxes reminiscent of coffins.

In painting, by the mid-1970s, many emerging Canadian artists drawn to the possibilities of abstraction, are mapping out their own territory. For these artists, what matters is the vocabulary of modernist expression: the result in their work is a kind of art history, restating the act of creation as a form of performance. They note the significance of the medium, the importance of form and surface. In painting, this often means the way pigment is applied, the significance of gesture, line, and mark-making. In retrospect, the work of these artists seems torn between lyrical impulse and rigorous adherence to Abstraction, with a glance at Minimal art. The result gives the work an interesting tension.

Paul Sloggett juxtaposed contrasting elements, often involving geometry, to develop sensitive renderings of spatial tensions in his neo-constructivist paintings (fig. 197). Perception was the subject of Richard Sturm, who in 1974 looked at a chain-link fence from a studio window until he saw it not as a barrier but as a sieve through which he strained information; he used the idea to develop paintings of different colour harmonies that resonate through an all-over structure of large dots, criss-crossed strokes, or flecks, which are grounded in some reality drawn from space and time as in *Zones of Preference* (1978, fig. 198). In the 1980s and 1990s, Sturm

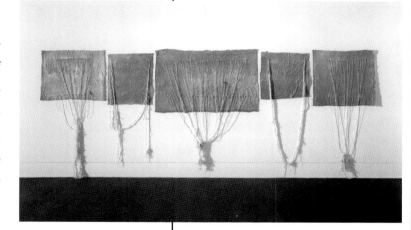

Fig. 196. An Whitlock (b. 1944)
For David, 1973
Rubberized wadding, cheesecloth, and cotton string (5 sections), 199.7 x 501.7 cm (overall dimensions)
National Gallery of Canada, Ottawa

Fig. 197. Paul Sloggett (b. 1950)
Northern Mystery, 1986
Acrylic and plywood on canvas, 152.4 x 137.2 cm
Robert McLaughlin Gallery, Oshawa
Photo: T.E. Moore

155

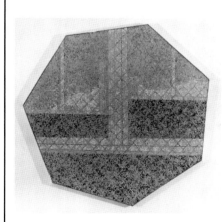

Fig. 198. Richard Sturm (b. 1944)
Zones of Preference, 1978
Acrylic on canvas, 203.2 diameter (heptagonal)
The Artist
Photo: T.E. Moore

Fig. 199. David Craven (b. 1946)
Lau Fin, 1978
Acrylic on canvas (triptych), 228.9 x 277.3 cm
Robert McLaughlin Gallery, Oshawa

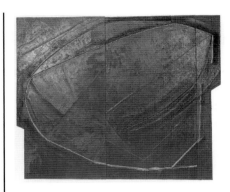

Fig. 200. Ron Martin (b. 1943)
One Human Substance No.12, 1976
Acrylic on canvas, 213.4 x 167.6 cm
London Regional Art and Historical
Museums, London

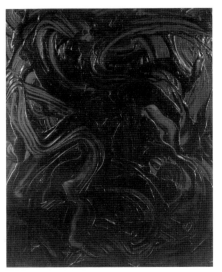

156

Fig. 201. Bobbie Oliver, 1978
(Third from left): Bobbie Oliver

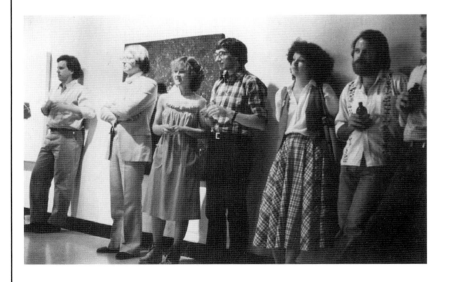

expanded on the theme in many vibrant paintings.

Other artists restlessly and resourcefully explored the nature of materials. David Craven used boldly expressionistic swoops of paint, and Ron Martin executed heavily encrusted and scraped monochromatic series of black, bright red, and white paintings as in *One Human Substance No.12* (London Regional Art and Historical Museums, London), often with rigid rules he imposed on the work (figs. 199-200). In 1978, Bobbie Oliver (fig. 201), who had worked as a sculptor, began to make definite objects, half painting, half sculpture, with thick, textured grounds of oil pigment,

wax, and varnish on thick plywood. Using a restricted palette, Oliver painted and incised these surfaces with simple geometric forms in ritualistic and gestural experiments (fig. 202). With a feeling of formal urgency, Ron Shuebrook, who moved to Canada in 1972 after graduating from the Masters of Fine Art program at Kent State University in Ohio, also restricted the vocabulary in his big sometimes unusually shaped canvases and charcoal drawings for the sake of creating more monumental works; he developed thickly painted, layered surfaces, and simple, geometric or architectural patterns (often a narrow central image), combined with a restricted colour range, as in *Untitled* (1989, fig. 203). The textures in different areas of his works varied from scraped shiny acrylic to matt oil painting. Sydney Drum, in her early work, translated physical gesture into paint, using her ability to stretch to direct the stroking she made in her floor and wall drawings, paintings, and prints. The forms in Drum's work, often discs or a succession of arches, reflected her way of spanning a surface (fig. 204). Starting in 1993, she engaged the viewer in a different way in her paintings; through a discussion of abstraction and representation, offering a pure abstraction side-by-side with an outdoor scene. Harold Klunder, from 1973 to 1979, worked with heavily layered and textured paint in his dense, vividly

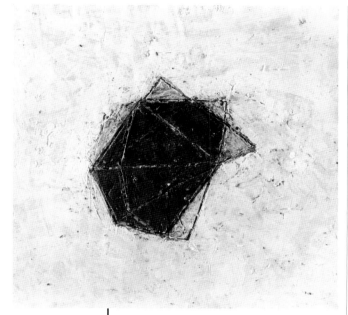

Fig. 202. Bobbie Oliver (b. 1948)
Painting, 1977
Beeswax, oil pigment on plywood,
60.96 x 60.96 cm
The Artist
Photo: Alexandra Conway

157

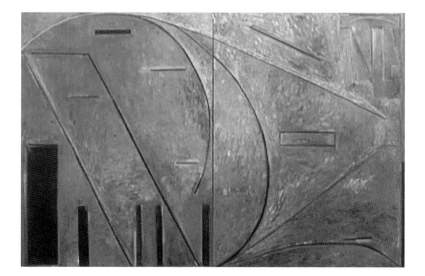

Fig. 203. Ron Shuebrook (b. 1943)
Untitled, 1989
Oil on canvas, 2'44.0 x 3'66.0 cm
Macdonald Stewart Art Gallery, University of Guelph, Guelph

coloured gestural abstractions, using a pool of images and patterns often taken from found objects and large geometric shapes. In the early 1980s, he began developing a figural reference through drawing. In constructing the images in his *Schoenberg Drawings*, he used composer Arnold Schoenberg's concept of music as repetition with continual minute changes to develop shifting points on the line bounding the figure. By the mid-1980s, Klunder had transformed his struggles with the right point of balance to portraits like *Untitled Mandala*

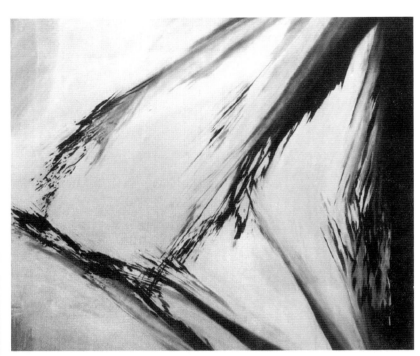

Fig. 204. Sydney Drum (b. 1952)
Untitled, 1979
Oil and magna on canvas, 205 x 230 cm
The Artist

158

(Self-Portrait 1) (1985-1987, fig. 205), a portrait of his father combined with a self-portrait, which displays a passionate, distinctive, and solid sense of materials and abstract language. He called such work "psychic realism."[18] "I don't think of this as abstract painting," he said.[19]

Scholarly retrospective exhibitions of the work of these artists are needed to understand their triumphs — as well as a comprehensive survey show of the period that will integrate their careers. Their ambition and invention has made them elusive to theory-minded scholars and for critics who find it hard to get beyond a description of stylistic change. In the future, we can expect much new critical writing on their work; they certainly have added provocative beau-

tiful pictorial effects and suggestive contrasts to the abundance of visual riches in Canadian art in the twentieth century. The message here is that the media of painting and sculpture, which remain above all surfaces to be animated and forms to be shaped, still contain much uncharted territory

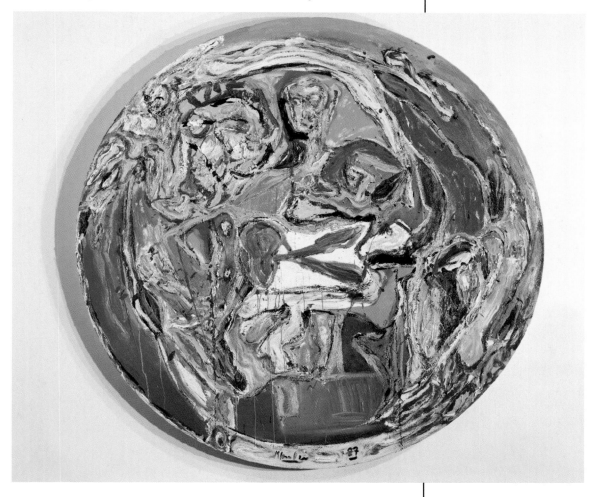

159

Fig. 205. Harold Klunder (b. 1943)
Untitled Mandala (Self-Portrait I)
Oil on canvas, 213.4 cm (circular)
The Artist

Fig. 206. Victor Cicansky (b. 1935)
Prairie Waterworks, 1973
Ceramic, wood, sand, enamel paint, epoxy,
48.3 x 71.1 x 45.7 cm
MacKenzie Art Gallery, University of Regina
Collection, Regina

Chapter Six
Alternate Practice

I n the late 1960s and 1970s, public and private galleries in Canada were eager to be first in picking up the latest trends. Some galleries, like the Edmonton Art Gallery (director Terry Fenton and curator Karen Wilkin), and the Robert McLaughlin Gallery in Oshawa even made abstract art part of the gallery's collection mandate. At the same time and equally pervasive was the emergence of counterculture, of artists who considered themselves "other" — that is, members of marginalized groups. They achieved art-world recognition with work that attempted to eliminate the distinction between high art and popular life through media long associated with crafts. New social forces, the publication of books like Judy Chicago's *Through the Flower* (1975) and Lucy Lippard's *From the Centre* (1976), and the founding of institutions dedicated to showing the work of women artists like Montreal's Powerhouse Gallery, founded in 1973 (in 1991, it changed its name to La Centrale), made clear the importance of sexuality and multiculturalism. Among the artists who led the way were women and men whose work was a hybrid of Conceptual art and narrative combined with colour-field painting. The results were theatrical and involved a drama of sorts, though engaging the audience was sometimes awkward. There was undeniable beauty in their use of medium, most often photography and videotape. Installation was also favoured. Ultimately, the medium, even when it meant the adaptation of a traditional material or older convention, was, with these pioneers, transformed.

Through the 1970s, dissenting gestures would focus more on Conceptual art, a form of expression aimed less at optical stimulation than at intellectual processes the viewer is invited to share with the artist. Conceptual art carried the reductive process of Minimal art still further so that the work, as one possibility, could exist in the realm of the artist's thought. One of Conceptual art's subjects was the art field itself; art-making could become a matter of elaborating a set of projects that took the gallery or art field as a physical resource and intervened in its character to suggest an ironic rereading of the production and support system of art. The result, while a serious criticism of

the susceptibility of art to commerce, could convey an obscure narrative and seem overloaded with information. Canadian Conceptual work was saved by a heady sense of energy, which made the artist's production ironic, entertaining, oddly amusing to look at, deceptively orderly, and very much in the spirit of the period.

Artists whose work was characterized by experimental approaches to natural materials and process include those in the community of ceramicists in Regina, Saskatchewan. Regina's involvement with clay was a result of the interaction of emerging artists with West Coast Funk ceramic art. California artist Ric Gomez, a student of San Francisco Bay area ceramic artist James Melchert, came to Regina in 1964. Regina's Victor Cicansky recalls attending a workshop Gomez gave and observing him mix glass fibre with clay to give clay the working properties of leather. But it was the encouragement Cicansky received from California's great "funkster" Robert Arneson (whom Cicansky had met at Haystack Mountain School of Art in Maine in 1967), a maker of colourful, ironic, larger-than-life ceramic tableaux, that led Cicansky to work in clay. As a result, he attended the university where Arneson taught (University of California at Davis) in 1968. In California, encouraged to work from experience, Cicansky began what became a series of ceramic tableaux on a prairie theme that invoked Arneson's free-wheeling spirit and even his subject; in the 1960s, this was, for Arneson, the ultimate ceramic in western culture — the household toilet. Cicansky, in sympathy, concluded that his subject in ceramics would be the outhouse. "I had grown up in the east end of Regina," he said, "and outdoor toilets made an impression on me."[1] Travel through small-town Saskatchewan assisted him in studying this architectural feature. In his *Prairie Waterworks* (1973, fig. 206), for instance, a piece with movable parts, Cicansky playfully turns an outhouse dwelling into a building with classical Greek elements fit for the ceramic geese that swim inside it in a tub of water and for the men posed outside. "Water always is a problem on the prairies," said Cicansky, with jovial humour, of the piece.[2]

In Regina, in 1970, influenced by California Funk, and ceramic artists such as David Gilhooly and Gomez, Joseph Fafard, who was teaching sculpture at the University of Regina, turned away from the kinetic abstract sculpture he had been making and began to sculpt in plaster eerie busts of fellow faculty

members. In the 1970s, in his engaging ceramics of farm animals, portraits of individuals drawn from his community and luminaries such as Queen Elizabeth, Fafard developed his personal artistic strategy and his own psyche. In the 1980s, he worked in a widening variety of formats like his ongoing series of portraits of great modern artists (Picasso, Matisse) and political figures. His bronze *The Politician* (1987, fig. 207) is a spirited evocation of John G. Diefenbaker, thirteenth prime minister of Canada. The sculpture, half-life-size, convincingly captures the public persona of the man in action. Though Fafard had seen Diefenbaker in Winnipeg in the 1960s, he invented the posture and situation. "Dief" stands on a chair, pushing his pelvis forward as he cantankerously surveys the room through pale-blue eyes with reddened lower lids.

Regina's Marilyn Levine turned to sculptural ceramics in 1968 when a trip to California allowed her to study Pop/Funk art at first hand in the work of clay artists like James Melchert. She reflected the encounter in asymmetric geometric sculptures, then in the following two years, did graduate work in ceramics at the University of California at Berkeley. After a brief flirtation with consumer objects like low-fired ceramic Coke bottles (*Soft Empties — Coke No.1*), Levine settled on meticulously rendering in clay leather objects like a knapsack or shoes. It was an approach Levine continued over the next three decades. To her depiction of worn boots with bent tops, she added specific information

Fig. 207. Joe Fafard (b. 1942)
The Politician, 1987
Bronze, paint, and patina,
107.0 x 35.0 x 24.0 cm
MacKenzie Art Gallery, University of Regina
Collection, Regina

163

Fig. 208. Marilyn Levine (b. 1935)
John's Mountie Boots, 1973
Clay, 35.6 x 33.0 cm
MacKenzie Art Gallery, University of Regina
Collection, Regina

about the original use of the objects, signs of wear that convey the personality of the owner (in *John's Mountie Boots*, sculptor John Nugent of Lumsden, Saskatchewan) (fig. 208). Her way of recording the passage of time reflected

themes of the 1970s in other media and body art, a form of art that uses overtly recognizable bodily images and processes.

In Vancouver, at much the same time, Gathie Falk was working with clay; her work was life-size or larger and imbued with oddly personal effects. She studied pottery and sculpture at the University of British Columbia with Glenn Lewis, later of the Western Front artists' group, and the extraordinary gift she developed in the 1960s through performance art and her "theatre art works," nonsense sequences with performers freezing into tableaux, transformed the mundane and sometimes the fetishistic into graceful scenarios. She was interested in men's shoes, objects from the grocery store and kitchen and living-room chairs. To these objects, Falk added junk-shop curios. In 1973, her ceramic *Eighteen Pairs of Red Shoes with Roses* (fig. 209), included the lines and creases left by wearers. Lining these up in a series (there's a rose decal inside each shoe) suggests, by contrast with Levine, a more indirect reference to the real world. Falk buttressed a brand of Surrealism by lining up her components across a large space; the accumulation of objects harnessed their associative capacity. In 1978, Falk began to paint, using as a subject her garden, then branching out to many different series, among them *Night Skies, Beautiful British Columbia Thermal Blankets, Cement Sidewalks, Theatre in B/W and Colour, Pieces of Water* and *Hedge and Cloud.* Compelling imaginative-

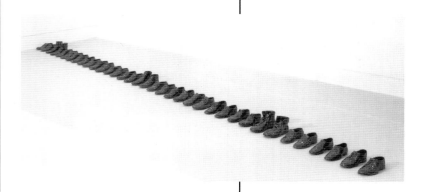

Fig. 209. Gathie Falk (b. 1928)
Eighteen Pairs of Red Shoes with Roses, 1973
Red glazed ceramic, decals,
16.5 x 584.2 x 30.5 cm
National Gallery of Canada, Ottawa

ly and formally, they often suggest an illusory, slightly dreamy space that reflects a poetic resonance. Falk's rueful irony that memorializes the present, and her conjunctions of images have had a wide-ranging influence, particularly on women artists like Toronto-based Jane Martin who paid tribute to Falk in her installation *Gathie's Cupboard* (1988-1998), an exhibition of feminist paintings, drawings, and prints.

Falk's impact suggests the significance of art by Canadian women artists of the 1970s. Such art constituted the first phase of philosophical engagement with questions of gender, questions that began to permeate the institutional framework of the gallery world; there, research began into the qualities that

constitute a women's aesthetic, particularly the use of the body or body imagery to explore identity.

Montreal's Betty Goodwin used male clothing, notably vests, from 1969 to 1974, channelling her attraction to these articles into printmaking (fig. 210) and collage. In 1974, in *Vest-Earth*, to signal the end of the series, she buried three vests in earth in a plexiglas case. In her subsequent *Tarpaulin series* paintings, she developed a grand, austere, but slightly lumbering presence, again by working on worn materials imprinted by human lives. Her *Tarpaulin No. 9* (1976, fig. 211), a huge piece of cloth complete with holes, painted red and black, is an imposing sight, a good example of what scale can mean in a well conceived piece. Hung as a canvas, the work stands as an eloquent testimony to the passage of time and the impact of life upon the artist; Goodwin's comments by adorning the pre-existing surface with accentuations of existing surface marks. In the room-sized installations that followed, Goodwin developed equally oblique if not necessarily more richly poetic narratives.

Other formal and material contrasts to Minimalism occurred in the obsessive, handmade work of the pioneering Montreal artist Irene F. Whittome. Her

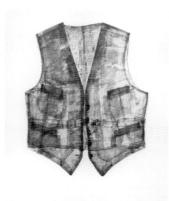

Fig. 210. Betty Goodwin (b. 1923)
Vest Eight, 1972
Etching on paper, 87.5 x 66.0 cm (paper);
70.3 x 55.5 cm (image)
Robert McLaughlin Gallery, Oshawa
Gift of Georges Loranger, 1983

Fig. 211. Betty Goodwin (b. 1923)
Tarpaulin No. 9, 1976
Oil on tarpaulin, 366 x 361 cm
Montreal Museum of Fine Arts, Montreal
Gift of Martin Goodwin in loving memory
of Paul Goodwin

165

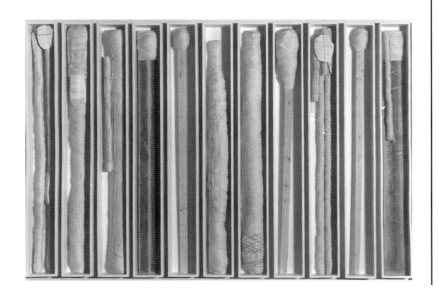

Fig. 212. Irene F. Whittome (b. 1942)
The White Museum II, 1975
Cotton, wood, etc., 220 x 361 x 16 cm
Canada Council Art Bank, Ottawa
Photo: Yvan Boulerice

Fig. 213. Irene F. Whittome (b. 1942)
Slate 41.34 from Paperworks,
1977-1978
Wood, various papers, encaustic, pins, powder pigment, felt pen, graphite, india ink, masking tape, metal, bone, plexiglass.
Photo: Montreal Museum of Fine Arts, Montreal

Fig. 214. Ron Moppett (b. 1945)
Veiled Threats, 1975
Acrylic with collage of photo-serigraph, cardboard, cloth, and bandages on canvas,
170.0 x 452.4 cm
National Gallery of Canada, Ottawa

reputation in the Canadian art world came from her five-part 1975 series, *The White Museum*, works composed of club-shaped organic-looking objects set in white boxes on the wall (fig. 212). Whittome tightly wrapped these shapes with string, incorporating labour-intensive repetitions of binding and tying. Constricted, these shapes seem about to burst their bonds. They look like fetishes — but at the same time they reflect Whittome's notion of the museum and its way of classifying, preserving, and presenting objects. Whittome called them metaphors for memory.

Repetition was at the heart of Whittome's enterprise and characterized most of her work, as in her *Paperworks* (1977-1980), in which she made installations of paper (library catalogue cards, old art history notes, player piano rolls) mounted on cardboard, marked by pencil and pen, masking tape, pins, and cloth in an obsessive ritualistic manner (fig. 213). Her theme was the exploration of the nature of time and numbers; using materials with a ready-made quality, she superimposed patterns and systems. Whittome keenly sensed the technique of fieldwork that lies behind museum culture and the symbolic significance of collecting. To recall catalogues of archaeological specimens or books, she overlaid panels like her *Notes of the Course of the History of Art I* (1977-1980, Montreal Museum of Fine Arts, Montreal) with fragments of material culture she collected. In more recent work, often site-specific installations like *Musée des traces* (1989), she continues to respond to institutional archi-

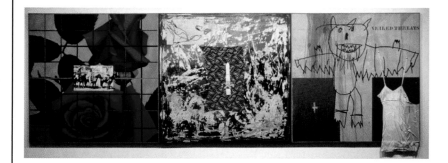

tecture and archives. Whittome's use of the body and its imprint, and the way she develops repetitive hand labour into a narrative that alludes to traditionally female domestic crafts, is a model lesson for artists seeking to pursue the theme of identity through the content of their work.

Calgary's Ron Moppett is an artist not unlike Whittome in the way his multi-

media paintings are animated by the possibilities unleashed by Funk and issues of identity. From the mid 1970s, he has explored abstraction with painterly panache, using layered and aggressive symbols. Among them are reproductions from photographs, magazines and newspapers, and found objects. At best, his work, as in *Veiled Threats* (1974, fig. 214), is imbued with poetic imagery. Through his use of collage effect, Moppett raises questions about religion, power, and taste.

Artists often turn to photography as the medium most suited to their objectives, working directly with subjects of identity and gender.3 Suzy Lake, Barbara Astman and Geneviève Cadieux base their work on photography though each uses it for different reasons: Lake tackles social activism, role-playing, vulnerability, and control; Astman, memory, relationships, communication and its discontents; Cadieux, concepts of vision. In Lake's early work (1973-1975), influenced by training in mime, she stages and manipulates images as the basic armature of her discursive themes. In

1976, Lake's *Choreographed Puppets* photographs (1976-1977), consisting of thirteen pieces, documents a moment of physical helplessness when Lake hung from strings in a rough wooden frame (fig. 215). Like a marionette, she was controlled from above by two anonymous figures. Her camera, set at slow shutter speed, blurs her movements and identity: here form seems to be losing out, half visible, half disappearing. Vulnerability and the state of suspension in actions or decisions imposed by others or in events beyond one's control are again her focus in *Impositions No.1* (1977, fig. 216), nine black-and-white stretched photographs that play off one another in terms of rhythm. Lake complicates matters by manipulating, distort-

167

Fig. 215. Suzy Lake (b. 1947)
Choreographed Puppets, 1976-1977
Each photograph 76.2 x 96.5 cm
Photo: Tim Clark

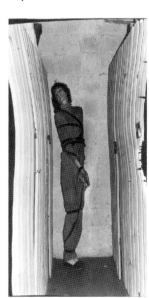

Fig. 216. Suzy Lake (b. 1947)
Impositions No.1 (Section #7), 1977
Photograph, 139.3 x 72.2 cm
The Artist

ing, and blurring the image of her tied-up self to invent the uneasy feeling caused by powerlessness: sometimes her body seems taller, sometimes shorter. The larger and taller images in combination with the smaller ones provide an erratic frenetic rhythm. Lake continues to play upon the themes of identity, *angst*, confinement, and vulnerability in photographs, mostly in black-and-white, such as *Are You Talking to Me?* (1979), a series of larger-than-life images of the artist caught mid-sentence. As in earlier work, she manipulates the photographs to add to their impact, stretching the negatives, re-photographing them and sometimes printing them in colour.

Barbara Astman is best known for self-portrait photographs in which she appears with her face cropped and blurred. She takes relationships, memory, and language as her subjects. Her target is the personal world, through recollection or revelation. She effectively began to update the theme of visual narrative early in her work; beginning in 1976, large-scale murals composed of hand-tinted black-and-white photographs or individual colour photocopier prints read as storyboards. In these works, Astman replaces the backgrounds of the images with scenes of her own choice taken from around the world, then copies the collage on a photocopier machine. As she writes:

> I was involved with inventing stories which, through the process utilized, appeared truthful. It felt like lying, but the technique provided the evidence that the episode could have really happened. The final piece created an element of confusion which I found vital to the work. There was an attempt to include writing with the images, usually by stating who the person was, where they were or the fabricated activities in which they were involved.[4]

In the work that follows for which she used the Polaroid camera, like her *Visual Narrative Series* (1978), Astman continues to explore storyboard technique but increases the importance of writing; it appeared in her earlier work only as an undercurrent. Now words play an important role in exploring the relationship of image and text. These photographic murals consist of six images created with a Polaroid camera with six corresponding sentences. By 1979, in the *Untitled, I Was Thinking About You* mural series, Astman combines words and

images, layering a text over a Polaroid photograph in the emulsion stage, then re-photographing and enlarging the image. In the final result, the letters of the words act as a textured barrier or veil between the viewer and the image. The "story," such as it is, can only be read with difficulty. In *Dear Jared* (1979, Robert McLaughlin Gallery, Oshawa) the letter (to her then-dealer, Jared Sable, of the Sable-Castelli Gallery in Toronto) recounts the time she first asked him to look at her work.

In 1980-1981, in *Untitled (Red)*, twenty self-photographs, Astman touches on essentially the same theme but makes something more visually dynamic. In each photograph Astman appears with real objects, mostly household tools and utensils, sprayed with brilliant red enamel car paint. In one photograph, *Red* (1980, fig. 217), she holds a watering can and pineapple and stands in front of a black almost tactile background. As in her stories, the colour in *Untitled (Red)* delivers a subtle message. Astman bases her series on the specifically heavily saturated quality of red, but the use of cool fluorescent light records the skin as a cool surface. The result, plus the wealth of body-object contrasts, suggests through body language, setting, camera work, and colour that her art-making is a composite of unusual resonance that transforms the photographic medium into something that recalls painting.

Fig. 217. Barbara Astman (b. 1950)
Red, 1980
SX-70, Ektacolour mural, 122.0 x 122.0 cm
Art Gallery of Hamilton, Hamilton

169

In the late 1980s, Barbara Astman became an investigative reporter's photographer. Increasingly fascinated by the aging process, she explored ideas that centred on a definition of time's passage, as in her *The Fruit* series (1990), fruit set in earth photographed over a year and a half. Selecting a limited number of visuals from the plethora of images, Astman produced mural scale enlargements, painting the background with oil stick, then melted wax with earth embedded in it. The multi-media works that resulted were admirable for their abstract qualities, their decaying forms contrasting starkly with the medi-

um, amplifying the sense of change that underlies so much of Astman's work. Her *Rock* series (1991-1993), in which five or six stones float in an indeterminate space, is brighter and more straightforward, but in purely formal terms conveys a similar combination of worn surface and remoteness that triggers different readings. Each work demonstrates interactions and mutual effects according to colour, hue, tone, and position that seem infinitely subtle and varied and sum up her special mixture of alluring yet ambiguous mysteries.

In the mid-1990s, in *Seeing and Being Seen* and *Scenes from a Movie for One*, Astman reintroduces her self into her work. *Seeing and Being Seen* speaks to the experience and significance of eye contact: here she physically alters Polaroids, then layers the resulting images, which are digitally scanned and printed onto frosted mylar to refer to skin. She uses the same process in *Scenes from a Movie for One*, which deals more directly with the body,

Fig. 218. Barbara Astman (b. 1950)
Thirty-two frames from Scenes from a Movie for One, 1997
Transfer print on artist paper, image size: 34.3 x 77.5 cm

but in a visually abstracted way as in her earlier autobiographical work (fig. 218). The images in *Dreaming Impressionism* are constructed from details extracted from Impressionist paintings, which are then taken through a conceptual and physical process that enables her to recontextualize them. Astman's art practice has been one of continual investigation of identity and systems of representation, as well as gender perspectives.

Montreal's Geneviève Cadieux keeps the viewer's mind and eye in rewarding motion by reworking photography that talks as much about style and form as the human condition. Her images exemplify psychological tension. Through them, Cadieux meditates on the real and unreal in life and art. From 1978, she's dealt with larger-than-life images of parts of the human body seen in sequence or interaction, as well as with the presence and absence of the body, juxtaposed for effect. Her installations read as a kind of text, with each work linked to its neighbour to form new meanings. During the 1980s, Cadieux developed projections, using photography, that combines a complicated blend of fiction and billboard-size photographs. The general concept of her pieces is evocative and very much of the decade. *Voices of Reason/Voices of Madness* (1983)

involves two slide projections of images on opposite walls: one of them is a black-and-white portrait of a person crying out with pain, going in and out of focus; one is a calm-faced person in colour that remains fixed. In *The Shoe at Right Seems Much Too Large* (1986), Cadieux stages a central element in which she frames a pair of eyes as an object; across from it are two enigmatic figures, an X-ray of a woman in high-heeled shoes and a shadow that resists positive identification. Across the image of the eyes, a kinetic mechanism within the structure reflects shadows in continual motion. Her language, muted and ambiguous, has many similarities with that of other artists of the period, but Cadieux goes further in evoking a cinematic quality. Her theatrical photographs and the use of the magnified close-up as in *Memory Gap, an Unexpected Beauty* (1988, fig. 219) create greater participation on the part of the viewer. More recently, Cadieux's work has grown; her images are less ironic, and she is more open about their meaning, proving the merits of both commitment and practice. In *Blue Fear* (1990), she ponders the subject of age and the dissolution of the body, using an image in colour of a pair of eyes overlaid by a photograph of a man's back in such a way that the two pictures seem to make up another face.

Fig. 219. Geneviève Cadieux (b. 1955)
Memory Gap,
an Unexpected Beauty, 1988
Dye coupler print and mirror on wood,
208.0 x 472.0 x 14.0 cm
National Gallery of Canada, Ottawa

In London, Ontario, in the early 1970s, Jamelie Hassan began her contribution to the question of identity by examining her cultural origins. A first-generation Canadian of Lebanese descent and Islamic background, Hassan introduced the experience of a Middle Eastern Canadian into her paintings and installations. At first, she added images of veils, roses, and waterplants to her canvases, then created roses and water plants in cloth and glass fibre in installations such as *Victoria Regia in Pond* (1977). For Hassan, the concept of consciousness-raising was essential; she believed she could attain her ends through conjuring her culture. She has continued to explore her Lebanese roots in a series of installations involving Arabic manuscripts and found objects (1996), as well as world wide tyranny. The ceramic fragments scattered on the floor in her *Los Desaparecidos* (1981, fig. 220), bear the names of those

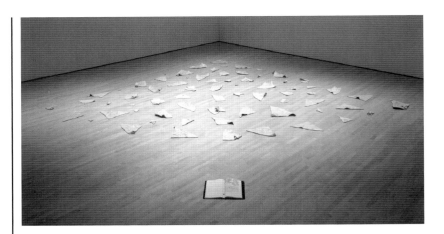

Fig. 220. Jamelie Hassan (b. 1948)
Los Desaparecidos, 1981
Ceramic (various sizes)
National Gallery of Canada, Ottawa

172

Fig. 221. Evergon (b. 1946)
Homage to Caravaggio, 1984
Colour Polaroid print, 2.0 x 1.0 m
Canadian Museum of Contemporary
Photography, Ottawa

who disappeared during Argentina's Dirty War.

Gay relationships were the subject of Ottawa artist Evergon in the mid-to-late 1970s examined through colour photocopier prints of the male nude. Trips of the imagination to the Mediterranean, Polynesia, or Central America inspired his enthusiasm for certain found images from magazines; he combined these with photographs he printed in black and white, then chemically toned and hand-coloured. A vivid sense of the medium, an audacious imagination and an irrepressible joie-de-vivre found voice in his lively work. In 1981, long familiar with technically innovative processes, Evergon began to make photographs on the large scale as in *Homage to Caravaggio* (1984, fig. 221); these are often Polaroids of boys and men. His "reenactments," repossessing classical and biblical subjects found in paintings from the sixteenth to eighteenth centuries, serve as tribute to great painters like Caravaggio, Goya, and Titian. Using costumes, props, and lighting, Evergon creates carefully staged elaborate mise-en-scenes that reveal his acute sense of texture and form and a rich sensuality. His work — bold, funny, passionate — with flamboyant colour and interesting technical manipulations brought photography, and in 1990, holography, into gay art with striking success.

The 1990s saw a shift in Evergon's work away from colour into large black-and-white silver gelatin prints. He began to produce the *Ramboys: A bookless novel* and large installations of multiple smaller prints as in *Manscapes: Truckstops and Lover's Lanes*. Though he developed the two series from large format negatives, they differed in tone.

Performance art and a wide range of expression by groups that co-author

provide further examples of how radical content can be embodied in alternative media. Tom Graff (born Thomas Graefe), who was a performer for John Cage in San Fransisco in 1962, worked with Gathie Falk in her "performance sculpture" as early as 1971, and is one of the pioneers in this area. Like Falk, he carefully composed his work, incorporating task-oriented activity with well-constructed props and elaborate costumes. His productions might display a high-spirited complexity to capture the psychic and physical reality of his subjects, as in his *We Should Take the Mona Lisa at Face Value*, first presented at the Vancouver Art Gallery in 1971, a lecture in the form of contrapuntal verbal quotations.[5]

One of the earliest co-authoring art groups in Canada was N.E. THING CO., incorporated in 1966 in Vancouver by Ingrid and Iain Baxter; it quickly racked up an impressive list of international and national credits. Since they wished to fuse ordinary life and the artist's take on it, they developed a new terminology for art, calling the artist a visual informer and the materials of art, "visual sensitivity information;" they assembled their work from painting, sculpture, photography, film, and many other media. N.E. THING CO. was an umbrella to handle their activities, they said, so they could have different departments for their wide-ranging ideas; these extended from using a gold corporate seal as the group's signature to encasing still-lives in plastic and making inflatable sculpture (fig. 222). Art became in their hands a running commentary on everything from landscape to a take-off on a real corporation in which art was business.

The project the Baxters developed for the Newport Harbor Art Museum in Newport, Rhode Island, in 1968 was characteristic of their way of regarding the entire physical landscape as material. They placed a sign on the highway that read, "You will soon pass by a one-quarter mile N.E.THING CO. landscape." A hundred yards further down the road, a sign read, "Start Viewing." A quarter-mile later yet another sign read, "Stop Viewing." Over time, they shifted more towards language and image studies, photography, and the international transmission of information anticipating such formats as video and correspondence art. Eye Scream, a restaurant they opened in Vancouver (1977-1978), was the

Fig. 222. N.E. Thing Company Limited
President of a Company
Face Screwing, 1969
Coloured photographs, mounted
(Photographs of Ingrid Baxter, Co-president,
N.E. Thing Company; signed corporate gold
seal lower right corner)

173

Fig. 223. Western Front building, Vancouver

first restaurant in the country run by an artist collective.

The Western Front Society in Vancouver similarly combined personal vision, formal sophistication, and headlong momentum. Founded in 1973 when a group of artists purchased a former lodge hall at 303 East 8th Avenue, the Society had its own community art centre and working (and living) space (fig. 223). Directors, including Michael Morris, Glenn Lewis, Eric Metcalfe, Vincent Trasov, and Kate Craig, were elected, and the Front was incorporated under the British Columbia Societies Act as a non-profit cultural society with the aim of holding exhibitions, performances, concerts, and poetry readings. This so-called "parallel gallery" runs (it is still going strong) experimental programs related to, though unlike, those at the Vancouver

174

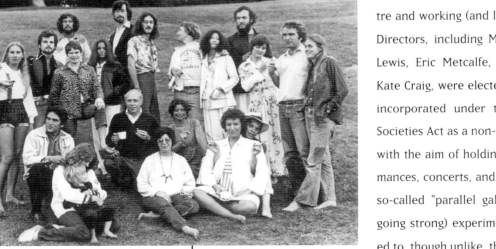

Fig. 224. Western Front regulars and visiting artists, 1974
(from left): Myra Peanut, Dwight Dayman, Lady Brute, David Tomkins, Susax X, Patrick Ready, Andy Grafitti, Hank Bull, Ann Allan, Martin Bartlett, Jim Bennett, Notary Sojac, Penny X; seated, Dr. Brute, Cory, S.S. Tell, X, Bobs Shapiro, Granada Gaxelle, and Bill X.

Art Gallery. Perhaps the most consistent feature of the Front in the 1970s was the sense of fun in its parodies of North American life. Artists changed their names to those of characters such as Flakey Rosehips (Glenn Lewis), Dr. Brute (Eric Metcalfe), Lady Brute (Kate Craig), and Mr. Peanut (Vincent Trasov) (fig. 224). Identities were sustained — Mr. Peanut actually ran for mayor of Vancouver in 1974.

Vancouver's Evelyn Roth, who had been an active participant in that city's

Intermedia artists' collective (1966-1970) founded by the Baxters among others, worked through a wide range of media. Her activities ranged from costume to dance, to installation and performance involving ritual and ecology. Much of Roth's work reflects a trend that threads through the art of the era toward the familiar, the close at hand. By 1967-1968, she had begun to knit with strips of leather, the first to do so in Canada. Inevitably, she became a "recycler" (new in Canada in 1970-1971), using various common discarded fabrics — leather, furs, nylon, rope, wool from unravelled sweaters, newspapers, and even videotape. She discusses her concepts and techniques in *The Evelyn Roth Recycling Book* (1975). She often adapted the motif of "wearables,"

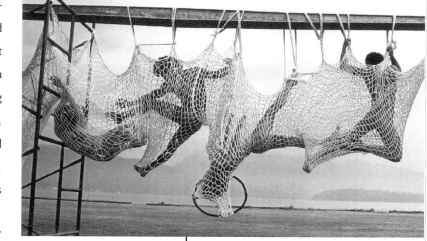

Fig. 225. Evelyn Roth (b. 1936)
Possum Times, 1976
Moving Sculpture company in crocheted nylon cord

fabricated works from found materials and ingeniously used them in festivals, events, or exhibitions.

Roth's most comprehensive work was her "moving sculpture," made from dancers in movement within a net of knit or crocheted fabric accompanied by music, which she titled *The Evelyn Roth Moving Sculpture Society* (1975) (fig. 225). Her projects might involve the use of the environment in a gargantuan way. For the Habitat Conference held in 1976 in Vancouver Roth recycled five abandoned airplane hangars. The ceiling cloth in hangar five, half the size of a football stadium, was designed by Haida First Nations artist Bill Reid, and produced by Roth in rejected nylon fabric appliqued by sewing machine. In the mid-1970s, Roth became banner co-ordinator for the city of Vancouver. In 1976, in response to an invitation from Robert Davidson to participate in the Haida salmon ceremony on the Queen Charlotte Islands, she created a thirty-minute Salmon Dance celebrating the fish's life cycle (choreography by Gerry Thurston and costume by Hannelore, her favourite collaborator). It featured Roth's first inflatable sculpture, the fifteen-metre salmon, from which dancers emerged. Roth has been a catalyst for many creators with a wide variety of interests in many countries. Her projects are concerned with creating effects that are essentially positive in spirit; she represents a position

175

of powerful engagement within the field of alternate practice.

In Toronto, the art community grouped itself in one area, Queen Street West, and found places for Performance art like the Cabana Room in the Spadina Hotel (1979) and the Cameron Public House (1981). In the mid-1970s, artists became personalities, and Queen Street itself almost a mythical place. Artists like those who formed General Idea in 1968 — Michael Tims from Vancouver (a.k.a. A.A. Bronson), Ron Gabe from Winnipeg (a.k.a. Felix Partz) and Jorge Saia (a.k.a. Jorge Zontal) from Parma, Italy — brought together various objects and situations in diverse media from performance and installation to painting, sculpture, photography, video and print. They realized that in order to make art they had to have a scene. Much of their early work, while they marketed themselves as artists and satirized contemporary North American society, the art world, and mass media, was aimed at pulling together a new audience. Positively reinforcing themselves, they said, "We knew that if we were famous and glamorous, we could say we are artists, and we would be. We did and we are. We are famous, glamorous artists."[6] Their *Miss General Idea* Pageant, presented at the Art Gallery of Ontario (1970, 1971), became an ongoing fourteen-year project that allowed them to explore a mythical past in *The 1984 Miss General Idea Pavilion*. In 1972, to make the scene seem more established than it actually was, they started *File* Megazine (the name came from *Life* scrambled) to dramatize and glamorize the art scene in Toronto; it lasted until 1989. In 1973, they founded Art Metropole, a Toronto non-profit distribution centre for videos and books by artists. In the 1980s and early 1990s (both Saia and Gabe died in 1994), they delineated the ongoing disaster of AIDS in works like *One Year of AZT* (1991, fig. 226), five giant capsules that represent a yearly dose of a drug taken to combat AIDS. Theirs was an art that appropriated mass-media forms but filled them with their own wit, ambiguity, and imperturbable aesthetic.

Other artist personalities in Toronto that attracted small but significant art-

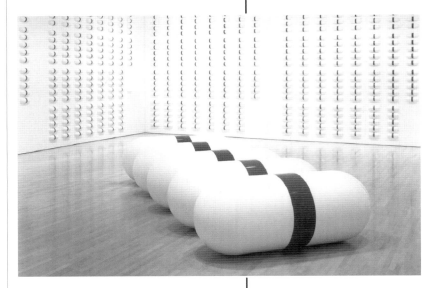

176

Fig. 226. General Idea
One Year of AZT, 1991
1825 units of vacuum-formed styrene with vinyl, 12.7 x 31.7 x 6.3 cm
National Gallery of Canada, Ottawa

world audiences included the Clichettes, a group of four women (originally, Elizabeth Chitty, Janice Hladki, Louise Garfield, and Johanna Householder) and David Buchan. Their work might involve the artists themselves and others in role-playing; the Clichettes lip-synched to Leslie Gore's pop hit, *You Don't Own Me*, Buchan appearing as the singer Lamonte Del Monte and performing with the Fruit Cocktails, a musical group, in a Tele-Performance in 1978. Performances of the Clichettes and Buchan had a compressed explosive energy, which continues to resonate vividly both in video-documentation and in eye-witness account.

From the mid-1960s to the 1970s, artists, in the desire for total control of the work, increasingly used communication technologies: photography, film, video, and the audio cassette. Particularly in video, in works that played most frequently on a television set, common themes included the clever theatrical play of imagery as well as the concept of the work of art as a social and political vehicle. The Activist art that was emerging was often unapologetically didactic. It bypassed aesthetics and mixed artmaking with issues such as identity (sexual, cultural, national, racial), politics, society, and the environment. In video art, Colin Campbell was an early pioneer, creating anecdotal confessional theatrical monologues in black-and-white. In *True/False* (1972), addressing the camera frontally and in profile, Campbell stated a series of potentially revealing statements such as "I snort coke," which he affirmed and denied as "True, False." Beginning with *Sackville, I'm Yours* (1972), Campbell used a cloaked persona (here, a character called Art Star) for his intimate confessions. Other pioneers like Rodney Werden also used video to explore aspects of sexuality, gender, and stereotyping. Sorel Cohen, in her video *Houseworks* (1976), dealt with daily domestic activities as ritual. In *Birthday Suit - with Scars and Defects* (1974, fig. 227), Lisa Steele put together a shrewdly conceived show that treats self-image as an elaborate fic-

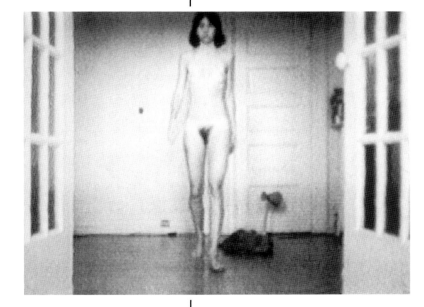

Fig. 227. Lisa Steele (b. 1947)
**Birthday Suit with Scars
and Defects, 1974**
Still photograph from videotape
Photo: V Tape, Toronto

177

Fig. 228. Ian Carr-Harris (b. 1941)
137 Tecumseth *(detail)*
Installation at Susan Hobbs Gallery,
Toronto, 1994-1995
Wood, arborite, steel, ellipsoidal spotlight,
lens, motor/pulley, variable dimensions
(427 x 330 x 1490 cm)
National Gallery of Canada, Ottawa
Photo: Isaac Applebaum, Toronto

178

tion, part a catalogue of successive body defects, part farce. Here, in a sparsely furnished apartment, a young woman, nude (the artist herself), stands in front of a camera, the object of her own rapt attention. In this twelve-minute tape, Steele chronicles her passage through time, detailing the scars on her body caused by being clumsy or unwell. The date is her twentieth-seventh birthday, and the account goes up to the recent past: the performer speaks about the removal of a benign tumour below her right breast when she was twenty-six. Steele poses many questions — about narcissism and the body — and does so with Conceptual wit and formal flair. But her approach to identity politics is through irony rather than hard-line pronouncement. The result has an uncannily mesmerizing fascination.

Conceptual artists who began their careers in the early 1970s explored options in material and slyly expressed humour and memory. Like performance artists, they emphasized subject matter, autobiography, and narrative through the use of allusive and elusive imagery. Ian Carr-Harris in Toronto made thought-provoking wood constructions with differing, often manufactured, components arranged in a wary balance; he used sculptural presentations to refer to matters as disparate as the body or products of the body, tools, and their uses and language. Carr-Harris himself said that his work "always dealt with the intimate relations between the physical and intellectual world: physicality and conceptual awareness."[7] For him, art-making meant a way of approaching a concrete idea or gesture using photography and language. In *But it's nice to have both, really, isn't it?* (1977, National Gallery of Canada, Ottawa), a multi-media installation with a black-and-white film component, Carr-Harris documents a conversation that pre-exists the situation in the work. The title of the piece is taken from a comment by one of the people in the film. Carr-Harris's approach usually involved a paradox between his theatrical setting and commonplace speech. Linking them, he was able to play off the ideal against the particular. To understand the work, the spectator had to get involved in the situation Carr-Harris establishes. His basic structure involves a form of demonstration and the use of different narratives. In the 1990s, Carr-Harris expanded these ideas to fictional representation (here, of light), as in the installations *137 Tecumseth* (1994, fig. 228) and *231 Queen's Quay West* (1998). He made the window pattern of the buildings, the reference in the

titles, into a template to function as a projection, although one not limited to exhibition in the original locations. Discrepancies come from the orientation and trajectory of the projected light and from condensing the passage of time.

From the mid-1970s, the work of Toronto artist John Massey was equally filled with comments on conceptual matters. At first glance, *The Embodiment* (1976, National Gallery of Canada, Ottawa), an installation of a metal bed plus an oversize child's bed sculptured in wax, feels personal, even diaristic, but it soon sug-

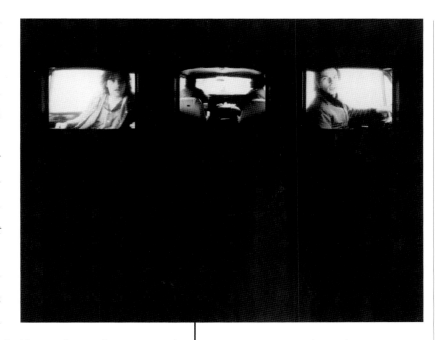

gests a parody of childhood memories. In 1981, Massey directs the viewer to the photograph, and his form of sculpture deals more with projection and commonplace elements and perception. *As the Hammer Strikes (A Partial Illustration)* (1982, fig. 229) displays three laser videodisc players with a sound track; the central monitor, in colour, shows a continuous thirty-minute take of a driver and passenger having a conversation in a moving van. The two flanking monitors show black-and-white filmed images that illustrate the potential origin of the words exchanged.

Robert Wiens, like Carr-Harris, uses sculpture to analyze language and images, particularly issues of representation, but he has sought to locate his works within broader social issues. His theme becomes sculpture itself and its

Fig. 229. John Massey (b. 1950)
As the Hammer Strikes
(A Partial Illustration), **1982**
One 16mm colour film and two 16 mm b/w films, 30 minutes each, with three projects and synchronizing system
National Gallery of Canada, Ottawa

Fig. 230. Robert Wiens (b. 1953)
The Tables, 1982
Tables made of various materials bearing various objects with photostat wall texts, installation dimensions variable
National Gallery of Canada, Ottawa

179

relationship with contemporary types of monuments and the strategies of power they express. His intention is to deconstruct the monumental, monolithic tradition. *The Tables* (1982, fig. 230), consisting of six small tables accompanied by a printed text, presents personal stories of displacement and loss.

In something of the same mood, Robin

Fig. 231. Robin Collyer (b. 1949)
*Vacuum Cleaner Factory
(after Walker Evans), 1993*
Susan Hobbs Gallery, Toronto
Photograph courtesy of Susan Hobbs Gallery, Toronto

180

Fig. 232. Bill Vazan (b. 1933)
Worldline, 1971
(Montreal segment)
Photo: The Artist

Collyer, in the 1970s, uses simple technical procedures of cutting and bending to create enigmatic three-dimensional assemblages arranged on the floor or against a wall. His work looks Minimal, but the way he disperses elements — both functional objects and ready-made materials — across space makes it a form of staged theatre. Like Carr-Harris, Collyer introduces elements the viewer recognizes. Collyer views sculpture as a way of transforming landscape and critiquing technology using a simulated stage set (fig. 231). He has also worked with photography to record modern habitats and sites that, to him, constitute visual sculpture.

With the rise of Conceptual art, the environment took on a new and special importance in the materials of art. The ambitious work of Montreal artist Bill Vazan tested this category. In the 1960s and early 1970s, he introduced the idea of earth demarcations, especially land drawings, spirals and maze patterns, as well as developing global linkup projects like his *Worldline* (1971); simultaneously installed at twenty-five sites it was a forerunner of his photo globe and visual sphere pieces (fig. 232) This communication project involved the extension of an "art" sensibility into a worldwide situation composed of time, gesture, and sensation. Vazan organized the laying down of black tape simultaneously on the floor of art centres in many parts of the world, including the Institute of Contemporary Arts in London. His work gains meaning from his photographic documentation of his projects, and from the pattern of activity that he engenders in his various mazes, spirals, and snow walks. The references in his work can be multiple. In *Pressure/Presence*, for instance, a chalk drawing he made on the

plains of Abraham in Quebec City in 1979, Vazan used the unfolding circular shape to symbolize an earth tremor, a finger digital imprint (his cultural intervention), and to indicate continuing tensions within the French and English communities in Canada (fig. 233).

Garry Neill Kennedy introduced other themes of Conceptual art, not only through his work but through the program of the Nova Scotia College of Art and Design in Halifax, once Canada's only degree-granting art college; he was president there for twenty-three years (1967-1990). His work is usually presented in visually striking ways in simple, even basic, materials. The result is open-ended. In his wall-paintings (installations that involve painting directly on gallery walls), for instance, Kennedy used commercial wall-paint organized by name and often applied in alphabetical order to criticize art, the gallery system, and the art world in general. For instance, he analyzed the Art Gallery of Ontario's contemporary Canadian painting collection in *Canadian Contemporary Collection — The Average Size, The Average Colour* (1978, fig. 234). The work totalled the paintings of thirty-two Canadian artists, including

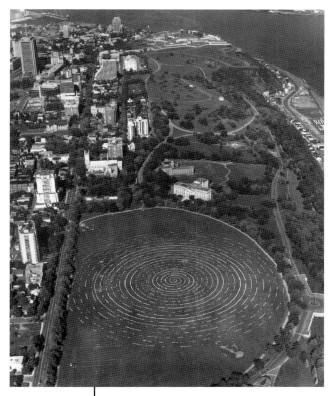

Fig. 233. Bill Vazan (b. 1933)
Pressure/Presence, 1979
Chalk on turf, 4,572 m diameter
(installed on Plains of Abraham, Quebec City)
Photo: The Artist

181

Fig. 234. Garry Neill Kennedy (b. 1935)
***Canadian Contemporary Collection —
The Average Size, The Average
Colour, 1978***
Colour photograph, ink, graphite and acrylic
(32 drawings); black and white photograph,
graphite and paper on paperboard (1 drawing); acrylic on canvas, 50.8 x 61.0 cm
Art Gallery of Ontario, Toronto
Photo: Carlo Catenazzi

Borduas, Pratt, and Coughtry, reducing each painting to a number and colour chart. By computing the average dimensions of all the paintings and converting this average into its square equivalent, and mixing the thirty-two average colours together, he boiled them all down to a murky equation: a dull grey, square canvas. What such a construction meant mattered less than the methodology pursued by Kennedy.

The strength of Conceptual art, by comparison to modernism, is the way it showcases the offbeat and the unexpected along with the ordinary. While no common thread ties the work of these artists together, they are united by their sensibility. Their work confers significance on the compelling and subtly funny; to some extent, Conceptual art serves as the conscience of Minimal art, establishing a tension between weirdness and pristine formalism. The results are often inspired lunacy, both exhausting and exhilarating at one and the same time.

A similar reductionist and Conceptual agenda inspired the art of Gerald Ferguson, who arrived in Canada in 1968 to take up a teaching position at the

Nova Scotia College of Art and Design. Informed by Minimal sculpture, Ferguson soon developed a challenging relationship with contemporary painting, examining its conventions through the persistent use of alphabetic stencils. One of the issues he addressed — as in his *One Million Pennies* (1980, fig. 235), a mound of one million newly minted pennies — was the commodity value of art through an absurd gesture of stockpiling (tongue-in-cheek, Ferguson offered the work for sale at precisely $10,000). He was also one of the new band of artists that subverted ideas from the popular culture of art, especially the public idea of what makes art. Ferguson has always been involved with re-inventing himself as an artist. In the late 1980s he began to use figurative stencils which had their antecedents in folk art of the nineteenth century. By the mid-1990s, he returned to the aesthetic of the hardware store and the procedural distancing of his paintings of the late 1960s.

Fig. 235. Gerald Ferguson (b. 1954)
One Million Pennies, 1979
Photo: The Gallery, University of Lethbridge

From 1970 to 1976, Gary Lee-Nova, who grew up in Vancouver, received formal art education at the Vancouver School of Art (now the Emily Carr Institute of Art and Design) and the Coventry College of Art in England. In *Out to Metric* (1975, fig. 236), he explores measurement regarded as a language system. When Lee-Nova realized that the Imperial system of measurement with which he had grown up would be replaced by metric measurements, he felt that a certain aspect of the nature of language had been

Fig. 236. Gary Lee-Nova (b. 1943)
Out to Metric, 1975
Wood and rulers, 256.7 x 198.2 x 183 cm
Vancouver Art Gallery, Vancouver
(below, detail of interior)

revealed to him. As a result he made an artefact out of a tool generated by the Imperial system of measurement: *Out to Metric* looks as though it was made of yardsticks. Such mocking sculptures are proof that the pervasive irony of Conceptual art can be usefully adapted to all manner of situations, however dissimilar.

Conceptual art lent itself to art-making that was philosophically provocative. Its accumulation of hits and misses spoke volumes about the evolution (or devolution) of culture. The results look hermetically coded and urbane but have a way of questioning the mainstream. In the end, the work seems far less significant in itself than as part of an era in which an art world liberating itself from Abstract Expressionism was searching for a new direction. The real challenge to modernism would come from a return to representation.

183

184 Fig. 237. Alex Colville (b. 1920)
Dog in Car, 1999
Acrylic on board, 36.8 x 63.5 cm
Mira Godard Gallery, Toronto

Chapter Seven
Developments in Representation; Post-Modernism; New Image Painting

D uring the 1960s and 1970s a strong group of artists gave representation a distinctly Canadian spin. Among them were the Maritime artists, including Alex Colville, and Christopher and Mary Pratt, who produce paintings of the figure, landscapes and still lifes with a strangely palpable presence; John Hall in Calgary; and the extraordinarily talented group of idiosyncratic artists centred in London, Ontario — among them Jack Chambers, Greg Curnoe, John Boyle, and Paterson Ewen. At the same time a group of artists who used fantasy as one of their strategies, including artists as dissimilar as the painters Jean Paul Lemieux, Louis de Niverville, and Ivan Eyre, sculptor Mark Prent, and *faux* folk-art painter David Thauberger, produced a sardonic yet romantic collision of realism and the imagination.

Alex Colville and Christopher and Mary Pratt have long been respected for the remarkable qualities of verisimilitude in their paintings, their technical and colouristic virtuosity, and their heightened expressive power. Their work reveals that they pursue a common goal — to make the painted image vividly present and render the unseen palpable. To achieve this goal, they employ a variety of pictorial strategies like the depiction of detail to convey an experience of everyday life. These artists engage the viewer by showing figures that serve as metaphors for ourselves in the way they are posed, gesture or are related to each other — and their development as painters can be traced in their novel treatments of age-old themes, innovative approaches to landscape, remarkable effects of colour and light, and vivid experience of contemporary life. The strengths of their work include simplicity of design and clarity of depiction. Their enterprise has helped produce a record of Canada, not only one of its landscape but of its more incorporeal and subtle substance.

The world as explored by the Maritime artist was touched by the unpredictable. Alex Colville of Wolfville, Nova Scotia, in particular, regards art as

raw material for an investigation of philosophy and sociology. His subjects, always figurative, at first give an impression of serene simplicity; later, they appear more inexplicable. Often, Colville seizes on a fugitive instant to present a coincidence as a timeless occurrence — with disquieting effect. In his way of relating objects to illuminate the ultimate inexplicability of existence, Colville's work recalls the paintings of the surrealist René Magritte.[1] To evoke a mysterious effect, Colville, like Magritte, often displays two familiar objects brought together in an improbable way, enhancing what is specific and enigmatic about each. However, by contrast with Magritte's paradoxes that usual-

ly concern the operations of the unconscious mind, Colville's work often has a hypothetical quality: it expresses "what if" something happened on the conscious level. Like other painters in the Maritime School, he developed a specific visual language, though Colville's involves geometry.[2] His work presents smooth, sculptural, shadowless figures, a sensation of stillness and immobility, complex linear rhythms, peripheral, off-beat stories (that often involve himself or his family), muted subtle colour, and matt handling. *Dog in Car* (1999, fig. 237) seems to suspend time.

Fig. 238. Christopher Pratt (b. 1935)
Girl in the Spare Room, 1984
Oil on masonite, 69.9 x 92.7 cm
Montreal Museum of Fine Arts, Montreal
Gift of Reginald S. Bennett

There is a mythic resonance as the archetypal woman and dog participate in what seems to be an elemental scene from daily life, one as enduring as the armoured truck in the background.

Newfoundland's Christopher Pratt was schooled at the Glasgow School of Art and New Brunswick's Mount Allison University, where he worked with Colville. In 1960 the jury for the National Gallery of Canada's biennial lauded Pratt's *Boat in Sand*, and his career was launched. His subsequent work includes landscapes, portraits, nudes, and above all, domestic interiors; these, in their mood of isolation, recall a tradition of North American painting stretching from Edward Hopper to Andrew Wyeth. For Pratt, the domestic interior in particular serves to trigger a magic that transforms prosaic fact into haunting

186

poetry. Although these canvases might be described as views of his home in St. Mary's Bay, Newfoundland, Pratt extracts from them a quiet mood. Looking at these interiors with their spare furnishings and sombre light, particularly if a nude is in the space as in *Girl in the Spare Room* (1984, fig. 238), the viewer feels like an observer of a private life whose story remains a secret. Often, Pratt's rooms are empty, only barren enclosures of rigorously rectilinear mouldings, windows, and doorways modulated through his awareness of abstraction. Pratt makes telling points: the nude body modelled by light, the edge of a sofa seen through a door, the open chest in an attic. Through such views, we sense the scene's stillness and serenity. To create his special point of view Pratt developed a method of compression, angling a nude in front of a window, wedging a bed in a small room or placing a radiator in an alcove under a window. His scenes, often painted in tones of grey, white, and ochre, have a stark austere

Fig. 239. Christopher Pratt (b. 1935)
Benoit's Cove: Sheds in Winter, 1998
Oil on board, 68.6 x 152.4 cm
Mira Godard Gallery, Toronto

187

beauty. His message is of hard-to-achieve order in a familiar universe, but he hints at an outer world that is different, more open. Light slanting through a window or falling on architectural forms as in *Benoit's Cove: Sheds in Winter* (1998, fig. 239) takes on precious weight. In 1995, Pratt said about his work:

> I have a profound sense of the power of ordinariness, and of ordinary things ... I mean ordinary in the sense that this is a person, place or thing that has nothing going for it but the fact of its own existence, the fact that it *is* ... I make both intuitive and conscious decisions to preserve the neutrality of circumstances."3

In her works of the mid-1970s Mary Pratt often used objects found in the kitchen or garden, particularly food; in the late-1980s, in big works on paper, she took such images out-of-doors. Some of her early paintings are whimsical. Later works, sometimes ambitious figure paintings in a large format like *Service Station* (1978) are more sombre. She studied at Mount Allison University (1953-1956) under Alex Colville, Lawren P. Harris, and drawing master Ted Pulford, graduating in 1961. In her early paintings, her technical skill, sense of scale and elaborateness of subject relate her to American photo-realists such as Richard Estes. The difference lies in her technique and point of view: her images, placed centrally, are presented with the loving attentiveness of a Renaissance painter. The results are elegant and intimate: her close-ups of food amplify the concentration, power, and detail that has always been in her painting. *Cherries*

Fig. 240. Mary Pratt (b. 1935)
Cherries in the Garden, 1998
Oil on canvas, 55.9 x 71.1 cm
Mira Godard Gallery, Toronto

188

in the Garden (1998, fig. 240) gives a good idea of her work: clean, intelligent, elusive in meaning.

Attention throughout Canada was curatorially captured around the early 1970s by what has been suggested as an exciting "return" of possibilities. In Calgary, John Hall, with fastidious attention to detail and texture, began painting assemblages of still-life objects drawn from the paraphernalia of popular culture. In 1971, he first used the plastic rose that became a *leitmotif* of his par-

odies. Densely arranged in boxes or in fixed reliefs, Hall's tableaux reveal a debt to Surrealist art, as well as to Pop artists and American sharp-focus realist painters. By contrast to Pratt, Hall's *trompe l'oeil* feats sometimes have a disquieting quality; they can appear calculated, grim or repellent. *Doll* (1971, fig. 241), the first painting in which he used his characteristic artificial rose, also featured a rubber kewpie doll and cardboard Coca-Cola carton, but, because of the way his things take centre-stage, the effect was of a drama with an uncertain plot. Through the 1980s, Hall's work, with photographs and assorted ephemera, became increasingly eclectic, ironic, and nostalgic: he chronicled more autobiographical matters, especially his travels.

Nostalgia permeated the work of most "realists" in Canada, who remained what they have always been — figurative painters of a traditional kind, dependent upon the presence of the model in the studio or on observable circumstances. Toronto's Christiane Pflug, for instance, formed her realistic style from study in Paris and Tunis. The paintings, gouaches and oils of city scenes she painted in Paris from 1954 to 1956 convey architectural and landscape forms in strongly designed painterly shorthand. A stay in Tunisia, beginning in 1957, led to an increase in light and shade as well as to a greater attention to detail and clearer colour in Pflug's work. In Toronto from 1959 until her death in 1972, she evoked the Toronto skyline and emblematic scenes of the everyday life of the homemaker. Her work, imbued with a complex emotional tone, is at its best magisterial in structure and rich in observed detail. Paintings like *Kitchen Door with Ursula* (1966, fig. 242) may be seen as coded mes-

Fig. 241. John Hall (b. 1943)
Doll, 1971
Acrylic on canvas (3 panels), 162.1 x 411.5 cm
National Gallery of Canada, Ottawa

Fig. 242. Christiane Pflug (1936-1972)
Kitchen Door with Ursula, 1966
Oil on canvas, 164.8 x 193.2 cm
Winnipeg Art Gallery, Winnipeg
Purchase with the assistance of the Women's
Committee and the Winnipeg Foundation

189

sages of freedom and entrapment. Pflug painted the work over a period of eight or nine months, following the seasons. In it, reflected in the panes of an open glass door is the image of a child, the artist's daughter Ursula absorbed in a book. In the child's world, the season is summer, by contrast with the stark interior space of the artist which looks onto a snowy Toronto street.

The naturalistic painting style of London's Jack Chambers was rooted in his training in Madrid at the San Fernando Academia de Bellas Artes (1953-1959). His emergence as an artist of national rank was a slow process, one marked by constant experiment. When he returned to Canada in 1961, Chambers began to simplify and unify his work using a soft sultry Impressionistic touch and cool colours. In the early 1960s, he explored film. In his film *Circle* (1966-1967), he investigated the perennial art theme of the four seasons; in *Hybrid* (1967), child slaughter in Vietnam, and in *Hart of London* (1970), city life. During the period from 1967 to 1969, Chambers began to use silver paint, collage, plastic, and juxtaposed images in Pop-inspired constructions using a montage of images. From 1968, Chambers sought to convey in his work a realism where the object appears in a way that is emotionally empathetic but psychologically opaque. The concept brought a new incisiveness to his subjects, which involved new takes on old themes of human harmony with nature (he substituted architectural forms — the highway, the hospital), or the interior and the nude. In *Mums* (1968), Chambers studied the domestic environment. The scene of a dresser with flowers and paraphernalia on top in a hallway is rich in observed detail. In *Nude No. 4* (1972, fig. 243), the slim body of the model — in type recalling Giorgione, one of Chambers's favourite artists — focuses the eye of the observer on the figure's volumes and the special cool light of the artist's studio. The use of the body as

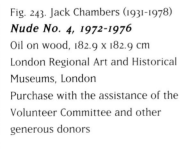

Fig. 243. Jack Chambers (1931-1978)
Nude No. 4, 1972-1976
Oil on wood, 182.9 x 182.9 cm
London Regional Art and Historical
Museums, London
Purchase with the assistance of the
Volunteer Committee and other
generous donors

a design element, like the black lines of the radiator and carefully placed light sockets, makes the scene tranquil and luminous.

Chambers's close friends included Kim Ondaatje, whose paintings, prints, films, and photographs suggest her sympathy with aspects of Chambers's work; she added her own lyric intensity and impassioned primness, calling her style "minimal realism." She was also one of the first painters in Canada to use interiors as subject matter. A house on Picadilly Street provided the series of fifteen acrylic paintings and nine silkscreen prints *Picadilly Suite*. In these works, Ondaatje's images provide clues, hints, and suggestions: rooms seen through empty rooms, paintings within paintings, mirrors within mirrors, but she balances her careful attention to surfaces and telling details with a reverential silence. In the *Factory* series (1970-1974), twelve paintings and seven prints of industrial plants, she explores the industrial image to focus on geometric form and the individual vagaries of different architectural facilities. Ondaatje invites the viewer to almost walk into her work: she often shows an entrance, as in *Streetley on Highway No.5* (1971, fig. 244). Hers is a kind of participatory democracy in art; she wants to share her way of seeing.

Along with Chambers, Ondaatje served as a significant artist activist. In 1968, with Chambers, Tony Urquhart, Greg Curnoe, and John Boyle, angered by the National Gallery of Canada's abuse of copyright, she helped establish Canadian Artists' Representation (CAR). Along with Chambers and Curnoe, in the face of American Abstract Expressionism, she was devoted to Regionalism, which Chambers defined, perhaps with deliberate ambiguity, as a "love for what you have grown out of."[4]

Among the Isaacs artists, the late Greg Curnoe was most associated with a Regional message: Regionalism was practically his campaign slogan. The term had been frequently used in connection with Canadian art of the 1930s and 1940s but imprecisely;[5] Curnoe used it to suggest that artists develop (if they do not already have) a positive attitude towards their immediate environment. He believed that the place where artists had roots should form part of their art, and he chose to forge an artistic universe from

Fig. 244. Kim Ondaatje (b. 1928)
Streetley on Highway No.5, 1971
Acrylic/mixed media on canvas,
183.6 x 269.6 cm
Robert McLaughlin Gallery, Oshawa
Gift of Pat Marshall, 1988
Photo: T.E. Moore

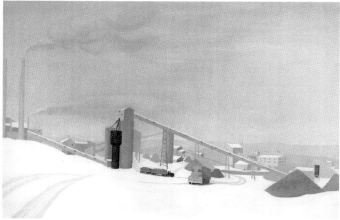

191

his home turf of London, Ontario. Curnoe documented local culture and campaigned against American cultural imperialism. However, the idea of Regionalism goes beyond ideas about the region itself. The issues it raises are both peculiarly Canadian and characteristic of the multicultural 1990s. Is an artist born or made? And if the answer is the latter, then what is responsible for his making? His country or some validating establishment? For Curnoe, Regionalism was a badge of pride, and he attempted to provide a political rationale for art that drew its sustenance from a shared region. However, although his conviction had validity in an era when abstraction seemed not only omnipresent but inevitable, the idea had already appeared in the earlier decades of twentieth-century art in Canada. Curnoe's further development was enhanced by his work for a silkscreen company in 1956, which reinforced his feeling for bright flat colour and use of primaries; for contour and clean outline; for his rejection of modelling; for his use of cut-out shapes and his spare deft handling. These features, combined with subjects that acknowledged international developments in Pop art and the return of the figure, contributed to what was, in fact, an extension of realism.

Curnoe did not dislike New York's Abstract Expressionism; he just didn't want it imitated in Canada. He devoted himself to recording the real world in paint, even in the series of word paintings he made from 1959 on with rubber stamps given him by a London artist (Michael Snow added to his collection in 1961). With these in hand, and the idea of a journal combined with a love for *The Voyeur* (1955) by novelist Alain Robbe-Grillet and Robbe-Grillet's way of scrutinizing space with focused attention, Curnoe began to stamp descriptions of events and their settings onto his subjects. These paintings proceeded at the same time as his more painterly canvases.

By 1963, Curnoe's paintings of lovers and the female body echoed those of others on the Toronto scene. But the following year, in *Spring on the Ridgeway* (1964, Art Gallery of Ontario, Toronto), he found a way of combining words with a subject he found irresistible, the daily spectacle of his world. In the painting, Curnoe stamped words around the edge describing the passage of time at the moment of work's creation. Attached to the painting are a curtain hanging from a metal rod and a yo-yo. There's a cut-out for the radio. But the nude, seen from the rear, though lushly painted, is in the style of the

day. She is flatly patterned with the clarity of shape characteristic of Pop art and 1960s abstraction.

Other works of the same period like Curnoe's *Feeding Percy* (1965, fig. 245) exhibit the same combination of vernacular images with faintly humorous details; these range from sequential flashing coloured lights and plastic inserts to a cut-out bird ("Percy"), who says "cluck cluck" in stamped letters. In Curnoe's winning combination of collage, words and flatly painted scenes, he used harmonious colour (like the American painter Robert Delaunay) and country-town carnivals, robust oranges, and greens or rainbow tints.

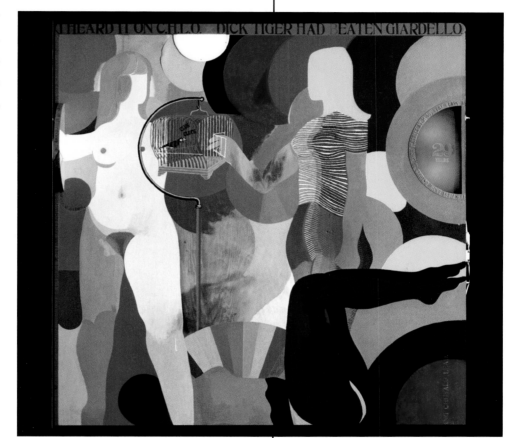

Extending his unpredictable range in later years, Curnoe painted watercolours of his Zeus ten-speed bike and wheels — he was a competitive amateur cyclist — along with watercolours of his nude wife, and of the CN Tower in Toronto. In many ways, these works reveal Curnoe at his best, most personal, relaxed and animated. Away from painting, Curnoe continued to improvise: he played in the random-action Nihilist Spasm Band, along with his friends, artists Murray Favro and John Boyle. His influence and that of his circle extended to artists as diverse as Tony Urquhart and Paterson Ewen, both of whom were nurtured by developments in London, Ontario.

Murray Favro, who grew up in London, created multimedia evocations of things that celebrate his ability as a model-maker and inventor. In 1969, he began his "Projected Reconstructions," film loops or slides projected onto

Fig. 245. Greg Curnoe (1936-1992)
Feeding Percy, 1965
Oil on plywood with sequential flashing coloured lights and plexiglass,
190.5 x 165 x 35.4 cm
London Regional Art and Historical Museums, London

193

white three-dimensional objects. His unconventional use of unconventional materials marked him as a practitioner of the process-oriented art of the 1970s and 1980s, but his inventiveness, even among such forays, is wonderful to behold. Favro made his multi-media construction of *Van Gogh's Room* (1973-1974, Art Gallery of Ontario, Toronto) of rough wooden furniture bathed in light from a projected slide of Vincent van Gogh's painting of his *Bedroom in Arles.* Favro's *Country Road* (1971-1972, fig. 246), consists of a 1961 Corvair and a stump with maple leaves set on, or beside, a white stage on which three projectors throw colour slides of a country lane. The images are at once and the same

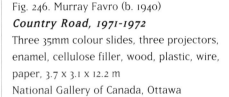

Fig. 246. Murray Favro (b. 1940)
Country Road, 1971-1972
Three 35mm colour slides, three projectors, enamel, cellulose filler, wood, plastic, wire, paper, 3.7 x 3.1 x 12.2 m
National Gallery of Canada, Ottawa

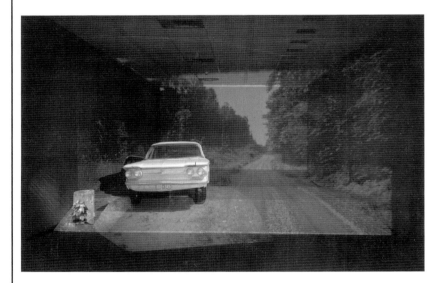

time cinematic and ingenious in evoking the artist's voice — softly nuanced, intimate, ultimately ambiguous.

John Boyle vigorously applies paint to large surfaces so the effect is of a heavy impasto; his colour is flat and expressive; his subjects culturally or historically grounded in his life. A favourite theme involves the combination of historical, art or sports heroes with the tradition of Ontario landscape, as in his *Midnight Oil, Ode to Tom Thomson* (1969, London Regional Art Gallery and Museums, London). In this he uses the figure of Tom Thomson, portraits of models, a view from his studio (then situated in the environs of St. Catharines, Ontario), and the canoe of the Canadian Broadcasting Corporation research crew that did a feature film on Thomson. In the base of the work, as a sort of homage to Thomson, is a freestanding construction of a flashing amber light.

Other pieces show similar quirky combinations, and the play in Boyle's work of humour, affection, and self-conjured myth on the subject of Canada is occasionally hard to interpret. Some of his most successful works are his variations on Plains First Nations's tipis like *Cape Croker* (1977-1979, fig. 247); it is made in three sections and painted with images of artists such as Carl Ray with bison, aboriginals in canoes appropriated from old photographs, and personalities like Norman Bethune that were important to him. The landscape evokes the First Nations reserve on the Niagara Escarpment at Cape Croker near Wiarton. Boyle, who began painting in 1960, was confirmed in his decision to become a painter in 1962-1963 after seeing a mammoth Vincent van Gogh exhibition at the Detroit Institute of Fine Arts. As he recalled:

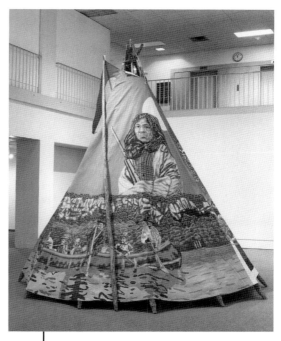

Fig. 247. John Boyle (b. 1941)
Cape Croker, 1977-1979
Tipi of cotton duck canvas painted with acrylic, 11 interior cedar tent poles lashed together with rope and two exterior cedar tent poles, with separately attached lodge door panel of acrylic on canvas, 4.45 x 4.14 m
National Gallery of Canada, Ottawa

> What struck me was the immediacy and potency of the image as a mode of communication. I was able to instantly absorb the power effect of enhanced colour and of simplified large scale imagery drawn from a specific life experience.[6]

His work, at first rough and developed from a how-to-paint book, became more assured with time, but it has always retained the immediacy of impact of van Gogh: it is vivid and communicates meaning in a determinedly direct way.

Tony Urquhart, who lived in London, Ontario, from 1960 to 1972 discovered American Abstract Expressionism at the source, with studies at the Albright Art School in Buffalo, New York (1954-1958), and the University of Buffalo. He first exhibited as a painter; then, after a year's travel in France and Spain (1963-1964), excited by three-dimensional work with the indefinable presence he was seeking, Urquhart came home a "thing-maker." He made his first boxes, tiny cubes with landscapes painted on their sides, in 1965. A second trip to Europe in 1967, during which he took a close look at altarpieces and small hinged sculptures, inspired his subsequent work. In 1968, after a period of experimentation with drawing and watercolour, Urquhart began to play with the idea of opening his box sculptures. Constructed of plywood, plaster, and materials like sand and twigs, these curious painted three-dimensional constructions in

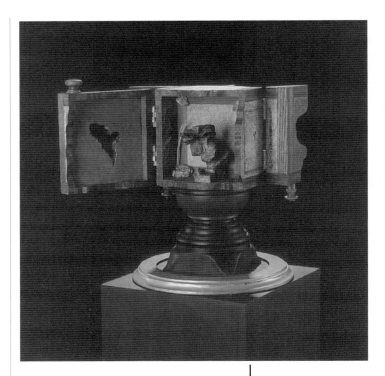

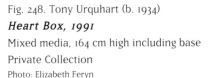

Fig. 248. Tony Urquhart (b. 1934)
Heart Box, 1991
Mixed media, 164 cm high including base
Private Collection
Photo: Elizabeth Feryn

196

the shape of coffins or elaborate balustrades have doors that open to reveal microcosms within (fig. 248).

In this format, one situated between painting and sculpture, Urquhart found an ideal way to create a series in which he could vary colour, shape, texture, volume, and even gesture; he became an expert at surreal juxtapositions of unlike things, allusions, and visual quotations. The interiors combined spaces that were more or less straightforwardly illustrative with those that were more metaphysical. They might be of parts that recall the body, hung with paper bits, or mobile paintings. Collectively, they provided puzzling road maps to landscape. That his doors could be manipulated meant that he introduced the element of time into what is essentially a timeless art. Urquhart always stressed that his boxes were private reveries, shaped for home use, a way for the viewer to re-discover senses we once had but have now lost.

For Paterson Ewen, London, Ontario, where he moved from Montreal in 1968, provided a new home. His interest in the image dating from 1971 has resulted in a large body of paintings scraped in wood, often with collage elements. To develop the image, he transformed his work, changing it from the simple shapes and strong colours of 1960s abstraction. Ewen had always been drawn to geology, which he studied at McGill University in Montreal. Due to the influence of Borduas and the Automatists, whom Ewen met through his

wife, the artist and dancer Françoise Sullivan, he grew interested in gestural abstraction. In the 1960s, he was inspired by Guido Molinari to paint more formal compositions. In London, he found himself increasingly drawn to an imagery dating back to the earlier years of his life, one that touched on the sciences. Of the role that science plays in his life, Ewen has said:

> I thought all during my boyhood that I wanted to be a geologist until I took my first course and found that geologists are not so interested in the shapes and colours of formations but in their specific density and other mathematical and scientific data. So I learned pretty quickly that geology wasn't for me — but I continue my interest in that which is under the earth, various surface phenomena — mostly those that connect with the sky — and beyond that, an interest in space ...7

For Ewen, the beginning of his breakthrough came in a painting, *Traces through Space* (1970, The Artist), in which he used gesso to cover the canvas but instead of using brushes, he created an image by dipping a piece of felt in paint and making a dotted line. The experience made him think about the largely unclaimed territory bordered by science and art. He took strands of his earlier work, discarded those he did not want and reached back into his past to braid the whole into what was for him a new way of making art.

Ewen's next step came in 1971 through the process of woodblock printing. The normal procedure would mean placing a sheet of paper face down on the woodblock and rubbing it to transfer the image. However, as Ewen hand-gouged a sheet of plywood to make the matrix for a large woodblock print, he realized that the work was nearly finished, and, instead of using it to make a print, he painted the plywood with acrylic to complete it. The change meant the development of a new technique in his work; one in which Ewen used large sheets of plywood that he gouged with an electric router to form the "drawing" of the work. As images, as in *Gibbous Moon* (1980, fig. 249), Ewen selected scientific phenomena from diagrams and photographs found in old scientific and navigational books, dictionaries and

Fig. 249. Paterson Ewen (b. 1925)
Gibbous Moon, 1980
Gouged plywood and acrylic,
228.6 x 243.8 cm
National Gallery of Canada, Ottawa

197

encyclopedias. Alternatively, he might look to nature or to art history for an image. In using the history of art, he might appropriate a famous work from the past. He based his *The Great Wave: Homage to Hokusai* (1974, Art Gallery of Windsor, Windsor) on *The Great Wave* (c. 1830) by one of the great masters of the woodblock print, the Japanese artist Katsushika Hokusai (1760-1849).

One sign of Ewen's confidence in emulating Hokusai is that in painting sky and water, he did not hesitate to cut off nearly half the print and to omit many details of the composition and the cartouche; he invented his own means to resemble its graphic effect through incised lines and subdued colour. In accord with his preoccupations, Ewen made the image into a template for notions of mutability and the shifting pull of gravity.

Though the subject he selected had a personal appeal to Ewen, he felt deeply about the process. He believed he was the key to making his technique respond, using any means at his disposal including unusual materials he found at hand and wrapping up science lessons with episodic sensation-packed verve. Despite Ewen's apparent disregard for the imagery he recycled, his work has about it a sort of romance about nature, an operatic take on what looks like subject matter recalling the Group of Seven. He has continued to explore material surfaces and scale.

A similar sense of ambition and sharp transformation characterizes the art-making of Quebec's Jean Paul Lemieux, who in 1956, at the age of fifty-two, changed his style, simplifying the subject matter he had been using since the 1930s and refining his painting technique. His paintings like *The Visit* (1967, fig. 250) consist of emblematic scenes of French Canadian landscape (here a family group in front of a snow-covered land) and ethereal melancholy figures that capture the spirit of his complex homeland. His scenes of vast spaces in quiet tones of taupe, black, grey, and white from which figures loom are powerful in structure. Lemieux's take on his subjects was often ambiguous, and his willingness to let his art be inscrutable is provocative.

The subject matter of Louis de Niverville (fig. 251) — he focuses on the edge of vision, the visual jest with its sense of paradox — is characteristic of his approach to art. Collage has been one of his principal working methods. In these collages, de Niverville explores an unconventional technique; they appear to have been executed with the utmost freedom and spontaneity, yet

Fig. 250. Jean Paul Lemieux (1904-1990)
The Visit, 1967
Oil on canvas, 170.0 x 107.3 cm
National Gallery of Canada, Ottawa

198

every bit is invested with mean-
ing, either representational or
expressive. He works them as
though they are paintings, com-
bining techniques and radically
reworking before making deci-
sions and gluing down papers.
They range from his *The First
Collage* of 1965 to *Old Folks at
Dusk* (1969, The Artist) in which
the title makes the point the
forms suggest, amid many exam-
ples. The size of his work also
varies widely, from his *Family
Series* to the noble *Madame
Takes a Bath No. 1* (1974, fig. 251).
One of his favourite subjects is
time. De Niverville's collages on
this subject echo the kind of

Fig. 251. Louis de Niverville (b. 1933)
Madame Takes a Bath No. 1, 1974
Airbrushed acrylic collage on paper on
masonite, 242.8 x 122.2 cm
Robert McLaughlin Gallery, Oshawa

game he has always played in his art. The forms slip back and forth to create a
contained world, Surreal in content but one with zest and amusement. That
said, there's nonetheless a tough astringent qual-
ity just below the surface.

The fantasy world of Winnipeg's Esther
Warkov evokes a similar feeling of nostalgia and
draws on similar concerns — sexuality, the fami-
ly, the environment, but her way of placing her
diverse images in symmetrical or asymmetrical
structures, her sense of theatre, her painting
technique and subtle colour, as in *Memories of
an Autumn Day* (1968, fig. 252), create a different
effect, one lower in key. This large rectangular
painting combined with cut-out parts, in which
she uses wedding garments, a church steeple, a

Fig. 252. Esther Warkov (b. 1941)
Memories of an Autumn Day, 1968
Oil on canvas, 157.6 x 208.2 cm
Beaverbrook Art Gallery, Fredericton
Purchase with funds from the Canada
Council's Director's Choice programme and
the Beaverbrook Art Gallery

199

child holding flowers, a doorway and a ghostly man reading the paper, combined with a circular shape of a ghostly couple exchanging a wedding kiss, suggests a mood rather than tells a story. In 1979, she described her ideas:

> A lot of my work has to do with melancholy and depression, loss and sadness. I don't deliberately have a mood that I am trying to convey, but these just seem to come out.... The thing that comes out in my work is sadness, a gentle sadness.[8]

The artist she admires is Jack Chambers and his way of addressing reality. She sees him as a major influence on her Surrealistic pictures.

William Kurelek, a Canadian-born Ukrainian farm-boy who grew up on the prairies, responded warmly to the austere emptiness of Western Canada, favouring in his later paintings broad panorama, a distant high horizon, a limitless expanse. A monumental grandeur is inherent in his structure; people are almost overwhelmed by the setting. His landscape, though sometimes anachronistic — his rural paintings portray a way of life that largely had disappeared by the 1960s — was a way of appropriating the country, beautiful and picturesque even when interlaced with evidence of human use. Through his paintings, Kurelek reclaimed an identity with the Ukrainian community in which he grew up[9] and expressed personal religious feelings (he converted to Catholicism in England in 1957). He wanted to record in paint a complete history of the Canadian mosaic and celebrated French Canada and the Irish in Canada, before his death in 1977. *The Ukrainian Pioneer No. 6* (1971, National Gallery of Canada, Ottawa), the last panel of a six-part series, conveys a typical message to the viewer, one that involves a warning: in the painting, a farmer examines the wheat in his field, unaware of the nuclear explosion (signified by a mushroom cloud) in the background. Typically for Kurelek, in painting the figure in the painting, he expresses a debt to one of his heroes, the Flemish painter Pieter Bruegel the Elder. Kurelek's *The Painter* (1974, fig. 253), which he painted of himself at work, has a more idyllic mood.

Ivan Eyre, living in St. Norbert on the south edge of Winnipeg, also developed a specific visual language through which he could explore the nature of existence in an intriguing innovative way, often focusing on the cosmic within

Fig. 253. William Kurelek (1927-1977)
The Painter, 1974
Oil on canvas, 121.9 x 91.4 cm
Photo: T.E. Moore
Photograph used courtesy the Estate of William Kurelek and the Isaacs Gallery, Toronto

200

the microcosmic. Many of his mysterious landscapes like *Winter Cloud* (1992, fig. 254) begin with a few decisive moves on canvas; Eyre acts as co-ordinator of his memories, the area around him, dreams. His landscapes appear true to many climes, and people often tell him that they recognize places he has painted. Often Eyre ingeniously plays with different sorts of space, both two- and three-dimensional, and objects of different sizes. In *Green Echo* (1996, Pavilion Gallery, Winnipeg), for instance, in one of his common formats, Eyre places a still life before an open window. On first reading, the subject seems to be about art, but the ambiguity of the forms soon propose a deeper meaning, one that has more to do more with mythic narratives. Eyre has always been technically innovative, combining oil and acrylic paint, and using glazes in the belief that the act of painting involves resourcefulness and innovation.

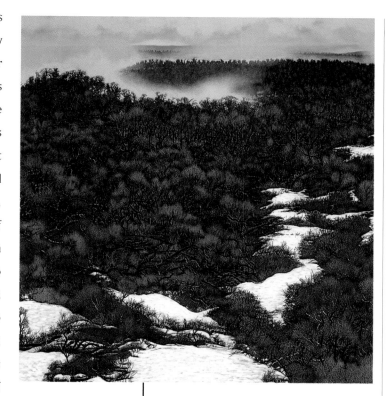

Fig. 254. Ivan Eyre (b. 1935)
*** Winter Cloud, 1991***
Acrylic on canvas, 127.0 x 116.8 cm
The Artist

In the 1970s, Polish-born Montreal sculptor Mark Prent blended technical wizardry with macabre subjects, humour, and a specific vision involving body parts cast in glass fibre and polyester resin and painted to question what is ultimately real. He used horror as a formal approach — his specialty was death and disfigurement — to elaborate visual tableaux of socially and culturally unacceptable subjects. As a result, in 1972 and 1974, his dealer, Avrom Isaacs in Toronto, was charged under a section of Criminal Code with exhibiting "disgusting objects."

Prent's art has a traditional source, however. He studied at Sir George Williams University in Montreal (1966-1970) with modernist sculptors like John Ivor Smith. There he learned to develop sculpture in the round and to use assemblage. Many of the sculptures Prent made at the start of his career in 1971 reflect his interest in found objects, particularly pieces of leather and metal more than fifty years old. Prent often uses his own face and body in his sophisticated questioning work, as well as incorporating real objects in his installations like grocery-store mechanical rocking horses, bus station

201

Fig. 255. Mark Prent (b. 1947)
Ringturner, 1975
Mixed media, polyester resin, and fibreglass, life-size figure
The Artist
Photo: J. Littkemann, Berlin

202

Fig. 256. Evan Penny (b. 1953)
Murry, 1998
Resin, pigment, hair, 167 cm

photograph booths, Victorian bric-a-brac, and such freakish situations as a circus side-show. He taps the potential of each, relating it to the figure and how it participates with the object and the ideas he wants to convey. The emphasis is on the intersection of normalcy and the bizarre. The personal touch predominates; his objects are unique, tenderly crafted, and manipulated. Often, too, Prent's work seeks to make viewers check out their ideas. In *Ringturner* (1975, fig. 255), a naked man, bald, with a deformed neck, is suspended eternally short of the ring he wishes to grasp. Around his waist he wears the ring that gymnasts use: it is the same size as the ring for which he reaches. Prent knew the situation was absurd and impossible because the figure would have had to have grown in the ring — it hadn't been opened up and then bolted together. For him, it was a "humorous piece just because he had pushed it to the degree that he couldn't see how one could relate it to a real life situation."[10] In the 1980s,

Prent became interested in kinetic art. In his *The Incurable Romantic* (1981, Private Collection), the eyes of a simulated shrunken wizened "alligator-man" seated in a real Victorian child's barber chair, rove constantly to confront the viewer. Prent's extended realism lends itself to excessive reactions. He himself stresses the aesthetic involved in his use of the horrific, and the beauty of his work in terms of texture, form, and colour, but his critics find it hard to attend to these in the face of his subjects.

Sophistication of another kind marks the work of Toronto artist Evan Penny. The reputation of Penny, who came orig-

inally from South Africa, rests upon a very different kind of polychrome polyester resin sculpture. His whole figures or their fragments fall between superrealism and idealism, since he fuses the classical ideal with real people. Due to the size of his sculpture, four-fifths life-size, viewers are encouraged to see these uncannily accurate figures as fiction. Penny's intense idiosyncratic works such as *Murry* (1998, fig. 256) get more interesting as you study them.

Since the 1980s, art has often been concerned with a return to the image. After working through all sorts of permutations, artists of widely varying sensibilities have turned to representation to engage a certain quality of North American culture and make some mysterious new discoveries. David Thauberger in Regina, for instance, uses a level of realism in his dead-pan paintings of local architecture — farm houses, grain elevators, Masonic temples, and blown-up postcards of landscape. In *Eclipse* (1983, fig. 257), he applied all the "wrong" things he could think of to his canvas: dividing the composition exactly in half, using garish colour and rendering the two halves (top and bottom) of the painting in different ways (the top with airbrush and sand, the bottom, poured paint). Thauberger also paints landscape, appropriating his images from sources like a postcard, colour television, or *Field & Stream* magazine. Thauberger's attachment to place, and his adversarial relationship with high-art modernist culture as dictated from New York, recalls the art of Curnoe, but his formal invention — basing his art on techniques characteristic of popular culture such as stencilling — and the approach of his images to folk art is more satirical.

203

Fig. 257. David Thauberger (b. 1948)
Eclipse, 1983
Acrylic, glitter on canvas, 167 x 228.6 cm
MacKenzie Art Gallery, University
of Regina, Regina

As the 1950s drew to a close, new information about the world began to invade the domain of the individual; television brought politics into everyone's living room. The influence of the mass media, particularly its exposure of violence, became the subject of Toronto-based painter Claude Breeze in the early and mid-1960s. His response is personal, and his paintings show distant echoes of Francis Bacon's tortured faces and bodies, German Expressionism — and

Fig. 258. Claude Breeze (b. 1938)
Guardian of the City, No.1
[From the Faceless Angel series], 1991
Acrylic and oil stick on canvas,
190.5 x 137.2 cm
The Artist

204

the nervous line, agonized subject, and high-pitched colour of the macabre cartoons of Gahan Wilson. The paintings in Breeze's *Home Viewer* and *Control Centre* series often contain television knobs and the fronts of televisions. For the pictures of murder, riots, and war he inserts on the screen he drew upon the evening news or newspapers. In one painting, *Sunday Afternoon (from an old American Photograph)* (1965, Department of External Affairs Collection, Ottawa), he was inspired by a photograph in the University of British Columbia student newspaper, *The Ubyssey*, of a southern American lynching that shows two black people hanging from a tree. Breeze depicted the scene with the bodies partially nude and a pyre of flames like hands licking at their feet.[11] His 1964-1965 *angst*-ridden series *Lovers in a Landscape* works critically upon the audience's understanding of what it believes sexuality to be. Paintings like *A Hill Raja's Dream* (1963-1964, Vancouver Art Gallery, Vancouver) deal with lust. Its bold eroticism (he includes the Raja's erect penis, the smiling sideways head in the background and other less direct sexual imagery) indicates the influence of Persian art, which Breeze first saw in a show of miniatures at the Vancouver Art Gallery. The *Lovers in a Landscape* series number fourteen paintings in which naked figures appear in some sort of configuration. Breeze's approach varies from the violent to the erotic; he passionately portrays sensual desire without love and a kind of madness to "strip the skin off" the sick 1960s, he said.[12]

In the decade following 1973, Breeze, with restless eclecticism, explored a variety of subjects; these ranged from expressionistic visions in biting colour of the Canadian landscape mediated through his unconscious in the *Canadian Atlas* series (1973-1975) to an exciting form of abstraction that combines the organism and the environment. In the early 1980s, his fascination with oriental cultures and his practice of martial arts led to a series of lithographs, woodcuts and a group of eccentric paintings, each of which contains a wrapped symbolic weapon. During the late 1980s and throughout the 1990s, Breeze has investigated and used computer technology as it relates to the making of art while still maintaining his concerns with social and political issues in his paintings. His *Guardian of the City No.1* [From the Faceless Angel series] (1991, fig. 258) has a charged, in-the-thick-of-things immediacy that reveals his involvement in the emerging art scene.

Breeze was in a way a pioneer of a new way of regarding nature — as a landscape of signs. By the 1970s, this idea, reinforced by cultural theorists like Roland Barthes, evolved into a re-examination of the pre-Modernist past. Theoreticians tended to link this with the revival of specifically classical forms first in architecture and then in art which came to be known as "Post-Modernism." Post-Modernist architecture borrowed forms from the repertoire of classical art. In a similar spirit, Post-Modernist painting was a way of subtly twisting or adjusting information about composition, colour, and pictorial devices from the Old Masters to invoke the complex dynamics of gender and power. Post-Modern art claims that modern culture and the ideas that emerge from it are shaped by an illogical pattern of thinking arising from an abundance of opposing viewpoints. It detaches the image from a fixed time and place to link images of the old and the new, the mythic and the historical in what can look emblematic. Appropriation is one of the tools the Post-Modernist uses to create an art that is metaphorically evocative and formally inventive: the effect is clean and witty. The result is a reconfiguring of meaning, often one away from an assertion of identity or the idea that art emanates from personality; this art combines a profusion of disparate images with a multitude of styles and techniques drawn from a wide range of sources. Representative artists in Canada include David Bierk in Peterborough, Joanne Tod in Toronto, and Vancouver-based Jeff Wall.

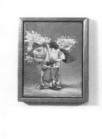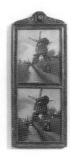

Fig 259. David Bierk (b. 1944)
Art in America Triptych, 1987
Oil on canvas, oil on board, photo-lithographic print on paper,
66.0 x 111.8 cm (installed)
Robert McLaughlin Gallery, Oshawa
Gift of Lynn Wynick and David Tuck, Toronto
Photo: T.E. Moore

David Bierk's installations and paintings, for instance, combine photographs of high and low art and art magazines covers, along with the work of past masters. In his *Art in America Triptych* (1987, fig. 259), Bierk reproduces a painting by Edouard Manet and presents it along with an *Art in America* cover and two framed and nearly identical panels of a Dutch scene. Bierk uses such combinations to create a kind of fantasy space and with theatrical flair plays with pattern and materials to create a transformation of his sources.

A prominent painter who effectively combines many of the policies of Post-Modernism is Toronto's Joanne Tod. Like many of her contemporaries, she has

205

206

Fig. 260. Joanne Tod (b. 1953)
Identification/Defacement 1983
Acrylic on canvas, left panel: 144.5 x 86.0 cm
right panel: 140.5 x 80.5 cm
Gallery/Lambton, Sarnia, Ontario
Purchased with funds from Wintario, 1985
Photo: Peter MacCallum, Toronto

been preoccupied with the potential of representation. Her work reveals that she holds herself and her painting close to artistic tradition and to history, but while she invokes the past, her images come from photography culled from the popular media or her own home images, combined in intriguing visual situations. These sources reflect an activist mood on her part — a need to make art that generates an active response to social and political issues like identity, gender stereotyping, race and representation, power and culture. More recently, Tod has examined the representation of objects. Through flat meticulously painted images and laid-back humour, which she uses as a device to add to the ambiguity of her work, Tod invites a variety of interpretations. In the early 1980s, she played with a process of substitution for the subject, often herself, replacing her image with others linked to the idea of desire. In *Self Portrait* (1982, Private Collection), for instance, the subject is derived from a 1940s *Harper's Bazaar* advertisement of a fashion model in a ball gown descending from the Lincoln Memorial in Washington, D.C. beneath a night sky. The image is undercut by the words "neath my arm is the colour of Russell's Subaru" painted in yellow over the lower portion of the dress. Tod introduces the prosaic thought — it refers to the shade of a friend's car — to satirize the seductiveness of glamour and its objectification of women. "The text," said Tod in 1987, "is a Koan-like, ambiguous phrase that gets its source from the way text is used in advertising."[13] In other works, she deals more specifically with issues of race and representation. *Identification/Defacement* (1983, fig. 260 The Gallery/Lambton, Sarnia), a diptych of an image of a black woman in bridal dress, has Tod's name written in yellow across the model's eyes. In the first panel, she identifies herself with the model; in the second, a panel with a similar composition, she recognizes that she cannot really identify with her and that her name is a defacement. Besides serving as a self-portrait in which the painter identifies herself as the marginalized "Other," the canvas through its title hints at the power of the artist to create and destroy and at Tod's complicity in the process of (mis)identifying women.[14] Her work of the mid-1980s continues to favour a sardonic mocking approach to the question of racial difference and the role of the patriarchy with regard to women; then as the decade wears on, Tod's subjects become extremely personal and idiosyncratic, and she complicates the reading of her paintings by switching to

207

collage and overlapping images. Through her use of irony, she seeks to insinu-
ate the viewer's tacit responsibility. But, despite the didactic tone, the impact
of her work lies primarily in its disquieting and subtle beauty. Tod's object-ori-
ented work, in which things are formally fragmented and displayed, reveals her
ability to handle three-dimensional space and to engage the viewer in the
physical reality of her subject. In the recent *In the Bedroom* (1998, fig. 261), Tod
returns to her earlier way of invoking the complex dynamics of gender and
power through juxtaposition; here she places in the same space a nude model
on a bed and a painting in the background of the space. In *In the Kitchen*, Tod
paints an image she found in a Japanese bondage magazine of a very athletic
figure suspended upside down. That the woman is in a kitchen matters to Tod:
for her, being in that space makes the woman in bondage the ultimate symbol
of vulnerability. She contrasts *In the Kitchen* with *In the Bedroom* where the
model lies on the bed in an informal pose that suggests a certain level of inti-
macy and trust. For Tod, the painting is about communication with another

Fig. 261. Joanne Tod (b. 1953)
In the Bedroom, 1998
Oil on canvas, 144.8 x 213.4 cm
Robert McLaughlin Gallery, Oshawa
Photo: Peter MacCallum

Fig. 262. Jeff Wall (b. 1946)
Bad Goods, 1985
Cibachrome transparency, fluorescent light,
plexiglass, and steel, 365.0 x 250.0 x 30.0 cm
Vancouver Art Gallery, Vancouver
Vancouver Art Gallery/Jim Gorman,
VAG 85.89

208

woman; although the model is black, it is not about the race. She finds the work more of a reference to art history: the placement of pillows and the figure recalls *putti* flying on clouds in Baroque painting. The result is a visual treat, beguilingly laced with suggestive references.

Post-Modernism's way of using the photograph as quick sketch, focusing attention on the off-kilter in the modern dream, shows to particular advantage in the work of Vancouver artists Jeff Wall and Ian Wallace; since 1970, they have concentrated on the dysfunctional side of North American, particularly urban, life. Wall's work, large elaborately staged photographic images presented in rear-lit display cases, exhibits incidents of everyday life that look impromptu but are carefully produced — with hiring of a cast through a casting agency, rehearsals and a script line developed jointly between artist and actor. Characterization is improvised from Wall's instruction. His use of memory and way of relating to art's past — through meditation on historical and conceptual reference points found in masterpieces of Western Art or in advertising or film — is Post-Modern in essence. Like Tod, he seeks to make viewers aware of stereotypes and their own cultural assump-

Fig. 263. Ian Wallace (b. 1943)
My Heroes in the Streets, 1986-1987
(one section of three)
Photograph, 182.9 x 304.8 cm
Catriona Jeffries Gallery, Vancouver

tions. *Bad Goods* (1984, fig. 262), for instance, punningly trades on middle-class fears.[15] In the 1990s, Wall's work has increased in complexity, with many more individuals involved, more fantastic stagings though in more realistic places, and the use of the computer to compose and manipulate images. What interests him are massive subjects. His long colour photograph *Restoration*, for instance, depicts restorers repairing an actual large-scale panorama. Wall uses black-and-white, by contrast, to return to earlier concerns, often people who pass unnoticed in society.

Ian Wallace combines large-scale photographs with abstract painting in photomurals to explore gesture and movement in relation to architecture. *My Heroes in the Streets* (1986-1987), consists of three large canvases; each has a rectangular colour photograph of people moving (on an escalator or walking on the street), balanced by rectangles of uniformly painted white canvas on either side (fig. 263). Though the photographs seem like casual snapshot images, like Wall's, they are posed; the individuals are Wallace's friends.

Toronto's Colette Whiten incisively addresses similar concerns, though her focus has been on the suppressed messages and incipient violence of news media. In the mid-1970s, at the start of her career, she was a sculptor of structures, often in plaster, that took the measure of people. In the 1980s, Whiten began to make extended narratives using photo-based images which she embroidered in traditional cross-stitch. In 1993, she turned to beadwork to reinforce her images, using photographs or headlines reproduced in newsprint and enlarged by photocopying (fig. 264). "I found that beads are able to break down the media image in a different way and still have the look of being digital," said Whiten. "The individual beads are like the digital dots of media photos."[16] In her *I Witness* (1996-1998),

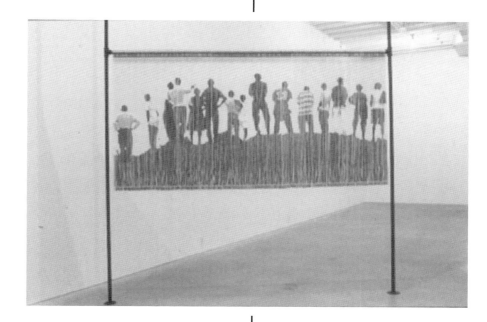

Fig. 264. Colette Whiten (b. 1945)
Haitians Watch, 1994-1996
Wire, black pipe, glass beads, lead,
127 x 229 x 5 cm
National Gallery of Canada, Ottawa
Photograph courtesy of Susan Hobbs Gallery, Toronto

Fig. 265. Tim Zuck (b. 1947)
Untitled #96, 1979
Oil on canvas, 91.4 x 91.4 cm
Private Collection

210

Fig. 266. Richard Gorenko (b. 1954)
Lead Products
for the 21st Century, 1984
Acrylic, gel medium, oil on masonite panel,
61.0 x 242.0 cm
Mendel Art Gallery, Saskatoon
Purchase with funds from the Canada
Council Special Purchase Assistance
Program and monies raised by the
Gallery Group, 1984

accumulations of beadwork portraits on embroidery cloth in glass balls attached to the wall (portraits of friends and acquaintances in the cultural community), she plays off conventions of photography. The curiously opaque commercial-style portraits have an intriguing complexity and an admirable sense of craft but, in the manner of photography itself, obscure and deceive as much as they reveal.

New Image Painting, by contrast to Post-Modernism, developed from a reaction to Conceptual art and involves an attempt to re-insert the personal into art. The term comes from a show that opened at the Whitney Museum in New York in 1978, which focused attention on work that had been evolving over the preceding decade. It refers to the general revival of painting involving the figure or landscape, often with strident imagery and abrasive handling. Painter Tim Zuck, who today lives near Midland, Ontario, uses a simplified motif in his work, but his orientation is towards abstraction, not traditional representational painting. His subjects — in the late 1970s and early 1980s, people, architectural forms, and boats expanded into a wider range of things that interest him — concern him less than their relationships and the process of art-making (fig. 265). Other New Image Painters like Richard Gorenko, a

native of Saskatoon, share his search for specific content through generalized symbols although, as in Gorenko's painting *Lead Products for the 21st Century* (1984, fig. 266), the symbols can become explicit.

The work of these masters of representation marks the beginning of a fruitful new relationship between form and content that is on-going. It expresses the dislocation of contemporary experience, a stage whose social and visual dynamics has always attracted artists. What artists distil from their living experience is a way of blending anxiety, intuitive design, and pictorial effects that are personable and distinctive; they are reconsidering the meaning of authorship, identity, and history.

212

Fig. 267. Sybil Goldstein (b. 1954)
Bacchus and Ariadne, 1982
Ceiling mural centre rondo, acrylic on paper,
approximately 304.8 cm in diameter
Cameron Public House, Toronto
Photo: Peter MacCallum

Chapter Eight
Themes of the 1980s and 1990s: Identity and Difference; Memory; the Environment

I t remained for a host of new artists in the 1980s to continue the critique of modernism initiated in the 1970s — to expand on issues of identity, originality and authenticity, memory and the environment, while drawing on new technologies like the computer. The work of these artists shifted direction, moving from a focus on the nature of art. In this shift of interest, certain subjects come to the fore as artists recast art that concerns the body, look at history as a pattern of manoeuvres, at the exploitation of familiar objects, at the environment. Art practice in the 1970s often involved modes of dramatization; the 1980s transformed the sense of tension into one of ambiguity or obliqueness. Artists also brought abstraction, the fundamental concern of artists of this century, to ever more relevant forms. The frontiers of art became indistinct and began to shift between contemporary styles, though flash points still continue to occur in the area of identity politics, cultural debates, and confrontations. The result is the appearance in art of continuity and design, the orchestration of pattern, texture, colour, and light to produce a single aesthetic experience. With the 1990s, those who were excluded from mainstream cultural experience were assimilated in the production and reception of art.

In the gallery world, the single most exciting development was the founding in 1983 of Le Centre International d'Art Contemporain de Montréal (CIAC), a corporation outside the traditional museum structure, one with the objective of encouraging and facilitating research into contemporary art. CIAC's exhibition of *100 Days of Contemporary Art in Montreal* organized between 1985 and 1996, which combined international and national artists, set a new standard of national aspiration. The nature of exhibitions of contemporary art in Canada expanded too. They became mosaics of various forms of expression, often curated by a group of scholars and critics, with the curator serving as co-ordinator; such an exhibition opened the decade of the 1980s, *Pluralities,* orga-

nized by curator Jessica Bradley at the National Gallery of Canada in Ottawa. Shows throughout the 1980s and 1990s can often be described as sprawling, absorbing "convocations," though, by and large, in the 1990s, elaborate spatial installations were replaced by subtler contributions. Exhibitions often relied on an arresting theme and the linking of two or three artists; sometimes exhibitions present wonderfully miscellaneous collections and a breathtakingly spacious exhibition concept. Movements in art display a similar restlessness and range of interests.

Neo-Expressionism, a movement in painting and sculpture that emerged in the late 1970s characterized by subjective feeling and an aggressive handling of materials, appeared in Canada in the early 1980s. Primarily a painting movement, it was limited to two cities: Toronto and Vancouver. Its practitioners usually selected subjects related to the figure. The work had a dark vision of the universe, the paintings characterized by subjective feeling, strong surface activity and a sense of the importance of art history. For critics and curators of the period like Toronto's Richard Rhodes and Vancouver's Scott Watson, the work felt fresh, vital, and larger than life, but also rooted in its time and place. In Toronto, the ChromaZone/Chromatique Collective (1981-1985) counted among its members Andy Fabo, Oliver Girling, Sybil Goldstein, and Rae Johnson. In Vancouver, the Neo-Expressionistic *Young Romantics* show, curated by Scott Watson at the Vancouver Art Gallery (1985), featured Attila Richard Lukacs, Angela Grossmann and Vicky Marshall. In both cities, the movement renewed interest in the figure and art that previously explored the subject of the figure. The work of Andy Fabo and Sybil Goldstein, both in Toronto, and Mina Totino in Vancouver teemed with an awareness of Greek mythology and representational modes (see fig. 267). Rae Johnson in Toronto and Attila Richard Lukacs and Charles Rea in Vancouver, by contrast, achieved powerful fusions of Christian vision and material sumptuousness.

The most compelling feature of Neo-Expressionism was its fresh interest in the figure. Many artists began to reinvent this crucial aspect of art for themselves. Betty Goodwin in Montreal continued her steep learning curve after exploring the porous borders of abstract form by returning to the figure in her large-scale *Swimmer* drawings. Swimming so fascinated her that she did many versions of it, recasting it in her own terms. A lover of humanity and a

lamenter of the wrongs of the twentieth century, Goodwin in her multi-media works melded beautiful layerings of improvisational drawing, rich colour, complex narrative, and literary associations with the emotive gestural rhetoric of Abstract Expressionism. Her swimmers by the late 1980s became more vulnerable. Her works, like *Porteur* (1986-1987, fig. 268), where a figure that looks flayed is carried by two worn companions, relate more to distant echoes of art history combined with references to recent human-generated cataclysms like the Holocaust. In *Beyond Chaos no. 7* (1998, Musée d'Art Contemporain, Montreal), the scene is of clouds with a vortex at the centre. In a lower register lies a person, seemingly dreaming. Goodwin herself spoke of her work in terms of memories of the body, but her inspiration ranges widely and addresses matters of global politics.

Goodwin's work is similar in theme to that of Montreal artist Barbara Steinman, who creates combined video/photograph installation pieces. In her inventive and beautifully made installation, *Cenotaph* (1985-1986, fig. 269),

Fig. 268. Betty Goodwin (b. 1923)
Porteur, 1986-1987
Graphite, oil pastel, and wash on polyester film, 226.0 x 213.4 cm (imp.)
Art Gallery of Ontario, Toronto
Purchase with the support of the Volunteer Committee in celebration of its 50th Anniversary, 1996
Photo: Carlo Catenazzi

215

Fig. 269. Barbara Steinman (b. 1950)
Cenotaph, 1985-1986
Video in plexiglas tetrahedron with painted wood base, three engraved granite slabs, two two-way mirrors with rear-projected black-and-white slides, 8.4 x 6.6 x 4.8 m
National Gallery of Canada, Ottawa

Steinman took a sentence from Hannah Arendt's *Totalitarianism* and divided the words into sections engraved on three granite slabs. Placed upright in the centre of a darkened room, these tablets form a massive pyramid. Concealed within the monument, inside a painted wood sculpture with glass, is a monitor and video equipment that plays the image of an eternal flame on a sheet of glass suspended above the structure. Placed in opposite walls of the structure are a pair of arched windows composed of two-way mirrors. Slides of anonymous grave sites, book burnings, and faces of those who died in the Holocaust flash onto the surfaces of the transparent mirrors for a few seconds each. As curator Barbara London observes:

> These historic images refer to the relentless diaspora of this century. They also represent the colliding perceptions found at the edges of collective memory ...[1]

Steinman's later works, such as *Hourglass* (1998), continue the layering of personal experience and world history through the medium of photography, as well as addressing time and memory. This four-part photographic work merges the form of an hourglass with images from the 1998 ice storm in Quebec to create a layered, textured result. Steinman plays effectively with the visual images, moving from a scene in the grip of winter to a final "breaking loose" which has the sense of a revelation.

In the 1980s, expertise was ever-inventive, and it was impressive that material and technique so seldom repeated. Artists ambitiously explored possibilities.

Sylvie Bélanger, working at the University of Windsor, Ontario, is one of the more recent contributors to the theme of the body and technology. In *He* and *She* (1992, fig. 270) she covered two colour photographs of a man and a woman with sandblasted glass printed with elaborately etched scrolls reading "he" and "she." The writing that lies over the face plays off the photograph in a way that is both intellectually witty and mysterious. In work like *The Silence of the Body* (1993-1994, Musée du Québec, Quebec), a complex installation of back-lit black-and-white transparencies,

Fig. 270. Sylvie Bélanger (b. 1951)
He; She, 1991
Colour photograph and sand-blasted glass,
(each) 76.2 x 101.6 cm
Macdonald Stewart Art Centre, University
of Guelph, Guelph

video cameras, video projection, and fluorescent lights, Belanger explores the fragmentation of the body by technology, with a reference to global surveillance. As with Cadieux, it remains for the viewer's vision to unite the work. Her video projection of *Le regard du Silence* (1998, Art Gallery of Windsor, Windsor) continues her theme of transformation: here, pages turn on a screen to build an image of a woman's face, which again reverses to turn into pages turning.

Time and our interaction with the space created by our bodies, and the identification of objects by their physical appearance, are the subjects of Liz Magor, who moved to Toronto from Vancouver in 1981. A skillful process artist with an idiosyncratic, sometimes absurdist, sensibility, Magor had been working with natural processes and materials that she fabricated into images of remembrance as in *Time and Mrs. Tiber* (1976, National Gallery of Canada, Ottawa). While visiting Tiber Bay on British Columbia's Cortez Island, Magor discovered a collection of preserves and recipes in an old building once owned by a Mrs. Tiber.[2] She dismantled the collection and shelving and brought them to Vancouver where she added jars of her own. To the inner shelving and recipe files, she added newspaper references to time and death. The production of the work was mostly by her subject — Magor's activity was represented by the shelf of preserves, for her an analogy to the work of the artist. In her Toronto works, such as *Production* (1980) and *Dorothy, A Resemblance* (1980-1981, National Gallery of Canada, Ottawa), she conveys not only a similar message but makes the relationship between form and content more specific. In *Production*, an installation of brick-like forms she made from soaked and compressed newspaper in a moulding device, Magor develops the theme of process and repetition, the way an artist makes one thing after another. In *Dorothy, A Resemblance*, Magor uses sculpture as a means of investigating the formation of identity by setting up four tables mounted on springs so they become scales on which she set lead shapes that constitute her subject's life — food, household items, books, and means of transportation, each stamped with text. Each table group corresponds to the weight of her subject at a certain period of her life, and the heights of the table tops physically illuminate the changes to her subject's body. Dorothy's factual but commonplace narrative accompanies the measures of weight:

217

I have always weighed 98 lbs. Once I weighed more, when I was first married I weighed 124 lbs. But that year we worked so hard taking those darn boats up and down that I lost some of that weight and went down to 98 lbs. And I stayed there, 60 years, until this trouble with my eyes. After my operation I was down to 82 lbs. but I thought to myself "this is no good" and I got myself back up to 98 lbs. again and that's where I am now.[3]

In more recent work such as *Messenger* (1996), her reconstructed nineteenth-century pioneer cabin, Magor has continued her exploration of the shapes of past or present lives.

Fig. 271. Micah Lexier (b. 1960)
A Minute of My Time (December 7, 1998 21:57 - 21: 58), 1998
Waterjet-cut hot-rolled steel, urethane finish, metal posts, 182.9 x 645.2 cm
Jack Shainman Gallery, New York

218

Other artists in the 1990s, such as Toronto's Micah Lexier, draw on the resources of Conceptual art to explore the passage of time and the aging process. Lexier made his first "minute" drawings, consisting of a series of small doodles, each made in one minute, in what became an ongoing project, *A Minute of My Time* (1995). The imagery offered him a way of presenting the beauty of line, specifically line that was greatly enlarged. Subsequently, Lexier produced minute drawings in a variety of media from acid-etched stainless-steel, to prints, to chalkboard drawings. In different installations of the series, he presented a "history of the minute series," including in each case a large site-specific hand-painted wall minute drawing, a variety of acid-etched steel pieces, a variety of other works (coins, box pieces, prints), and at each venue, a unique public project. At the Dunlop Art Gallery in Regina in 1998, for instance, this consisted of publishing in the local newspaper one different minute drawing per day for the five consecutive days leading to the exhibition;

at the Charles H. Scott Gallery in Vancouver, Lexier produced an edition of flags (actually three flags that had one third of a minute drawing on each) in an edition of ten. The exhibitions consist of small stand-alone items, but the effect is one of total immersion. The gigantic waterjet-cut steel doodles, in particular, like *A Minute of My Time (December 7, 1998 21:57 - 21:58)* (1998, fig. 271) underscore the formal sophistication of this artist's work, often a meditation on the variables possible in materials and contexts.

Another major theme of the 1980s and 1990s concerns the dimensions of the inner self. Shelagh Keeley's work orchestrates drawing to inhabit the enigmatic area between representation and abstraction and obliquely explores subtexts of the 1980s and 1990s. With pastel, chalk, oilstick, wax, dry pigment, charcoal, and plaster, she makes marks on paper, walls, and found objects such as steel panels to produce powerful large-scale works, hand-made books, and site-specific installations. In 1980, Keeley made a large wall drawing on a crumbling hundred-year-old plaster-and-lath wall covered with marks and soon to be refinished. In her imagery, "psychological structures," as she called them, she referred to cycles of life and death, day and night, and spatial archetypes of light and shade.[4] She fills her drawings with ambiguous shapes, suggesting ideas drawn from her dreams and imagination, and the effect on her of a year in Africa (she was in Kenya, Ethiopia, and Tanzania from 1974 to 1975). Keeley's next drawings combined different materials on paper and wall surfaces. In more complex pieces, like *Room with a View* (1984), an installation she did at 684 Queen Street West, Toronto, Keeley ingeniously used the shape of the wall and her memories of architectural decoration and pattern to create a large intricate painterly surface that suggests one animal preying on another. Other strong works include her *Fragments of the Wall/for Pasolini* (1984), installed at the Art Gallery of Harbourfront in Toronto. In subsequent works, like *Writing on the Body* (1988, fig. 272), Keeley continued to expand on her theme of walls, sometimes using photographs accompanied by marks in black

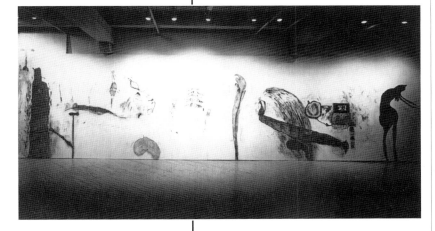

Fig. 272. Shelagh Keeley (b. 1954)
Writing on the Body, 1988
Wax, pigment, chalk, pastel, graphite, collage, and pencil on wood, 360 x 2310 cm

219

Fig. 273. Jana Sterbak (b. 1955)
Vanitas: Flesh Dress for an Albino Anorectic, 1987
Flank Steak, dimensions vary

and red to suggest oppression.[5] She also has attempted to map the interior of the body, half scientifically, half intuitively, again using wall as her canvas.[6]

Montreal-based Jana Sterbak has been making sculpture since the 1970s, but much of it wasn't seen until her 1988 show at the Power Plant in Toronto. That exhibition showed the full range of Sterbak's powerfully eccentric work, ending with her *Vanitas: Flesh Dress for an Albino Anorectic* (1987), a shift of twenty-three kilograms of raw, sewn-together flank steak, which indicated her ongoing project of interrogating the human condition and the body (fig. 273). The dress made viewers cringe, by reminding them (particularly women) of the nature of carnal things. The work made a direct reference in both structure and motif to the *Vanitas* paintings of the Baroque period and to the philosophical issues that lie behind them: mortality and vulnerability. That the meat aged and dried out as it was left to hang in the gallery was appropriate to the intention of the work. Some observers believed that Sterbak, through her use of hormone-injected meat, was satirizing the North American regimes of chemical supplements.[7] In 1991, during Sterbak's retrospective exhibition, *States of Being*, at the National Gallery of Canada, the "flesh" dress was criticized in Parliament (by the head of the Federal Task Force on poverty) as being wasteful of public money, bringing Sterbak to widespread public attention.

States of Being was a model exhibition for a midcareer artist. Given large well-lit galleries and organized thematically, the show drew the viewer's attention to clothing and wearable objects as metaphors for the body. The twenty-five pieces provided a map of the artist's path from 1987 and effectively changed the way the artist was viewed not only by the public but by the critic and scholar. Sterbak is one of the noteworthy artists in Canada. Her sculpture has extraordinary range; she has moved from making small poetic sculptures that normalize materials or forms associated with women — using oddly assorted objects like measuring tapes coiled into little conical shapes — to making more didactic statements. The latter involve some unusual new materials drawn from industry and from everyday life. In *I Want You to Feel the Way I Do ... (The Dress)* (1984-1985, fig. 274), for instance, the dress was com-

posed of wire-mesh. Sterbak wrapped it with the middle
uncoiled stove wire, which glowed deep red when someone
walked into the room. "I don't want to hear myself think,
feel myself move," read part of the text projected on the wall
behind the work. "I want to slip under your skin: I will listen
for the sound you hear, feed on your thought, wear your
clothes." The electric dress seemed an appropriate
metaphor not only for anger but for jealousy and passion.
(The genesis of the dress was the story of Medea in the
Euripedes play.)

Sterbak has always approached her work with irony.
Born in Prague (she emigrated to Canada in 1968), the
daughter of parents who were intellectuals, Sterbak early
learned to be sceptical of authority and to communicate
critical opinions through humorous and ironic allusions.[8]
Issues of control and the constraint placed on the individual
by society are major themes. Diana Nemiroff, curator of her
show at the National Gallery, says that one of Sterbak's sub-
jects is the paradox of destruction as the means to creation,
and the recurrence of the idea links her to a romantic cur-
rent in European thought. Yet the ambiguous wide-ranging
way Sterbak approaches her subject allies her with North America. Her terrain
is identity, the persona and society. "My work has to do with the limits of the
individual, limits that are defined as they always have been, and always will be,
by our mortality," said Sterbak in 1998.[9] In the third of her dress works,
Remote Control I and *Remote Control II* (1989), two cage-like motorized crino-
lines glide through space, manoeuvred from a distance by a radio-operated
remote-control. In 1992, Sterbak created a male counterpart, *Sisyphus II*, which
was shown at the Museum of Modern Art in New York. In it, a chrome struc-
ture is displayed with a film in a darkened room. The film shows a muscular
man inside the sculpture, rocking it. More recently, Sterbak has taken her ideas
in more casual and playful directions and turned her focus on technology,
imbuing it with poetry and her own sense of the absurd. In her video installa-
tion, *Declaration* (1993) (Jacobsen version), a young man with a severe stutter

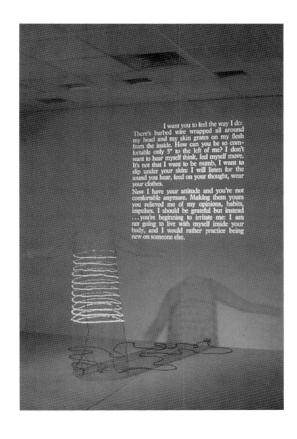

221

Fig. 274. Jana Sterbak (b. 1955)
*I Want You to Feel the Way I Do ...
(The Dress), 1984-1985*
Live uninsulated nickel-chrome wire mount-
ed on wire mesh, electrical cord, and power,
with slide-projected text,
144.8 x 121.9 x 45.7 cm
National Gallery of Canada, Ottawa

reads in reverse order Thomas Paine's *Declaration of the Rights of Man and the Citizen* of 1789, a defence of human rights and the French Revolution. In 1997-1998, for a mid-career survey of her work at the Museum of Contemporary Art in Chicago (1998), Sterbak created an interactive work, *Baldacchino* (1996-1998), with a head-high metallic canopy on wheels that moves independently around the gallery and pursues the unwitting viewer.[10]

Political issues and identity have been major themes in art of the 1980s and 1990s, and they're still going strong. Krzystof Wodiczko, who emigrated to Canada in 1977 (he moved to New York in 1983) had been an artist, industrial designer and teacher in Poland; in Canada, he developed the idea of the work of art as a public act. Angry over the coldness of the city where he lived — Toronto — and the lack of communication between individuals, he began to associate the strictures of the society with its buildings; one made the other unresponsive, he believed. For Wodiczko, behind much of the monumental architecture he disliked lay Canada's colonial eighteenth century: this heritage put the present century into a straitjacket, Wodiczko felt. His observation of Toronto buildings led him to study

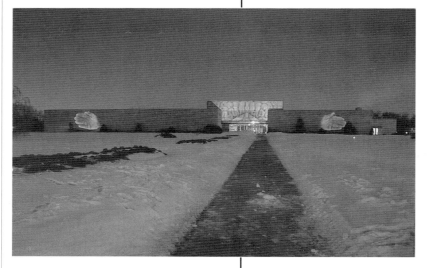

222

Fig. 275. Krzystof Wodiczko (b. 1943)
***Public Projection at the Museum of
Natural History, Regina,
Saskatchewan, 1983***
Photograph courtesy of MacKenzie Art Gallery,
University of Regina, Regina
Wodiczko projected an image of a brain and
images of hands onto this building. A text carved
on the facade dedicates the museum "... to those
who came from many lands...." but the bas-relief
next to the text depicts a white pioneer family,
which reveals the architecture's hidden bias and
its meaning as an icon of, and monument to, the
colonizing power of "western civilization."
Wodiczko's intention was to demythify this monu-
ment.

bureaucratic architecture across Canada and abroad, and he developed a critique of the language of power materialized in such architecture. "This will be a symbol-attach, a public psychoanalytical seance, unmasking and revealing the unconscious of the building, its body, the 'medium of power,' he wrote.[11] Using a building and its functional significance as something of a found object Wodiczko projected his own slide image onto its exterior at nighttime, a slide in which he sought to demolish the myth of the building. Such projections, often of objects and body-parts, commented on the building's function and structure, its status in the community and the social meaning of its architecture (fig. 275). Using slides, Wodiczko opened up the implications of the structure, explored its symbolism or challenged the building on its own ground. On some occasions, he disclosed the nature of the building's formal operation to

reveal a hidden militarism. To refer to apartheid and imply that South Africa was killing itself over the issue of white supremacy, Wodiczko projected onto the vertical shaft of Toronto's South African War Memorial, a clenched fist plunging a dagger into a stomach (1983). To raise questions about capital punishment, incarceration, freedom, and the law, he projected onto the facade of the Federal Court Building in London, Ontario, two hands grasping prison bars (1984). Wodiczko described his work as architectural "epic theatre." He viewed the city as an already existing semiotic system that he had opened for reinterpretation, by engaging the public. In this respect, his work recalls certain features of AgitProp theatre, as exemplified by Bertold Brecht, in which the playwright attempts to create a continuum with reality.

Like Wodiszko, artist Ron Benner, of London, Ontario uses cultural myths to question the way these myths have been represented. Most notable among his many installation and photography pieces from 1985 to 1995, is Benner's work with the sources, politics, and meaning of food. In *Trans/Mission:*

Thanksgiving (1991/1994), an installation of five black-and-white photographic murals, and a display of corn plants, corn cobs, beans, squash, and spent ammunition, for instance, Benner links images from historical paintings of Thanksgiving to a history of violence, contrasting them with the 1990 Oka crisis (central panel). He frames all three panels with enlarged details from a painting by Benjamin West, *The Death of Wolfe* (1771). The effect is oddly moving.

223

Fig. 276. John Scott (b. 1950)
September Song, 1993-1994
20 ink on paper drawings, control box,
light bulbs, cassette tape
(John Scott singing "September Song"),
149.0 x 472.0 cm (wall pieces)
Robert McLaughlin Gallery, Oshawa
Photo: Blake Fitzpatrick, Oshawa

Toronto's John Scott shares certain features with Benner: cultural erudition and an interest in marrying unusual combinations. In his offbeat and unexpected works, edgy currents eddy and swirl. Scott has used drawing with darkly comic imagery, like sad-faced bunnies, or the image of a skull and crossbones repeated in a multiple to form an installation combined with the sound of his own voice (on tape) shakily singing the 1940s tune *September Song* (1993-1994, fig. 276). In 1989, in the only act of self-mutilation thus far in Canadian art, Scott evoked the horrors of the Holocaust in a work titled *Selbst*. In this

Fig. 277. John Scott (b. 1950)
Trans-Am Apocalypse, 1988
1981 Trans-Am car with primer and latex
paint, incised with text from the Book of
Revelations of Saint John the Evangelist,
fuzzy dice, 1.27 x 1.78 x 5.0 m
National Gallery of Canada, Ottawa

224

installation, he presented a piece of his skin, surgically removed, which he had arranged to have tattooed with three small roses and a six digit number to commemorate concentration camp victims during the Second World War. In an exhibition in Toronto in 1990, Scott used a reproduction of the work as the invitation to his show as well as displaying the piece in a metal and glass case. In another unusual installation combined with engraving he combined a vision of Armageddon with a potent symbol: in his *Trans-Am Apocalypse No. 2* (1993, fig. 277), he had the text of the *Book of Revelations* of St. John the Divine in the New Testament scratched onto the surface of a black Pontiac Trans-Am automobile.

Another recurrent theme is identity. It concerns Toronto's Vera Frenkel in her engrossing work *...from the Transit Bar* (1992, fig. 278), a six-channel videodisc installation in the form of a functional piano bar; this has recorded and live sound, furniture and props, texts, photographs, and six channels of orchestrated video. In the work, Frenkel explores displacement and loss — themes that have in different ways informed all of her multi-media projects. Here, a group of artists, regulars at a bar, consider the possibility of reinventing a connection to an earlier artist and an absent work; the narrative concerns tales of personal displacement within a larger historical context. *Body Missing* (1994), another six-channel installation and website (1995) considers

Fig. 278. Vera Frenkel (b. 1938)
...from the Transit Bar, 1992
Six-channel video installation/piano bar,
built at documenta 9, Kassel, 1992; recon-
structed 1994-1995, Power Plant Gallery of
Contemporary Art, Toronto
(partial installation view)
Photo: Isaac Applebaum, Toronto

the relationship between collecting fever and the Kulturpolitik of the Third Reich. Linking *...from the Transit Bar* and *Body Missing,* Frenkel's related Web site is structured around six major areas — Artists, Bartenders, Beyond Information Sources, Piano Players, and Video — made accessible through Transit Bar imagemaps. *The Institute: Or, What We Do for Love* (1998), a radio-video-web poly-serial narrative on the travails of a large cultural institution, follows her earlier themes of exile and cultural memory into the bureaucratization of everyday life.

Other ways to represent identity are on view in the work of Vancouver's Jin-me Yoon, who came to Canada from Korea. In her light box installation *Souvenirs of the Self (Lake Louise)* (1991-1995, fig. 279), Yoon places herself in the centre of a stereotypical view of Banff National Park to define the inclusion of racial minorities in a typical representation of Canada. On the verso, she creates a text that ironically honours Princess Louise, for whom Lake Louise was named. To record the same experience, Yoon also published six postcards in a perforated strip in an edition of 2800, with captions in English, French, Korean, Japanese, and Mandarin.

Photographer Rafael Goldchain's smart and funny *Self-Portrait* triptych (1999, fig. 280) offers three stereotypes about the cultures that form his personality — Spanish conquistador (he was born in Santiago, Chile), member of the Canadian Mounted Police (he became a Canadian citizen in 1983), and rabbi (he descends from Polish Jews). He explores the rich veins of what is coming to be a constant source of contemporary art. So does Janieta Eyre, the surviving sibling of a Siamese-twin birth. However, Eyre, in photographic tableaux like *Twin Manicurists* (1996, fig. 281), a surreal double portrait, also evokes our

Fig. 279. Jin-me Yoon (b. 1960)
***Souvenirs of the Self
(Lake Louise), 1991-1995***
recto and verso
Duratran, metal, vinyl lettering, edition 1/2,
66 x 77.5 x 11 cm;
Kamloops Art Gallery, Kamloops

225

Fig. 280. Rafael Goldchain (b. 1953)
Self-Portrait triptych (1998)
Chromogenic photographic print,
101.6 x 76.2 cm (each)
The Artist

226

Fig. 281. Janieta Eyre (b. 1966)
Twin Manicurists (1996)
Black and white photograph, selenium toned
fibre based print, 76.5 x 102.cm
Macdonald Stewart Art Centre, University
of Guelph, Guelph

chaotic culture, its growing fascination with freaks and mascots, harking back to the photographs of American Diane Arbus. In the mysterious diptych *For My Trip to the Under World* (1998), shown as part of her *Black Eye* series (1999), Eyre photographs herself in her typical seventeen-second exposure, front and back, dressed in a flowing robe with gauze over her eyes and a Mickey Mouse hat against a background of rich materials. The mood is subdued, as though she were thoughtful over the philosophical implications of her investigations.

Thoughts on originality and authenticity have been laid out in depth by artists of the 1980s and 1990s. Cultural heroes, quotes from earlier art work, often shore up aesthetic aspirations. An important painter in Canada, Attila Richard Lukacs of Vancouver, has shown often in Berlin and elsewhere in Europe since the mid-1980s. His painting searches for roots and self-definition; he expresses the power of homosexual culture. His large canvases centre on naked human bodies playing out explicit or implicit activities, metaphors or rituals with props, gestures or actions. Pictures like *This Town* (1990, fig. 282), one of his *E-werk* series (the abbreviation of the German expression for power plant as well as the name of Lukac's favourite club) reveal his inspiration — here, skinhead workers who clean and reblock the pavement located in front of the Altes Museum in Berlin. Between the museum columns, screens read "Peter John Day 1949-1990," a memorial to the Toronto curator and writer. The references in Lukacs become increasingly arcane, sometimes seemingly neo-

Nazi or Communist, sometimes a kind of invented set of archetypes taken from a multitude of sources, Western and non-Western like the Persian miniature. The subject is always the male body portrayed explicitly and presented centrally. Props may include Doc Martens boots and tattoos. The emphasis is on the shared life of men, on symmetry, confrontation, and non-specific but clearly art-historical references. The painting of Lukacs is bold, cold, wrapped in silence, and charged with sensuality, mystery, and menace.

Fig. 282. Attila Richard Lukacs (b. 1962)
This Town, 1990
Oil, enamel, and tar, 389.8 x 608.8 cm
Musée d'Art Contemporain de Montréal, Montreal
Gift of Helen and Joseph Lukacs
Photo: Denis Farley

There's a curious tension between ethnicity and poignant loneliness in the work of Natalka Husar. One could read the paintings she began to make in the mid-1980s as allegories of identity or as windows onto the primitive collective unconscious of modern society. Still, it's the free play of imagination and the inventive draughtsmanship of swathes of bedding to cast-off shoes that one values most. Like Evergon, Husar occasionally bows to art history: she casts a sharp eye on the way the Neoclassical painter Jean-Auguste-Dominique Ingres paints garments, for instance. Although her work is representational, Husar likes to think of herself as a formal painter; her work is an amalgam of representational narrative and formal substructure.[12] In its blend of real and unreal, she may touch on the layered effect of collage, and, in her fantastic combinations of private fears and imaginings, on Surrealism. In *Dream/Scream* (1988), Husar represents herself haunted in the privacy of sleep by three images of idealized women, Superwoman among them. She also appears in the curtains as though she were a murderer. In *Have My Cake and Eat It Too* (1988, fig. 283), Husar paints herself as an old woman in a baby carriage being pushed by herself as a child. She also appears as a mature woman, trying to close a door through which a parade of people, herself included — one carrying a birthday cake with lit candles — enters a room. On the wall, her formal portrait appears in a gold frame: Husar as a commodity. Scattered in the room are high-heeled shoes, the kind women buy but never wear. In 1990, Husar's work grew

227

Fig. 283. Natalka Husar (b. 1951)
Have My Cake and Eat it Too, 1988
Oil on linen canvas, 178.6 x 203.4 cm
Robert McLaughlin Gallery, Oshawa

Fig. 284. Rene Pierre Allain (b. 1951)
Open Warp No. 1, 1996
Steel, clear sealer, 152.4 x 188.0 x 15.2 cm
Lonsdale Gallery, Toronto

more complex, and she changed from paint to drawing with oil stick. In 1992, a visit to the parental homeland led to a new series that explored not only the subject of Ukrainian but Canadian consciousness. The results, six large, oil-on-linen works with a whirlwind of people and objects that refer to the Ukrainian community and North American consumers, are imposing.

René Pierre Allain, Leopold Plotek, Regan Morris, and Neil Marshall are among the interesting abstractionists of this generation. Best known for his plaster paintings with a few broad stripes of sombre colour housed in elaborate steel frames, Montreal's Allain, who now lives in New York, also manipulates large steel pieces that he calls "warps" (fig. 284) He creates steel bands and plates, often darkened with gun blue, configured as a pictorial surface. These industrially precise pieces which exist in the crossover area between painting and sculpture seem to float on the wall.

Like many in his generation, Leo Plotek in Montreal creates physically appealing abstractions that refer to landscape, architecture, and the presence

of objects (fig. 285). His fragmented imagery conveys his allusive, eliptical narrative. Toronto's Regan Morris, by contrast, in works like *Oscar Wilde's Last Words* (1993, fig. 286), creates patterned paintings with layers of latex and shellac applied to cotton sheeting treated with caulking: through his "peeled" technique (the latex cracks because it dries more quickly than the caulking), which recalls dry mud or skin, and images that hint at memory and history, Morris subtly evokes order and decay, the AIDS crisis. As curator Carolyn Bell Farrell has pointed out the process involved in his surfaces simulates living cells invaded by viruses.[13] His subject in *Floor Show* (1999), a series of wall works that recalls floor patterns, is brown-and-white checkerboards or abstract patterns stained with what look like body fluids, often scuffed-looking or with glitter added to the peeling paint surface.

Equally subtle is the evocative technique used by Neil Marshall, who lives in New York. In his *Cinders and Apparitions* series (1994-1995), black paint outlines white shapes that reverberate with hallucinatory effect (fig. 287). Marshall took the word "cinders" from Jacques Derrida's book *Cinders* (1991) in which

Derrida wrote that language has been burned beyond recognition, rendered useless. "Apparitions" came from Marshall's sudden rushes of memory of people who have died. He developed the series into complex, elegantly simple, and delicate meditations on nostalgia, memory, identity, and loss, exploring personal issues that have social and political relevance (like the loss of friends to AIDS). He also uses the series as a metaphor for a dead world full of ghosts with all that implies — from vanishing species to unknown lives. Though his paintings are contemplative and filled with haunting and mysterious forms, they are not elegiac but exude energy and power.

Since 1980, sculpture has been inventing work that combines logic and the imagination. Judith Schwarz, using forms attached to the wall or resting on the floor and combining metal and wood, constructs frameworks for thought with slightly eccentric formal, representational or conceptual additions. In *Parallel*

Fig. 285. Leopold Plotek (b. 1948)
The Exactio, 1992-1995
Oil on canvas, 198.1 x 156.9 cm
Barry Joslin, Toronto
Photo courtesy of the Artist
and Olga Korper Gallery, Toronto

Fig. 286. Regan Morris (b. 1957)
Oscar Wilde's Last Words, 1993
Acrylic, latex, gauze, masonite,
304.5 x 1645.9 cm
Photo: Peter MacCallum

229

Fig. 287. Neil Marshall (b. 1948)
Drifting Shades, 1994
Oil on canvas, 152.4 x 182.9
The Artist
Photo: Long Fine Art, New York

Fig. 288. Judith Schwarz (b. 1944)
Parallel Language, 1987
Steel and English Oak, 274.3; 25.4 x 632.4 cm
Photo: Isaac Applebaum

Fig. 289. J.C. Heywood (b. 1941)
Still Life with Glass Bottle and Guitar
(A Study in Surfaces), 1999
Screenprint on paper (edition of 50),
68.6 x 86.4 (imp.)
Mira Godard Gallery, Toronto
Photo: Mira Godard Gallery, Toronto

Language (1987, fig. 288), she presents her point of view. There are four parts to this sculpture: a trapezoidal steel plate that rests on the floor with a form like a leaf or flame cut out of it, a section of a real English oak tree flush with the wall, a steel beam that lies on the floor and a wall-mounted steel disc.[14] The work appropriates forms from a wide pool of images and patterns, and through its evocation of trees and distant nebulae, sneakily interrupts our everyday habits of perception and cognition. Schwarz has expanded on the idea of perceptual play in her works of the late 1990s, as in *Crossover* (1998) where she creates a spotlit metal rose window of geometric design, whose pattern is doubled on another wall to create an interplay of light and space.

Investigating perception is also the subject of the inventive Toronto-based installation sculptor Tom Dean. Some of his ideas result in grand and bizarre assemblages like his nine-metre high, dot-covered *Floating Staircase* (1978-1982), which he situated on Lake Ontario where it sailed with ponderous grace, then was set afire. The installation piece, *Beds* (1979), (Dean believes most people move from bed only with difficulty), consists of a row of hospital beds also covered with tiny dots. Dean's subjects, such as his *Cock Photos* (1973), of painful-looking masturbation, could look startling but more often seem like poetic discoveries. In his *Amazing Grace* (1998), for instance, a refrigerator plays a recorded sound track of the well-known hymn. The music stops when the viewer opens the door of the fridge; the effect is eerie.

Printmaking continues in full force, often with a sophisticated blending of form and imagery. Through the 1980s, one of the most innovative printmakers in Canada, René

Derouin, worked with large-scale prints and installation, drawings, paintings, relief sculpture, and ceramics. Kingston-based J.C. Heywood is remarkable for his immaculate large etchings and recent screenprints that combine consummate craftsmanship with fastidious technique, like *Still Life with Glass Bottle and Guitar (A Study in Surfaces)* (1999, fig. 289). The eccentric printmaker Otis Tamasauskas, also working in Kingston, Ontario, exuberantly explores large scale hand-coloured editions in a series of highly experimental constructions composed of found artefacts and print elements. Working intuitively, inspired by the physical properties of the material, Tamasauskas incorporates different processes and motifs in painterly prints with witty references to forms like a favourite Japanese fan, or a trout, or birds (fig. 290). Tamasauskas exemplifies

Fig. 290. Otis Tamasauskas (b. 1947)
On the River I Drifted While the Red Birds Danced, 1987
Print on paper 2/5, 71.0 x 103.9 cm
Robert McLaughlin Gallery, Oshawa

a new kind of printmaker — one who works loosely with the medium. Jeannie Thib in Toronto conveys the same relaxed attitude by screen printing onto unconventional materials like blackboard slates, leather gloves, and oiled and sewn paper — components like lace handkerchiefs, floral motifs, maps and texts — to explore a wide range of concerns, mostly female identity.

Fig. 291. Peter Krausz (b. 1946)
Bathsheba, 1989
Colour photocopy, dry and oil pastel on collage, 127 x 76 cm
Private Collection

The significance of memory was probably never as earnestly probed as by artists of the 1980s and 1990s. The weight of history presses heavily on the landscapes and urban scenes of Peter Krausz, working in Montreal, making them a personal form of testimony; this is where humanity has been, he says, in the age of totalitarianism. In his multi-media *Fields (Peaceful Landscape)* (1986, Robert McLaughlin Gallery, Oshawa), using as inspiration a photograph of Birkenau concentration camp, Krausz evokes the view of railroad tracks leading to the site. In the foreground of the painting, he paints a floating head to indicate that the piece is one of the imagination. Other multi-media works

231

Fig. 292. Peter Krausz (b. 1946)
Landscape and Memory #22
Oil paint on plaster, 91.4 x 203.2 cm
Videotron
Photo: Pierre Charrier

Fig. 293. Stephen Andrews (b. 1956)
Album, 1995 (Simplicity) #5
Graphite and oil stick, with chalk and
coloured pencil on parchment paper, 30.0 x
23.0 (each of 43 sheets)
Art Gallery of Ontario, Toronto
Purchased with support of Salah Bachir and
the Canada Council's Acquisition Assistance
Program, 1996
Photo: AGO Sean Weaver

232

of the 1980s like *Bathsheba* (1989, fig. 291), with their haunting references to the body and art history, equally express Krausz's visual sensuousness. His *Landscape and Memory* frescoes (1992-1998, fig. 292) explore tortured symbolic terrains in spare but powerful areas of colour. In Krausz's oil on lead *Sky of Lead* series (1991-1996), which has one hundred and seventy-five panels, he explores the theme of the sky and over-paints names of sites and dates describing two thousand years of Jewish history in France. In a more recent work, *Mediterranean Breviary No. 2* (1998), he bases the arrangement of his thirty-one panels on a wall composed of fragments he saw in the church of Santa Maria de Trastevere in Rome. The separate panels in this mural interact with each other: the viewer has to piece it together to sense that they are united by his sensibility.

The subjects of the gifted draughtsperson Stephen Andrews are similarly wide-ranging. In *Facsimile* (1991-1992), a deceptively simple portrait series, he poses questions for the viewer; the works are likenesses of individuals lost to AIDS-related illness. Andrews, who trained as a photographer but gravitated to drawing, memorialized these likenesses from a Toronto gay weekly newspaper on bleached beeswax sheets coated with graphite; he gives the portraits, some of which are blurred or indistinguishable, a snapshot feel. In a series begun in 1994, *Fingerprints*, he develops parallels between his own fingerprints and portraits that recall yearbook vignettes, which have been, again, altered by time. *Album*, a suite of drawings in 1996, combines the calendar with the diary; using subtle and evocative shapes drawn from nature on parchment paper, Andrews introduces paraphernalia like calendar pages, reproductions of snapshots, and letters (fig. 293). He referred to both of these series as part of the *Before* group, along with three additional series — *Sonnets*, *Personals*, and *Crosswords*. Together, they comprised the 1996 exhibition, *Three Hundred and Sixty-Five Pictures*. After the exhibition, Andrews created the *After* series, fifty images of densely packed crowds in mixed media on parchment paper, which he titled the *hoi polloi* (from the Greek, meaning the common people). As in his earlier work, he used photography.

Fig. 294. Angela Grauerholz (b. 1952)
Travellers, 1997
Silver print, 121.9 x 183 cm
Art 45, Montreal

Like Andrews, Montreal's Angela Grauerholz draws on
the photograph in her delicate mappings of time. A fascinat-
ing suite of large-scale silver-gelatin-print photographs,
Travellers (1996, fig. 294), based on our memory of what "the
future used to look like," is one of Grauerholz's contribu-
tions to the theme.[15] Featuring scenes that recall snapshots
in a family album, say of people waiting on line to board a
plane, each of these nine scenes that flirt with imprecision is
a persuasive construction of past lives and future prospects.
In smaller scale "museum works," she selects images from
her own "archives," to modulate our perception of collect-
ing, time and memory.

Photography serves Vancouver artist Kevin Madill in his
creation of murals that explore aspects of the portrait *genre*.
Like Grauerholz, he is concerned with the larger issue of the individual in con-
temporary society. His fantasy-portraits such as *Swinger (picture for a ceiling)*
(1996, fig. 295), a mural of a man acutely foreshortened on a swing, are spa-
tially and emotionally disturbing, links to the eroticization of the male body. In
constructing his images, Madill combines digital technologies with art history.

Vancouver's Stan Douglas is a shrewd social critic with a gift for disentan-
gling the different voices present at significant moments in history. Using video
and film, he reconsiders past events, the forces that drive these moments, and

233

Fig. 295. Kevin Madill (b. 1955)
Swinger (picture for a ceiling), 1996
Lambda Digital Type-C mural, 279 x 279 cm
Vancouver Art Gallery, Vancouver

Fig. 296. Stan Douglas (b. 1960)
***Accompaniment to a Cinematographic
Scene: Ruskin, B.C. — Western Edge of
the Dam below Hayward Lake, 1992***
from portfolio of 10 colour photographs,
edition 9/10, 30.5 x 22.5 cm
Kamloops Art Gallery, Kamloops
Photo: Roger Boulet

234

the relationship of individuals to twentieth-century modernism. Douglas's style in his multifaceted work is one of nuance and understatement; his tools, ambiguity, paradox, and multiple viewpoints. His studies of the past cover a number of moments in history, media, and culture, from the eighteenth century with European imperialists on the west coast of Vancouver Island to the nature of allotment gardens in Germany. Douglas's use of different media is dramatic; his work, often in video, may consist of photographs sequenced to resemble a film loop. Individually, they are subtle and filled with rich detail. *Accompaniment to a Cinematographic Scene: Ruskin, B.C.— Western Edge of the Dam below Hayward Lake* (1992, fig. 296), for instance, a colour photograph for a 1993 film installation, *Pursuit, Fear, Catastrophe: Ruskin, B.C.,* reflects his continued interest in the mythologies of urban and natural worlds. Here, he bases his narrative on an incident in the history of Ruskin, British Columbia, which exposed the town's ugly prejudices. It involved the unexplained disappearance of a Japanese-Canadian named Hiro in around 1929 (Douglas derived the account from reports in the archives of the daily diaries of the B.C. Provincial Police). The photograph, along with nine others that focus on the town's hydro-electric plant and dam, montaged into film, was projected to Arnold Schoenberg's *Accompaniment to a Cinematographic Scene: Threatening Pursuit, Fear, Catastrophe* (hence, Douglas's title). The result — intelligent, and

Fig. 297. Stan Douglas (b. 1960)
Der Sandmann, 1995
Film still from a 16mm film loop installation
for 2 film projects, soundtrack, black and
white, sound, 9 minutes, 50 seconds each
rotation, edition of 2
Solomon R. Guggenheim Museum, New York;
Sammlung Hauser & Wirth, Zurich
Photo: David Zwirner, New York, and the artist

elusive in meaning — is something of an exercise in pictorial choreography. Douglas's *Der Sandmann* (1995, fig. 297) is a black-and-white film installation that consists of two 360-degree rotations in a continuous pan from a garden shed into a garden, the second of which visually and verbally repeats the first. Here, the voice-over is based on three characters in the tale *Der Sandmann* (by the writer of fantasy E.T.A. Hoffman, 1776-1822); they read updated versions of the three letters of Hoffmann's story. We see the Nathanial character, hear Clara and Lothair but there is only one text, twice repeated, slightly out of sync from the lips of the speaker, a young man. In the meantime, we watch the image being formed of a garden plot in the 1970s and 1990s. One image replaces the other in a cycle during which "the Sand-man" appears. Douglas's work poses many questions — about race, class, self-image, Victorian melodrama, authenticity, and post-colonialist fantasy but leaves the answers up to us.

In work that similarly swirls with ideas and strategies, Will Gorlitz uses ordinary objects in his hybrid drawing, painting, and painting/installation. Often he focuses on the separate parts of the piece, joining an image to a text, commenting on the way the viewer reads the work. *Three Essays on the Theory of Sexuality* (1990), with English, French, and German versions (fig. 298), mix ideas and formal ploys like so many ingredients in a recipe for strange beautiful new "paintings." Using the essay of Freud on sexuality, Gorlitz's drawings in pastel are layered over reproduced pages of Freud's text. The drawings are slightly larger than life and of objects — apples and pears, a leaf, a cup of coffee, a five-dollar bill, a scrub-brush, a candle, smouldering matches on a clay brick, an umbrella — that challenge the viewer to complete the reference, while hinting at relationships.

235

Fig. 298. Will Gorlitz (b. 1952)
Three Essays on the Theory of Sexuality (Drei Abhandlungen zur Sexual Theorie), 1990
Oil pastel on photocopied text, seventeen panels (three works each), each individual work 25.4 x 33.0 (mounted three to a frame) (German version), University of Toronto, Toronto

Artists have also picked up on one of the underlying currents of Canadian culture — its interest in the environment. In the west, for instance, the subject of land is the concern of painters as diverse as Lethbridge-based Jeffrey Spalding, David Alexander in Saskatoon, and Landon Mackenzie in Vancouver,

all of whom reach for a spiritual dimension and universal meaning in paintings that explore the enormity of nature with wonderful inventiveness. In Spalding's *Sudden Squall (from the Glacier Queneech overlooking Courtney-Comox)* (1991, fig. 299), with a glance at a compositional device of the nineteenth century in the crack in the clouds, he depicts the grand mysterious theatricality of weather conditions in the north. Alexander explores the Canadian High Arctic in his *Ellesmere's Sky Fire and Sky Hooks* (1990, fig. 300). Mackenzie paints large colourful works infused with signs of process, interwoven images, and, illusionistic details (fig. 1).

Elsewhere in Canada, instead of painting the land, artists address social, environmental, and political issues. Since 1985, Winnipeg's Eleanor Bond, a skillful painter, has used her notions of urban communities and built environments to forecast the future. With brilliant colour and a vigorous application of paint on canvases of imposing size, she creates sometimes sharply focused, sometimes Impressionistically blurry, bird's-eye views, urban or industrial buildings in tilting perspective or lush imaginary parks. Bond's paintings are almost photographic, even mildly hallucinatory, in the way they energetically capture action and contrasts of light and shade. Her *Rock Climbers Meet with Naturalists on the Residential Parkade* (1989, fig. 301) prophesies today's environmental crisis. Bond addresses the issues of social upheaval through urban migration and constructed "nature" sites in this painting. Public galleries in Canada have showed Bond often in the 1990s — as representative of the "new spirit" in painting — to a substantial tide of critical endorsement.

Artists across Canada use photography with an equally activist agenda. Christos Dikeakos in Vancouver, for instance, inquires into colonialism and its way of distorting histories; he stakes out the places in his photographs of landscapes with signs of earlier (often, First Nations) names and their unofficial

Fig. 299. Jeffrey Spalding (b. 1951)
Sudden Squall (from the Glacier Queneech overlooking Courtney-Comox), 1991
Oil on wood, 91.6 x 213.6 cm
Robert McLaughlin Gallery, Oshawa
Photo: T.E. Moore

Fig. 300. David Alexander (b. 1947)
Ellesmere's Sky Fire and Sky Hooks, 1990
Acrylic on canvas, 150.1 x 173.0 cm
Robert McLaughlin Gallery, Oshawa

narratives. His prints overlaid with glass on which floats sandblasted text also call into question the medium of photography, among others, to provide visual evidence. For *The Boite Cabinet Valise, Sites and Place Names, Vancouver 1991-1994* (Art Gallery of North York, North York, Ontario), Dikeakos designed a storage unit beautifully crafted from cherry wood and detailed with brass carrying handles, locking clasps and wheels that is reminiscent of the field desks used on military campaigns

Fig. 301. Eleanor Bond (b. 1948)
Rock Climbers Meet with Naturalists on the Residential Parkade, 1989
Oil on canvas, 243.8 x 365.0 cm
MacKenzie Art Gallery, University of Regina, Regina
Purchase with the assistance of friends in memory of Ian Phillips, 1992

in the nineteenth century. Meticulously engraved on a side panel are the words "Sites and Place Names." Inside are books and brochures on the history of Vancouver, an aboriginal woven box, and, on a pull-out shelf, binders containing archival photographs of Vancouver that date from the early 1900s. Dikeakos attached a map diagramming the forty-four locations chosen for the project to a collapsible plexiglas frame mounted to one side; stacked in the box are forty-four panoramic photographs in which he integrates a non-European history of the Vancouver area into contemporary settings. Dikeakos himself wrote that his catalogue of subject-matter of landscape was all-inclusive, ranging from the depiction of wilderness to the retreat of nature, including themes like the lost idyll, or nature severed from the sacred or from its own history.[16] To comment on the vast tracts of landfill that have redefined the shoreline of Vancouver, for instance, Dikeakos photographed a view of the former Expo site and superimposed its Musqueam name; its translation — "hole in bottom" — refers to the method used to fish sturgeon out of False Creek. Dikeakos includes as well a diagram of the technique. In other photographs, the interaction of image and text reveals different layers of history: the words "salmon" and "trout" placed in the middle of a residential street recall the rivers and streams redirected or relegated underground with the development of subdivisions; the words "killer whale" and "octopus" superimposed on the industrial waterfront of Burrard Inlet invoke once-abundant sea life. In the image *Skwtsa's 1/1* (1992, fig. 302), the First Nations graveyard looks forgotten, the

237

Deadman's Island skwtsaʾs "means Indian Graveyard"

Fig. 302. Christos Dikeakos (b. 1946)
Skwtsaʾs 1/1, 1992
Photographic C print, glass, 53.3 x 104.1 cm
Art Gallery of North York, Toronto

238

Fig. 303. Edward Burtynsky (b. 1955)
Nickel Tailings No. 31,
Sudbury, Ontario, 1996
Photograph, edition of 10, 76.2 x 101.6 cm
Mira Godard Gallery, Toronto
Photo: Mira Godard Gallery, Toronto

common fate of past uses of the land.

Edward Burtynsky in Toronto and Jean-Marie Martin in Montreal carry the story one step further. Burtynsky evokes in large elaborate colour photographs images of contaminated or waste disposal sites, sometimes seen from a bird's eye as in *Nickel Tailings No. 31* (1996, fig. 303); it reveals the strange beauty of industrial processes laying waste to the earth (here, Sudbury, Ontario). Martin has made a *Toxic Landscape* series of paintings that uses paint products that are either banned or toxic to the environment. For him, the medium of paint is a way of alerting the public.

The collaborative pair known as FASTWÜRMS includes Toronto artists Dai Skuse and Kim Kozzi. In 1979, they began to mingle media, disciplines, and art forms to question nature and the environment: they particularly question issues of power. Their *Green Christ* (1987, fig. 304), in which a central Christ-like figure is worshipped by woodpecker and beaver, addresses their beliefs in an exciting blend of elegance and funk. Other works are more oblique. In *Beaver Boss* (1990), a large installation, in one of its two wall pieces shaped like a lily pad, they con-

structed another of their engaging works based on critical inquiry. The title is displayed as a tablet of Cree syllabics meaning "conservation officer," which they, using C. Douglas Ellis's *Spoken Cree* (1983), literally translate into English as "Beaver Boss." For them, the question is — who has the power to boss the beavers? A boss beaver, the Cree people, or (through the image on the loonie coin) Queen Elizabeth? It is difficult, if not impossible to have a close relationship to nature if you believe you are the boss, they write. "Beavers and birch trees, plants and animals that we take the time to know well, become part of our extended family, and in keeping with our faith in the Old Religion, familiar."[17] There's a core of defiance to their enterprise, a refusal of the usual restrictions and imperatives of high art in favour of the delight of improvisation. On the other hand, their creative process is not uncontrolled. Out of the tension between structures of natural order, and the way they have animated them using suggestions from high school science, grows a ramshackle display that is a kind of schematic model of the mind of a twentieth-century naturalist at play. The pair's most impressive work has been large-scale commissions; their installation for the 1997 expanded Metro Toronto Convention Centre recalls the land occupied by the centre as a primordial green swamp (until development pushed back the shore line): *Woodpecker Column* combines a gigantic pileated woodpecker and a yellow-bellied sapsucker perched on a hollow, industrial-scale, light-pecked steel column; *Turtle Pond*, turtle-shell patterns and images of a dividing frog egg, a tadpole, and a raven. Their use of materials is more inventive than humorous: their imagery often involves snakes for which they have great affection (their name, a registered trademark, comes from their own fast editing style in film plus "würm," German for serpent). The imagery of the raven and the soft shell turtle is connected to *Green Christ*: both offer a kind of pagan revisioning of Christian symbolism. The raven and the turtle both have twigs in their mouths, a reference to the Biblical story of Noah and the Ark: Noah sent the raven out to find land and it did not return, but the dove, sent on the same errand, did. In the version of FASTWÜRMS, the raven travels to Canada and sets up shop as an important cultural and religious figure.

First Nations artists, who have moved into the mainstream of Canadian

Fig. 304. FASTWÜRMS
(Kim Kozzi, b. 1955 and Dai Skuse, b. 1955)
Green Christ, 1988
Acrylic, epoxy coating, paper, birch bark, twigs, wire, paint, beans, fungi on wood, 223.5 x 171.0 cm
Robert McLaughlin Gallery, Oshawa
Photo: T.E. Moore

239

Fig. 305. Robert Houle (b. 1947)
New Sentinel, 1987
Oil on wood panel, ribbons and encaustic
on cow skull
Robert McLaughlin Gallery, Oshawa
Photo: Ernest Mayer, Winnipeg Art Gallery

240

contemporary art, are characterized by a steadfast commitment to their heritage; in making art, they are involved in consciousness-raising, cultural affirmation, and writing history to reclaim their traditions. Often their aim is to reconcile contemporary art and native tradition, or at least acknowledge the contradictions that form their aesthetic. Among the innovators are important Anishinaubae (Ojibway) artist Norval Morrisseau, around whom developed the "Woodland School," and the late Bill Reid, who, from 1952, drew upon his Haida heritage to produce exquisite gold and silver jewellery. In the 1980s, Reid created a series of public sculptures, canoes, and totem poles, the most important of which was his *The Spirit of Haida Gwaii* (1988-1989). The first bronze cast for this work (called *The Black Canoe*) stands before the Canadian Embassy in Washington, D.C. (the original plaster cast is in the Canadian Museum of Civilization, Ottawa). Here, Reid empathizes with living representations of his people's spirit creatures; thirteen of them appear in a canoe. The result is a scene of quiet tumult that contrasts strikingly with the calm of the forms.

Toronto-based Saulteaux artist Robert Houle has a different message. For Houle, the key issue is power, and the injustice he perceives. In his early installation works, he remembers seven extinct indigenous nations. In later works, he positions his images between those of Canadian art history and those of the First Nations. *New Sentinel* (1987, fig. 305), is characteristic of his earlier work. Here, a real white cow skull with long coloured ribbons protrudes from a dark background on which are stencilled the names of tribes such as the Cree and Dene. For Houle, the ribbons recall "wapina son," the holy offerings hung in trees following Sun-Dances, carrying one's prayers.[18] By 1989, with *Seven in Steel* (1989, National Gallery of Canada, Ottawa), he dwells on Canadian art. Here, in memory of lost tribes, he sets seven highly polished steel slabs in a dark blue base against the wall. On the top part of each panel, he incorporates small differently coloured vignettes. The central three paintings contain freehand copies of Tom

Thomson paintings. These are flanked by Houle's impressions of the landscape: in one panel, maple leaves; in the other, a grove of trees. The end panels are copies of a drawing of hunting spears and animal figures by the Cape Dorset artist Parr (1893-1969) and a detail from a totem pole, both in the permanent collection of the McMichael Canadian Art Collection in Kleinburg (where, in 1989, Houle worked as artist-in-residence). Houle relates *Seven in Steel* to landscape painted by the Group of Seven.[19] More recently,

Fig. 306. Robert Houle (b. 1947)
Kanata, 1992
Acrylic and conté crayon on canvas,
228.7 x 732.0 cm
National Gallery of Canada, Ottawa

Houle again based a work in Canadian art history. In *Kanata* (1992, fig. 306), in red conté, he appropriates Benjamin West's history painting *The Death of General Wolfe* (1770). In this scene of the general's death the Delaware wears colourful robes and paraphernalia. He appears in parenthesis surrounded by gigantic blue and red rectangles that symbolize England and France. Houle's intention was to indicate that these countries were the dominant players in the making of Canadian history.

One of the major concerns for First Nations artists is the environment and all that it entails. Lawrence Paul Yuxweluptun meditates on toxic land and the effects of clear-cutting in paintings and drawings that borrow elements from the vocabulary of Surrealism and the imagery of his people. *Scorched Earth, Clear-cut Logging on Native Sovereign Land. Shaman Coming to Fix* (1991, fig. 307) is imbued with a deep feeling for nature and the spiritual power of the First Nations. In the painting, the sun, a pole figure

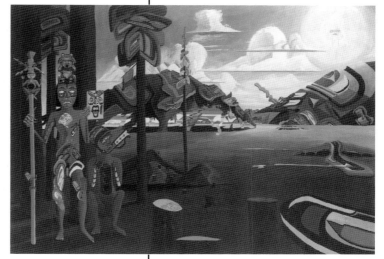

241

lying against a hillside, and a mask that lies on the beach, drip tears. The shaman, theoretically "coming to fix," looks aghast at the viewer who comes to him to be healed amid a despoiled countryside. The result is a convincing and compelling call to arms. In Ontario, Ojibway artist Carl Beam uses a collage technique style to place himself within the broad context of history, interna-

Fig. 307. Lawrence Paul Yuxweluptun (b. 1957)
Scorched Earth, Clear-cut Logging on Native Sovereign Land. Shaman Coming to Fix, 1991
Acrylic on canvas, 195.6 x 275.0 cm
National Gallery of Canada, Ottawa

tional events and technological developments. One of his recent concerns has been with the food we eat, and for that reason, one of his projects has been to grow hominy corn, a corn sacred to the First Nations of North and South America, the corn of legend and lore.

Identity, meditations on the way humans acquire sacred knowledge, and the power of older women as seers are the subjects of Cree artist Jane Ash Poitras, born in Fort Chipewyan, Alberta. She makes use of traditional iconography and symbols (for example, a photograph of a contemporary sweat lodge, and porcupine quills or an eagle feather to symbolize native life) and believes that, through her eyes and her art, she is personally repatriating images of her people. But her way of making art — collage, half painting, half things she has found in life's journey — is part and parcel of the contemporary scene. In her painting *Diluted Indians Ride Across History* (1990, fig. 308), she collages into painted aboriginal bodies photographs by Edward Curtis (a nineteenth-century photographer of the First Nations), of herself, and of individuals who in some way helped her establish a personal reference point. For instance, she links a photograph of herself and her child with one of Queen Elizabeth and her extended family — she circled all the woman with red paint. "History," the painting reads. Through Poitras's way of working, she is repatriating native names, images, and people, she feels. She thought of the idea of collage because a curator at the Heard Museum in Phoenix, Arizona, showed her shirts from the turn of the century in which Indians had preserved newspaper photographs of themselves by sewing them onto the fabric. "I observe Indian tradition by wrapping such images into my work," she said of the painting.[20]

Such a way of incorporating references to aboriginal experience underscores visual, conceptual and physical contact of First Nations artists with their environment. The work of Blood Indian Faye HeavyShield often rests on mem-

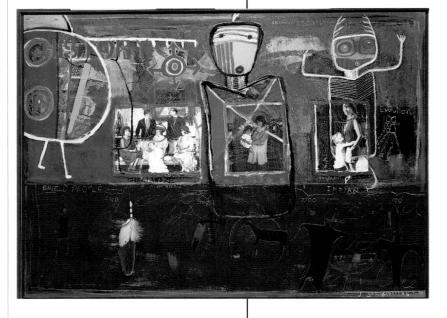

Fig. 308. Jane Ash Poitras (b. 1951)
Diluted Indians
Ride Across History, 1990
Mixed media, 112.1 x 153.0 cm
Robert McLaughlin Gallery, Oshawa
Photo: T.E. Moore

242

ory. In 1992, she used biomorphic images of skeletal armatures with flesh in *Untitled* (1992, fig. 309) to recall memories of her father skinning a deer. In 1998, in Calgary, she created a spiral of friends' red-dyed clothes as part of an installation, *Spiral and Other Parts of the Body.*

David Ruben Piqtoukin, an Inuit sculptor who grew up on the Arctic coast north of the Mackenzie River Delta, explores the new influences on his people. There is considerable appeal in his use of derived-from nature-forms combined with oral and shamanic topics. But the work is uncanny, too, in its expression of modern-day *angst.* His sculpture in the 1990s features his trademark acculturation themes, along with less stereotypical works like *Tradition Lost* (1996, fig. 310), an abstract evocation of nature's forms in stone, which can be read as a reference to the death of his culture, or, equally, to an igloo melting in the spring season.

In Cape Dorset, the inventive Ovilu Tunnillie cleverly transforms typical illustrations of the picturesque aspects of Inuit life by sculpting Western-style clothes, even a high-heeled shoe. Her sculptures bring to the surface the anger that fuels Inuit life with a directness that feels like a breath of fresh air. Among her subjects are rape, abuse, and grief (fig. 311).

Artists like Piqtoukin and Tunnillie remind us that artists today are caught in a multitude of affiliations — natural and technological — that extend beyond the limits of social groups. Kim Adams, in Ontario, works cheerfully to take viewers out of the art gallery and into the larger world of site-specific work. Like most of the art of the 1980s and 1990s, his image-jammed miniature universe created with model cars, trains, figures, and buildings combines categories in an interesting merging of sculpture, installation, and

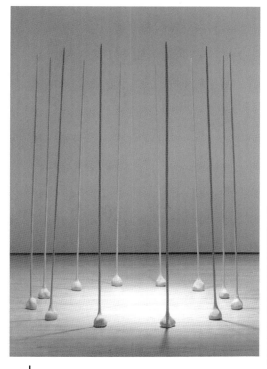

Fig. 309. Faye HeavyShield (b. 1954)
Untitled, 1992
Wood, cement, acrylic, 244.5 x 13.5 cm
National Gallery of Canada, Ottawa

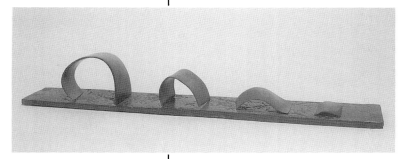

assemblage. His playful constructions, although large in scale, appeal to the miniaturist and the environmentalist. In *Earth Wagons (First Wagon)* (1989-1991, Winnipeg Art Gallery, Winnipeg), the first of the series Adams began to make in 1989, minutely detailed toy-train-mountains loom upwards from the base of a real utility trailer. Around the middle, a railway car pulls a length of vans. The work is full of narrative detail; the mountain has had an industrial

Fig. 310. David Ruben Piqtoukun (b. 1950)
Tradition Lost, 1996
Brazilian soapstone, slate,
11.4 x 76.3 x 12.8 cm
Private Collection

243

Fig. 311. Ovilu Tunnillie (b. 1949)
Grieving Woman, 1997
Stone, 35.0 x 12.5 x 11.3 cm
Winnipeg Art Gallery, Winnipeg
Gift of the Volunteer Committee to the
Winnipeg Art Gallery in commemoration
of the Volunteer Committee's 50th
Anniversary, 1948-1998
Photo: Ernest Mayer, Winnipeg Art Gallery

244

spill, there's a tunnel and above it, a metal bridge, a power station and a heli-copter. Adams here, as in most of his work, has made his work mobile (else-where, his structures ride on trailers, truck or car beds or carts) and ridden with references to a diverse range of disasters. His more recent work contin-ues this wide-ranging reference. In 1998 for the Montreal Biennale, for instance, Adams's large *Toaster Work Wagon* (1997, fig. 312), featured several "Siamese" tricycles built for two whose riders sat back to back, folding chairs, and a Volkswagon van. His artfully arranged constructions have paradoxical traits; a careful attention to surfaces and telling details lance his themes with poetry and understated humour.

Noel Harding, who started in the field as a video artist in 1972, opted in his sculpture to concentrate on unconventional images that combine live effects with mystery and funky comedy. Best known for his *Enclosure for Conventional Habit* (1980, fig. 313), he portrayed the effects of animals (here, six white chickens) in a transaction with technology, catching them on a tread-mill. His large-scale installations, informed by a vigorous eccentricity, share qualities with performance art and especially with earlier Happenings. There's an amusing parodistic quality to his work. In *1st, 2nd & 3rd Attempts to Achieve Heaven* (1983, Art Gallery of Ontario, Toronto), for instance, Harding mocked our incapacity to achieve heaven in our lives using a big steel tripartite block sloping towards the end with two small non-aligned, motorized birds' wings attached on either side. In his installation, Harding used light to create an eerie

Fig. 312. Kim Adams (b. 1951)
Toaster Work Wagon, 1997
1960s VW bus car parts, bicycles (every
which way)
Photo: courtesy Wynick-Tuck Gallery, Toronto; Galerie
Christiane Chassay, Montreal

effect: blinking on the ceiling in a steady pattern; shining through a hole in the block, where to one side, as a wing is lowered, a red light glints; on the other side, disturbed by each rise and fall of the wing, light flickers on the floor. Harding's work has always had the madcap nonchalance that comes from a will to experiment. From 1984 to 1986, he made occasional use of the figure as a grounding device with the jacketed mannequin he called "Blue Peter," a reference he continued in *The Potato Eaters* (1990, Mississauga Civic Centre, Mississauga), three steel towers of different heights with legs and circular neon heads that seem to stride up and down while carrying trees.

Harding's most monumental project to date is *The Elevated Wetlands* (1998, fig. 314). Here, with the help of the Canadian Plastics Industry Association, which commissioned the work, he placed massive plastic sculptures that recall the animal form along side the Don Valley Parkway, a major Toronto artery. Filled with plastic (used bottles, automobile fluff, resin chips, and shredded automobile tires) and watered by solar pumps that help support plant and tree growth, the sculptures recycle contaminated water from the Don Valley. This balance of staged installation and concern for the environ-

Fig. 313. Noel Harding (b. 1945)
Enclosure for Conventional Habit, 1980
6 chickens, treadmill, feed and rest station, belt wash unit, motor, dive and gears, live tree, motorized cart, grow light unit, mist devices, track, audio speakers, 3 sound cassettes, water and power lines, automatic devices, rope, wire, polythene.
Installation dimensions variable
(approximately 500 x 1200 cm)
Photo location:
Musée d'Art Contemporain, Montreal.

245

Fig. 314. Noel Harding (b. 1945)
The Elevated Wetlands, 1997, 1998
6 sculptures made of expanded polystyrene foam, acrylic stucco coating, solar-powered irrigation system, recycled plastic soil structure, native plants, and water from the Don River.
Photo location: Taylor Creek Park, Toronto

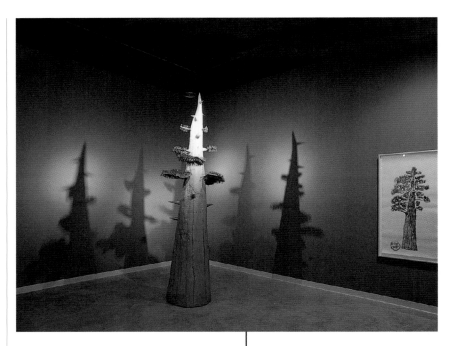

Fig. 315. Tom Benner (b. 1949)
Homage to the White Pine, 1984
Cold rolled metal with nails, 312.4 x 91.4 cm
Art Gallery of Windsor, Windsor
Gift of James B. MacNeill, 1996
Photo: John Tamblyn, Windsor

246

ment places Harding's work in a special category, one that seems part of the history of an era rather than uniquely personal.

At the end of the twentieth century, the art world is paying close attention to the history of art, as if probing for predictions. Tom Thomson and the Group of Seven fashioned something from the environment that was complex and complete: a self-contained universe that was internally coherent and connected exhilaratingly with a wider world. Throughout the century, the environment has been transformed; so has the art that attempts to convey that environment to a broad public. Do Harding's strange figural sculptures that play between artifice and nature foretell a rebirth of interest in the environment? It's hard to know. 1990s art has an enigmatic quality, each work interacting with its neighbours to form new meanings. Taken together, these new works allude to possibilities of a raised consciousness of what art-making can be. One likes to think that the Group of Seven would have been impressed. These artists mirror the sensibility of earlier artists, which combined imagination and a highly developed concern for Canada, but though they feel the gravitational pull of the century they are leaving, they are moving inexorably into the next.

An eerie tree by Tom Benner, his *Homage to the White Pine* (1984, fig. 315) — a tree found in Canada's northern woods — symbolizes the change in consciousness. The tree, which is well over the head of the viewer, could be formed from wood but is in fact formed from metal held together with rivets, with brush-like shapes for branches. As you walk around it, it looks dead; it's a tribute of sorts.

Some may wonder what such a tree is doing in a gallery; others may see it as a sinister apparition, a token of over-logging in an age fraught with anxieties about natural disasters and machines gone awry. Since the tree is of metal, it

supports this idea — as well as referring to the hall of mirrors of our present day in which even nature seems out of joint. The work is both playfully Surreal and unnerving: it could be a projection of the future — the last tree on earth. At the same time, it presents us with a perspective on earlier depictions of trees in art. Throughout time, the tree has been a symbol and a metaphor for the relationship between humans and the divine. It is a symbol of the cycle of life. It recreates itself continually. As we look at *Homage to the White Pine*, we recall the world of Tom Thomson and the Group of Seven. But *Homage to the White Pine* is a work made for the late twentieth century: it contends with the realities and ambiguities of our century as it winds to a close.

In the rush to mark the millennium, many artists have been looking into the future. *Homage to the White Pine* proposes that we focus on the present even as we take stock of the past: it raises unsettling questions about our age and our use of the land. Benner has transformed history into an imaginary landscape, one that is bleak but offers a timely perspective — physical, political and mental. In a way, Tom Benner is characteristic of Canadian artists today, speculative as they venture into familiar — and unfamiliar — territory.

Chapter Notes

Introduction

1 John Barber, "The Canoe North strong and free...," *Globe and Mail*, July 24, 1998.

2 Liz Wylie, *In the Wilds: Canoeing and Canadian Art* (exhibition catalogue) (Kleinburg: McMichael Canadian Art Collection, 1998), 8, quoting from Shelagh Grant, *Canexus: The Canoe in Canadian Culture* (Toronto: Betelgeuse Books, 1988), 6.

3 I follow here Catherine S. Ross's description of the soul boat in "Nancy Drew as Shaman: Atwood's *Surfacing*," *Canadian Literature* 84 (Spring 1980), 15, quoted in Wylie, 19.

4 Marshall McLuhan, *The Medium is the Message: An Inventory of Effects* (1967), with Quentine Fiore.

5 For a definition of modernism and Post-Modernism, see the helpful definition of Connor, Steven in David E. Cooper (ed.), *A Companion to Aesthetics* (Oxford: Blackwell Publishers, 1995), 288-293.

Chapter One

1 See Diana Dimodica Sweet, "American Tonalism: An Explanation of Its Ideas Through the Work and Literature of Four Major Artists," *tonalism: an american experience* (exhibition catalogue) (New York: Grand Central Art Galleries, Inc., 1982), 30.

2 J.A. Radford, "Canadian Art and its Critics," *Canadian Magazine* 29, 6 (October 1907), 513-519.

3 Louis Vauxcelles, "The Art of J.W. Morrice," *Canadian Magazine* 34 (November 1909-April 1910), 169.

4 I am indebted here, and in the two paragraphs that follow, to Carol Lowrey, "Within the Sanctum: Newton MacTavish as Art Critic," *Vanguard* 14, 9 (November 1985), 11-14.

5 J.W. Morrice, letter to Edmund Morris, 12 February 1911. Edmund Morris Letterbooks Archives, E.P. Taylor Art Reference Library, Art Gallery of Ontario, Toronto.

6 For a handy definition of modernism, see the definition of Steven Connor in David E.Cooper (ed.), *A Companion to Aesthetics* (Oxford: Blackwell Publishers, 1995), 288-293.

7 Letter from J.W. Morrice to Edmund Morris, April 11, 1913, Edmund Morris collection, Letterbook, vol. 1, Library of the Art Gallery of Ontario, Toronto.

8 Henri Matisse, letter to Armand Dayot [late 1925], printed in *James Wilson Morrice* (Paris: Galleries Simonson, 1926), 6-7.

9 A.Y. Jackson, *A Painter's Country* (Toronto: Clarke, Irwin & Company Limited, 1958), 19.

10 For a discussion of Milne's participation in the Armory show, see Rosemarie L. Tovell's review of David P. Silcox's *Painting Place: The Life and Work of David B. Milne, Journal of Canadian Art History* 19, 2 (1998), 77.

11 I follow here John O'Brian in *David Milne: The New York Years 1903-1916* (exhibition catalogue) (Edmonton: Edmonton Art Gallery, 1981), 28, and David P. Silcox, *Painting Place: The Life and Work of David B. Milne* (Toronto: University of Toronto Press, 1996), 52.

12 Letter from David Milne to Donald Buchanan [c. 1936], National Gallery of Canada, Ottawa.

13 Michael Tooby, "Coming to Terms with Milne," *Literary Review of Canada* 6, 8 (November 1997), 14.

14 Letter from A.Y. Jackson to Dr. J.M. MacCallum, 13 October 1914, MacCallum Correspondence, National Gallery of Canada, Ottawa.

15 Letter from F.H. Varley to Dr. J.M. MacCallum, October 1914, MacCallum Correspondence, National Gallery of Canada, Ottawa.

16 See Judi Freeman, "Surveying the Terrain: the fauves and the landscape," *The Fauve Landscape* (exhibition catalogue) (New York: Los Angeles County Museum of Art & Abbeville Press, 1990), 13.

17 Interview with A.Y. Jackson by the author, 4 March 1971. Joan Murray, Tom Thomson Papers.

18 Jackson interview.

19 John Ralston Saul, *Reflections of a Siamese Twin* (Toronto: Penguin, 1997), 100.

20 Lawren S. Harris, quoted in B. Harris & R.G.P. Colgrove [eds.] *Lawren Harris* (Toronto: Macmillan, 1969), 43.

21 See Maria Tippett, *Lest We Forget* (exhibition catalogue) (London: London Regional Art and Historical Museums, 1989), 23.

22 A.Y. Jackson as quoted by F.B. Housser in *A Canadian Art Movement: The Story of the Group of Seven* (Toronto: Macmillan Company of Canada Limited, 1926), 77.

23 Housser, 143. Housser quoted from an article by MacDonald in the Canadian magazine *Spectator*, as Paul Duval points out in *The Tangled Garden* (Scarborough: Cerebrus Publishing Company Limited, 1978), 94. [Housser thought it was the English *New Statesman*.]

24 Housser, 145.

25 Thoreau MacDonald, *The Group of Seven* (Toronto: Ryerson Press, 1944), 15.

26 Housser, 13, 18; Arthur Lismer, 1950 radio talk quoted in Marjorie Lismer Bridges, *A Border of Beauty* (Toronto: Red Rock, 1977), 128.

27 Interview with Doris Speirs by Paul Bennett, August 4, 1971. Joan Murray Papers, Robert McLaughlin Gallery, Oshawa.

28 Doris Speirs interview.

29 Carl Schaefer recalled MacDonald's advice, quoted by Duval in *The Tangled Garden*, 139.

30 Housser, 17.

31 Housser, 156.

32 See Lynda Jessup, "Art for a Nation?," *Fuse* 19, 4 (Summer 1996), 11-14.

33 For an analysis of the membership, see Susan Avon, "The Beaver Hall Group Redefined," *Imposture* 6 (Winter 1992), 56-61.

34 Emily Carr, *Growing Pains* (Toronto: Oxford, 1946), 306.

Chapter Two

1 I am following the definition of abstraction applied by Mark Rosenthal in his introduction to the catalogue, *Abstraction in the Twentieth Century: Total Risk, Freedom, Discipline* (exhibition catalogue) (New York: The Solomon R. Guggenheim Foundation, 1996), 1.

2 For the suggestion that the painting differed from the sketch, which had a naturalistic cast to it, I am indebted to Nancy Townshend, "The Origins of Modernism in Alberta," Nancy Townshend and Mary-Beth Laviolette, *A History of Art in Alberta*, commissioned by Alberta 2005 Centennial History Society, manuscript prepared for publication in 1999 by the University of Alberta Press, ms. 19.

3 Bertram Brooker's "out-of-body" experience occurred, apparently, in 1923 or 1925. He wrote about it, and the consequences such an experience can have on people like him in "Mysticism Debunked," a review of John Middleton Murry's *God: An Introduction to the Science of Metabiology, Canadian Forum* 10 (March, 1930), 202-203. His diary entry of August 24, 1925, in his papers in the University of Manitoba, describes a mystical experience that took place "downtown." Phyllis Brooker Smith, Brooker's daughter, recalled the incident took place in 1923 by a stream in Dwight in Northern Ontario. David Arnason agrees with the 1925 date. See D. Arnason, "Reluctant Modernist," *Provincial Essays* 7 (1989), 80. Brooker's experience is also discussed by Joyce Zemans in "First Fruits: The World and Spirit Paintings," *Provincial Essays* 7 (1989), 20. Brooker may have been a person who, because of a near brush with death or illness in his youth, regarded himself as specially chosen because he survived. Brooker had almost died of typhoid as a child, as Phyllis Brooker Smith recalled in conversation, December 6, 1993. In a note in the Bertram Brooker collection at the University of Manitoba, Brooker dated "Typhoid" "1905," the date of his illness.

4 For a good discussion of Brooker at this moment, see Ann Davis, *The Logic of Ecstasy; Canadian Mystical Painting 1920-1940* (Toronto: University of Toronto Press, 1992), 158.

5 A. Brook, "February Exhibitions," *The Arts* 3 (February 1923), 134.

6 Raymond Henniker-Heaton, *Paintings by Henrietta Shore* (exhibition catalogue) (New York: Ehrich Galleries, 1923), n.p..

7 Henrietta Shore to Edward Weston, January 8, 1939, Edward Weston Archive, Centre for Creative Photography, University of Arizona.

8 Arthur Dove's *Based on Leaf Forms and Spaces*, or *Leaf Forms* is reproduced in Ann Lee Morgan's *Arthur Dove: Life and Work* (Newark: University of Delaware Press, 1984), 104.

9 See Joyce Zemans, Elizabeth Burrell, and Elizabeth Hunter, *New Perspectives on Modernism in Canada: Kathleen Munn, Edna Taçon* (exhibition catalogue) (Toronto: The Art Gallery of York University, 1988), 20.

10 Conversation with Phyllis Brooker Smith, 6 December 1993.

11 Joyce Zemans, "First Fruits: The World and Spirit Paintings," *Provincial Essays* 7 (1989), 26.

12 Schaefer as quoted in Paul Duval, *A Tangled Garden* (Scarborough: Cerebrus/Prentice Hall, 1978), 139.

13 Schaefer.

14 See John O'Brian, *David Milne and the Modern*

Tradition of Painting (Toronto: Coach House Press, 1983), 95.

15 Warrener to Schaefer, January 11, 1925, Carl Schaefer Papers, National Archives of Canada, Ottawa, MG 30, D-171 (Gift of 1983).

16 Warrener to Schaefer, January 11, 1925.

17 Warrener to Schaefer, January 11, 1925.

18 Warrener to Schaefer, February 24, 1925.

19 Joyce Zemans makes this point in "First Fruits: the World and Spirit Paintings," *Provincial Essays* 7 (1989), 24.

20 Interview with Lowrie Warrener by Joan Murray, November 23, 1982, Joan Murray Papers, Robert McLaughlin Gallery, Oshawa.

21 Warrener interview.

22 Warrener interview.

23 Warrener interview.

24 Warrener interview.

25 Ann Davis, *The Logic of Ecstasy: Canadian Mystical Painting 1920-1940* (Toronto: University of Toronto Press, 1992).

26 Lawren Harris to the Exhibition Committee, Art Gallery of Toronto, December 1926, reprinted in L.R. Pfaff, "Lawren Harris and the International Exhibition of Modern Art: Rectifications to the Toronto Catalogue (1927) and Some Critical Comments," *RACAR* ll, 1-2, 84.

27 Dennis Reid has noted the similarity between the stylized head of the figure in Brooker's *The Dawn of Man* and a sculpture of Baudelaire by Raymond Duchamp-Villon well-known to him since it was owned by friends (both the canvas and the sculpture are now in the collection of the Art Gallery of Ontario.) Dennis Reid to Joan Murray, 5 February 1994. See also his *Bertram Brooker* (Ottawa: National Gallery of Canada, 1973), 13. Pfaff, in the article cited above, discusses the works in the show in detail.

28 Charles Comfort, "Sketches from Memory," (unpublished autobiography, c. 1974), Charles Comfort Papers, National Archives of Canada, Ottawa, MG 30, D81, vols. 8-9.

29 Victoria Baker, *Emanuel Hahn and Elizabeth Wyn Wood: Tradition and Innovation in Canadian Sculpture* (exhibition catalogue) (Ottawa: National Gallery of Canada, 1997), 47.

30 Interview with Isabel McLaughlin by Joan Murray, 13 November 1983, Joan Murray Papers, Robert McLaughlin Gallery, Oshawa.

31 Roger Jellinek, "Rolph Scarlett - Twentieth-Century Painter," *Canadian Art* 23-25 (May/June 1965), 23.

32 See Marianne Lorenz, "Rolph Scarlett," *Theme & Improvisation: Kandinsky and the American Avant Garde, 1912-1950* (exhibition catalogue) (Dayton, Ohio: Dayton Art Institute, 1992), 177-178.

33 For this observation on the work of Irène Legendre, I am indebted to Jean-René Ostiguy, *Modernism in Quebec Art, 1916-1946* (exhibition catalogue) (Ottawa: National Gallery of Canada, 1982), 114.

34 Pearl McCarthy, "Edna Taçon's Contextualist Art Wins Admiration at Eaton Gallery, *Globe and Mail*, 25 January 1947.

35 Ostiguy, 134.

36 Another helpful book for Harris was Annie Besant and C.W. Leadbeater's *Thought-Forms*. It had a handy colour table at the front, showing the steps from "High Spirituality" to "Selfish Religious Feeling" in colour squares. Peter Larisey suggests that Harris may have used the figures as sources for shapes in his abstract paintings. See Larisey's *Light for a Cold Land* (Toronto and Oxford: Dundurn Press, 1993), 162-163.

37 Dennis Reid, *Bertram Brooker* (Ottawa: National Gallery of Canada, 1973), 10. Brooker also read Kandinsky.

38 J.W.G. Macdonald to Maxwell Bates, 30 July 1956, McCord Museum, Montreal, quoted in Joyce Zemans, *Jock Macdonald: The Inner Landscape* (exhibition catalogue) (Toronto: Art Gallery of Ontario, 1981), 54.

Chapter Three

1 André Bieler, address at the conference on Canadian-American affairs, Queen's University, Kingston, Ontario (June 1937), 14-18.

2 Paraskeva Clark, "Come Out From Behind the Pre-Cambrian Shield," *New Frontier* 1, 12 (April 1937), 16-17.

3 Paul Strand, "Photography and the New God," *Broom* (November 3, 1922), 252, quoted by Richard Guy Wilson in "America and the Machine Age," *The Machine Age in America, 1918-1941* (exhibition

catalogue) (New York: the Brooklyn Museum and Harry N. Abrams, Inc., Publishers, 1986), 23.

4　Francis Steegmuller makes this point in *Cocteau* (London: Constable and Company Ltd., 1986, reprinted 1992), 280.

5　Louis Lozowick, "The Americanization of Art," in *Machine-Age Exposition Catalogue*, printed in the *Little Review* 11 (1927), 18-19, quoted by Richard Guy Wilson, 30.

6　Richard Guy Wilson, "Machine Aesthetics," *The Machine Age in America*, 43.

7　Rosemary Donegan, *Industrial Images* (exhibition catalogue) (Hamilton: Art Gallery of Hamilton, 1987).

8　Besides the Ontario College of Art, Yvonne McKague Housser taught at the Art Gallery of Toronto (now the Art Gallery of Ontario) in Saturday morning classes of the late 1920s; at the University of Toronto, where she taught extension courses in 1932 and 1940; and at Ryerson Institute, where she taught in 1943. After she retired, she taught summer sessions at the Doon School of Fine Arts, evening classes in painting at the Art Gallery of Toronto, outdoor painting in Oshawa at the studio of painter Alexandra Luke, and adult art classes for societies and collegiates throughout Ontario.

9　See Yvonne McKague Housser, "Mining Country," *Northward Journal*, 16, 1980, 21 ff. In her "Autobiography, Early Years: Paris," Yvonne McKague Housser Papers, MG30 D305, National Archives of Canada (hereafter YMH NAC), she recalls that the date might have been 1919 or 1920.

10　Interview with Yvonne McKague Housser by Joan Murray, June 24, 1985, Joan Murray Papers, Robert McLaughlin Gallery, Oshawa.

11.　T. Gray, Yvonne McKague Housser (unpublished manuscript), 8, YMH NAC.

12　Gray manuscript.

13　Gray manuscript.

14　See Michael Barnes, *Fortunes in the Ground: Cobalt, Porcupine, and Kirkland Lake.* (Toronto: Stoddart Pub. Co. Lim., 1986).

15　See also Alicia Boutilier, *4 Women Who Painted in the 1930s and 1940s: Rody Kenny Courtice, Bobs Cogill Haworth, Yvonne McKague Housser, Isabel McLaughlin* (exhibition catalogue) (Ottawa: Carleton University Art Gallery, 1998), 29.

16　For the suggestion that the influence on Stevenson was André Dunoyer de Segonzac, I am indebted to Nancy Townshend, "The Origins of Modernism in Alberta," Nancy Townshend and Mary-Beth Laviolette, *A History of Art in Alberta*, commissioned by Alberta 2005 Centennial History Society, manuscript prepared for publication in 1999 by the University of Alberta Press, ms. 23.

17　Pegi Nicol MacLeod, "Miller Brittain," *Maritime Art* 1 (April 1941), 14-18.

18　A.Y. Jackson to W.J. Wood, Midland, 4 February 1942 (Collection of A. Walling Ruby, Toronto), quoted in Christine Boyanoski, *The 1940s: A Decade of Painting in Ontario* (exhibition catalogue) (Toronto: Art Gallery of Ontario, 1984), 10.

19　Americans find the similar qualities in a certain strain of American art extending from John Singleton Copley to Donald Judd (see William C. Agee, "Precisionism & the dawn of American modernism," *New Criterion* 13 (May 1995), 47).

20　George Pepper to Canada Council, 1959, Canadian Group of Painters Papers, Robert McLaughlin Gallery Archives, Oshawa.

21　Isabel McLaughlin, "Group Attitude," notes on a meeting with the Montreal members of the Canadian Group Painters (CGP), 1943, Canadian Group of Painters Papers, Robert McLaughlin Gallery Archives, Oshawa.

22　Randolph Patton, "Canadian Group of Painters," *Winnipeg Tribune*, February 23, 1952.

23　Arthur Lismer, copy for CGP catalogue, November 13, 1945, Canadian Group of Painters Papers, Robert McLaughlin Gallery Archives, Oshawa.

24　Jack Bush to Philip Clark, March 24, 1958, Canadian Group of Painters, Robert McLaughlin Gallery Archives, Oshawa.

25　Harold Town, "Note to critics: light bulbs have no lessons for the sun," (Review of Paul Duval's *Four Decades: The Canadian Group of Painters 1930 - 1970*), *Globe and Mail*, November 25, 1972.

26　Maria Tippett, *Lest We Forget* (exhibition catalogue) (London: London Regional Art and Historical Museums, 1989), 26.

27 Harold Beament to Joan Murray, June 6, 1983.

28 Beament letter.

Chapter Four

1 Serge Guilbaut, *How New York Stole the Idea of Modern Art: Abstract Expressionism, Freedom, and the Cold War* (Chicago: University of Chicago Press, 1983), 189.

2 André Breton, *Manifestes du Surrréalisme* (Paris: J.-J. Pauvert, 1962), 40, quoted in Edward Lucie-Smith, *Movements in art since 1945: Issues and Concepts* (London: Thames and Hudson, 1995), 25.

3 Denise Leclerc, *The Crisis of Abstraction in Canada: The 1950s* (exhibition catalogue) (Ottawa, National Gallery of Canada, 1992), 43.

4 Paul-Émile Borduas, *"Refus Global" & "Refus Global: Ten Years After."* The following translations of the original manifesto and the 1958 epilogue to it are by François-Marc Gagnon and Dennis Young as found in *Paul-Émile Borduas: Ecrits/Writings 1942-1958* (Halifax: Press of the Nova Scotia College of Art and Design, 1978), 45.

5 Borduas, *Refus Global*, 51.

6 Interview with Françoise Sullivan by Joan Murray, 15 April 1992, Joan Murray Papers, Robert McLaughlin Gallery, Oshawa.

7 Jean-Paul Jérôme, "La peinture, 'un jeu de l'esprit,' affirme le plasticien Jérôme," *La Presse* (Montreal), 1 December 1954, as quoted in Leclerc, 130.

8 See William Ronald, "Abstracts at Home," *Canadian Art* 11, 2 (Winter, 1954), 51-52.

9 Town, transcript of a talk with the general public, 3 March 1971, Joan Murray Papers, Robert McLaughlin Gallery, Oshawa.

10 Interviews with Ray Mead by Joan Murray, 4 September 1977 and 4 January 1979, Joan Murray Papers, Robert McLaughlin Gallery, Oshawa.

11 Mead interview, 1977.

12 Mead interview, 1979.

13 Mead interview, 1977.

14 Interview with Harold Town by Joan Murray, 11 February 1979, Joan Murray Papers, Robert McLaughlin Gallery, Oshawa.

15 Canadians Abroad: Rebels in Manhattan," *Time* (Canada) 67, 19 (May 1956), 38.

16 See Ken Carpenter, "The Evolution of Jack Bush," *Journal of Canadian Art History* 4, 2 (1977/78), 124-125.

17 Alexandra Luke diary, 30 October 1958, The Robert McLaughlin Gallery archives, Oshawa.

18 Letter from Jock Macdonald to Maxwell Bates, Toronto, 12 November 1958. McCord Museum archives, Montreal.

19 *Painters Eleven with ten Distinguished artists from Quebec* (exhibition catalogue) (Toronto: The Park Gallery, 1959).

20 Jack Bush, "Reminiscences," *Jack Bush: A Retrospective* (exhibition catalogue) (Toronto: Art Gallery of Ontario, 1976).

21 William Ronald interviewed by Michael Hanlon in "Talking with Painter William Ronald," *Globe and Mail*, 23 March 1963.

22 Besides such outlets, the 1960s also saw the birth of the Canadian printshop movement. The person who served as the catalyst to the reawakening of interest in the medium was the traditional printmaker Albert Dumouchel, who in 1955 travelled to Paris to study with master printers. Upon his return, he began to teach printmaking at the École des Beaux-Arts and at the Institut des Arts Graphiques in Montreal. His student, Richard Lacroix, also went to Paris to study (1961-1963). Upon his return, Lacroix established l'Atelier Libre de Recherches Graphiques in Montreal in 1963, the first printshop in Canada to specialize in contemporary art. For more information on print workshops, see Grandbois, Michele. *L'art quebeçois de l'estampe* (exhibition catalogue) (Quebec: Musée du Québec, 1996); Geraldine Davis and Ingrid Jenkner, *Printshops of Canada: Printmaking South of Sixty* (exhibition catalogue) (Guelph: Macdonald Stewart Art Centre, 1987).

23 See, for instance, Karen Wilkin, "Montreal and the Collective Unconscious," *Modern Painting in Canada* (exhibition catalogue) (Edmonton: The Edmonton Art Gallery, 1978), 71-75.

24 I follow here Scott Watson's discussion in *Jack Shadbolt* (Vancouver/Toronto: Douglas & McIntyre, 1990), 39-75.

25 Interview with Gordon Smith by Joan Murray, 24

253

October 1979, Joan Murray Papers, Robert McLaughlin Gallery, Oshawa.

26　Ian M. Thom, "Gordon Smith: The Act of Painting," in Ian M. Thom and Andrew Hunter, *Gordon Smith: The Act of Painting* (Vancouver: Douglas & McIntyre and Vancouver Art Gallery, 1997), 19.

27　Roy Kiyooka interviewed by Joan Murray, April 17, 1978, Joan Murray Papers, Robert McLaughlin Gallery, Oshawa.

28　I follow here Terrence Heath, *Ronald L. Bloore: Not Without Design.* (exhibition catalogue) (Regina: MacKenzie Art Gallery, 1993), 28-29.

29　See Denise Leclerc, *Robert Murray: The Factory as Studio* (exhibition catalogue) (Ottawa: National Gallery of Canada, 1999), 70.

Chapter Five

1　See Irving Sandler, *Art of the Postmodern Era: from the Late 1960s to the Early 1990s* (New York: IconEditions, 1966), 21. John Paoletti, lecturer on the 1960s at the Metropolitan Museum of Art in 1999, calls the work of Eva Hesse and Robert Smithson in American Art "Maximalism" by contrast with Minimalism.

2　Serge Tousignant quoted in Joan Murray, *The Best Contemporary Canadian Art* (Edmonton: Hurtig, 1987), 176.

3　Jack Bush, interview by Leslie Fry and John Newton, March 13, 1975, Joan Murray Artists' Files, Robert McLaughlin Gallery, Oshawa.

4　I follow here Karen Wilkin's discussion in *Daniel Solomon: Paintings and Sculptures: 1988-1992* (exhibition catalogue) (Oshawa: Robert McLaughlin Gallery, 1992), unpaginated.

5　Paul Fournier quoted in James Purdie, "Moods of nature filtered through the artist's mind," *Globe and Mail*, April 7, 1979.

6　Otto Rogers, *Trees for Your Thoughts* (exhibition catalogue) (Sarnia: Sarnia Public Library and Art Gallery, 1980), unpaginated.

7　I follow here Otto Rogers in Joan Murray, *The Best Contemporary Canadian Art* (Edmonton: Hurtig Publishers Ltd., 1987), 148.

8　Gershon Iskowitz, interview with Merike Weiler, *Iskowitz* (exhibition catalogue) (Calgary: Glenbow-Alberta Institute, 1975), n.p.

9　Michael Snow, "Admission (or, Marcel Duchamp)," *The Michael Snow Project: The Collected Writings of Michael Snow* (Waterloo: Wilfrid Laurier University Press, 1994), 286.

10　For a discussion of the show, see Dennis Reid, "Exploring Plane and Contour: The Drawing, Painting, Collage, Foldage, Photo-Work, Sculpture and Film of Michael Snow from 1951 to 1967," *The Michael Snow Project: Visual Art 1951-1993* (exhibition catalogue) (Toronto: Art Gallery of Ontario/The Power Plant/Alfred A. Knopf Canada, 1994), 83.

11　John Perrault, "Plastic Man Strikes," *Art News* 67, 1 (March 1968), 37.

12　Jill Johnston, "The Art of Supply & Demand," *ARTSmagazine* (March 1967).

13　Dennis Burton in Joan Murray, *Dennis Burton Retrospective* (exhibition catalogue) (Oshawa: Robert McLaughlin Gallery, 1977), 22.

14　For a full discussion of the influence of Paul Klee on Snow, see Reid, 119.

15　Michael Snow, "Mmusic/Ssound," *Music/Sound* (edited by Michael Snow) (exhibition catalogue) (Toronto: Art Gallery of Ontario/ The Power Plant, Alfred A. Knopf Canada, 1994), 26.

16　Joan Murray, *John MacGregor: Painter as Time Traveller* (exhibition catalogue) (Oshawa: Robert McLaughlin Gallery, 1993), 4.

17　James Patten, *Modern Metal: Roland Brener, Robert Murray, Royden Rabinowitch* (exhibition catalogue) (London: London Regional Art and Historical Museums, 1995), unpaginated.

18　Christopher Hume, "Klunder goes after a different likeness," *The Star* [Toronto], November 24, 1993.

19　Hume, *The Star*, November 24, 1993.

Chapter Six

1　Victor Cicansky in conversation with Joan Murray, November 14, 1998.

2　Cicansky in conversation.

3　On the role of the photographic media with feminism, see Annette Hurtig, *Art Now: An Expansive Field of Play* (exhibition catalogue) (Kamloops, B.C.: Kamloops Art Gallery, 1998), 25-26.

4　Barbara Astman, *Barbara Astman* (exhibition cata-

logue) (London, Ontario: McIntosh Gallery, 1980), n.p.

5 I follow here Joan Lowndes in "Live Collage: The Performance Art of Tom Graff," *artmagazine* (Dec. 82/Jan/Feb/83), 26.

6 General Idea, "Stolen Lingo," *FILE Magazine* 3, 1 (Autumn, 1975), 21.

7 Ian Carr-Harris, interviewed by Meriké Weiler, "Interview with Ian Carr-Harris," *Art Post* (June/July 1984), 28.

Chapter Seven

1 For this quality in the work of René Magritte, see Paul Crowther, *The Language of Twentieth-Century Art* (New Haven and London: Yale University Press, 1997), 114.

2 See Philip Fry, *Alex Colville* (exhibition catalogue) (Montreal, The Montreal Museum of Fine Arts, 1995).

3 Christopher Hume, "Images of a life devoted to art," *The Star* [Toronto], November 12, 1995.

4 Jack Chambers interviewed by Joan Murray, November 8, 1973, Joan Murray Artists's Papers, Robert McLaughlin Gallery, Oshawa.

5 See Virginia Nixon, "The Concept of "Regionalism" in Canadian Art History," *Journal of Canadian Art History* 10, 1 (1987), 30-39.

6 John B. Boyle, "From the Periphery," *John Boyle Retrospective* (exhibition catalogue) (London: London Regional Art and Historical Museums, 1991), 7.

7 Paterson Ewen in conversation with Doris Shadbolt, *Paterson Ewen Recent Works* (exhibition catalogue) (Vancouver: Vancouver Art Gallery, 1977), n.p.

8 Esther Warkov interviewed by Joan Murray, April 2, 1979, Joan Murray Artists's Papers, Robert McLaughlin Gallery, Oshawa.

9 For this suggestion, I am indebted to [Charles C. Hill], *William Kurelek* (exhibition catalogue) (Ottawa: National Gallery of Canada, 1992-1993).

10 Mark Prent interviewed by Joan Murray, March 9, 1979, Joan Murray Artists's Papers, Robert McLaughlin Gallery, Oshawa.

11 See Barry Lord, "Sunday Afternoon," *artscanada* 24 (January 1967), 13.

12 Claude Breeze in Val Sears, "You don't hang Breeze in the parlor," *The Star* [Toronto], July 1, 1967.

13 Joanne Tod, lecture, Robert McLaughlin Gallery, Oshawa, April 2, 1987. Transcript, Artists's Papers, Robert McLaughlin Gallery, Oshawa, 3.

14 See Bruce Grenville, "Joanne Tod: The Space of Difference," *Joanne Tod* (exhibition catalogue) (Saskatoon and Toronto: Mendel Art Gallery and The Power Plant, 1991), 17. 15. Jerry Zaslove, "Faking Nature and Reading History, The Mindfulness Toward Reality in the Dialogical World of Jeff Wall's Pictures," *Jeff Wall 1990* (exhibition catalogue) (Vancouver: Vancouver Art Gallery, 1990), 90.

16 Colette Whiten, interviewed by Marnie Fleming, Marnie Fleming, *Colette Whiten: Seducing the Receiver* (exhibition catalogue) (Oakville: Oakville Galleries, 1995-1996), 19.

Chapter Eight

1 Barbara London, "Visionary Transformations," *Barbara Steinman: Uncertain Monuments* (exhibition catalogue) (Regina: MacKenzie Art Gallery, 1992), 22.

2 See Arthur Perry, "Liz Magor," *artmagazine* (May/June 1979), 77-78.

3 Philip Monk, *Liz Magor* (exhibition catalogue) (Toronto: Art Gallery of Ontario, 1986), 19, 35.

4 Shelagh Keeley, Canada Council Project Grant Form, October 26th, 1982. Joan Murray Artists' Files, Robert McLaughlin Gallery, Oshawa.

5 See Catherine D. Siddall, *Shelagh Keeley: On-Site Wall Drawings* (exhibition catalogue) (North Bay and Oakville, White Water Gallery and Oakville Galleries, 1985), 5.

6 See Carolyn Bell Farrell, *Shelagh Keeley* (exhibition catalogue) (Oakville: Oakville Galleries, 1990).

7 Robert Everett-Green, "Imagining the body," *Globe and Mail*, March 25, 1995.

8 Diana Nemiroff, Jana Sterbak, *States of Being* (exhibition catalogue) (Ottawa: National Gallery of Canada, 1991).

9 Jana Sterbak quoted in Ann Wilson Lloyd, "An Absurdist Who Savors the Poetry of Technology," *New York Times*, October 4, 1998.

10 Amada Cruz, "Introduction: Sterbak's Dilemma," *Jana Sterbak* (exhibition catalogue) (Chicago:

Museum of Contemporary Art, 1998), 4.

11 Krzysztof Wodicko, "Public Projection," *Canadian Journal of Political and Social Theory* 7, 1-2 (Winter/Spring, 1983), 187.

12 Peter Wilson, "Trip to Ukraine inspires series of haunting images," *Sun* [Vancouver], May 8, 1995.

13 Carolyn Bell Farrell, "Regan Morris: In Absentia," *Regan Morris: In Absentia* (Oakville: Oakville Galleries, 1991), 2.

14 I follow here the description of Judith Schwarz's *Parallel Language* provided by Grant Arnold in *Judith Schwarz* (exhibition catalogue) (Windsor, Art Gallery of Windsor, 1990), 13.

15 Angela Grauerholz quoted by Ian Carr-Harris, "Fellow Traveller," *Canadian Art* 14 (Fall 1997), 87.

16 Christos Dikeakos in *Sites and Place Names: Vancouver/Saskatoon* (exhibition catalogue) (Saskatoon: Mendel Art Gallery, 1994).

17 FASTWÜRMS quoted in Linda Jansma, *Environmental CANADA Project* (exhibition catalogue) (Oshawa: Robert McLaughlin Gallery, 1997).

18 Robert Houle quoted in Gerald McMaster, "The Persistence of Land Claims," *Robert Houle: Indians from A to Z* (exhibition catalogue) (Winnipeg: Winnipeg Art Gallery, 1990), 43.

19 Robert Houle quoted in Gerald McMaster.

20 Jane Ash Poitras quoted in Joan Murray, *Home Truths: A Celebration of Family Life by Canada's Best-Loved Painters* (Toronto: Key Porter Books, 1997), 65.

Chronology

1900 Wilbur and Orville Wright conduct first glider experiments at Kitty Hawk, North Carolina (first airplane completed there in 1903).

1901 Death of Queen Victoria.

1906 Picasso conceives *Demoiselles d'Avignon*.

1907-1915 Canadian Art Club, Toronto.

1909 Arnold Schoenberg, the Austrian-born composer, arrives at concept of *atonality*.
First synthetic polymer (plastic) introduced

1910 James Wilson Morrice in London, England to see Manet and the Post-Impressionists at the Grafton Gallery; event marked the coining of the term "Post-Impressionist."

1911-1912 Morrice accompanies Henri Matisse on visits to Morocco.

1912 Wassily Kandinsky, *Concerning the Spiritual in Art*.

1912-1913 Morrice accompanies Matisse on a second trip to Morocco.

1913 John Lyman and A.Y. Jackson show work in the Thirtieth Spring Exhibition of the Art Association of Montreal.
The International Exhibition of Modern Art at the 69th Regiment Armory in New York (the so-called Armory Show).

1912-1917 Tom Thomson's painting career.

1914 Studio Building built in Toronto by Dr. James MacCallum and Lawren Harris.
Clive Bell, *Art*.

1914-1918 First World War.

1916 Canadian War Memorials Program established by Canadian government in Ottawa.
Canadian Society of Painter-etchers and Engravers formed.

1919 Russian revolution.
Prohibition (U.S.).

1920-1931 Group of Seven founded in Toronto.

1920-1922 Beaver Hall Hill Group founded in Montreal.

1922 U.S.S.R. formed.

1924 Surrealist movement begins.

1927 *Canadian West Coast Art, Native and Modern* at the National Museum of Canada in Ottawa includes work by Emily Carr.
International Exhibition of Modern Art from the Collection of the Société Anonyme, New York, shown in Toronto.

1928 Sculptors' Society of Canada founded in Toronto.

1929 David Milne settles in Canada for good.
Crash of the Canadian stock market.

1929-1932 Yvonne McKague Housser paints industrial subjects in Rossport, Lake Superior, and Cobalt.

1933-1969 Canadian Group of Painters founded in Toronto.
Co-operative Commonwealth Federation (the CCF) launched at Regina.

1934 Jock Macdonald paints first abstraction, *Formative Colour Activity*.

1936 Lawren Harris decides that the approach to art by way of abstraction is best for him.

1936-1939 Spanish Civil War.

1937 Pegi Nicol MacLeod moves to New York.

1939-1948 Contemporary Arts Society in Montreal founded by John Lyman.
Museum of Non-Objective Painting opens in New York (subsequently renamed the Solomon R. Guggenheim Museum).

1939-1945 Second World War.
Transcendental Group of Painters founded in Santa Fe, New Mexico (Lawren Harris a member).

1940 Alfred Pellan returns from Paris to Montreal.

1941 Federation of Canadian Artists founded in Toronto.
First National Conference of Canadian Artists, held at Queen's University, Kingston.
Bombing of Pearl Harbor.
German invasion of Russia.
André Breton, Max Ernst, and Marc Chagall arrive in New York.

1943 Fernand Léger in Montreal to lecture.

1943-1945 Official War Artists' program.

1943-1954 Automatist movement founded in Montreal.

1944 Labour Arts Guild founded in Vancouver.

1945 Germany surrenders.

1946 Cold War begins.
Mass production of television begins in the United States.

1947 Jackson Pollock begins his "drip" paintings.

1948 Borduas publishes the collective manifesto *Refus Global* in Montreal.

Barnett Newman begins to make colour-field paintings in New York.

1950　Kenneth Lochhead appointed director of the Regina College School of Art.

1950-1953　Korean War.

1951　First commercial computer (UNIVAC).

1952　Alexandra Luke in Oshawa organizes *Canadian Abstract Painters*, a touring exhibition.

American critic Harold Rosenberg coins the term "Action Painting."

1952-1959　Vincent Massey, Governor-General of Canada.

1953　Stalin dies. McCarthy era begins (U.S.)

1953-1960　Painters Eleven group, Toronto and Oshawa.

1955　Jauran (a.k.a. Rodolphe de Repentigny) publishes the Plasticien manifesto in Montreal.

Kenneth Lochhead and Arthur McKay in Regina expand the program of the Emma Lake school near Prince Albert.

New Design Gallery, started by Alvin Balkind and Abraham Rogatnick, opens in Vancouver.

1956　First indoor shopping mall opens in Bloomington, Minnesota.

1957　Founding of the Canada Council in Ottawa.

U.S.S.R. launches *Sputnik*.

1958-1966　Ronald Bloore from Toronto director of the then Norman Mackenzie Art Gallery in Regina.

1959　Avrom Isaacs changes the name of the Greenwich Gallery in Toronto to the Isaacs Gallery (in existence till 1991).

Walter Moos opens Gallery Moos in Toronto.

1960　Saskatchewan sculptor Robert Murray moves to New York, planning to stay for a year.

1960-1975　Vietnam War.

1961　Formation of the Regina Five in Regina.

Berlin Wall constructed (comes down in 1989).

The Art of Assemblage, Museum of Modern Art, New York.

Clement Greenberg's *Art and Culture* published.

1962　Greg Curnoe opens the first artist-run gallery, the Region Gallery, in London, Ontario.

Clement Greenberg gives the Emma Lake workshop.

Andy Warhol paints Marilyn Monroe and Campbell's Soup cans in New York.

1963　David Mirvish opens his gallery in Toronto (in existence till 1978).

Mixed Media and Pop Art, Albright-Knox Art Gallery, Buffalo.

John F. Kennedy is assassinated. U.S. begins involvement in Vietnam.

1964　Founding of the Musée d'Art Contemporain de Montréal by the Quebec Cultural Affairs ministry.

Clement Greenberg organizes the exhibition *Post-Painterly Abstraction*, Los Angeles Country Museum of Art (includes work by Jack Bush, Kenneth Lochhead and Arthur McKay).

1965　*The Responsive Eye*, The Museum of Modern Art, New York (includes work by Guido Molinari).

1966　Iain and Ingrid Baxter start the N.E. THING CO., in Vancouver.

Intermedia artists' collective is formed in Vancouver (by the Baxters, among others) (in existence till 1970).

Carmen Lamanna opens a commercial gallery in Toronto (in existence till 1991).

Eccentric Abstraction show curated by Lucy Lippard in New York.

CARFAC (Canadian Artists Representation/ Front des artistes canadiens) is formed by Jack Chambers, Greg Curnoe, John Boyle, Kim Ondaatje, and others, in London, Ontario.

Richard Lacroix founds the Guilde Graphique in Montreal.

Marshall McLuhan and Quentin Fiore, *The Medium is the Message: An Inventory of Effects*.

Roland Barthes, *Système de la Mode*.

Cultural Revolution (China).

1967　Michael Snow makes *Wavelength* in New York.

Robert Forget in the Educational Film Department of the National Film Board acquires the first portable half-inch video recorder in Canada from New York.

1968　General Idea — Jorge Zontal, A.A. Bronson,

258

and Felix Partz — founded in Toronto.

Garry Neill Kennedy becomes president of the Nova Scotia College of Art and Design, Halifax (till 1991).

Pierre Eliot Trudeau elected prime minister of Canada.

Paterson Ewen moves from Montreal to London, Ontario.

Martin Luther King assassinated.

1970 Richard Sewell and Barbara Hall found Open Studio in Toronto.

1971 The 1971 Miss General Idea Pageant Entries, Art Gallery of Ontario and A Space, Toronto.

1972 General Idea founds *File* Magazine in Toronto.

Canada Council establishes Art Bank program.

Vancouver Art Gallery begins to publish *Vanguard*.

1973 *The Western Front Society* founded in Vancouver.

Powerhouse Gallery founded in Montreal (in 1991, it changes its name to La Centrale (Powerhouse)).

1974 Nixon resigns in the aftermath of Watergate.

1976 Michael Snow has a one-person show at the Museum of Modern Art in New York.

Print organizations merge into the Print and Drawing Council of Canada.

1977 Opening of the Centre Pompidou, Paris.

1978 *New Image Painting*, Whitney Museum of American Art, New York.

1979 Germaine Greer publishes *The Obstacle Race: the Fortunes of Women Painters and Their Work*.

Judy Chicago, *The Dinner Party*.

1980 Ydessa Hendeles opens Ydessa Gallery in Toronto, founds Ydessa Art Foundation in 1988.

John Lennon assassinated.

1981-1985 ChromaZone/Chromatique Collective in Toronto.

1982 Coining of the acronym AIDS.

1983 First compact discs.

Discovery of greenhouse effect.

1985 *Young Romantics* show organized by Scott Watson at the Vancouver Art Gallery.

Gorbachev comes to power in the U.S.S.R. Beginning of *perestroika*.

1986 *The Spiritual in Art: Abstract painting 1890-1985*, Los Angeles Country Museum of Art (includes Lawren Harris).

1987 Vincent van Gogh's *Irises* sells for $53 million.

1989 Oil spill by Exxon Valdez.

1990 The National Gallery of Canada spends 1.76 million dollars on a painting by American Barnett Newman.

Germany reunited.

Collapse of the U.S.S.R.

1991 Jana Sterbak's *Vanitas: Flesh Dress for an Albino Anorectic* on view at the National Gallery of Canada, Ottawa, in her retrospective, *States of Being*.

1993 Internet system links 5,000,000 users.

1995 Andrew Wysotski starts the first web site gallery in Canada, in Oshawa.

1998 Noel Harding, *The Elevated Wetlands*, in Toronto.

259

Further Reading

It would be impractical to present a complete bibliography of the vast amount of literature that has appeared about Canadian art of the twentieth century. This is a selection of more recent material relevant to the aim of this book, or of value to the general reader, particular the rich body of material found in exhibition catalogues. The reader is encouraged to consult the *Art Index to Periodical Literature*, which lists articles in the art magazines by subject and author.

The standard text for introductory studies of Canadian painting is Dennis Reid's *A Concise History of Canadian Painting* (Second edition) (Toronto: Oxford University Press, 1988). Reid's account of painting in Canada over three centuries is well-structured. The last painting he discusses in his book is a 1978 work by Toronto painter Shirley Wiitasalo, which leaves over two decades of the century uncovered. Like most of the texts that follow, he does not discuss in depth the art of the First Nations.

J. Russell Harper. *Painting in Canada: A History*, originally published in 1967 (be sure to use the second edition, 1977), is still helpful.

Another helpful guide to twentieth-century movements in Canada, but like Reid and Harper only about painting, is *Modern Painting in Canada: Major Movements in Twentieth Century Canadian Art*, a catalogue written by Fenton, Terry and Karen Wilkin for an exhibition organized by the Edmonton Art Gallery in 1978, published as a book by Hurtig Press the same year. Fenton writes in his introduction that the book isn't a comprehensive survey, and that the authors concentrated on the major movements and groups of painters that created modern painting in Canada (according to them). The book skips the Canadian Art Club and the Canadian Group of Painters but sensitively discusses developments in Montreal and Western Canada. Handy format.

David Burnett and Marilyn Schiff's *Contemporary Canadian Art* (Hurtig Publishers Ltd. in co-operation with the Art Gallery of Ontario, 1983) surveys painting and sculpture from the Second World War to the present. Like Fenton and Wilkin, the emphasis is on the leading developments and the artists who have brought these about. The book has been prepared as a guide for a broad audience. Has a selected bibliography.

In *Visions: Contemporary Art in Canada*, edited by Bringhurst, Robert and Geoffrey James, Russell Keziere and Doris Shadbolt (Vancouver/Toronto: Douglas & McIntyre, 1983), six writers explore art in Canada in a multiple cross-section of Canadian art since the Second World War. After an introductory survey, the book investigates postwar art along five of the paths of recent artists: art as response to place, art as art, art as social response, art as personal statement, art as idea. The pluralist view is an idea of the 1980s. Includes art of the First Nations.

Among exhibition catalogues, note the four-part series published by the Kamloops Art Gallery in Kamloops, British Columbia in 1998 on the occasion of its twentieth anniversary: *Towards the Group of Seven and Beyond: Canadian Art in the First Five Decades of the Twentieth Century*, *Changing Spirits: Canadian Art of the 1960s and 70s*, *Art Now: An Expansive Field of Play*, and *Home Base: Notes to an Installation*.

For a recent gift of a contemporary Canadian collection, see *Temps Composés: La Donation Maurice Forget* (exhibition catalogue) (Joliette, Quebec: Musée d'Art de Joliette, 1998). Includes an account of Quebec Art from the 1940s by Stéphane Aquin and a bibliography.

Smaller, but helpful, studies include the following:

For a theme that unites the century:
Wylie, Liz. *In the Wilds: Canoeing and Canadian Art* (exhibition catalogue) (Kleinburg: McMichael Canadian Art Collection, 1998).

For sculpture:
Holubizky, Ihor. *shape shifters* (Hamilton: Art Gallery of Hamilton, 1907).

For a technique that unites over half of the century:
Murray, Joan. *Canadian Collage* (exhibition catalogue) (Oshawa: Robert McLaughlin Gallery, 1997).

For studies of gender and power:
Nelson, Charmaine. *Through An-Other's Eyes: White Canadian Artists — Black Female Subjects* (exhibition catalogue) (Oshawa: Robert McLaughlin Gallery, 1998).

For a racial study:
Trépanier, Esther. *Jewish Painters and Modernity: Montréal 1930-1945* (exhibition catalogue) (Montreal: Centre Saidye-Bronfman, 1987).

For documents see the following:
Fetherling, Douglas (ed.) *Documents in Canadian*

Art. Peterborough: Broadview Press, 1987.

Bradley, Jessica and Lesley Johnstone (eds.) *SightLines: Reading Contemporary Canadian Art* (Montreal: Artextes editions, 1994) (has an excellent introduction to contemporary Canadian art).

For women artists, the best introduction is Maria Tippett's *By a Lady* (Toronto: Viking, 1992). See also Karen Antaki. *Montreal Women Artists of the 1950s.* (exhibition catalogue) (Montreal: Concordia Art Gallery, 1988).

For art criticism, see Monk, Philip. *Struggles with the Image: Essays in Art Criticism* (Toronto: YYZ Books, 1988); Pontbriand, Chantal. *Fragments critiques (1978-1998)* (Paris, Éditions Jacqueline Chambon, 1998).

From the 1900s till today, magazines about Canadian art have proliferated. An excellent guide to Canada's art and pictorial press exists: McKenzie, Karen and Mary F. Williamson's *The Art and Pictorial Press in Canada* (Toronto: Art Gallery of Ontario, 1979). At the end of this section, I have attached a checklist that includes most of Canada's well-established general interest art journals and magazines post-1940.

1. Tonalism to Post-Impressionism

For the Canadian Art Club, see Lamb, Robert J. *The Canadian Art Club 1907-1915* (exhibition catalogue) (Edmonton: Edmonton Art Gallery, 1988).

For Impressionism in Canada, see Lowrey, Carol. *Visions of Light and Air: Canadian Impressionism, 1885-1920* (exhibition catalogue) (New York: Americas Society Art Gallery, 1995).

The main interpretations of the Group of Seven are as follows:

Hill, Charles C. *Art for a Nation* (exhibition catalogue) (Ottawa: National Gallery of Canada, 1995), and see review by Lynda Jessup, "Art for a Nation?," *Fuse* 19, 4 (Summer 1996), 11-14.

Nasgaard, Roald. *The Mystic North* (exhibition catalogue) (Toronto: University of Toronto, 1984).

For the impact of post-Impressionism, see *The Advent of Modernism: Post-Impressionism and North American Art, 1900-1918* (exhibition catalogue) (Atlanta: High Museum of Art, 1986).

For the Armory show, see Brown, Milton. *The Story of the Armory Show* (New York: Joseph Hirschhorn Foundation, New York Graphic Society, 1963).

For Franklin Carmichael, see Bice, Megan. *Light and Shadow: The Work of Franklin Carmichael* (exhibition catalogue) (Kleinburg: McMichael Canadian Art Collection, 1990).

For Emily Carr, see Shadbolt, Doris. *Emily Carr* (Toronto: Douglas McIntyre, 1990); Moray, Greta. *Unsettling Encounters: The Indian Pictures of Emily Carr.*

For Lawren Harris, see Larisey, Peter. *Light for a Cold Land* (Toronto: Dundurn, 1993).

For John Lyman, see Dompierre, Louise. *John Lyman 1886-1967* (exhibition catalogue) (Kingston: Agnes Etherington Art Centre, 1986).

For David Milne, see Tovell, Rosemarie L. *Reflections in a Quiet Pool: The Prints of David Milne* (Ottawa: National Gallery of Canada, 1980 (contains a catalogue raisonné of Milne's prints); O'Brian, John. *David Milne, The New York Years: 1903-1916* (exhibition catalogue) (Edmonton: Edmonton Art Gallery, 1981); O'Brian, John. *David Milne and the Modern Tradition of Painting* (Toronto: The Coach House Press, 1983); Thom, Ian M. (ed.) *David Milne* (Vancouver: Douglas & McIntyre, 1991); Silcox, David P. *Painting Place: The Life and Work of David B. Milne* (Toronto: University of Toronto Press, 1996), and review by Tovell, Rosemarie L., *Journal of Canadian Art History* 19, 2 (1998), 74ff; Milne, David, Jr. and David P. Silcox, *David B. Milne: Catalogue Raisonné of the Paintings*, 2 vols. (Toronto: University of Toronto, 1998).

For Tom Thomson, see Murray, Joan. *Tom Thomson: The Last Spring* (Toronto: Dundurn, 1994); *Tom Thomson: Design for a Canadian Hero* (Toronto: Dundurn Press, 1998); *Tom Thomson: Trees* (Toronto: McArthur & Co. 1999).

2. Approaches to Abstraction

For a good introduction, see Davis, Ann. *The Logic of Ecstasy: Canadian Mystical Painting 1920-1940* (Toronto: University of Toronto Press, 1992).

For Fritz Brandtner, see Duffy, Helen and Frances K. Smith, *The Brave New World of Fritz Brandtner* (exhibition catalogue) (Kingston: Agnes Etherington Art Centre, Queen's University, 1982).

For Kathleen Munn and Edna Taçon, see Zemans, Joyce; Elizabeth Burrell; and Elizabeth Hunter. *Kathleen Munn and Edna Taçon* (exhibition catalogue) (Toronto:

Art Gallery of York University, 1988).

For Jock Macdonald, see Zemans, Joyce. *Jock Macdonald: the Inner Landscape* (exhibition catalogue) (Toronto: Art Gallery of Ontario, 1981).

For the Sculptors' Society of Canada, see Millar, Joyce. "The Sculptors' Society of Canada: The First Fifty Years, 1928-1978," *ESPACE* 29 (1994), 34-36.

For the Société Anonyme, see Herbert, Robert L.; Eleanor S. Apter, Elise K. Kennedy (coeds.), *The Société Anonyme and the Dreier Bequest at Yale University*; *A Catalogue Raisonné* (New Haven and London: Yale University Presss, 1984).

For Lowrie Warrener, see Daniels, Lisa. *Lowrie L. Warrener* (exhibition catalogue) (Sarnia: Sarnia Public Library and Art Gallery, 1990).

3. Innovations of the 1930s

Hill, Charles C. *Canadian Painting in the Thirties* (exhibition catalogue) (Ottawa: National Gallery of Canada, 1975).

Boyanoski, C. *The 1940's. A Decade of Painting in Ontario* (exhibition catalogue) (Toronto: Art Gallery of Ontario, 1984).

For André Biéler, see Smith, F.K. *André Biéler: An Artist's Life and Times* (Toronto and Vancouver: Merritt, 1980).

For Charlevoix County, see Baker, Victoria A. *Scenes of Charlevoix 1784-1950* (exhibition catalogue) (Montreal: Montreal Museum of Fine Arts, 1982); Smith, Jori. *Charlevoix Country, 1930* (Toronto: Penumbra Press, 1998).

For the Contemporary Arts Society, see [Varley, Christopher]. *The Contemporary Arts Society, Montréal, 1939-1948* (exhibition catalogue) (Edmonton: Edmonton Art Gallery, 1980).

For Yvonne McKague Housser, see Murray, Joan. *The Art of Yvonne McKague Housser* (exhibition catalogue) (Oshawa: Robert McLaughlin Gallery, 1995.)

For Prudence Heward, see Luckyj, Natalie. *Expressions of Will: The Art of Prudence Heward* (exhibition catalogue) (Kingston: Agnes Etherington Art Centre, 1986.)

For Pegi Nicol MacLeod, see Murray, Joan (ed.). *Daffodils in Winter: The Life and Letters of Pegi Nicol MacLeod, 1904-1949* (exhibition catalogue) (Moonbeam, Ontario: Penumbra Press, 1984).

For Isabel McLaughlin, see Murray, Joan. *Isabel McLaughlin: Recollections* (exhibition catalogue) (Oshawa: Robert McLaughlin Gallery, 1983).

For modernism in Quebec art, Ostiguy, Jean-René. *Modernism in Quebec Art, 1916-1946* (Ottawa: National Gallery of Canada, 1982).

For Goodridge Roberts, see Paikowsky, Sandra. *Goodridge Roberts 1904-1974* (exhibition catalogue) (Kleinburg: McMichael Canadian Art Collection, 1998.)

For sculpture, see the following:

Baker, Victoria. *Emanuel Hahn and Elizabeth Wyn Wood: Tradition and Innovation in Canadian Sculpture* (exhibition catalogue) (Ottawa: National Gallery of Canada, 1997.)

Boyanoski, Christine. *Loring and Wyle: Sculptor's Legacy* (exhibition catalogue) (Toronto: Art Gallery of Ontario, 1987)

Cloutier, Nicole. *Laliberté* (exhibition catalogue) (Montreal: Montreal Museum of Fine Arts, 1990.)

For contacts between Canada and the United States, see the following:

Boyanoski, Christine. *Permeable Border: Art of Canada and the United States 1920-1940* (exhibition catalogue) (Toronto: Art Gallery of Ontario, 1989).

Bice, Megan and Udall, Sharyn. *The Informing Spirit* (exhibition catalogue) (Kleinburg and Colorado Springs: McMichael Canadian Art Collection and the Taylor Museum for Southwestern Studies, Colorado Springs Fine Art Center, 1994).

For the early societies and groups, see the following:

Varley, Christopher. *The Contemporary Arts Society, Montreal, 1939-1948* (exhibition catalogue) (Edmonton: Edmonton Art Gallery, 1980.)

Murray, Joan. *Pilgrims in the Wilderness: The Struggle of the Canadian Group of Painters (1933-1969)* (exhibition catalogue) (Oshawa: Robert McLaughlin Gallery, 1993), has a handy list of members.

Handy introductions to Canadian Artists of the First and Second World Wars include Tippett, Maria. *Lest We Forget* (exhibition catalogue) (London: London Regional Art and Historical Museums, 1989), and (about the Second World War), Murray, Joan. "You'll Get Used to It," in Granatstein, J. L. and Neary, P. *The Good Fight* (Toronto: Copp Clark Ltd., 1995).

For the war art of Molly Lamb Bobak, see Foss, Brian. "Molly Lamb Bobak: Art and War," in Richmond, Cindy, *Molly Lamb Bobak: A Retrospective* (exhibition catalogue) (Regina: MacKenzie Art Gallery, 1993).

For Michael Forster, see Jansma, Linda. *Order out of chaos: Sixty Years of a Canadian Artist* (exhibition catalogue) (Oshawa: Robert McLaughlin Gallery, 1993.)

4. Abstract Expressionism in Canada

For a good general introduction, see the following:

Leclerc, Denise. *The Crisis of Abstraction in Canada* (exhibition catalogue) (Ottawa: The National Gallery of Canada, 1992) (has an excellent bibliography).

Ellenwood, Ray. *Egregore: A History of Montreal Automatist Movement* (Toronto: Exile, 1992).

For individual studies, see:

Davis, Ann. *Frontiers of Our Dreams: Quebec Painting in the 1940s and 1950s* (exhibition catalogue) (Winnipeg: Winnipeg Art Gallery, 1979).

Hale, Barry. "Out of the Park, Modernist Painting in Toronto, 1950-1980," *Provincial Essays* 2 (1985).

McKaskell, Robert; Sandra Paikowsky; Virginia Wright; Allan Collier. *Achieving the Modern: Canadian Abstract Painting and Design in the 1950s* (exhibition catalogue) (Winnipeg: Winnipeg Art Gallery, 1993).

For Ron Bloore, see Heath, Terrence. *Ronald L. Bloore: Not Without Design* (exhibition catalogue) (Regina: MacKenzie Art Gallery, 1993).

For Paul-Émile Borduas, see Gagnon, François-Marc (ed). *Paul-Emile Borduas, Ecrits/Writings, 1942-1958* (Halifax: Press of the Nova Scotia College of Art and Design, 1976); Gagnon, François-Marc. *Paul-Émile Borduas* (exhibition catalogue) (Montreal: Montreal Museum of Fine Arts, 1988).

For Jack Bush, see Wilkin, Karen (ed.) *Jack Bush* (Toronto: McClelland and Stewart in association with Merritt Editions Limited, 1984); Carpenter, Ken. *The Heritage of Jack Bush: A Tribute* (exhibition catalogue) (Oshawa: Robert McLaughlin Gallery, 1981).

For Anne Kahane, see Millar, Joyce. *Anne Kahane: Dualities* (exhibition catalogue) (Montreal: Leonard & Bina Ellen Art Gallery, Concordia University, 1999).

For Rita Letendre, see *Rita Letendre: The Montréal Years, 1953-1963* (Montreal: Concordia University Art Gallery, 1989); Roberge, Gaston. *Rita Letendre: Woman of Light* (Laval: Belle Publisher, 1997).

For Alexandra Luke, see Rodgers, Margaret. *Locating Alexandra* (Toronto: ECW Press, 1995).

For Art McKay, see *Arthur F. McKay: A Critical Retrospective* (exhibition catalogue) (Regina: MacKenzie Art Gallery, 1997).

For Guido Molinari, see Campbell, James D. *Molinari Studies* (New York: 49th Parallel, 1987); Dufour, Gary, and others. *Guido Molinari 1951-1961, The Black and White Paintings* (exhibition catalogue) (Vancouver: Vancouver Art Gallery, 1989); Marchand, Sandra Grant.

Guido Molinari, une rétrospective (exhibition catalogue) (Montreal: Musée d'Art Contemporain, 1995); *reConnaître Guido Molinari* (exhibition catalogue) (Grenoble, Musée de Grenoble, 1999).

For Robert Murray, see Leclerc, Denise. *Robert Murray: The Factory as Studio* (exhibition catalogue) (Ottawa: National Gallery of Canada, 1999); Walsh, Meeka (introduction) and Robert Enright (interview), "Dance with Steel: The Sculpture of Robert Murray," *Border Crossings* 18, 2 (May, 1999), 30-43.

For Painters Eleven, see Fox, Ross. *The Canadian Painters Eleven (1953-1960)* (exhibition catalogue) (Amherst: Mead Art Museum, 1994).

For William Ronald, see Belton, Robert. *The Theatre of the Self: The Life and Art of William Ronald* (Calgary: University of Calgary Press, 1999).

For Jack Shadbolt, see Watson, Scott. *Jack Shadbolt* (Vancouver: Douglas & McIntyre, 1990).

For Gordon Smith, see Thom, Ian M. and Andrew Hunter. *Gordon Smith: The Act of Painting* (Vancouver: Douglas & McIntyre and Vancouver Art Gallery, 1997).

For Mashel Teitelbaum, see *Mashel Teitelbaum; A Retrospective* (Hamilton and etc., Art Gallery of Hamilton and etc., 1992).

For Claude Tousignant, see *Claude Tousignant: Charged Spaces, 1955-1998* (exhibition catalogue) (Montreal: Galerie de Bellefeuille, 1999) (includes a full bibliography).

5. Post-Painterly Abstraction, Minimal art, and Post-Minimal art

For more information on print workshops, see Grandbois, Michele. *L'art quebeçois de l'estampe* (exhibition catalogue) (Quebec: Musée du Québec, 1996); Davis, Geraldine, and Jenkner, Ingrid. *Printshops of Canada: Printmaking South of Sixty* (exhibition catalogue) (Guelph: Macdonald Stewart Art Centre, 1987);

For Graham Coughtry, see Hale, Barrie. *Graham Coughtry Retrospective* (exhibition catalogue) (Oshawa: Robert McLaughlin Gallery, 1976).

For Gershon Iskowitz, see Burnett, D. *Iskowitz* (exhibition catalogue) (Toronto: Art Gallery of Ontario, 1982); Freedman, A. *Gershon Iskowitz: Painter of Light* (Toronto/Vancouver: Merritt, 1982).

For Harold Klunder, see Fraser, Ted. *Harold Klunder: In the Forest of Symbols* (London: London Regional Art and Historical Museums, 1999).

For Les Levine, see Schmidt, Johann-Karl (ed.) *Art*

Can See, Les Levine: Media Sculpture (exhibition catalogue) (Stuttgart: Galerie der Stadt Stuttgart, 1997).

For Roland Poulin, see Nemiroff, Diana. *Roland Poulin Sculpture* (exhibition catalogue) (Ottawa: National Gallery of Canada, 1994).

For David Rabinowitch, see *David Rabinowitch: The Gravitational Vehicles* (essay by Whitney Davis) (exhibition catalogue) (Vienna and Paris: Galerie nachst St. Stephan, Galerie Renos Xippas, 1991). *Pacing The World, Construction in the Sculpture of David Rabinowitch* (exhibition catalogue) (Boston: Harvard U., Fogg Art Museum, 1996).

For Gordon Rayner, see Murray, Joan. *Gordon Rayner Retrospective* (exhibition catalogue) (Oshawa: Robert McLaughlin Gallery, 1978).

For Otto Rogers, see *Otto Donald Rogers* (exhibition catalogue) (Vancouver: Buschlen Mowatt Gallery, 1998).

For Michael Snow, see the essays by Dennis Reid, Philip Monk, and Louise Dompierre in *The Michael Snow Project: Visual Art, 1951-1993* (exhibition catalogue) (Toronto: Art Gallery of Ontario; The Power Plant; A.A. Knopf, 1994).

For Jacques de Tonnancour, see Bourgie, Pierre. *Jacques de Tonnancour: De l'art de la nature* (exhibition catalogue) (Montreal: Musée d'Art Contemporain, 1999).

For Joyce Wieland, see [Fleming, Marie] *Joyce Wieland* (exhibition catalogue) Toronto: Art Gallery of Ontario, 1987).

6. Alternative Practices: Body Art; Performance Art; Conceptual Art

For overview see McKaskell, Robert (ed.), *Making it New! (The Big Sixties Show)* (exhibition catalogue). Windsor: Art Gallery of Windsor, 1999.

For Barbara Astman, see *Barbara Astman, personal/persona: a twenty year survey* (exhibition catalogue) (Hamilton: Art Gallery of Hamilton, 1995).

For Geneviève Cadieux, see Gale, Peggy. "Skin Deep," *Canadian Art* 7, 1 (Spring 1990), 58-65.

For Colin Campbell, see *Colin Campbell: Media Works* (exhibition catalogue) (Winnipeg: Winnipeg Art Gallery, 1991).

For Evergon, see Hanna, Martha. *Evergon 1971-1987* (exhibition catalogue) (Ottawa, Canadian Museum of Contemporary Photography, 1988).

For Gathie Falk, see *Gathie Falk Retrospective* (exhibition catalogue) (Vancouver: Vancouver Art Gallery, 1985).

For Betty Goodwin, see Bradley, Jessica and Matthew Teitelbaum (eds.). *The Art of Betty Goodwin* (Vancouver and Toronto: Douglas & McIntyre, and Art Gallery of Ontario, 1998).

For Suzy Lake, see Hanna, Martha. *Suzy Lake: Point of Reference* (exhibition catalogue) (Ottawa: Canadian Museum of Contemporary Photography, 1993).

For the Toronto Art Community, see Philip Monk. *Picturing the Toronto Art Community: The Queen Street Years*, insert in *C international contemporary art 59* (September-November 1998).

For Bill Vazan, see Grande, John K. *Bill Vazan: Jumpgates* (exhibition catalogue) (Peterborough: Art Gallery of Peterborough, 1996).

For Western Front, see Wallace, Keith (ed.), *Whispered Art History: Twenty Years at the Western Front.* Vancouver: Arsenal Pulp Press, 1993.

For Irene Whittome, see *Irene F. Whittome: Consonance* (exhibition catalogue) (Montreal: Centre International d'art contemporain de Montreal, 1995).

7. Developments in Representation; Post-Modernism; New Image Painting

For Alex Colville, see Burnett, David. *Colville* (exhibition catalogue) (Toronto: Art Gallery of Ontario, 1983).

For Greg Curnoe, see Théberge, Pierre. *Greg Curnoe* (exhibition catalogue) (Montreal: Montreal Museum of Fine Arts, 1982).

For Paterson Ewen, see the following: Teitelbaum, Matthew. *Paterson Ewen: the Montreal Years* (exhibition catalogue) (Saskatoon: Mendel Art Gallery, 1988); Teitelbaum, Matthew (ed.) *Paterson Ewen* (exhibition catalogue) (Toronto: Art Gallery of Ontario, 1996).

For Ivan Eyre, see Woodcock, George. *Ivan Eyre* (Don Mills: Fitzhenry & Whiteside, 1981); Heath, Terrence. *Personal Mythologies/ Images of the Milieu: Ivan Eyre, Figurative Paintings, 1957-1988* (Winnipeg: Winnipeg Art Gallery, 1988); *Ivan Eyre* (Winnipeg: Pavilion Gallery, 1999).

For William Kurelek, see Murray, Joan. *Kurelek's Vision of Canada* (Edmonton: Hurtig, 1983).

For Jean-Paul Lemieux, see Robert, Guy. *Lemieux* (Toronto: Gage, 1975).

For Evan Penny, see *Evan Penny* (exhibition catalogue) (Zaragoza: Galeria Fernando Latorre, 1999).

For Christopher Pratt, see *Christopher Pratt* (Toronto: Key Porter Books Ltd., 1995).

For Mary Pratt, see Moray, Gerta. *Mary Pratt* (Toronto: McGraw-Hill Ryerson, 1989); Smart, Tom. *The*

Art of Mary Pratt: The Substance of Light (Fredericton: Beaverbrook Art Gallery, 1995).

For Lisa Steele, see Gale, Peggy. "Lisa Steele: Looking Very Closely," *Video by Artists* (ed. Peggy Gale) (Toronto: Art Metropole, 1976), 201-204.

For Joanne Tod, see Grenville, Bruce. *Joanne Tod* (exhibition catalogue) (Saskatoon and Toronto: Mendel Art Gallery and the Power Plant, 1991).

For Tony Urquhart, see Vastokas, Joan M. *Dialogues of Recociliation: The Imagination of Tony Urquhart* (exhibition catalogue) (San Francisco and Peterborough: Meridian Gallery and Art Gallery of Peterborough, 1991).

For Jeff Wall, see Dufour, Gary. *Jeff Wall, 1990* (exhibition catalogue) (Vancouver: Vancouver Art Gallery, 1990); *Jeff Wall* (exhibition catalogue) (Copenhagen: Louisiana Arts Centre, 1992). Crowe, Thomas. "Profane Illuminations: Social History and the Art of Jeff Wall," *Artforum* 31, 5 (February 1993), 62-69; *Jeff Wall: Restoration* (Lucerne: Kunstmuseum. Luzern: Dusseldorf, Kunsthalle. Dusseldorf, 1994); De Duve, Thierry, Arielle Pélenc, and Boris Groys. *Jeff Wall* (London: Phaidon Press, 1996). *Jeff Wall* (exhibition catalogue) (Los Angeles: The Museum of Contemporary Art; Zurich and New York: Scalo, 1997); Lussier, Réal. *Jeff Wall: Oeuvres, 1990-1998* (exhibition catalogue) (Montreal: Musée d'Art Contemporaine, 1999).

For Colette Whiten, see Fleming, Marnie. *Colette Whiten: Seducing the Receiver* (exhibition catalogue) (Oakville: Oakville Galleries, 1996).

For Tim Zuck, see Cook, Ramsey (ed.) *Tim Zuck: Paintings and Drawings* (Canmore: Altitude Publishing Canada Ltd., 1997).

8. Themes of the 1980s and 1990s: Identity and Difference; Memory; the Environment

For memory and territory, see Gale, Peggy, "Both Memory and Territory...Where is Canada? four artists," *Real Fictions: Four Canadian Artists* (exhibition catalogue) (Sydney [Australia]: Museum of Contemporary Art, 1996) (includes discussion of Stan Douglas, Robert Houle, Ken Lum, Liz Magor.

For sculpture in the 1980s, good starting points are the excellent essays by Barbara Fischer, and Ihor Holubizky in Greer, Rina (ed.). *Toronto Sculpture Garden* (Toronto: CJ Graphics Inc. Printers and Lithographers, 1998).

For Kim Adams, see *Kim Adams* (Zurich, Switzerland and Winnipeg: Shedhalle and Winnipeg Art Gallery, 1990); *Kim Adams: Earth Wagons* (exhibition catalogue) (Toronto and Oakville: The Power Plant and Oakville Galleries, 1992); Enright, Robert (interview). "A Model Artist: observations on art and play from kim adams," *Border Crossings* 18, 1 (January 1999), 16-25.

For Stephen Andrews, see Andrews, Stephen. *Three hundred and sixty-five pictures* (Toronto: Gallery TPW (Toronto Photographers Workshop), 1998).

For Sylvie Bélanger, see [Fleming, Marnie] *The Silence of the Body* (Oakville: Oakville Galleries, 1994).

For Ron Benner, see *Ron Benner: All That Has Value* (London: McIntosh Gallery, 1995).

For Geneviève Cadieux, see *Geneviève Cadieux* (exhibition catalogue) (Montreal: Musee d'Art Contemporain, 1993).

For René Derouin, see Ainslie, Patricia. *Frontiers: René Derouin* (exhibition catalogue) (Calgary: Glenbow Museum, 1998).

For Stan Douglas, see Watson, Scott; Diana Thater; Carol J. Clover. *Stan Douglas* (London: Phaidon Press Limited, 1998); *Stan Douglas* (exhibition catalogue) (Vancouver: Vancouver Art Gallery, 1999); Laurence, Robin, "The Pleasure of Confoundment," *Border Crossings* 18, 2 (May 1999), 53-56.

For General Idea, see *The Search for the Spirit: General Idea 1968-1975* (exhibition catalogue) (Toronto: Art Gallery of Ontario, 1998).

For Rafael Goldchain, see *Rafael Goldchain* with essays by Manguel, Alberto and Claude Baillargeon (exhibition catalogue) (Hamilton: Art Gallery of Hamilton, 1993).

For Angela Grauerholz, see Fleming, Marnie. *Putting the Past in Order* (exhibition catalogue) (Oakville: Oakville Galleries, 1994).

For Peter Krausz, see Campbell, James D. *Peter Krausz: Sites, 1984-1989* (exhibition catalogue) (Oshawa: Robert McLaughlin Gallery, 1989); Roy, Denyse. *Peter Krausz: Les Paysages* (exhibition catalogue) (Joliette: Musée d'art de Joliette, 1999).

For Liz Magor, see Monk, Philip. *Liz Magor* (exhibition catalogue) (Toronto: Art Gallery of Ontario, 1986).

For John Scott, see Murray, Joan. *John Scott: Edge City* (exhibition catalogue) (Oshawa: Robert McLaughlin Gallery, 1994) (contains writings of John Scott, and of many authors about Scott); also *John Scott: Engines of Anxiety* (exhibition catalogue) (Montreal: Gallery of the Saidye Bronfman Centre for the Arts, 1997).

For Barbara Steinman, see *Barbara Steinman: uncer-*

tain monuments (Regina: MacKenzie Art Gallery, 1992).

For Jana Sterbak, see Nemiroff, Diana. *Jana Sterbak: states of being* (exhibition catalogue) (Ottawa: National Gallery of Canada, 1991); also Amada Cruz. *Jana Sterbak* (exhibition catalogue) (Chicago: Museum of Contemporary Art, 1998).

For Video art, see Gale, Peggy (ed.). *Video by Artists* (Toronto: Art Metropole, 1976); Gale, Peggy. *Videotexts* (Waterloo and Toronto: Wilfrid Laurier University Press and The Power Plant, 1995); Gale, Peggy and Lisa Steele. *Video re/View: The (best) Source for Critical Writings on Canadian Artists' Video* (Toronto: Art Metropole/VTape, 1996) (includes complete bibliography for ovr twenty-five years of writings on independent video productions and writings by Canadian artists).

For Performance, see Gale, Peggy and A.A. Bronson (ed.). *Performance by Artists* (Toronto: Art Metropole, 1979).

For First Nations Art, see the following:

McLuhan, Elizabeth and Tom Hill. *Norval Morrisseau and the Emergence of the Image Makers* (Toronto: Methuen, 1984).

McMaster, Gerald and Lee-Ann Martin (ed.) *Indigena: Contemporary Native Perspectives* (Vancouver: Douglas & McIntyre, 1992).

Robert Houle (exhibition catalogue) (Winnipeg: Winnipeg Art Gallery, 1990).

The Spirit Sings: Artistic Traditions of Canada's First Peoples (Toronto/Calgary: McClelland and Stewart/Glenbow, 1987).

Swinton, George. *Sculpture of the Inuit* (Toronto: McClelland and Stewart, 1992).

Tippett, Maria with photographs by Charles Gimpel. *Between Two Cultures: A Photographer Among the Inuit* (Toronto: Viking, 1994).

YoungMan, Alfred. *North American Indian Art: It's a Question of Integrity* (exhibition catalogue) (Kamloops, B.C.: Kamloops Art Gallery, 1998) (includes an excellent bibliography).

Wight, Darlene Coward, *Between Two Worlds: Sculpture by David Ruben Piqtoukun* (Winnipeg: Winnipeg Art Gallery, 1996).

For the Environment, see the following:

Gablik, Suzi. *Conversations Before the End of Time.* (New York: Thames and Hudson Inc., 1995).

Grande, John K. *Balance. Art and Nature* (Montreal: Rose Books, 1994).

Annette Hurtig, "The Culture of Nature," *Art and its Practices: An Investigation of Contemporary Art — The Culture of Nature* (exhibition catalogue) (Kamloops, British Columbia: Kamloops Art Gallery 1996).

Wilson, Alexander. *The Culture of Nature: North American Landscape from Disney to the Exxon Valdez* (Toronto: Between the Lines, 1991).

Selected Canadian Art Magazines, 1940-

Artfocus 1992-

Artichoke 1989-

Art Impressions 1985-

artmagazine 1969-1983; in 1983 became Art Post; in 1992 became Artfocus

Artists Review 1977-1980

ArtsAtlantic 1977-

artscanada 1967-1982 (see also Canadian Art; Maritime Art)

Artword Artists Forum 1992-1996

Border Crossings 1985-

Border/Lines 1984-

C 1983-

Canadian Art 1943-1966; 1984-

The Canadian Forum 1920-

Collapse 1995-

Cube 1997-

ESPACE 1982-1985, 1987-

Etc. Montreal 1987-

Exile 1972-

Fuse 1980-

Inuit Art Quarterly 1986-

Journal of Canadian Art History 1974-

Magazin' Art 1988-

Maritime Art 1940-1943; in 1943 role expanded, name changed to Canadian Art; in 1967 became artscanada; in 1984 became Canadian Art

Matriart 1990-

Mix (formerly Parallelogramme) 1995-

Parachute 1975-

Public 1988-

Racar* 1974-

The Rebel 1917-1920

THE STRUCTURIST 1960-

Vanguard 1972-1989

Vie des Arts** 1956-

Westbridge Art Market Report 1992-

Workseen/Workscene Artists Forum 1989-1992; in 1992 became Artword

*The method section of this magazine provides abstracts of articles in French language periodicals.
**For an excellent article on the contribution of this magazine to the discourse of the visual arts in Quebec during the 1950s and 1960s, see Moreau, Louise. "L'Art de la Modernité," *Journal of Canadian Art History* 19, 1 (1998), 52-85.

Index

269

272